Erika Lederman

About the Author

KATE BERRIDGE is the author of *Vigor Mortis* and has contributed to *Vogue, The Spectator, The Sunday Times,* and *Town & Country,* among other publications. She lives in London.

Also by Kate Berridge

Vigor Mortis: The End of the Death Taboo

Madame Tussaud

A Life in Wax

KATE BERRIDGE

HARPER ⬤ PERENNIAL

NEW YORK • LONDON • TORONTO • SYDNEY

HARPER ● PERENNIAL

First published in Great Britain in 2006 by John Murray (Publishers), a division of Hodder Headline, under the title *Waxing Mythical*.

A hardcover edition of this book was published in 2006 by William Morrow, an imprint of HarperCollins Publishers.

FIRST HARPER PERENNIAL EDITION PUBLISHED 2007.

The Library of Congress has catalogued the hardcover edition as follows:

Berridge, Kate.
 [Waxing mythical]
 Madame Tussaud : a life in wax / Kate Berridge.—1st ed.
 p. cm.
 Published under the title: Waxing mythical. London : J. Murray, 2006.
 Includes bibliographical references and index.
 ISBN-13: 978-0-06-052847-8
 ISBN-10: 0-06-052847-8
 1. Tussaud, Marie, 1761–1850. 2. Wax modellers—France—Biography.
 3. France—History—Revolution, 1789–1799. I. Title.

 DC146.T9B47 2006
 736'.93092—dc22
 [B] 2006048134

ISBN: 978-0-06-052848-5 (pbk.)
ISBN-10: 0-06-052848-6 (pbk.)

07 08 09 10 11 ID/RRD 10 9 8 7 6 5 4 3 2 1

For Sebastian

Contents

Illustrations

We cannot imagine how difficult it must have been for her to make casts from the faces of her dead friends. But she had no choice. She was more or less told, 'Do it, or you'll be the next one to have your head cut off'

<div align="right">Anthony Tussaud, great-great-great-grandson, 2002</div>

Prologue

THIS IS A story about a queue which started in Paris in around 1770 and which still snakes around cities all over the world – London, New York, Las Vegas, Amsterdam and Hong Kong. In London, the perpetual queue is a familiar landmark, and taking up a place in it is a rite of passage, with those who went as children returning as parents. Undeterred by long delays and London rain, people of all ages and nationalities wait patiently for their turn to pass through the doors of a vast, windowless building, purpose-built in 1884 to accommodate their rising numbers. The building has the architecture of secrecy about it, and there are no clues as to what lies inside, but if you raise your eyes above the height of the passing double-decker buses you will see a silhouette portrait of the woman whose name the building bears, with the dates of her life: Madame Tussaud 1761–1850.

Madame Tussaud has generally been neglected as a quaint irrelevance to mainstream history. Rather too readily dismissed as a pretentious show-woman, she has received barely a mention in the footnotes of historical record. Marginalized by the Establishment, she has been seen as only slightly more credible than a fairground entertainer – not authoritative enough to be taken seriously as either an artist or an historian. To a degree, she has suffered from the prejudice that still treats popular culture as an embarrassing nouveau-riche relation to art and culture proper. The celebrity-filled waxworks presented under her name are all too readily written off as a flashy, frivolous entertainment. This is to underestimate their original function in a period with a limited pictorial reference, when they supplied a visual narrative of events.

When the notion of a personal copy of a newspaper was still a long way in the future, her wax artefacts supplied a commodity which in

Georgian England was in short supply: information, the most basic unit of which was news. As visual dispatches, her figures were an accessible format of both foreign and home news. When most illustration was monochrome, and primitive woodblocks provided only poor-quality likenesses, her life-size colourful mannequins of murderers and monarchs were a source of wonder and delight.

Nowadays, when every picture sells a story, one could say Madame Tussaud was the original tabloid journalist, her topical tableaux supplying the mass market with a constant stream of the sensational and newsworthy. Reporting royal news was a particular strength, and coronations became her stock-in-trade. These were not confined to legitimate claimants to crowns – a story that in her hands ran and ran was the rise and fall of Napoleon, an epic narrative of self-made success for which her status-conscious audience never lost their appetite.

As well as reporting the present, Madame Tussaud represented the past. She prided herself on the pedagogical function of her exhibition, and applied her ethos of learning and leisure to historical biography. Her interpretation of history in human terms, rather than as an impersonal series of laws and wars, struck a chord with an audience for which the lives of great men of the past – besides patriotic pride – were starting to kindle fantasies of their own aspirations. This version of the past was subjective, but always determined by public interest.

Most of the few museums and national art galleries that existed in the first half of the nineteenth century seemed to do everything in their power to keep the public out, whereas Madame Tussaud strived for accessibility. Long before governments deemed public museums and libraries a worthwhile addition to the civic welfare agenda, Madame Tussaud blazed an impressive trail of private enterprise in the service of public interest. It was only after her death that the profits from the Great Exhibition were deployed to fund the three core repositories of public learning, the Victoria & Albert Museum, the Natural History Museum and the Science Museum.

The backdrop to Madame Tussaud's life story is fear of the crowd. This engendered a form of cultural apartheid whereby the pleasures and cultural diet of different classes were strictly regulated. In her lifetime she witnessed the most destructive capability of people en masse, which continued to haunt the Establishment. But in tandem

with this was a more positive aspect of people power – as mass-market consumers curious to know about the human face of both history and the here and now. Madame Tussaud recognized this and, tailoring her entertainment for the burgeoning middle classes in particular, she set in motion the mechanics of her own success, melting existing hierarchical barriers in the process. By catering to the crowd as consumers, not patronizing them as philistines or fearing them as a serious threat to public order, she took a radically different stance from the custodians of culture in Georgian and early Victorian England. Instead of fearing the barbarians at the gate, she charged them admission and sold them catalogues. Significant aspects of her achievement were her exploitation of public interest and her recognition of the binding power of popular culture. As Joseph Mead wrote in 1841, 'Madame Tussaud has built her fortune on common sympathies – thousands crowd her rooms: princes, merchants, priests, scholars, peasants, schoolboys, babies in one common medley.' Recognizing the rich pickings to be made from popular interest in the famous and infamous, she harnessed her considerable entrepreneurial energy to cater to it, outclassing all the rivals for the same market.

An article in *Chambers's Journal* at the turn of the century considers both the perennial appeal of the waxworks and the phenomenon of their fame:

> The taste for waxworks is universal, and one upon which we might moralise at great length. It is part and parcel of that taste for dolls, which most girls manifest, and which clings to the very many even when they have ceased to be children. Viewed in this light Madame Tussaud's exhibition is a huge glorified dolls' house with a strong human element attached. But it is more than this. It is a kind of national monument and the name of its foundress is more familiar too, and probably more thought about by thousands of English men and women, than is the name of the genius who built St Paul's.

In terms of brand recognition, Madame Tussaud's is one of the most successful names in the commercial world. It has a familiarity which even in her lifetime extended abroad and, more pertinently, across classes. Long before Mr Henry Harrod went to the rescue of one of his trade customers, a grocer in Knightsbridge, and overhauled his

ailing business so that it became one of the most famous shops in the world, and before Monsieur Schweppes got the lucrative contract for distributing non-alcoholic 'effervescent beverages' to refresh the visitors at the Great Exhibition, Madame Tussaud imprinted her name in the minds of an impressive number of the population of England, Scotland and Ireland, and became a byword for commercial success. In establishing herself as a brand, she recognized the role of advertising, and at a time when this industry was in its infancy she proved herself a pioneer in exploiting and innovating various forms of publicity.

In the wake of her own extraordinary rise to fame and fortune, which peaked in the final decade of her life, her unique hall of fame came to exert a great influence, and she herself was regarded as an unofficial arbitrator of worldly success. In 1849 *Punch* magazine referred to 'The Tussaud Test of Popularity':

> In these days no one can be considered properly popular unless he is admitted into the company of Madame Tussaud's celebrities in Baker Street. The only way in which a powerful and lasting impression can be made on the public mind is through the medium of wax. You must be a doll at Madame Tussaud's before you can become an i-dol(l) of the multitude. Madame Tussaud has become in fact the only dispenser of permanent reputation.

Inclusion in her exhibition was the definitive proof that one had attained celebrity status. Conversely, exclusion pricked the pride of the most unlikely people: the great historian Thomas Babington Macaulay, on hearing of the death of Madame Tussaud, confided in a letter to a friend, 'I can wish for nothing more on earth, now that Madame Tussaud in whose Pantheon I hoped once for a place is dead.' The exhibition was both denigrated as an insignificant amusement arcade and venerated as a secular cathedral.

As a prism through which to see the present afresh, the story of Madame Tussaud provides an unparalleled perspective on the emergence of the cult of celebrity. Her long life saw a general cultural shift in interest away from posthumous glory in heaven to a greater preoccupation with self-definition on earth. For a society increasingly transfixed by the lure of earthly fame, Philippe Curtius, her

predecessor, mentor, and founder of the original waxworks exhibition in Paris, and Madame Tussaud after him, promoted a compelling form of secular idolatry. They pandered to a growing cult of admiration, in which a new regard for the standing of others in the public arena was a by-product of an increasingly status-conscious society. In times effervescent with change, and a period of history in which democratic currents were destabilizing the status quo, the waxworks exemplified an emerging culture of impermanence. They highlighted the mutability of fame, and the shadow side of human nature that is reflected in our propensity to topple those whom we have placed on pedestals. From its earliest origins in pre-Revolutionary Paris, the exhibition showed how the ascent of human ambition celebrated in wax can be followed by meltdown, just as Icarus 'felt the hot wax run, unfeathering him': those no longer of public interest are ignominiously removed. The waxworks were and are a brutal index of our voyeuristic fascination with the fall as well as the rise of celebrities, and of the waning of our loyalties that make us fickle fans.

Underpinning the rise of Madame Tussaud's exhibition is a remarkable personal story of survival, weathering reversals of fortune, and life-threatening incidents that would have defeated a lesser being. Success was a triumph over cultural, commercial and personal setbacks. And what of the woman herself? One of the most famous names in the world belongs to a woman whom many people in the queue think is a fictional character. Long-standing myths and anecdotes repeated so often they have assumed the credibility of facts have fuelled a sense of someone larger than life, but whose life is never really fleshed out. It is a central proposition of this book that many of these myths were given birth by her, as she created her own image as deftly as one of her models.

The public persona she assumed when she came to England was an integral part of her branding. Having presented herself as a victim and survivor of the French Revolution, Madame Tussaud remains for all time suspended in people's imagination as a young woman with a guillotine-fresh head in her lap. The image of an innocent woman in a bloody apron being forced to make death heads to save her own neck elicited both sympathy and curiosity in her public. The power of this image was increased by her claims to have known many of the people

whose heads she was forced to mould. She made much of her early life as a pet of the palace of Versailles, where in the final days of the *Ancien Régime* she was art tutor to Madame Elizabeth, sister of Louis XVI.

The most effective way in which her early history fed the myth was via the official memoir published when she was in her late seventies as *Madame Tussaud's Memoirs and Reminiscences of France, Forming an Abridged History of the French Revolution*. This is the principal source of information about Madame Tussaud for the first half of her life, until she came to England. Written in the third person by a family friend and émigré, Francis Hervé, as if dictated to him, the book seems curious in style to present-day readers. It is telling that Hervé even puts in a disclaimer, attributing any inaccuracies to Madame Tussaud's great age: 'For although the memory of Madame Tussaud is remarkably clear for events, it is not the same for dates, being nearly eighty years of age and having passed so considerable a period of her life in a state of excitement, the recollections must sometimes be in a degree confused and impaired.' After this apologia, in a rather opportunist way, he recommends the more reliable work on the Revolution that his brother has written. More recent biographers have not been so cautious, and have tended to disregard or downplay the lacunae in Madame Tussaud's own version of her early life, and so the myths have endured.

Unpicking the embroidery of her early life in France from the flimsy framework of fact is complicated by scant sources. Until the middle-aged Madame Tussaud steps off the packet ship in England and into her identity as victim and survivor of the Revolution, the only previous references to her are in a handful of legal documents.

In three distinct phases of her life she is concealed by different means. For the first half of her life in France, her unreliable memoirs conceal far more than they reveal. She is least clearly seen in her apprenticeship years, learning her craft. In contrast to her charismatic mentor Curtius, whose presence in public records confirms his pre-eminence in the Paris entertainment scene, we can only imagine his talented charge, a slight-framed girl, anonymous in the pullulating crowds of the entertainment district where the original exhibition had a site. Her omissions are glaring. There is nothing about personal relationships with her mother and Curtius, just a smokescreen of anecdote and half-

truths, giving the overall impression of a real person being obscured by an illusory identity.

Later, in England, it is not just psychological but also physical absence that is the challenge. From 1802 for almost twenty-seven years Madame Tussaud was on the road, among the travelling showmen whose tracks are so faint in historical records. To track this phase of her progress we have only a paper trail of entertainment ephemera (precious remnants of her publicity material) and a few letters home, which stop abruptly in 1804.

In the final phase of her life, at the height of her fame, the identification of her with her exhibition is complete. Now she is hidden behind the institution, and eclipsed by the brand she has built. Although her creation had almost a permanent presence in the press, and she was regularly sighted at the exhibition until almost the very end of her life, the woman who enabled a paying public to get close to the famous remained ironically elusive. Like a waxwork, she seems more lifelike than alive. We have few insights into either her feelings or her opinions and those things that convey the texture of personality.

At both the personal and general levels, Madame Tussaud's life raises interesting questions about history. Unlike archaeological remains, her relics and artefacts had an agenda. They were designed, made and displayed with a specific purpose – to generate takings at the till. Similarly, her self-propaganda and the way she marketed herself as a victim and survivor of the French Revolution also served her purpose, engendering an authenticity for her figures that set her apart from the competition.

An as yet unconsidered aspect of Madame Tussaud's life that this book will explore is her role as an historian. It is an important consideration, for aside from any harmless embellishment of her own personal history is the more serious point that her revolutionary relics, death masks and heads have been a highly influential visual account of the French Revolution.

If, as Queen Victoria averred, history is an account not of what actually happened, but of what people think happened, then this is particularly pertinent to Madame Tussaud. For too long her biographical claims have been unchallenged. In the absence of hard

facts, it seems appropriate to ask more questions. Over two hundred years after her birth, and some 200 million visitors later, Madame Tussaud remains enigmatic. What is more clearly defined is her identity as a brilliant businesswoman, artist, publicist and pioneer of mass-market entertainment. But how much of her story is history, and how much hoax?

1

The Curious Cast of Marie's Early Life

IN HER MEMOIRS, Madame Tussaud claims that she was born in Berne, Switzerland, in 1760, and yet a baptismal record dated 7 December 1761 from the register of Old St Peter's Catholic Church authenticates Strasbourg, in France, as her birthplace. The brevity of this single paragraph written in a clergyman's spidery scrawl belies its importance, for it testifies to more than the baptism of the child, christened Anna Maria (but known as Marie to distinguish her from her mother, of the same name). It records the absence of the father, and it names as a godfather the sexton of the parish, Johannes Trapper. More intriguing is the absence of the child's mother at the christening, for it is the local midwife, cited as 'Obstretrix Müllerin', who is recorded as bringing the baby girl to church. It is generally safe to assume that the summaries of our lives that are the three pieces of paperwork recording birth, marriage and death are straightforward, and yet with Madame Tussaud there is more to them than meets the eye. In a life where so little can be verified, these documents are valuable factual fragments that point to discrepancies in her personal claims.

The absentee father, named as Joseph Grosholtz, remains a paternal phantom, for no other records exist that flesh him out. The sole source of information about him is the extraordinary woman his named daughter became. In her memoirs she attributes the paternal absence to his death two months before she was born. She describes him as a soldier of some distinction – specifically an aide-de-camp to General Wurmser and veteran of the Seven Years War, in which 'he was so mutilated with wounds that his forehead was laid bare, and his lower jaw shot away and supplied by a silver plate.' There is a certain grim poetic resonance in this grizzly image of her facially disfigured

father. It foreshadows one of the most famous exhibits in her Chamber of Horrors, namely Robespierre's death head with smashed features as a result of the self-inflicted wound when his suicide attempt backfired and he blew away most of his jaw.

Her deceased father, she assures us, was from a distinguished family, the Grosholtz name 'being as renowned in Germany as Percy in England, Montmorency in France or Vicomti in Italy'. Yet there is some evidence that, rather than being blue-blooded, the family tree had blood dripping from its branches. Members of the Grosholtz family were distinguished only as having been public executioners in Strasbourg and Baden-Baden in a line of office stretching back to the fifteenth century. So perhaps Madame Tussaud's predilection for horror was hereditary. As for her absent mother, an earlier parish record at the same church verifies that she was baptized there too, and sets her age at eighteen at the time of her husband's death and daughter's birth. And as for the young mother's antecedents, Madame Tussaud describes the clan Walter (the register of baptism writes the name as 'Walder') as being 'of a highly respectable class, and their husbands were members of the Diet or parliament of Switzerland'. These connections hint at a genealogical aggrandisement that was to manifest itself in different ways throughout her life, for such grand relations seem strangely at odds with the humble church in the heart of a working-class district of Strasbourg with a local midwife as a proxy parent and the village sexton as godfather.

A further hint at Marie's lowly station was the fact that her mother was in domestic service, and Madame Tussaud's story properly starts with the young bachelor for whom her mother went to work as a housekeeper shortly after Marie was born: Philippe Guillaume Mathé Curtius, native of Switzerland and resident of Berne. When Marie was about two, in the city she claimed as her birthplace this young doctor received a visit from the Prince de Conti, a cousin of Louis XV, who was visiting Rousseau in exile in Neufchâtel and Berne. The royal visitor was seeking out Curtius not for advice on his health, but to admire his wax miniatures. This small private collection in Curtius's home drew first a trickle of interest from locals, and then visitors from further afield as word spread of the doctor's artful representation of the human form and the quality of his anatomical waxes. In the

absence of refrigeration, the preservation of bodies for medical teaching was greatly restricted, and wax models fulfilled a vital role as an educational resource. However, the line between education and eroticism was elastic, and Curtius's lithe lovelies with flip-open navels – anatomical Venuses as they are sometimes called – were prototypes for more overtly titillating tableaux he made later.

Curtius's facility for replicating the texture and tint of living flesh inspired him to redirect his talents to portraiture, but whether portraits or pornography were the main reason for his renown and de Conti's interest is unclear. But evidently de Conti was so impressed by what he saw that he made Curtius an immediate offer of patronage if he would move to Paris and develop his talent on a much bigger stage. Instead of being an amusing diversion for the burghers of Berne, Curtius was to be plunged into the centre of a city with a voracious appetite for pleasure. The journalist and writer Louis-Sébastien Mercier (1740–1814) described pre-Revolutionary Paris as a city 'of limitless grandeur, of monstrous riches and scandalous luxury. She guzzles greedily both men and money.'

Curtius began his new life in a gracious apartment in the Rue Saint-Honoré, one of the most prestigious neighbourhoods in the city and especially popular with the growing number of aristocrats who preferred the pace and colour of Paris to the stultifying formality of the court at Versailles. De Conti was of this number – an urban sophisticate who, as well as being a patron of playwrights, painters and writers, was a roué of some renown. He is said to have commemorated his conquests with snuffboxes and rings that at his death ran into the hundreds. It is therefore likely that he enjoyed Curtius's erotic tableaux, which from his earliest days in the city the doctor established as a lucrative sideline to his work on public display. As a contemporary put it, 'The sale of little groups of wanton and licentious figures to the curious for their boudoirs brought him in more money than his salon.' (Boudoirs all over the city were evidently busy places, for, while Curtius sold risqué accessories, quacks did brisk business with venereal-disease cures that sweetened the sting of sin by lacing mercury with chocolate syrup.)

With the support of de Conti – whom Marie recalled as a generous patron whose 'liberality and kindness not only equalled but rather

surpassed his promises' – Curtius quickly distinguished himself as an entrepreneur-cum-artist of astute judgement and prolific output. Financial security from both private commissions of miniature portraits and the public exhibition of full-scale wax figures and busts of the luminaries of the day meant that in around 1768 he felt confident enough to invite his former housekeeper and her young daughter to live with him.

His evident attachment to the mother and daughter and their status in his life have fuelled speculation ranging from the theory that Anna Maria was his sister, and he was therefore Marie's natural uncle, to the theory that he was Marie's father as the result of an adulterous affair. Marie refers to her mother's culinary prowess, but the degree of Curtius's loyalty to them both, and his life-long commitment to their welfare, would seem to be founded on more than appreciation of Alsatian casseroles. She describes him as 'her uncle who afterwards assumed towards her the character of a father, both in regard to tenderness and authority', and she goes so far as to say that 'he legally adopted her as his child'. In fact there is no evidence of either formal adoption or a blood-line connection – an omission that would cause bureaucratic difficulties later on. Nevertheless, the paternal role played by Curtius is acknowledged within the Tussaud family history, for a faded Edwardian letterhead for official correspondence lists the credentials of the various founders and artist modellers in the firm's history, and here Curtius is billed as 'Madame Tussaud's Maternal Uncle and Foster Father'.

When the six-year-old Marie first came to Paris, Louis XV, bloated and bored, was in the final decade of his long reign. In the words of Madame Campan, the educator and friend of Marie Antoinette, he was 'weary of grandeur, fatigued with pleasure and cloyed with voluptuousness'. His popularity had plummeted from the early years when his people called him 'the well-beloved', and in 1763, when a grand equestrian statue showing the King flanked by figures depicting the classical virtues had been erected in a square in central Paris, the satirists had quipped, 'Virtues on foot, vice on horseback.' This signified a waning of regard for the *Ancien Régime* that was gathering momentum. Whereas formerly Versailles had fixed the cultural gaze of Paris, increasingly Paris was originating ideas, fashions,

movements and moods. In an unprecedented way, Versailles was now starting to look to the capital. There was such a buzz there that one aristocratic woman declared that she would rather be dead in Saint-Sulpice than alive in the country. (Saint-Sulpice was a church in a smart part of Paris where the VIPs went to RIP.) This was extremely propitious for Curtius.

The accomplished modeller was in the right place at the right time. Paris was in a ferment of change in the last twenty years of the *Ancien Régime* and, given its mutability, wax was an ideal medium with which to reflect a changing society that was rent with contrasts – rich and poor, old and new, religious and secular. As a source of light, destructible by heat, infinitely malleable into new forms, wax fitted the mood of this period when Paris itself was being remade. There was a building boom on such a scale and at such a speed that a proliferation of maps could not keep up and was out of date in no time. But the change was more profound: creeping secularism meant that wax, the medium that historically had been so closely identified with the Church – funeral effigies, devotional and votive artefacts – could be redirected by Curtius to cater for a new market whose aspirations were increasingly worldly.

Diderot and d'Alembert's *Encyclopédie* (1751–72) had set the tone. A letter from Diderot to Voltaire reveals the agenda: 'It is not enough for us to know more than Christians; we must show we are better.' Each volume, like a secular manifesto, presented a different way of thinking about the world based on reason rather than religion. Although the faith of the majority remained strong, the tenets of Christianity were being undermined by a variety of literary genres with a common emphasis on the power of the individual for self-advancement on earth.

This was an important theme in the work of Jean-Jacques Rousseau, and his ideas reverberated beyond his readership. Later on, the unfortunate Louis XVI would blame all France's problems on this controversial figure, whose *The Social Contract* of 1762, with its message of equality and accountability of governments to the people, had been like a grenade lobbed at the old order.

Such subversive elements were radical in a society where literacy and learning had hitherto been mediated by the Church, and

education was largely in Latin and had a one-subject syllabus of theology, with the ultimate objective of getting into the kingdom of heaven. Indicative of the atheistic currents, a man dressed as Harlequin drew large crowds by quoting extracts from a banned book about the life of Christ that claimed Jesus was 'no more than an enthusiastic, melancholy artisan, a charlatan from a carpenter's workshop who deluded men of the lowest class', and that the Gospels should be treated like an Eastern romance and were 'a little less worthy of credence than the 1001 nights'.

If religion was under attack, there were also aspects of the clergy that made them easy targets for anticlericalism. They represented some of the most iniquitous aspects of the system of privileges, including being exempt from many of the taxes on basic foodstuffs that pressed so heavily on the poor – for example the salt tax. They were also not always as diligent as they might have been about preparing their sermons, which gave rise to an unorthodox trade in religious tracts. Mercier provides an amusing insight into the transactions at a sermon shop in Mont Saint-Hilaire.

'And what can we do today for your reverence? A Conception? A Nativity? An Assumption? Fifteen Last Judgements going very cheap, a nice lot of "Forgive us our trespasses", thirty-two Passions – take your choice.'

'No,' says the deacon, 'It's an Immaculate Conception I want, and a Mary Magdalene as saint not sinner.'

'I can do it for Your Reverence, but I've only three copies left. Mary Magdalene without sins nearly as rare as Immaculate Conception: 8 francs a piece, lowest I can do them. But anything on charity I can let you have very reasonably 2 francs 50 a piece.'

In a reversal of the concept of self-denial to acquire spiritual worth, acquisition of things to increase social status became a common aim. Rampant consumerism was a powerful aspect of secularism, as Paris fell in love with shopping. Even the well-to-do, who traditionally did not frequent shops – suppliers going to *them* instead – deigned to grace the new wave of designer boutiques. A sighting of a duchess at a certain snuff shop resulted in a perpetual queue there for some weeks. But it was the affluent middle classes who most loved to shop, and the

Rue Saint-Honoré, where the Curtius/Grosholtz ménage first lived, was fast emerging as a premier shopping destination.

Glittering showrooms, with Venetian-glass cabinets and engravings of their celebrity clientele, attracted well-heeled tourists and locals. Here, to impress his Venetian amours, Casanova stockpiled stockings from Madame Barat, and here the famous fashion house Trait Galant became as renowned for the superstardom of two of its former shop girls as for its current collections. The two young assistants, who at different times and by different routes would rise from shop-floor humility to great fame and fortune, were Rose Bertin and Madame Du Barry, and each achieved the pinnacle of ambition that came from being a power behind the throne.

Bertin is often credited as the creator of haute couture, and at the peak of her power she turned Marie Antoinette into the costliest and most widely copied clothes horse in the world. Long before she acquired her own legendary showroom she served her apprenticeship at Trait Galant. And before the ravishingly pretty young Jeanne Bécu became Madame Du Barry and the mistress of Louis XV, with perks that turned her life into a perpetual shopping trip, that was where she trimmed hats and tended customers. Madame Du Barry – shown languid, long-necked and delectable on a daybed – was one of Curtius's earliest and most popular figures on public display. One of the wax portraits which Marie brought with her to England, this model can still be seen. When it was first shown, the sex life of the King was a topic of great interest, and there was a particular frisson in being able to get up close to a recumbent model of his mistress and indulge in salacious speculation in earshot but not hearing of her delicate waxen lobes.

After the rustic charms of Berne, a city of clogs and lederhosen and women with plaits, Marie as a little girl was plunged into a society where noble women wore wide hooped-skirts called panniers, towering wigs, and shoes designed not to be walked in. Madame de La Tour du Pin (born Henrietta-Lucy Dillon) whose journal spanning the demise of Louis XVI to the restoration of the monarchy is a brilliantly illuminating social history of this period, recalled 'narrow heels, three inches high, which held the foot in a similar position to when standing on tiptoe to reach the highest shelf in the library'. How strange these upper-class constrictions of high heels, high hair and

heavy skirts must have seemed to the gimlet-eyed child, whose keen powers of observation took in every detail. The restrictions of dress underscored the privileges of aristocratic indolence, and from early childhood Marie must have quickly grasped the gulf between classes as she contrasted the exotic immobility of the grand dames carried in sedan chairs or conveyed in fine carriages that came and went from the aristocratic enclave that was where de Conti first housed his protégée in Paris to the heaving bustle of street life and the coarse realities of the crowd that she and her mother had to brave as they familiarized themselves with the city.

For a curious child it was probably hard not to stare at the vivid vermilion cheeks, painted in garish circles, that were another affectation of aristocratic women. The more refined the woman, the more artificial the look: a natural blush, with associations of the flush of boudoir exertion, was suspect, and a lack of cosmetic colouring – too little make-up – could get a woman labelled a courtesan. The aristocrats lived in a world far removed from the mêlée of the masses, yet it was increasingly a world aped by the rising ranks of the middle classes. Advertisers cottoned on to aspiration as a selling point, as is evident from the marketing of such products as Rouge de la Reine and Savonette de la Cour.

Small-print advertisements from the papers of the day are like a spyhole on the preoccupations of the Paris that Marie knew. Columns are crammed with endless products to enhance the human canvas – paint and pomade, teeth-whitening and -strengthening products, hair dyes, wig-adhesives. Bear grease was regarded as a luxury hair conditioner – one brand was advertised as being made in America 'by the savages of Louisiana'. The importance attached to appearances was remarked upon by the American lawyer and man of letters Gouverneur Morris, who noted, 'They know a wit by his snuffbox, a man of taste by his bow, and a statesman by the cut of his coat.'

The importance attached to appearances undermined the former deference, and, as the force of fashion grew, it was as if a veneer of superficiality was being laid over the old order. Indicative of this was the way that feathers – traditionally associated with ceremonial dress and nodding plumes that commanded respect – became fashion accessories, and feather shops flourished. However, the effect was not

always what the wearers desired, and Mercier described how a sudden downpour lent 'erstwhile exquisites the appearance of wet hens'.

Whereas rank used to be evident from differences in appearance, now it was harder to assess, as the collective love affair with hairdressing filtered down to the lowlier ranks of society. Mercier wrote, 'The rage for hairdressing has become universal in every class. Shopboys, bailiffs, notaries, clerks, servants, cooks and scullions all wear tails and queues, and the perfume of various essences and of amber-scented powder assails you from the general shop as well as from the oiled and scented dandy.' Fashion was not merely frivolous: it was subversive. Self-invention, emulation and imitation were starting to bring a dangerous ambiguity to appearances. The proliferation of affordable clothes meant that people were not always quite what they seemed. A buoyant market for second-hand clothes operated from both permanent premises and market stalls. The Place de Grève, when not drawing crowds for public executions, became a colourful communal changing room, with rows of stalls putting the finery of respectable society within reach of all. Mercier writes, 'Here the wife of a clerk haggles for a grand dress worn by the dead wife of a judge; there a prostitute tries on the lace cap of a great lady's lady-in-waiting.' Demand did not always match supply, spawning a singular form of daylight robbery in which women assaulted well-dressed children and stripped them of their finery, replacing it with inferior garb. Mercier again: 'These women have lollipops and children's clothes already prepared but of small value; they have an eye for the best-dressed children and in a turn of the wrist possess themselves of good cloth, or silk or silver buckles, and substitute coarse rags.' A lacemaker accused of this unusual form of asset-stripping was whipped, branded and put in the pillory under a large sign saying 'Despoiler of Children'. This public humiliation was but the preliminary punishment before she was sent to La Salpêtrière prison for nine years.

Deception of dress also happened at the other end of the scale. Madame Roland relates how on one occasion she ventured out in her maid's clothes 'like a real peasant girl'. More used to the comfort of the carriage, she found the gutters and mud a shock – and even more so the experience of 'getting pushed by people who would have made way for me if they had seen me in my fine clothes'. Much more

famous are the clichéd images of Marie Antoinette dressed down as a dairymaid in an interior designer's dream of a dairy – all Delft tiles and clean cows – engaged in an extravagant pastoral fantasy. In fact the only time she assumed the role of innocent rustic was on the stage, as part of Versailles' version of amateur dramatics. In reality, virtually from the moment she became queen in 1774, when Marie was a girl of thirteen, the people of Paris were the sheep following every new style that Marie Antoinette adopted. So great was the desire to copy the Queen that one night, when she appeared in her box at the opera displaying a new hairstyle for the first time in public, the resulting crush to get a closer look gave a new seriousness to the term 'fashion victim'. Léonard, her hairdresser, was unashamed in the pleasure he took from this incident 'People in the pit crushed one another in their endeavour to see this masterpiece. Three arms were dislocated, two ribs broken, three feet crushed – in short, my triumph was complete.' In her memoirs, Marie relates how the Queen, aware of this mimicry of her every accessory, once played a joke on the public: 'In the zenith of her splendour, she would often smile at the servile imitation of her dress which was displayed by ladies of the court, and those even of the lower class; and to illustrate this mania, the Queen once went to the opera with radishes in her headdress; but the sarcasm was understood, and such ornaments were never adopted.'

Whether through dressing up or dressing down, the confusion of rank became a source of concern. The author of an anonymous tract first published in Montpellier proposed a practical solution to this new social problem. He advocated a legal requirement for servants – male or female – to wear a clearly visible badge on their clothes,

> for nothing is more impertinent than to see a cook or a valet don an outfit trimmed with braid or lace, strap on a sword and insinuate himself among the finest company in promenades. Or to see a chambermaid artfully dressed as her mistress, or to find domestic servants of any kind decked out like gentle people. All that is revolting . . . One should be able to pick them out by a badge indicating their estate and making it impossible to confuse them with anyone else.

That appearances could be deceptive seemed to capture the collective imagination of Paris. Embodying this theme was a charismatic

celebrity called the Chevalier D'Eon, whom Marie describes as 'one of the most remarkable individuals, of those in the habit of meeting at her uncle's house'. He was the subject of intense speculation, rumours and gossip, and there are many different accounts of his life. One version has it that, a man of noble birth with a distinguished military career, the Chevalier was sent on a delicate diplomatic mission to England, which went badly wrong. In order to extricate himself and to escape from his enemies without leaving a trail, he adopted the brilliant ruse of pretending to be a woman. On his return to France in 1777 he continued to wear women's clothes, and reports circulated that the Chevalier was to be found stepping out in high society in the latest fashions – modified to conceal the throat, to complete the impression of feminine grace. One account claims that the Queen took an interest in him, and sent him to be clothed by Rose Bertin. What the sixteen-year-old Marie made of this intriguing character she does not say, but her version of his circumstances is slightly different. She has it that the Chevalier had in fact been born a girl, but to prevent the disappointment of her father had been brought up as a boy. However, she concedes that 'there was something about D'Eon which always appeared to convey an air of mystery.' The uncertain status of the cross-dressing Chevalier and the way he captured the public imagination seem to exemplify the unstable boundaries and fluidity that were such important trends in the Paris of Marie's youth.

Another of the important forces weakening old structures was the growing power of the increasingly conspicuous middle class. The desire to make a statement was expressed pretty much the same way then as now, for in pre-Revolutionary Paris too one's vehicle was not merely an A-to-B device, but a status symbol. As Mercier said, 'A carriage is the goal of any man that sets out on the unclean road to riches: the first stroke of luck buys him a cabriolet, which he drives himself; the next a *coupé*; and the third step is marked by a carriage, and the final triumph is a second conveyance for his wife.' *Plus ça change.*

Things that had previously been available only to the rich minority materialized in a dazzling variety of affordable imitations. The famous wallpaper manufacturer Réveillon offered a cut-price slice of pretension with designs imitating the tapestries that hung in the

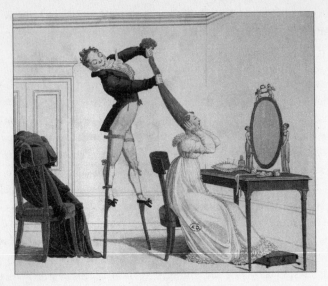

The 'rage for hairdressing'

palaces of the wealthy, and for those who wanted an instant library but without the expense of fine volumes, or the effort of having to read, instant bibliophile credibility could be had by installing imitation book spines. Stucco stood in for marble and porcelain for gold, and increasingly it was hard to spot the authentically aristocratic from the convincing fake, whether in interior design or in people.

From the humblest servant with a simple hand mirror to the elaborate rococo looking glasses in the homes of wealthy merchants, a new self-awareness tipped into an epidemic of vanity. Whereas the middle classes had once looked up to monarchy and those in positions of power, now it was their own reflection that concerned them. They could not stop looking at themselves, and self-definition in public was a preoccupation bordering on obsession.

Mirroring increased public access to a vast range of clothes, accessories, fixtures and fittings was the democratization of culture. Whereas formerly culture had been largely shaped from above, and functioned as an important part of the apparatus of elitism by means of which an absolute monarchy emphasized its power, now the

cultural framework was changing. A greater range of people were pursuing similar cultural interests, whether a shared newspaper in a café, a visit to the Salon, or a trip to the waxworks.

Further, in much the same way that what had once been luxury goods became commonplace items in many homes, this period sees the advent of the household-name celebrity figures, often self-made, whose fame was as real in aristocratic circles as it was in the homes of artisans and tradesmen. Social mobility brought with it a new possibility of prominence in public life. While not precisely the sons of the butcher, the baker and the candlestick-maker, Rousseau and Beaumarchais (the sons of watchmakers), Diderot (the son of a cutler), and Mercier (the son of an artisan) all became well-known figures. This marked a shift whereby the grounds for fame became increasingly hard to distinguish from familiarity to the wider public. This phenomenon anticipates contemporary culture, where often a celebrity's claim to fame is as tenuous as being photographed regularly, or being seen but not necessarily read, watched or heard. In the Paris of Marie's youth it was increasingly possible to be famous for being famous.

The waxworks were the ideal forum to cater for a phenomenal human interest in public figures that was distinct from respect for their work. In fact cultural achievement was not necessary at all to appear there: the admission requirement was to have attained sufficient public interest to guarantee a crowd; notoriety was as compelling as admiration. From the recently executed criminal to society beauties, Curtius guaranteed a close-up view of the most talked-about people of the day. As each person had their time in the spotlight of public interest, they would take their turn in his pantheon.

The new dynamics of fame fuelled by the growing power of public opinion meant that the elite private salon was shrinking in stature, and was being influenced from the outside. Madame de La Tour du Pin describes how Voltaire and Rousseau, the most famous 'philosophes', though not actually present at the most select salons run by those who moved in court circles, greatly influenced these circles, and discussion of their ideas animated these august gatherings. Certain aspects of these changes were less welcome. Rousseau was uneasy about the advent of a new fan base which made him, not his work, the focus of people's interest:

I met people who had no taste for literature, most of whom had not even read my works, but who nonetheless, from what they told me, had travelled a hundred, or three hundred miles in order to see and admire the illustrious man, the celebrated man, the most celebrated man: so I waited for them to start conversation, since it was up to them to know and to inform me why they had come to see me. Naturally this did not lead to discussions which interested me very much, though they may have interested them.

This anticipates the contemporary complaint of celebrities who compare fame to the one-sidedness that comes with amnesia or Alzheimer's – they are surrounded by people who seem to know everything about them, while they don't have a clue who these people are.

Rousseau's influence showed that intellectual ideas were as capable of being vulgarized as fine clothes. Tear ducts nearly ran dry during the success of his *La Nouvelle Héloïse*, a sentimental novel published in the year Marie was born. A national and international best-seller, reprinted many times throughout the century, this epistolary alpine romance charting the turbulent and tragic events when true love between a lowly tutor and a noble heroine is thwarted by aristocratic prejudice tapped a collective romantic nerve. In a letter to the author, Baron de La Sarraz confessed that he had had to read the book in private so that he could have a really good cry without being interrupted by his servants. Another fan sobbed, 'One must weep, one must write to you that one is choking with emotion and weeping.'

The upshot was that emotional correctness – a need to be seen to be sensitive – became de rigueur. At a performance of a new opera by Gluck (*Iphigénie en Aulide*, in 1774), to avoid the faux pas of being perceived to be insensitive Baron de Grimm took the precaution of shedding ostentatious amounts of tears throughout the entire performance. Even letter-writing styles gushed sentimentality, and the Queen was not immune to this trend, signing off letters to friends with the flowery flourish, 'A heart entirely yours'.

Rousseau also sparked a white-food fad – specifically for milk dishes that hinted at a delicate constitution, while evoking the rustic charms of cows and the wholesome delights of the Swiss countryside.

That a serious thinker influenced not only what people thought but what they bought was an innovation. His influence spanned a spectrum of fashions from wallpaper designs to hairstyles. The head-dress called a *pouf* involved an elaborate assembly of horsehair padding and false hair all bound together and accessorised with a variety of trimmings including a small bonnet precariously perched on top. The '*pouf de sentiment*' required the wearer to use her hairstyle to display her individuality in the best Jean-Jacques fashion by incorporating as many personal references as could be fitted on her head. Objects used to achieve this effect included stuffed birds, small dolls, flowers and foliage – all carefully arranged and attached with pins, gauze and pomatum (a strong scented paste). The Duchesse de Chartres set an impossibly high standard with the effort and detail of the biographi-cal allusions she wore in her hair. Towards the back of her head was an image of her son with his wet nurse, to the right a replica of her pet parrot shown picking at a cherry, to the left a doll representing her favourite serving boy. The ensemble also included locks of hair from the men in her life including her husband, the Duc de Chartres, her father and her father-in-law.

Although not all women went to such lengths in their homage to the great philosopher, the fad for expressing personality via one's coiffure resulted in some extraordinary creations, as observed by one of the most famous hairdressers of the day, Léonard: 'I saw poufs con-taining the strangest fantasies of caprice. Frivolous women strewed their heads with butterflies. Sentimental women nestled swarms of Cupids in their hair; the wives of officers wore squadrons of horses perched upon the front of their head; women of melancholic mood had poufs constructed of coffins and funeral urns.'

Curtius's genius was to give these changing facets of society tangible shape in the form of characters in his public exhibition. From his earliest arrival in the city, when still under the wing of his noble patron, he had been perfectly placed to exploit the burgeon-ing passion for fashion that was such an important catalyst in an emerging culture of impermanence. His combination of commercial aptitude and flair for cultivating influential people echoes the career trajectory of Rose Bertin, who shared his entrepreneurial brio. It is little surprise that their paths crossed. In one of his most astute moves,

when both their careers were booming he is said to have commissioned Bertin to supply couture costumes for his wax figure of Marie Antoinette that replicated what she had designed for the Queen.

Of course it is important not to overstate the extent of cultural transformation that was happening as Marie grew up. While concepts of social equality, religious tolerance and political liberty achieved an unprecedented prominence, being discussed and debated as never before, this happened against a background of vast social, economic and doctrinal division which even the Revolution would only briefly disrupt and would by no means eradicate. Nevertheless, Curtius's understanding of the dynamics of the new marketplace for fame, the power of publicity, and the commercial potential of a nascent mass market – particularly among the affluent middle class – was an integral part of his success. There was no more accurate index of what the public wanted than Curtius's waxworks. His exhibitions were the ultimate democratic cultural institutions. Although ostensibly looking at other people, when the people of Paris stared at the life-size figures in his salon they were looking into a new mirror of their own taste, aspirations and values.

At every turn Curtius capitalized on the growing interest in the here and now. Whereas formerly official culture would reinforce the status quo and precedence and tradition shaped artistic forms, now a new value was attached to novelty and change, and nowhere was this expressed more clearly than by the changing roster of waxen beauties, aristocrats, artists and villains. In the new marketplace, fame was transient. Becoming a household name was one thing, but in a society where taste was like a weathervane and people could come and go out of fashion, remaining famous was an altogether different challenge. Mercier summarized the wide-ranging market for novelty:

It is altogether correct to be mad for novelty, new dishes, new fashions, new books to say nothing of a new actress or opera; as for a new way of dress or hair, it is enough to set the whole crew of fashionables raving. The novelty, whatever it may be, spreads in the wink of an eye as though all these empty heads were electrified. It is the same with people: some man of whom nobody has previously taken the least notice suddenly becomes the rage and lasts six months, after which they drop him and start some other love.

'Change the Heads!', cartoon by P. D. Viviez 1787

For Curtius this dropping was a matter of chiselling the head off a model and replacing it with a freshly moulded face of someone whom the public were more interested in. This ignominious head-chopping was a brutal index of the fickle nature of the public, who demoted with equal dispassion the people whom with enthusiasm they had once elevated to glory. It was also morbidly portentous.

The path of Curtius's career echoes the changing mechanics of patronage. Instead of depending on a privileged system of patronage centred on a specific physical space such as the court or a private salon, artists, writers and performers now increasingly relied on recognition from the general public. The German playwright Schiller articulated the essence of this change when he described the public as 'my preoccupation, my sovereign and my friend', and exclaimed, 'The only fetter I wear is the verdict of the world.' While Curtius started out with an aristocratic patron who nurtured his talent and for whom he undertook commissions within polite society, it was being taken up by the general public that sealed his reputation. His success was such that by the time of de Conti's death, in 1776, he had made significant inroads in the burgeoning field of commercial entertainment and had a presence both at the fairs and in the bustling boulevards. The dates when he opened the different

branches of his enterprise are hard to pinpoint, but in rough chrono-
logical order he had two small exhibitions at the great fairs of Paris,
Saint-Laurent and Saint-Germain, a permanent exhibition at
20 Boulevard du Temple (where he also had his workshop and family
home) and finally his most famous and fashionable exhibition, the
Salon de Cire in the Palais-Royal, part of the estate of the Duc
d'Orléans. It was this site that made Curtius's name. He rented
premises here from its controversial redevelopment as a shimmering
complex of arcades, cafés and entertainments – a new kind of urban
amenity in the early 1780s – until just before the turbulent events of
1789, when he consolidated his various activities in one exhibition
in the Boulevard du Temple.

Curtius was a chameleon, both personally and professionally, as
happy in catering for the sensation-seekers paying a few sous at the
fair as he was in satisfying lucrative private commissions. He always
took great pains to adapt the content of the exhibition to circum-
stances. At the fairs his exhibitions were arranged more in the style of
a cabinet of curiosities, with an eclectic mixture of unusual objects and
artefacts alongside the waxworks. This was the world of the freak
and the hoax, where the more outlandish the dimensions, afflictions
and claims of any attraction, the better the takings. By painting a
monkey's face and gluing a false horn to it, a menagerie could proudly
present a new species from Peru. Sometimes the best-laid plans to
present a genuine animal as yet unseen in Paris went wrong, as hap-
pened to unfortunate Monsieur Ruggery, who had hoped to make a
killing with a very rare animal billed as the 'Tarir of L'Auta from
America'. The poor creature died en route, but so keen was Monsieur
Ruggery not to disappoint that, as he announced on his posters, he
had him 'stuffed with the greatest care by Monsieur Mauvé'.

If animals were commonly presented as more exotic than they
really were, then so too were people – the vast majority of 'giants'
were actors in five-inch heels, long skirts and tall wigs. Chez Curtius
the showman, it was the wonder of the real that amazed, the famous
and infamous replicated exactly as they were, and those who came
could not believe their eyes. This milieu was loud and louche, a din
and a scrum of unsophisticated pleasures, a tawdry, tacky playground.
That Curtius was there at all shows he was far less socially squeamish

than Marie, who as an adult loathed the association of waxworks with the fair. Several notches up in tone was his exhibition in the Boulevard du Temple.

This district was the eighteenth-century Parisian equivalent of Broadway or the West End, the geographical home of popular entertainment, with spectacular shows featuring acrobats and circus entertainments, magic and mystery as well as popular theatre. Here Curtius showed villains alongside his wax heroes. The Caverne des Grands Voleurs – literally the Cave of the Great Thieves – was a show within a show, the forerunner of the Chamber of Horrors. Melodramatic special effects set the tone, with blue light casting the criminals in a lurid otherworldly hue and, as a ghoulish garnish, fake blood. A contemporary account by Louis de Bachaumont states, 'As soon as Justice has dispatched someone Curtius models the head and puts him into the collection so that something new is always being offered to the curious, and the sight is not expensive for it only costs two sous. The barker shouts, "Come in, Messieurs, come and see the great thieves."'

Curtius discovered that crime paid. The Caverne des Grands Voleurs was an ingenious way of exploiting the public love of a juicy murder and a dramatic execution. Crime and punishment were topics of perennial interest, and being well informed about them earned you street credibility. As Mercier said, 'Some worthy cobbler, for instance, will know the history of the hanged and the hangmen as a man of good society knows the history of the kings of Europe and their ministers.' When Marie was sixteen, Paris was gripped by a particularly sensational double murder – of Madame La Motte and her son. On 6 May 1777 the perpetrator, Desrues, was executed in the Place de Grève; but what particularly excited public interest was the fact that Desrues was said to be a hermaphrodite – or, as Baron de Grimm put it more elegantly, 'Both the male and female sex would seem unwilling to own him.' This unusual personal background in conjunction with his bravery during his slow and brutal execution endeared Desrues to the crowds, and confirmed his place in criminal folklore. His mortal remains were revered as relics, and his life was commemorated in popular ballads and best-selling pamphlets. He was therefore an obvious subject to take up a prime position in Curtius's

hall of infamy. As Mercier noted, 'To the man in the street Desrues was a more illustrious name than Voltaire.' And it was the men and women in the street whom Curtius was targeting.

One important function of wax figures was as an illustrated supplement to the news of the day. The ballad singers on the streets were a valued broadcasting service. From royal sex scandals, to sensational murders and executions, they were a popular source of gossip, scandal and news. Curtius supplied for people's eyes what the balladeers gave their ears, and seeing the public's appetite for even the smallest crumbs of information about topical events instilled into Marie a life-long commitment to ensuring that the waxworks were up to date. Mercier noted that songs detailing the bloody acts and horrid deaths of criminals were always big hits: 'Some well-known personage ascends the scaffold, his death is set to music at once with violin accompaniment.' Curtius exploited this interest with his visual version of the sensations of the day.

At the Palais-Royal the waxworks were an elegant recreation of an aristocratic salon, and the central attractions were tableaux of the royal family. This was the classiest of Curtius's various sites, and the *plus*-snob style was achieved by a tiered admission system. As a writer in the early nineteenth century relates, 'The price of admission was two sous, but for twelve sous the public was permitted to approach and circulate near the figures, and though the charge was so moderate, Curtius's receipts were 300 francs daily.'

Then as now, people clamoured to get close to the most influential people of the day, and relished their chance 'to mingle with the mighty'. In the early days of the exhibition the latter included the military hero General Lafayette, who did so much to popularize America in France. (Later, however, Marie, in a rare expression of an opinion, felt his allegiance to the colonists had been misguided. 'Well-meaning short-sighted mortal! How little did he foresee the dreadful effects which ever must arise from suddenly conferring liberty on an enslaved and uneducated people!') In silent company with him was the man whom Marie regarded as his accomplice in bringing down France, Benjamin Franklin, of whom she said, 'To Dr Franklin's visit to France may be attributed the primary cause of the French Revolution, as Lafayette was not alone in becoming a disciple

of the transatlantic philosopher.' But not all the figures were controversial. Instead of propagating republicanism, the naturalist Buffon cultivated popular interest in the natural world. And when people were not crawling on the earth to study caterpillars they were gazing at the sky, as Paris was gripped by balloon-mania. Aeronauts were a new species of celebrity, and Curtius's wax tributes permitted life-size scrutiny of these pioneers normally seen only high high up and far away. Also on show when they were the talk of Paris were Mesmer and Cagliostro, the charlatan gurus who hoodwinked high society with their pseudo-scientific alternative-health claims.

Whereas in real life an invisible cordon segregated the classes, the faux exclusivity of the waxworks was an affordable and amusing way to infiltrate the usually private circles of privilege and the rarefied exclusivity of the court of Versailles. Curtius's salon became a regular fixture on tourist itineraries, and was highly recommended in the growing number of consumer-oriented publications in which there was a new emphasis on fashionable pursuits rather than antiquities and heritage sites. It became a must-see destination, and was very much à la mode.

The almanacs that were guides to what was on in Paris made frequent reference to Curtius's exhibitions. A prolific contributor to these publications was François Mayeur de Saint-Paul. In 1782 he praised the realism of Curtius's coloured heads, 'which appear to be living. One can see these heads in his Boulevard du Temple cabinet and at the Saint-Laurent and Saint-Germain fairs, where because they can obtain this pleasure for two sous they attract a great crowd of curious people from all classes.' He was also impressed by how the waxworks kept up with current affairs: 'Every unusual event gives him the opportunity to add to his collection.' Later, the 1785 edition of a publication entitled *A New Description of the Curiosities of Paris* recommended the Palais-Royal exhibition as a 'spectacle well worthy the attention of people of respectability and position'. The next edition of this publication reveals how it was public interest that was the chief criterion for the choice of figures shown: 'One may see here the figures of all celebrated personages representing all ranks of society from Voltaire to M. Deduit who writes verses and sings them at the cafés of the boulevards.' Public opinion was Curtius's guide, and it was

becoming a powerful authority: the Swiss businessman and French finance minister Jacques Necker described it as 'an invisible power that without treasury, guard or army gives its laws to the city, the court and even the palaces of kings'.

In catering to all sections of society, Curtius was part of a process distinctive in the final decades of the *Ancien Régime*, when the chasm between elite culture and popular culture began to close. In much the same way that people dressed up and dressed down, causing confusion over their rank, there was a similar crossover in the consumption of a wide range of cultural experiences.

Formerly, a strict code of cultural segregation had prescribed which entertainments it was appropriate for each class to attend. Elitist entertainment was concentrated on three revered institutions all concerned with the performing arts: the Opéra, the Comédie-Italienne and the Comédie-Française. At the bottom of the league was the fun of the fair. This hierarchy was reflected in the protocol for publicity, and advertisements for the three elite theatres took precedence on walls in prime sites. Mercier described this: 'The theatre bills observe among themselves a certain rank: those of the Opéra dominate the others; the fair spectacles are placed at the side out of respect for the great theatres.' Symbolically, in the years leading up to the Revolution the rise of popular entertainment was such that the crowd-pleasing shows beloved by the ordinary people were soon being advertised alongside their highbrow rivals, no longer marginalized but mainstream.

The protocol went beyond the appropriate siting of posters: fiercely restrictive state regulation also dictated what popular theatres were permitted to perform. One of Curtius's neighbours on the Boulevard du Temple was the theatrical impresario Jean Nicolet, who, like Curtius, had started out at the fair. Nicolet was banned from performing any play in five acts – the classical form that was the prerogative of the Comédie-Française and the Opéra. The entertainments he staged had to be in three acts, and the players were banned from speaking in verse. But this was no bar to providing the people of Paris with a good night out. In a constantly changing and affordable programme Nicolet mixed acrobats and rope-dancers with ballet and music. Night after night he received packed houses.

'Music noise and "filles" without end' was how Englishman Arthur Young described the shows of Paris in this neighbourhood, although it is hard to imagine the appeal of some of them – the 1779 ballet entitled *The One-Eyed Crippled Lover*, for example. Across the board, from the grand spectacles of the opera to the bawdy, sensational and sentimental entertainments of the Boulevard du Temple, the shows of Paris in the reign of Louis XVI became justly famous. The Russian man of letters Nikolai Karamzin, in his travelogue of Paris, observed, 'The Englishman trumps in Parliament and the exchange, the German in his study and the Frenchman in the theatre.'

Though the commercial theatre was dogged by restrictions about form and content, Curtius's exhibitions were outside the jurisdiction of censorship. This gave him creative licence, and he was able to impart a daring frisson to the arrangement of his figures. The notorious and the noble could be displayed in scandalous proximity to one another, and for a small charge anyone who so desired could gawp and gossip to their heart's content. The waxworks were an audacious extension of the mixing-up of different sectors of society that was starting to happen in the world outside.

Culture vultures of every class sought new habitats. The biennial displays of paintings at the Louvre were phenomenally popular, with the general public descending in droves. This astonished an English visitor, and made him blush for his philistine countrymen: 'I have often seen the lowest class of labourer with his two children and wife beside him stand before some fine picture explaining the part of scripture or history to which it referred and pointing out its beauties with all the taste of an artist.' While aesthete artisans appreciated the fine arts, with an element of social voyeurism well-to-do women braved the colourful crowds at the fair. Mrs Cradock, an English visitor, observed that 'It is good form to go to the fair,' and she was impressed by the calibre of some of the fairgoers. Similarly, it became common for aristocrats to abandon the elitist confines of the Opéra for the livelier shows in the popular theatres – the theatres that, Mercier sagely observed, 'everyone claims to despise, and which everyone frequents.'

When they exchanged their usual patronage of highbrow entertainments for the lively pleasure dens frequented by the general

public, however, the beau monde liked to keep a low profile. Mercier noted, 'Set in the fan which the pretty hand sways is a little round glass, through which my lady continues to see, unseen.' Some theatres went so far as to install grilles in boxes to satisfy their more aristocratic patrons' desire for anonymity. Private boxes were equipped with every comfort to make their occupants feel at home in unfamiliar surroundings – the statutory pair of pet spaniels, a foot-warmer, a chamber pot – and a friend with a spyglass would survey the audience as much as the actors. Such was the boom in light entertainment that when the English equestrian showman Philip Astley was in town, also at the Boulevard du Temple, the smart set defected en masse from the opera and the ballet. While the grand cultural institutions were ghostly quiet, there was almost a stampede to see horses dancing minuets at the Amphithéâtre Anglais.

Cultural influence was starting to percolate from the bottom layers of society upward. Baron de Grimm noted, 'The populace has its pleasures that it madly loves, and the well-to-do who never have enough do not always scorn those of the people.' This was an understatement, for, far from scorning the pleasures of the people, the well-to-do could not get enough of them. They not only flocked to the fairs, but they were also mad for the full spectrum of boulevard entertainments that proliferated in this period and which were found in a dazzling concentration in the Boulevard du Temple and, from 1783, the Palais-Royal – both sites where Curtius had prime locations.

The rise to prominence of the Temple district from the late 1770s onwards coincides with a falling away of support for the fairs. The more sophisticated brand of show business that appeared in the boulevard at this time filled the space between the bawdy banality of the fair and the starchy pretension of the elite cultural institutions. This new style of commercial entertainment perturbed the custodians of *Ancien Régime* culture, and they reacted by requiring commercial entertainers to pay fees to that stronghold of elite culture the Opéra. But it would take more than such taxes to quell the popularity of shows that were proving so ideally suited to the needs and interests of the growing ranks of prosperous self-made Parisians.

Through tapping into people's interest in the rich and famous, Curtius was fast becoming a wealthy celebrity himself. His Palais-Royal premises in particular were not only in tune with the times in appealing to all classes but were setting the pace. In an ultra-fashion-conscious society, the Salon de Cire was required viewing.

2

Freaks, Fakes and Frog-Eaters: An Education in Entertainment

AS FOR THE childhood and early life of Marie Grosholtz that incubated the character of the elderly woman we know as Madame Tussaud, we only have her word for what happened to her, filtered through Hervé in the 1838 memoir. It is from this single source that many of the most famous and enduring myths about Marie stem. Until she is named as the legatee of Curtius's estate in his will, she is overshadowed by him to the extent that, while his exhibition and talents are well documented in many sources, Marie Grosholtz is tantalizingly absent. A handful of legal documents, including his will, her marriage certificate, and assorted mortgage transactions, are the scant co-ordinates from which a very basic narrative of her life in France may be mapped.

The prominence of the original exhibition in the social landscape of pre-Revolutionary Paris meant that Marie grew up powerfully aware of the function the wax figures fulfilled in adjudicating fame. She grew up in a society where the seeds of the cult of celebrity were being sown, and Marie saw Curtius fêted for having created a perfect vehicle for exploiting this trend for personal profit. A precociously talented pupil, she quickly equalled him in modelling prowess and from an early age was contributing to the family business. Her youthful participation in the daily life of his various exhibitions was an apprenticeship that served her well. The art of wax modelling was just one of the skills he inculcated. He was an inspirational role model for entrepreneurial showmanship, and he deserves credit for the grounding he gave Marie in this, besides the material core of the exhibition that he passed on to her. He thus paved the way for Marie's success with her own version of the exhibition, which would in time eclipse the scope and renown of his original.

The currents of change in her early life made for a febrile atmosphere. As public opinion escaped from the shackles of officialdom during the reign of Louis XVI, tension escalated between official culture that was symbolically centred on Versailles and popular culture with a secular bias that was centred on Paris. Under the *Ancien Régime*, Church and state kept tight control of people's pleasures through a regime of suppression, censorship and vigilance. Certain information and ideas were treated like cultural contraband, confiscated from the public and impounded in the Bastille, although it was not only dangerous paper that was imprisoned: spells of incarceration or exile were almost badges of honour for Enlightenment writers. There were tight restrictions on the number of printers working in the city at any one time, and the majority of the most influential books in this period were published abroad. In a city where even a lost-dog poster required a signature from the lieutenant of police, Mercier wryly observed, 'There are in Paris only two documents which may be printed without leave from the police, the wedding invitation and the funeral card.' But, for all the attempts to control people's pleasures and to restrict their reading matter, restraint only made popular culture more lively, as Madame Campan sagely observed: 'Public opinion may be compared to an eel: the tighter one holds it the sooner it escapes.' The freeing of public opinion was the backcloth to Marie's life.

First as a vivacious little girl, then as a dependable and conscientious teenage assistant to Curtius, she saw him both monitor and profit from this trend. Growing up in the pre-Revolutionary period, she witnessed dramatic social change that gradually started to assume a political bent. In many respects Paris in the 1770s and '80s was like London in the 1960s: a heady mix of sex and shopping, with an anti-Establishment undercurrent. Beneath a shiny surface of fashion and frivolity a sense of social injustice was simmering. Marie witnessed the celebrity hairdresser and the fashion designer emerge as the new social heroes, and the clash between generations as the young kicked over the Establishment traces, rebelling with the height rather than the length of their hair. (Echoing every disgruntled parent, Maria Theresa, Empress of Austria, once wrote to her daughter Marie Antoinette, 'I must touch on a subject that I hear mentioned on all sides. It is a question of your headgear. I have heard that it rises

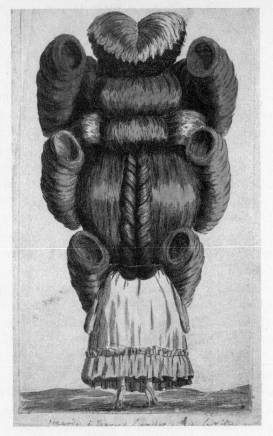

Hair-raising fashions

thirty-six inches from the roots of the hair and it is built up in a tower with countless feathers and ribbons.') The young, including the Queen, also caused shock waves by rejecting hooped underskirts in favour of see-through loose-fitting clothes – a liberation that at the time represented as signal a protest as bra-burning. One of the 'in' hairdressers, Beaulard, devised the perfect solution to following the new fashions without offending the oldies: a three-foot-high hair-do with a spring to adjust the height in an instant as soon as you encountered disapproving glares.

As a teenage girl Marie was probably familiar with Rose Bertin's famous boutique, La Grand Mogul, but she is unlikely to have been a customer. Although Curtius was wealthy, Bertin's creations were fabulously expensive and remained out of reach of all but a tiny seam of high society, of which the Queen was the most prestigious customer. With a business brain as sharp as her pins, Bertin came to be regarded as the most powerful woman in France, and was nick-named Minister of Fashion. In her memoir Marie remembers Bertin as a 'first-rate celebrity, and person of large property'. (She also relates that the great stylist lost her assets, and died in poverty in London. This is incorrect. Rose died in France, and was still supplying the courts of Europe with couture creations until shortly before her death.)

As the Ancien Régime lurched precariously from one public-relations disaster to the next (famously damaging was the Queen's association with the fraudulent purchase of a fabulously expensive diamond necklace in 1786), Marie observed at close quarters the establishment of a new form of absolute rule as the tyranny of fashion propelled Paris to a position of great power. Versailles bowed to Paris, as the ladies of the court obeyed every dictum from the hairdressers and stylists of the Rue Saint-Honoré. Growing up, Marie was barely more than a rolled-out bale of cloth away from the Rue Saint-Honoré, and, as we have seen, canny Curtius had commissioned fine clothes from Rose Bertin to enhance the feeling of authenticity of the costume of Marie Antoinette.

It was a society that treated serious subjects lightly, and light subjects seriously. Specifically, wars and the perilous state of the national economy inspired fashion accessories, hairstyles and light entertainment. For example, French involvement with the rebelling British colonies in America gave rise to a ballet themed on the conflict, and a hairstyle called *Les Insurgents*. There was also a commemorative hat with a warship in full sail to mark the naval battle of Belle Poule, and when the national coffers were empty, literally without funds, hats without crowns, '*sans fonds*', were fashionable, and named *à la Caisse d'Escompte*. In contrast, the length of a ruff and the cut of a coat were subjects of the utmost gravity. Appearances were taken even more seriously than behaviour, a blind eye was turned to vice,

but ridicule through inappropriate dress was social suicide, especially in court circles. These skewed priorities were reflected in the new fashion and lifestyle press that came into being at this time, with magazines such as *Galèries des Modes* and *Cabinet des Modes* being packed with tips on the latest looks for interior design and the textiles and prints to be seen in.

These priorities seem to have been adopted by Marie as well, for throughout her life she placed great emphasis on the details of dress (professionally, not personally), and her memoirs are most valuable for the amount of information about costume and uniforms, with barely any insights, analysis or opinions about the more serious issues of the day. Her descriptions are like entering a musty wardrobe. We get a vivid sense of the cut and cloth of famous historical persons' dress, but a less clear impression of the cut of their character. Typical of this approach is her account of Voltaire's appearance:

> He wore a large flowing wig, like those which were the mode in the time of Louis the Fourteenth, was mostly dressed in a brown coat with gold lace at the button-holes and waistcoat the same, with large lappets reaching nearly to the knees and small clothes of cloth of a similar description, a little cocked hat and large shoes, with a flap covering the instep and generally striped silk stockings. He had a very long thin neck and when full dressed had ends to his neckcloth of rich lace, which hung down low as his waist; his ruffles were of the same material, and according to the fashion of the day he wore powder and a sword.

In sharp contrast was the 'Armenian costume' of Rousseau, and the 'black corded velvet' favoured by Mirabeau.

Clothing reflected the heightened interest there was in the present. While leopards don't change their spots, people do, and when Louis XVI acquired a zebra stripes suddenly appeared on virtually every man of the moment, as recorded by Mercier: 'Coats and waistcoats imitate the handsome creature's markings as closely as they can. Men of all ages have gone into stripes from head to foot even to their stockings.' More formative for Marie's future development was her witnessing the perpetual drive for novelty, with the public embracing and then rejecting one person and product after another. There was Parmentier, the agriculturalist, who inspired potatoes as a motif on

everything from fans to cambric cotton prints and wallpaper. The much fêted ambassador Benjamin Franklin, who with his beaver hat and homely dress endeared himself to the Parisians as a man of the people, became a one-man Franklin Mint, his likeness made in endless statuettes, engravings and busts. His celebrity status prompted him to write to his daughter, 'The numbers of medallions sold are incredible. Those with pictures, busts and prints of which copies are spread everywhere have made your father's face as well known as the moon, so that he durst not do anything that would oblige him to run away, as his phiz would discover him wherever he should venture to show it.' Madame Campan relates how the market for Franklin medals was so great and trade so brisk that 'Even in the palace of Versailles, Franklin's medallion was sold under the King's eyes.' A few years later the gun-running dramatist Beaumarchais, in the wake of the phenomenal success of his Figaro plays, became not only wealthy, but the subject of commemorative merchandise. As an English visitor, Mrs Thrale, noted, 'Beaumarchais possesses so entirely the favour of the public, that women wear fans with verses on them out of his comedy.' Even the charlatan mystic Cagliostro, before he was exposed in 1787, inspired a range of ribbons – *rubans à la Cagliostro*.

Importantly, young Marie absorbed in every fibre of her being the unifying trait that Mercier described as 'the love of the marvellous'. From the age of six until her late twenties, when a dramatic change of tempo affected the whole of France, Marie was at the heart of a city discovering how to have fun. The myriad entertainments that flourished at this time cemented the reputation of Paris as the capital of hedonism, and the Parisian propensity to play hard became regarded as a national characteristic. Observers from different countries were united in their appraisal of their fun-loving French counterparts. The Earl of Clarendon remarked, 'In England a man of common rank would condemn himself as extravagant and culpable if he permitted his family to partake of amusements more than once or twice a week. In France, all ranks give themselves up to pleasure indiscriminately every day.' The Russian traveller Karamzin concurred: 'Not only the rich people who live only for pleasure and amusement, but even the poorest artisans, Savoyards and peddlers consider it a necessity to go to the theatre two or three times a week.' Gouverneur

Morris was struck by the indulgent lifestyle of the women in his circle. He paints a picture of the vacuous lifestyle of a lady of leisure: the few hours 'when she is not being tended to by the coiffeur she is giving to spectacles [exhibitions]'.

One of the most striking descriptions of the pleasures of Paris, and the decadence of the inhabitants, as compared to wholesome America, was made by Thomas Jefferson in a letter to Mrs Bingham on 7 February 1787. He paints a picture of leisured ennui, a cycle of pleasure-seeking, which he contrasts to his homeland: 'In America, on the other hand, the society of your husband, the fond chores of the children, the arrangement of the house, the improvements of the grounds, fill every moment with a healthy and useful activity.' (As if even all that time ago they were a nation of Martha Stewarts!)

Mrs Thrale was surprised by the round-the-clock, seven-days-a-week availability of amusements. Entertainment was a commodity peddled in forms ranging from the small-scale peep shows that Savoyard girls strapped to their backs to the spectacular displays of equestrian showmanship by Astley and the Franconi brothers in a floodlit hippodrome with twelve hundred jets of flame and a full orchestra. It is little wonder that later on in life Marie stressed her royal patrons, for she had witnessed the impact of Marie Antoinette's patronage on Astley's show. Horace Walpole complained in London, 'I shall not have even Astley. Her Majesty the Queen of France, who has as much taste as Caligula, has sent for the whole of the dramatis personae to Paris.' The King, a man miserable on the throne but happy on horseback, shared his wife's enthusiasm and was moved to present the equestrian stuntman with a token of appreciation in the form of a diamond-studded medal. Court interest in the people's pleasures is striking in this period. Axel von Fersen, the Queen's admirer and friend, described the Versailles passion for the shows of Paris as a mania. 'We miss none of them, and would prefer to go without drink, food and sleep than to ignore any spectacle.'

Among the usual urban congestion of crowds, carriages and street merchants in the immediate vicinity of Marie's home were diversions for all tastes and interests. From the elegantly macabre illusions of Monsieur Pinetti, who by stabbing shadows of birds seemed to make them bleed, to the bloody savagery of the live animal fight, where

bulls with horns cruelly removed were set upon by dogs and wolves, the spectrum of the beautiful and brutal was broad. Two of Curtius's neighbours showed a disregard for the show-business wisdom of not working with children or animals. The theatrical impresario Audinot scored a big hit with his troupe of child actors, and the star turn in Nicolet's troupe was Turcot the tightrope-walking monkey. Other celebrity performers of the show-business fraternity whom Marie and Curtius moved among, and who they could see when they felt like being entertained rather than entertaining, were the girl who danced with eggs tied to her feet and La Petite Tourneuse, billed as a human spinning top. There was also the Incombustible Spaniard, who drank boiling oil and walked barefoot on red-hot iron, and, strengthening national stereotypes, Jacques de Falaise, the eater of live frogs. The ironically named Beauvisage made a reasonable living merely by contorting his ugly pockmarked face into horrible grimaces, while much more stamina went into the acts of the jugglers and high-wire artists, some of whom even dressed up in hot and heavy wild animal costumes to stretch their skills to the limit.

In addition to physical feats, displays of mental agility by every species of savant amazed and delighted in equal measure. Munito the fortune-telling dog and a white rabbit with a talent for algebra enjoyed particular success. The long-eared mathematician was the star turn of a showman whose other attraction raised eyebrows for the wrong reasons. The 'pissing puppet', a marionette of a boy in the act of urinating, incited a few killjoys to call for a ban, or at least a Parental Guidance warning. Puppet shows in general were thought dubious family entertainment: 'Children who attend these shows retain all too easily the impressions they receive in these dangerous places. Parents are often astonished to find them informed about things that they should not know about, and they ought to blame the lack of prudence they have shown in permitting their children to be taken to shows that should have been forbidden them.'

Also on offer were clockwork automata and mechanical robots with bronze heads that seemed to speak like humans – part of a mania for 'philosophical toys' which was in part driven by the rationalist view of man as a machine with a soul. (The topical debate about what it was to be human added to the allure of Curtius's wax doubles.) There was

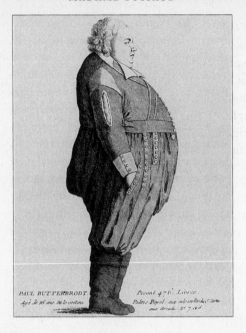

Paul Butterbrodt, the gigantic man employed to publicize
the waxworks

also every scale of magic-lantern show, ranging from tantalizing views
of foreign cities in the pay-per-view portable peep shows to elaborate
phantasmagorias that seemed to assume supernatural properties and
turn into ectoplasm that threatened to engulf a terrified audience. Just
as Curtius modelled the celebrities of the day in wax, for a time a
couple of enterprising impresarios enjoyed success on the back of their
famous look-alike marionettes. Perhaps the most unusual impersonation was by Turcot the monkey, who, as well as displaying his balancing skills, imitated the leading classical actor of the day. Equally
fashionable were the showman scientists, who tended to make
monkeys of the people who paid up only to find themselves duped by
such fraudulent 'philosophical' and 'mechanical' demonstrations as the
telepathic and magnetic presentations of Mesmer and Cagliostro.

Even distinction through ill fortune was turned to profit, although
it is debatable how much male sympathy there was for The Virile Boy,
a four-year-old of precocious sexual maturity and 'beyond the finest

proportions in the virile organ'. If the crowds were pleased to see him, it was because of his inability to conceal his pleasure in seeing some of them – especially pretty girls: 'It is especially at the appearance of a woman that his virility manifests itself.' Unusual human forms were almost commonplace on the commercial circuit, and Curtius is said to have employed the vast-girthed Paul Butterbrodt as a barker. Equally intriguing was The Boy Who Could See Underground, who made such an impact that he came to the attention of the academicians, who accredited his talent in learned journals. But if the subterranean talent spot had been taken, this was no problem for the man who won the highest praise for his demonstration of walking on water: 'St Peter himself could not have done better, perhaps with no more grace, nor with more assurance.' These were the sights Marie saw, and the people she moved among.

The Boulevard du Temple was much wider than the maze of dimly lit medieval streets around it, and every inch of space was occupied with the commerce of pleasure. To be seen more easily, street performers erected *tréteaux*, boards raised on trestles by way of simple stages, on which animal-based entertainments offered as much variety as their human competition. The stars of these miniature variety shows were duelling fleas, somersaulting birds and funambulist rats. Marie clearly liked the performing fleas, for she featured a flea circus in her own bill of entertainment at a later stage. Before billposters became more common, live action advertising was popular for theatrical entertainment. In this form of commercial trailer, actors on the theatre balconies that faced the street above the crowds treated passers-by to a taste of the fun they could have if they went directly to the ticket office. But by far the best description of the scope of the fun to be had on Marie's doorstep is that of a contemporary eyewitness: 'There are chairs set up for those who want to watch and for those who want to be watched – cafés fitted up with an orchestra and French and Italian singers; pastry cooks, restaurant-keepers, marionettes, acrobats, giants, dwarfs, ferocious beasts, sea monsters, wax figures, automatons, ventriloquists and the surprising and enjoyable show of the wise physicist and mathematician Comus.'

The neighbourhood was thronged with peddlers, ticket touts, conjurers and conmen. There was a constant crush of people as well as

carriages trying to pass through. The pedestrians, like eddies around rocks, would gather in greater numbers as a balladeer suddenly struck up with the last words of a newly executed criminal, and there would be a spontaneous singalong. But the magic of the area was the seemingly inexhaustible supply of new things to see. In this colourful community Marie witnessed daily the art of spin, as the public were persuaded to dip into their pockets and pay up to be amazed, amused or abused by a scam. Although as an adult she cultivated an image that conveyed a refined sensibility and emphasized respectable connections, in reality the tough and edgy street culture where Curtius built up the family business had exposed her from an early age to the harsh realities of life. The Boulevard du Temple was even nicknamed the Boulevard du Crime because the constant crowds made it a pickpocket's paradise.

With Curtius distinguishing himself as a showman of great skill, she also learned the art of keeping one step ahead, of anticipating and sustaining public interest. She learned not just how to survive but how to thrive in a fiercely competitive business. In fact Curtius seems to have cornered the market in waxworks, though there is the odd mention of anatomical waxes doing the rounds, and of a tawdry fairground-style wax figure called La Belle Zuleima. Presented as a mummified woman, like a grotesque sleeping beauty, she had very long hair which punters could lift up to inspect her lower body. But these presented not even a hint of a threat to Curtius and his wax wizardry. By contrast the rivalry between Nicolet and Audinot was especially fierce. 'One better at Nicolet's' was the latter's publicity slogan, and it looked as if he had triumphed in one-upmanship when Louis XVI granted the royal seal of approval by allowing him to rename his troupe Les Grands Danseurs et Sauteurs du Roi.

In the emerging collective culture of recreation, commercial entertainment in many new guises was proving to be a unifying force among people who were radically divided by almost every other aspect of their lifestyles. The waxworks were a particularly compelling form of escapism, unlike anything else on offer. While the desire for escapism was equally strong among aristocrats in their mansions and artisans in their attics, the motivations were completely different. For the rich it was to alleviate a stultifying ennui that they

sought stimulation. This even extended to Marie Antoinette, who in a letter to a friend in 1776 confessed, 'I am afraid of being bored and I am afraid of myself. To escape this obsession I need movement and noise.' At court, a mannered world-weariness became almost part of the protocol, as Madame de La Tour du Pin described:

> It was fashionable to complain of everything; one was bored, one was weary of attendance at court. The officers of the Garde du Corps, who were lodged in the chateau when on duty, bemoaned having to wear uniform all day. The Ladies of the Household in attendance could not bear to miss going two or three times to Paris for supper during the eight days of their attendance at Versailles. It was the height of style to complain of duties at court, profiting from them nonetheless and sometimes indeed often abusing the privileges they carried.

For the poor, escapism was a more urgent respite from an oppressive daily routine. Part of the appeal of the macabre and mysterious, bawdy and amusing, clever and incredible entertainments was as a release from very real hardships. Even before the horrors of the Revolution, Marie experienced that life was cheap. One of the more pernicious privileges of the wealthy was their freedom to hit and run. It was common practice for the carriages of the aristocrats to mow down pedestrians without stopping, causing serious injury and sometimes instant death. Visitors to Paris were horrified by this daily hazard, and Gouverneur Morris was shocked that the wealthy passengers permitted their coachmen to stop only if they thought their horses had been injured. Morris expressed this in a poem sent in a letter to a friend;

> Had I supposed a horse lay there,
> I would have taken better care.
> But by St Jacques declare I can,
> I thought 'twas nothing but a man.

The Paris where Marie grew up was also, in the words of a Russian visitor, 'just a whit cleaner than a pigsty'. Beneath a veneer of civilization the city was a mass of mud. In streets without pavements pedestrians had to pick a path around all manner of muck – animal, vegetable – and human – as a shocked Mrs Thrale noted: 'The women sit down in the streets as composedly as if they were in a convenient house with the doors shut.' Rain would turn this waste into noxious

molten channels. A common street cry was '*Passez! Payez!*' as, for a small fee, young boys would lay down planks for passers-by. Street valets similarly made a living with a form of on-the-spot dry-cleaning service so that people could still appear presentable. They would whiten stockings with a coating of flour, and blacken shoes with a mixture of oil and soot. The streets also stank of the animal and human ordure – hence the development of scent and a burgeoning consumer market for pleasant smells: the *parfum* for which Paris remains famous originated as air freshener.

One of the most precious commodities was water. Only a third of houses had their own wells, and migrants from the Auvergne carted large barrels through the streets from which they sold water for a few sous a pail. They did a brisk trade, as public fountains were often dry. In a city where daily newspapers were in limited supply, and literacy by no means commonplace, the water carriers also acted as a valued news service, taking the latest gossip from one district to another. With tallow factories, tanneries and slaughterhouses all sluicing out their waste into the Seine, cleanliness was ambitious, and spotting a vast gap in the market the Perrier brothers, before they started bottling water, pioneered water supply for domestic premises. Familiarity with filth gave rise to popular beliefs that it was actually beneficial, and it was widely thought that a thick crust of dirt on a baby's head would promote growth. Similarly, it was widely believed that bodily contact with water was harmful for health and weakened the internal organs, so bathing was not common practice. While Parisians prided themselves on keeping up appearances by wearing the requisite fashionable details such as lace ruffles and going to great trouble to style their hair, the reality was that under both the second-hand wigs of the poor and the society ladies' more elaborate horsehair padded wigs were itching weals on unwashed scalps. On closer inspection lace ruffles revealed a thin dusting of white powder to hide dirt, for as Mercier said, 'Cleanliness no one expects, but it is only decent to seem well to do.' The skewed priorities were such that a Parisian visited a hairdresser every day, but put on clean clothes only once a month.

As an entertainment district, the Boulevard du Temple was permanently thronged. Marie only had to step outside to be plunged into a mêlée of people selling a vast range of goods and services,

encompassing domestic needs and practical amenities, besides the purely recreational diversions. Given the restrictions on print for public display, street cries were still the most common form of advertising. The soundtrack of Marie's life then was a perpetual chorus of public announcements and invitations to buy, from the simple 'Portugal! Portugal!' of the orange-sellers to the barkers with their exaggerated claims for assorted entertainments. There were also the shouts of the oyster-sellers, or *écaillers* – the hot-dog vendors of the day – who could bisect the bivalves in seconds with an expert flourish of a knife and who sold sugared barley water in the months when oysters were not in season. Also part of the urban cacophony was the ubiquitous hurdy-gurdy.

Increasingly popular in the streets too were the mobile coffee-sellers, and the sheer numbers of them in this period represent the democratization of a drink that was formerly a luxury. Whereas an Englishman was said to have snuff in his pocket at all times, a Frenchman had sugar, for the increased sugar supply from the plant-ations in the West Indies had made sweetened coffee the preferred drink. Coffee wars broke out between the coffee women on the street corners, with their tin urns and earthenware cups, and the confec-tioners who sold the same coffee at more than twice the price in the mirrored splendour of cafés – although, as Mercier noted, workmen had neither the time nor the inclination to be looking at themselves while they drank. Whereas they were probably stoking themselves up for a whole day with their coffee, the leisured classes took a more cer-emonial approach and even dedicated verse to the various drinks – 'la fève de Mokka, la feuille de Canton'. In private homes it became fash-ionable to employ young black houseboys to pour and hand round porcelain cups of coffee and tea – a ceremony contrived to create con-trast with, and highlight, the milk-and-rose-petal pallor of the hostess's own complexion. This affectation was in marked contrast to the buzz of the public coffee house, which was emerging as a popular venue to discuss current affairs.

In her memoirs Marie makes mention of her mother's culinary skills, which take on a new significance when the food supply at this time is considered. Consumption of beef was the privilege of the nobility and clergy, and everyone else had to make do with cow meat.

As with clothes, appearances were deceptive, and the discovery of teeth in a steak was a common occurrence given that fragments of jawbone were commonly passed off as 'cutlets'. The poor food of Paris was ammunition for Anglo-French rivalry, and after a tour of Paris in 1775 Dr Johnson joked that the French meat was so bad it would be sent to jail in England. An article in the *Oxford Magazine* described it as 'so near to carrion that our butchers would throw it in the Thames; hence a variety of sauces and ragouts and every culinary trick is employed to hide what would otherwise be disgusting to the appetite.'

A good housekeeper was a prized asset, given that shopping and cooking required more initiative than one might think. Food was not stored but was bought daily, and the Parisian housewife needed her wits about her. Bad meat needed good seasoning, but it was common practice for grocers to make pepper go further by adding dog dung, 'which being blackened and powdered blends perfectly, so that innocent Parisians savour their food not with the spices of Malacca but a very different product'. Savvy shoppers insisted on having their pepper freshly ground in front of them.

While the less well-off tried to avoid eating dog excrement, the wealthy were developing a taste for the affected non-consumption of solid food – restaurants originated in response to the fad for restorative and extravagantly priced soups. The word 'restaurant' was coined from the 'restorative' bouillon that was their speciality, and on which the first celebrity chefs staked their reputations. Picky eating was a pernicious fashion, and as one social commentator noted at a new restaurant in the Palais-Royal, 'Even if he is not sick, a pretentious little fop often orders consommé because it gives him the aura of ill health.' The polarity of classes in pre-Revolutionary Paris is perhaps most clearly expressed by the perpetual struggle of ordinary people to keep body and soul together coexisting with the orthodox anorexia that was so fashionable among the well-to-do, and which did not impress Mercier: 'At grand dinners and rich men's tables it is not rare to see women drinking only water and leaving twenty dishes untouched, yawning and complaining of their digestions and men following suit by disdaining wine in affectation of the fashion.'

Another hazard of buying everyday provisions was that the grocer doubled as the druggist and used one set of scales for everything.

Arsenic and cinnamon might be weighed one after the other, and the upshot of misinterpreting chemical characters on boxes was frequently a quiet burial. The adulteration of food led to the beginning of branding. In order to establish consumer confidence in the reliability of the product, and thereby win customer loyalty, sellers realised the advantages of the association of a specific name with a product. This set in train the dynamics of advertising and it was the mechanics of publicity that Marie witnessed at this time that stood her in such good stead when she came to England, later distinguishing herself as a pioneer of commercial advertising. The growing sophistication of consumer-targeted publicity is striking in Paris during the first half of her life. One aspect of this was that, instead of using documents, obsolete papers, and pages of old books to wrap products, suppliers began customizing wrappings. The biggest paper wrapping in the century was created when Réveillon publicized his name on the paper balloon that hovered above the city in 1783, but more generally commercial marketing was in the air.

Traders started to realize the cachet that a famous customer could bring to their products. Rose Bertin, from virtually the day she had the custom of Marie Antoinette, made a point of emblazoning 'Milliner to the Queen' in large letters on all her bills. Similarly, Réveillon sought permission to refer to his wallpaper factory by the grand title of 'Royal Manufactory'. The adult Marie was prone to embellish her own royal connections, and always incorporated impressive lists of noble patrons in all her marketing materials – unlike Réveillon, she was not shy of manufacturing royal patronage and name-dropping royals for her own ends.

From an early age, then, Marie understood the value of publicity and the mechanisms of marketing. Her eyes and ears were permanently attuned to commercial opportunities. Other girls from the newly affluent backgrounds of the self-made went to fee-paying convents, but Marie pursued a worldlier curriculum. Instead of a formal education – she was barely literate as an adult – she learned how to read what the public wanted to see, and how to translate curiosity into takings. Numeracy and bookkeeping were the household priorities. Attendance figures were carefully recorded, and at the end of each day she and Curtius totted up takings rather than counting blessings.

Under Curtius she mastered all these skills while still a child, and her grasp of them stood her in good stead for the rest of her life. From her exposure to the most brazen practices of the showmen she observed that how you hooked the public was ultimately more important than what you showed them. Potential customers could decide not to come in, but once admitted they would receive no refund for disappointment. As economic and political problems escalated and prising extra francs from individual purses became more difficult, marketing savvy was the distinguishing feature between those who survived and those who sank to precarious subsistence. In adapting to changing circumstances, whether the customary difficulties of the showman or the extreme conditions that came later and which saw even Madame de La Tour du Pin reduced to embossing pats of butter with the family crest at her American dairy, Marie could not have had a better teacher in the rules of commercial survival than Curtius. On many occasions in her life this grounding gave her the grit to overcome adversities that would have defeated most people.

Empty stomachs rather than greedy hearts were the basis of the social unrest that escalated towards the end of the 1780s, and food – specifically bread – was a vital element in social division. Bad harvests, government control of grain supplies, and fluctuations in the price of a loaf led to a very unstable bread supply. It has been estimated that bread accounted for a staggering 50 per cent of the average French worker's income at this time. When the price of a four-pound loaf rose from an average of nine sous to nearly fourteen sous in 1775 a flour war broke out, and the aggrieved small players of Parisian society ransacked and pillaged bakers, and ran amok in the flour markets. In response to this, the most dedicated followers of fashion, for whom bread was always in abundant supply, adopted a hairstyle called *à la révolte*, the white flour in their heavily powdered hair motivated not by sympathy, but by the desire to be seen to be up to the minute. Mercier observed this profligate use of a valuable commodity by both women and men: 'Victims emerge with faces like ghosts, and as for the master's own coat it must carry three times its own weight of flour, six pounds at least. In addition to which if he is talkative he has probably swallowed something like four ounces.'

Light was similarly socially divisive. At one end of the social spectrum, a single candlestick with tallow was the meagre source of

light in the households of the poor; at the opposite extreme was the daily replacement, even if unused, of beeswax candles at Versailles under the supervision of a light-keeper. For a significant proportion of the population of Paris, daylight dictated their daily routine. Those with money conspicuously flaunted the fact by rising at noon and arranging their social lives until well past midnight. The later one rose, the greater the social cachet, and a woman keeping this pattern was called a 'lamp'. Public lighting was limited, with a mere 8,000 candles in lanterns servicing the city in 1770, and these were frequently snuffed out by the wind. In the course of her life, Marie saw the city illuminated by more lanterns, and then the introduction of oil. Inventories from the Curtius household show that she herself grew up in a household with plenty of light, and the number of candelabras testifies to a background of affluence. Light was also a key element in creating atmosphere in the various branches of the exhibition.

The inventories' listing of the many candelabras, glasses, fine objects and furnishings testify to the privileges that Marie enjoyed in the 1770s and '80s, on the coat-tails of Curtius's impressively swift ascent to fame and fortune. He even acquired a second home, a coveted trophy of the rising middle classes, and had enough capital to trade in fine art, where he showed astute judgement. Marie writes, 'In regard to pictures by the ancient masters he was most indebted for the fortune he acquired, frequently purchasing originals at a very modest price and disposing of them at a rate equal to their real value.'

In a cocoon of material comforts, the Curtius household had a very different perspective on daily life from the majority of Parisians, who were eking out an existence from one meal to the next. In fact Curtius's dining table was apparently the setting for an almost constant round of hospitality extended to the most illustrious public figures of the age. The house, we are told, was 'a resort of many of the most talented men of France, particularly as regarded the literati and artists; and amongst those who were frequently dining at her Uncle's, Madame Tussaud most forcibly remembers Voltaire, Rousseau, Dr Franklin, Mirabeau and Lafayette.'

Marie's memories of childhood provide a view of notable figures strikingly different from how they are encountered in official histories – Mirabeau, for example, 'much pitted with smallpox', and

the Duc D'Orléans, 'disfigured by pimples and red pustules'. Though she divulges nothing about her own family, and we learn nothing of either their character or what they looked like, the foundation of her memoirs is famous people glimpsed in private, in close-up. Voltaire's public persona, all vitriolic attacks on Church and state – 'I should like to see the last king strangled with the guts of the last priest' – is in stark contrast to the kind man of Marie's childhood memories: 'Voltaire used to pat her on the cheek and tell her what a pretty little dark-haired girl she was.' Later, however, in a catalogue she printed during her tour of Georgian England, she took a prudish stance in her assessment of the great writer. His biographical entry includes the warning: 'His writing contains a considerable portion of wit and general learning, but is not calculated for the perusal of youth, being mixed with much indecency and profaneness. The dross wants separating from the gold.' Here, as also in her memoirs, Marie seems to be playing to the English gallery, expressing a view that would appeal to her audience.

Her reminiscences give a vivid impression of wine-fuelled arguments that went on long into the night between Voltaire and Rousseau, who would hurl accusations of plagiarism at his rival. 'When Voltaire retired then Rousseau would give vent to all his rage against his arch rival, till he would exhaust all the abusive language of the French language in expressing his wrath, exclaiming "Oh! Le vieux singe! Le scélérat! Le coquin!" (Oh! The old monkey, the knave, the rascal!) until he was fatigued by the fury of his own eloquence.' She relates how Benjamin Franklin would attempt to remain on the sidelines when the philosophical fur was flying: 'Dr Franklin would calmly regard them, merely a faint smile sometimes enlivening his countenance, as he coolly contemplated the infuriated disputants.' Through the unworldly eyes of her teenage self, the man revered as embodying the Rousseau ideal of natural man is recalled more prosaically, and is of more interest as a dancing partner 'remarked for having particularly fine legs'. Indeed, many of these recollections assume the pattern of the song 'I danced with a man who danced with a girl who danced with the Prince of Wales.' Her name-dropping gives the impression of a constant procession of the rich and famous through the family home.

Given the clout de Conti had in Parisian society, it is reasonable to assume that his patronage secured Curtius private commissions from the privileged classes, and a network of influential contacts. However, on closer examination some glaring anomalies cast doubt on the veracity of some of Marie's stories. For example, Voltaire spent a considerable part of his life in exile from Paris, owing to the state's distrust of his writings. This meant that from 1759 he spent the bulk of his time at Ferney, his estate near the French–Swiss border, until he returned to a hero's welcome in Paris, at the age of eighty-three, in 1778. It is unlikely that he was a regular guest at the homespun salons that Curtius was supposed to have hosted, for he was not in Paris for more than a few weeks of Marie's entire lifetime, despite the fond childhood recollections of cheek-patting and petting that became such a potent and enduring part of the Madame Tussaud myth.

On many counts, Marie's version of her informal encounters with the great and the good over steaming dishes of home cooking seems too highly flavoured. A notable example is her description of Emperor Joseph II of Germany, who after a guided tour of Curtius's exhibition was supposedly stopped in his tracks by the mouth-watering smells emanating from Anna Maria's cooking pot. 'Oh mein Gott, there is sauerkraut!' he is said to have exclaimed, and the next thing, in a far from imperial way, he is entreating them, '"Oh, do let me partake!" when, *instanter*, a napkin, plate &c. was procured, and his Imperial Majesty seated himself at the table, not suffering an individual to rise from it, but joining the group en famille, and ate, drank, talked, laughed, and joked, with all possible affability and familiarity, making himself as much at home as if he had been in his palace of Schönbrusen.'

Marie's mother's cooking also apparently impressed not only the crowned heads of Europe but also the new band of hotheads and angry young men who were rising to public notice, notably Marat. He was very fond of good eating, according to Marie, and 'generally showed some anxiety as to what was for dinner'. In what is surely one of the more mundane utterances on record from l'ami du peuple, we see him in a different light with his instruction to young Marie, 'You young kind creature, let us have a dish of knoutels (a German dish something like macaroni) and a matelote (a sort of freshwater fish).'

More plausible, however, is a link between Franklin and Curtius. Marie's great-grandson John Theodore Tussaud wrote in 1919 that 'It is well known that Franklin had in his rooms in Paris many works that had emanated from Curtius's studio.' Indeed Reverend Cutler, a botanist and scholar, recorded details of a visit he'd made to Franklin's home in Market Street, Philadelphia, in 1787. Over the mantel he noted 'a prodigious number of casts in wax which are the effigies of the most noted characters in Europe'. As Curtius's signature items, it seems reasonable to attribute these to him, and to assume that Franklin acquired them from him in Paris. A further plausible Curtius–Franklin connection is mutual acquaintance with the great portrait sculptor Jean-Antoine Houdon. Franklin was so impressed by Houdon that he enlisted him to make a statue of Washington, and one can see the possibility of a triangle of connections in Paris founded on artistic admiration and interlocking commissions.

Houdon found fame and fortune with his expressive busts of the personalities of the day, and John Theodore Tussaud describes the eminent sculptor as 'a friend and companion of Curtius' who 'had been engaged by him to render him assistance in his work'. Certainly what many regard as Curtius's finest bust, of Voltaire, possesses an uncanny resemblance to the Houdon portrait. It seems reasonable to conjecture that work by the prolific sculptor may have been the source of some of Curtius's waxes.

While the degree to which the family home was a hospitality suite for the great and the good is debatable, what is not in doubt is that it was also a studio-cum-workshop. Human teeth, clay, sacks of straw, glass eyes, wigs, chisels, haberdashery, oil and of course vast quantities of vegetable wax were the strange components of Marie's domestic environment. Beeswax was stored at room temperature to ensure it remained pliable; slight hardening could be corrected by kneading. Moulds of heads and bits of torso fashioned from leather were part of the creative clutter that was not confined to the studio but spilled over into many parts of the house. Like being backstage at a theatre and privy to the secrets of illusion, this exposure to the mechanics of spectacle gave her the fullest understanding of the judicious use of props and presentation and how to create a lifelike deception with mirrors, costumes and lighting. But at the core of things were the artistry of

wax imitating flesh and the figures on whom their increasingly affluent lifestyle depended.

While still a child, Curtius instructed Marie in the art of modelling wax fruit and flowers, and how to observe and then reproduce petals and fronds and the texture and flesh of different fruits. From peel and leaf she then graduated to the mimicry of flesh and the more complex contours and colouring of the human form. The art of drawing was an integral part of the process. Preliminary sketches helped train the eye for the sculptural challenge of building up a clay portrait, the measurements of which were carefully calibrated to the life-size features of the subject. From the clay head a plaster-of-Paris mould was made. Once a layer of liquid plaster about one and a half inches thick had set sufficiently hard to preserve the imprint of the clay features that it was encasing, it was carefully removed in section. These sections, which might range from eight to eighteen different pieces depending on the individual head, were then carefully fitted together with a peg and socket system to make a perfectly aligned mould. This would be cleaned, reassembled and firmly bound with cord before molten wax was poured in. This was not like pouring milk from a jug, but required a steady hand to prevent air bubbles. A wobble of the hand could cause lines on the finished cast. Brimful, the moulds were set aside to cool.

Once the wax had cooled sufficiently to create a crust about two inches thick, the still runny excess in the centre was poured off and the mould was again set to cool down until it was quite cold. Then the sections of plaster of Paris would be removed and Marie and Curtius would be able to judge their success as they came face to face, but not yet eye to eye, with the wax facsimile of their subject. Each mould was cleaned, reassembled and securely tied before being carefully stored, forming an invaluable resource as new life could be created from old moulds ad infinitum.

It quickly became clear that Marie had a precocious talent. Curtius showed her the techniques required for every part of the process, and told her the secret formula for the tints – disconcertingly close to the patina of human skin tones – that were his signature skill. The colouring required skilful judgement to give precisely the right hue of health to complexions that, badly executed, would mean the living

would look more like the death masks for which Marie became so justly famous when she was older. By watching and helping she learned to blend the different waxes, to insert teeth and eyes and hair, and to refine the rough surfaces of casts into realistic, recognizable heads. For a novice and a child this was exacting work. Moulds left seams in the wax, which had to be carefully removed without destroying the fragile whole, and flaws had to be smoothed out. Surgical glass eyes were inserted from inside the hollow neck and, just as in any portrait, positioning the eyes was critical to the overall effect of verisimilitude. It took a lot of practice and precision to get the right depth and angle to give the effect of realistic expression, rather than comic cross-eyes and squints. Then there was the painstaking strand-by-strand insertion of hair, which required the wax head to be gently warmed until each hair could be pressed into it to a depth of a quarter of an inch. For a whole head of hair this process could take ten to fourteen days to complete. By comparison, dressing of wigs in keeping with the latest hairstyles – powdered and piled high on the women, and with side rolls for the men – was far less labour-inten-sive. Real human teeth were added where appropriate (perhaps sourced from the itinerant tooth-pullers), and particular care was taken with the hands, which were also modelled in wax. The bodies were little more than primitive dummies, of wood or leather stuffed with straw or horsehair, as they were really just padding for the clothes that were an integral part of the overall effect. Authenticity was sought down to the last button, buckle and lace ruffle. In a society that was becoming preoccupied with appearances this was not inci-dental, but vital information.

By the time Marie was sixteen, an exceptional artistic talent was matched with competence in other aspects of the business. This balance of the artistic and the administrative – creativity was always allied to commercial interest – was the cornerstone of her future success.

Contrary to popular belief, Curtius and Marie's famous subjects were rarely modelled with their consent at a formal sitting. 'From life', the phrase to which such weight is attached, could often mean that a representation was made using a sculptor's bust. The sculptor may have worked from the living subject, but the wax

version would have been a copy. The possibility that some of the busts were second-hand could explain why none of their famous subjects seem to have left recollections of their sittings with Curtius and his beady-eyed charge; the sole source of memories of such encounters is Marie herself. In the same vein as her picture of easy informality at the dinner table with the great philosophers of the day are her anecdotes about how she had to reassure some of her famous sitters not to be alarmed by a procedure which involved coating their oiled faces with liquid plaster, having inserted straws in their nostrils through which they could breathe. Modelling from existing busts does not in any way detract from Curtius and Marie's skills, however, because adapting casts was not a short cut or an easy alternative. On the contrary, the removal of sculpted hair and eyebrows necessitated an extra stage in the process.

A distinction between Marie and her mentor's creative output was that she never undertook the miniature portraits and small-scale pieces that he executed as private commissions. Nor did she seek recognition as an artist by displaying her work in the formal setting of the public art exhibitions – unlike Curtius, who displayed work at the Salon and in 1778 was admitted to the Académie de-Saint-Luc. Making money was more important to her than critical acclaim from cultural institutions. She only ever showed her work in the family-run exhibitions, and she never diversified from the format of life-size models and heads. Her talent for executing these was such that, even while a young girl, her work rivalled the quality of Curtius's, and in her words, 'it was impossible to distinguish as to the degrees of excellence between their performances.' Her skill in conferring character on cool wax was such, she tells us, that 'whilst still very young to her was confided the task of taking casts from the heads of Voltaire, Rousseau, Franklin, Mirabeau, and the principal characters of that period, who most patiently submitted themselves to the hands of the fair artist.' The trio of Voltaire, Rousseau and Franklin are some of her finest work, and these original pieces can still be seen in the London exhibition. They have been remade from the original moulds over the years, as wax darkens in time and, such is the deep tan conferred, then gives the impression that the subject had fallen asleep in the sun.

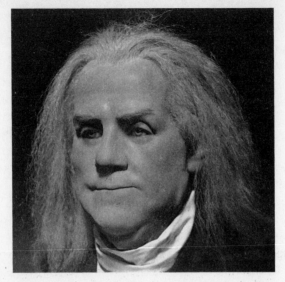

Benjamin Franklin: dinner guest, dancing partner, and one of
Marie's earliest works

Marie was seventeen when Rousseau died in the summer of 1778,
just a few weeks after his rival Voltaire. On the brink of adulthood,
she was living in a society poised between two eras, for, as Goethe
famously observed, if Voltaire had represented the end of the seven-
teenth century, then Rousseau heralded the beginning of a new age.
He was a bridge from reason to romanticism, and the emphasis he
placed on the individual reoriented society in ways that would have a
profound influence in the nineteenth century. Rousseau epitomized
the revolutionary spirit, yet, as Marie would discover, the idealistic
theories of human freedoms that dominated intellectual debate in her
girlhood would be horribly distorted in practice in the increasingly
combative political arena of her adult life.

3
The King and I: Modeller and Mentor at Versailles

AN ANONYMOUS ENGRAVING used as a frontispiece to her memoirs shows Marie as she was in 1778. This rare portrait looks nothing like the Madame Tussaud who is indelibly fixed in our minds as a crone-like vision in cap, bonnet, dowdy dress and spectacles. Here, a fresh-faced, slim, seventeen-year-old is a picture of feminine grace. The face that we are familiar with as severe and inscrutable is seen here as serene and unknowing. The aquiline nose is immediately recognizable, but the cascading hair elegantly styled with lace and fabric flowers, the feminine fichu similarly trimmed and the billowing lace sleeves of an attractive, tight-waisted dress hint at fashion-consciousness. Presumably Marie had a certain visibility within the exhibitions with front-of-house duties, and so it was important she be well turned out – and Curtius's wealth meant she was able to keep up to date with what she wore. Yet the gap this illustration underscores between the young Marie Grosholtz and Madame Tussaud is not just the usual one produced by the passage of time. It prompts one to think of the personalities of her young and older self, and to consider what feels like the bigger gap between her actual experiences in Paris and the version of them that has become so famous.

Propelled by her uncle's success into regular contact with people in public life, was this bright-eyed and handsome young woman someone brimming with confidence? Was she outgoing or shy? If she had habitually sat in the same room as the most influential thinkers of the day as they fraternized with her enterprising uncle, was she socially accomplished, a good conversationalist? Did she speak German or French? Endearments from Voltaire and dancing with Franklin must have boosted both a young girl's ego and her

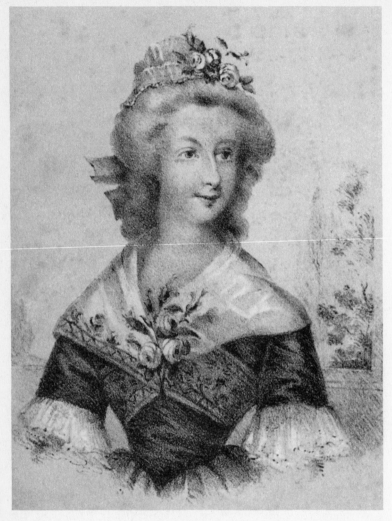

Marie Grosholtz aged seventeen

reputation. Yet her late and lacklustre marriage did not live up to the early promise of such advantageous social encounters. And her subsequent struggles when she first came to England bespeak lonely isolation rather than a string of introductions and the network that

would have been more fitting for someone with the connections she claimed. Does the lack of information about intimate friendships and relationships, especially with men, stem from reticence, or was her work the love of her life? Looked at closely, Madame Tussaud's version of Marie Grosholtz's girlhood starts to feel flimsy. In terms of any public profile preceding the one that she established by her own efforts, she is a missing person.

Waxworks are reality tricks, and perhaps, Coppelia-like, young Marie Grosholtz sometimes vivified the wax replicas of the famous and imagined the silent gallery coming to life, for wax mannequins elicit such fanciful ideas. This would have been innocent child's play. But Madame Tussaud's stream of anecdotes about the illustrious company she kept fulfil a different purpose. These cannot be dismissed as girlish fantasy, but are motivated by more worldly interest. They are also audacious in their claims, for according to the memoirs the bud of promise the pretty portrait conveys was about to bloom in the honeyed, moneyed splendour of Versailles.

The memoirs have it that Rousseau was not the most impressive luminary in Curtius and Marie's social circle. They kept company not only with revolutionary thinkers but also with royalty. Their span of connections that included 'the most conspicuous characters of France' extended from the broad base of the new wave of cultural activists to the very summit of the social pyramid and the royal family. It is not clear whether it was Curtius's personal reputation, founded on the quality of his private commissions for de Conti's circle, or the renown of his exhibitions as outstanding attractions in the competitive world of popular entertainment that attracted the attention of the royal family. However they came to hear of them, the memoirs state that they habitually visited the family home, where Curtius gave them conducted tours of his latest pieces. 'Amongst the different members of the royal family, who were often accustomed to call in at M. Curtius's apartments and admire his works, and those of his niece, was Madame Elizabeth.'

Although specific dates are hard to ascertain, it is widely held that in around 1780 Marie, by now nineteen, was recruited to teach the sixteen-year-old princess, sister of Louis XVI, who was 'desirous herself of learning the art of modelling in wax'. Given Curtius's

stature as a wax modeller, the emerging talent of his prodigy niece and the fame of the waxworks, it is not implausible that such an approach was made. Elizabeth had never really recovered from her separation from her elder sister, Clothilde. A big sister in every sense, Clothilde was nicknamed Grosse Madame. At the age of fourteen she had been dispatched for marriage to the Prince of Piedmont, giving rise to cruel jibes that he'd got two wives for one, but her eleven-year-old sister Elizabeth, who had been extraordinarily close to her, was bereft without her. A curriculum of embroidery, harpsichord and botany filled her days, and a pack of pampered greyhounds were objects of great affection, but not even a close bond with her lady-in-waiting, Angélique de Bombelles, could fill the great gap left by Clothilde. As time went on, faith emerged as Elizabeth's solace and her preoccupation. Whereas many young women measured out their pre-married lives by making endless wax fruit bowls and flower baskets, devotional not decorative models were Elizabeth's incentive for taking up wax modelling. Three years after her traumatic wrench from Clothilde, she is said to have enlisted Marie's help.

Marie's elevation from the colourful world of show business in the entertainment quarter of Paris to the inner sanctum of court circles at Versailles has seeped into the bigger legend her life story has become. The story of her time at court is a primer for the impact of the traumatic experiences that she claims to have suffered subsequently, for the knowledge that she was making death masks from former friends and colleagues adds great interest, and elicits sympathy for her as a victim of the Revolution, rather than as a profiteer. Her memoir did much to crystallize the credibility of her court connections that her display of figures of the French royal family had already planted in people's minds. It opens with an impressive display of her credentials as a reliable authority on the French royal family, being presented as 'the recollections of an individual who was for many years the companion of the unfortunate Elizabeth'. The press lapped this up, as is evidenced by an 1839 article in the *London Saturday Journal*, which reported:

So delighted was Madame Elizabeth with the young artist that she took lessons of her in the art of modelling, and at last obtained M. Curtius's

consent to take his niece to reside with her at Versailles. Here, Mlle Grosholtz had an opportunity of appreciating the saint-like qualities of this unfortunate princess, who perished on the scaffold at the age of 30, and of witnessing that reckless extravagance of other members of the royal family which finally exasperated the minds of the people to open rebellion.

Marie's account of Versailles is filtered through the teacher–pupil relationship. Madame Elizabeth is described as blue-eyed and handsome, with a fair complexion and light hair. Hinting at the corpulence that ran in her family is the information that 'Latterly, she became very stout, but ever remained elegant in her deportment.' Different sources all corroborate the picture of Elizabeth as a devout and conscientious child, who had more ambitions to enter a convent than to get married. Marie describes her as a paragon of affability and amiability, underpinned with self-discipline above her age. 'She was very regular in her manner of living; dined at four, retired early and seldom gave parties.' Another aspect of her maturity was her commitment to confession and communion: 'She was remarkably strict in her observance of religious duties.'

Marie's responsibility was to teach her pious pupil how to model religious votive pieces, specifically anatomically correct wax replicas of deformed or diseased body parts. In what is in effect a Christian version of the pagan belief in the power of doubles used maliciously in voodoo ritual, these wax replicas were then suspended in the churches of Saint-Geneviève and Saint-Sulpice in the belief that the relevant patron saint would intercede and heal those so afflicted.

Their closeness of age was at odds with the vast social chasm between protégée and tutor, the one cloistered in a rigid routine of court protocol, with around sixty staff to cater for her personal needs, the other exposed from an early age to the sink-or-swim extremes of life on a busy boulevard. Yet Marie relates how this did not prevent a strong bond developing between them. Such was this unlikely rapport that an appeal was made to Curtius to allow his niece to take up residence at Versailles, 'Madame Elizabeth desiring to have the constant enjoyment of Madame Tussaud's society'. (Of course she was still Mademoiselle Grosholtz, but out of respect for her age

and the fame of the name the memoirs refer to her throughout as Madame Tussaud.)

This elevation of her status – in this case from art tutor to mentor – is a consistent trend in the memoirs. Time and again she plays up connections, and is prone to enhancing her position. This aggrandisement even extends to the King and Queen. For example, she emphasizes her credentials as a royal commentator, having 'formed her opinion from a thorough knowledge of the character of Marie Antoinette', which she 'had the best opportunity of acquiring from having so long lived under the same roof as her royal mistress'. Marie defends the much maligned Queen, interpreting her behaviour with charity: 'That she was fond of pleasure, dress and admiration, there can be little doubt; and that to the latter she might lend too willing an ear, is possible; but that she was ever induced to be guilty of any dereliction from morality, Madame Tussaud regards as the foulest calumny.' But even more striking is Marie's account of her easy familiarity with the King. She relates how she often had 'opportunities of conversing with Louis XVI and found him very easy and unreserved in his manner' and 'perfectly free from that appearance of condescension, or air of protection, which persons of his rank so often adopt towards their inferiors'.

Reading rather like thespian anecdotes by a star-struck actor who in reality got more auditions than roles, her account of her life at Versailles has her centre stage with a stellar cast. A significant chunk of her memoir concerns her eight years at court, living among the people whose fate she so famously recorded for posterity. Her assertion to have been virtually the Princess's shadow, with a bedroom next door and a domestic routine that included intimate suppers together and being present when Elizabeth conversed with her brother the King, all reinforce the impression of Marie's role as a valued member of the royal household, like a noble lady-in-waiting. It is a picture of sentimental and inseparable female friendship of a sort that Rousseau had popularized, and that emulated the love-in between Marie Antoinette and the Duchesse de Polignac. More importantly, it is reminiscent of much that appears in Madame Campan's 1823 *Memoirs of the Private Life of Marie Antoinette*.

The contrast between Marie's background and that of Madame Campan was vast. The latter was a woman of noble birth whose con-

nections qualified her for the position of reader (*lectrice*) to the royal household. After her marriage to Marie Antoinette's private secretary, she was honoured with the role of First Woman of the Bedchamber, a position that she loyally fulfilled for twenty years, being on constant call for the Queen until the downfall of the monarchy in August 1792. As she herself wrote, 'I have spent half my life either with the daughters of Louis XV or with Marie Antoinette. I became privy to some extraordinary facts, the publication of which may be interesting, and the truth of the details will form the merit of my work.' Marie's time at court would have coincided with Campan's tenure there, but whereas Madame Campan makes no mention of Marie in her detailed commentary of domestic life at Versailles, Marie in her own memoir refers to Madame Campan as 'her most intimate friend' and relates how they had conspiratorial conversations about the court ban on discussing the politics of the day.

Less fly on the wall than flunky in the corner, Marie's vantage point allows us intimate glimpses of the private life of the royal family. The King's closeness to his sister was such that he often sought her out to discuss confidential matters. Marie relates how on one such occasion when he was consulting Elizabeth on a private matter, and she diplomatically rose to leave them alone, the King would not allow her saying, 'Restez, restez, mademoiselle.' Marie interpreted the ensuing sotto voce dialogue as a request to borrow money. The request denied, she relates how the King suddenly arose from his chair, and turning round upon his heel, said, 'Alors je suis tracassé de tous côtes' ('Then I am disappointed on all sides').

That the Crown was strapped for cash at this time is well known, but official records do not suggest that cash flow was so poor that the King was reduced to appealing to his young sister for handouts. Even Marie, as the handicraft teacher, was not immune from being asked financial favours, for apparently Elizabeth's charitable nature was such that 'she generally anticipated her allowance, and frequently borrowed from Madame Tussaud rather than reject the appeal of an individual who she thought merited relief.' One such supplicant was Rousseau's long-suffering mistress, who regularly approached Elizabeth, in floods of very genuine tears, with appeals to help the debt-oppressed writer, and one of the extra-curricular activities that

Marie says fell to her was to courier the requisite cash by carriage to Rousseau's lodgings in Paris.

Marie's reminiscences reveal the protagonists of the royal household as flawed and fallible human beings. She conveys the King's weakness in restraining his wife's hedonistic excesses, and gives an impression that the hapless monarch was as unable to stand up to his wife as he was to the Third Estate later on. 'After all his entreaties that the Queen would renounce or diminish the gorgeous fêtes and entertainments she was giving proved in vain, with a despairing air he would exclaim "Then let the game go on" and extravagance and pleasure and dissipation resumed their reckless fling.' This corroborates other accounts of the King's pathological inability to be assertive. A lack of authority is a dangerous failing in a monarch, and with Louis XVI it was a fatal flaw. The straight-talking Duc de Richelieu confronted the King with an unflattering comparison of his ineffectual style with the authority of his predecessors. In a killer summary of the decline of the French monarchy he said, 'Under Louis XIV one kept silent, under Louis XV one dared to whisper, under you one talks quite loudly.'

It is almost poetic irony then that, in the absence of iron will and nerves of steel, the King had a passion for metalwork. One of Marie's more striking images of him is as an obsessive lockmaker, constantly leaving the revelry around him to pursue his unusual hobby in private. 'He was so partial to making locks, that he was engaged in that occupation for some hours each day, and many of those now on the doors of the palace of Versailles were made by him.' There is further irony in the figure of the King imprisoned by destiny, unable to escape his dynastic duty, having this particular preoccupation. This is one example of a memory corroborated by Madame Campan, who relates how the King's hobby irritated the Queen. 'His hands, blackened by that sort of work, were often, in my presence, the subject of remonstrances and even sharp reproaches from the Queen, who would have chosen other amusements for her husband.' Other records provide fascinating through-the-keyhole views of the royal lockmaker. Hidden from public view, he was never happier than when forging and filing in his private workshop under the expert tuition of the locksmith Gamin. In fact the closest Louis XVI came to infidelity was in his love of the locksmith, who was smuggled up back stairs to these secret

rooms. Like finding lipstick on the collar, one can all too easily imagine the immaculate Marie Antoinette's dismay at her husband's telltale hands, as he returned from furtive sessions at the forge.

The King's corpulence is well known – his pre-hunting breakfast was typically four chops, a chicken, six eggs poached in meat juice, a cut of ham, and a bottle and a half of champagne, and he is said to have come back ravenous for a second sitting – but Marie gives another insight into the Bourbon greed gene with her account of the gluttony of the King's brother, the Comte de Provence, who later became King Louis XVIII. She describes his 'special private visits' to the pantry, where he furtively packed food in his pockets, and recalls 'gravy dropping from his coat skirts, as most vexatiously it oozed through his pockets, owing to the provender not having been wrapped up with sufficient caution, and in paper strong enough to keep the juice within its proper limits'. On top of his gluttony, she reveals his lechery, describing a close encounter of an unwanted kind on a staircase, 'when he was disposed to carry his complimentary politeness to too practical an extreme, and she judged it high time to give him a slap on the face'. This clearly cooled his ardour, for she relates that subsequently 'his Royal Highness restricted his expressions of politeness and regard towards her within more moderate bounds'.

Other accounts of court at this time describe a carefree cocoon of excess insulated from the worsening social inequalities beyond the gates. Madame de La Tour du Pin, for example, conveys the illusory security and carefree spirit: 'We were laughing and dancing our way towards the precipice.' This echoes the words of the Comte de Ségur: 'We stepped out gaily on a carpet of flowers little imagining the abyss beneath.' Marie shows us this indulgent lifestyle, oblivious to the rising tide of discontent: 'They had naught to employ their minds but to devise new inventions for varying their enjoyments.' Through her eyes we are given a picture of Versailles at the peak of its dazzling decadence, light years away from the chaos and hubbub of the Boulevard du Temple. It is 'a vortex of pleasure' and 'the acme of gaiety'. Spectacle was routine. For a reception to honour the heroic victor of Grenada in the West Indies, Marie Antoinette, we are told, asked Marie to distribute 'grenades' (pomegranates) from a basket entwined with flowers, and she was required with all the other women

present to wear white pomegranate flowers in her hair. When a group of Indian dignitaries, who had been impressed by Curtius's exhibition in Paris, came to court on a state visit, the King and Queen apparently played a practical joke on them, directing some of their courtiers to stand in glass cases to pretend to be waxworks. 'The king and queen were highly amused with the remarks of the Indians, who were much struck with the wax figures as they imagined them to be so exactly imitating life.' (Marie never dates incidents, but the Grenada ball happened in 1779 – a year before she is said to have gone to court – and the Indians' visit happened in August 1788.) From practical jokes to epic-scale entertainments with fireworks and fabulously lavish displays with no other purpose than their visual impact, Marie's portrait of a court on a perpetual quest for pleasure echoes the pictures painted by others, notably Madame Campan.

Marie's memoirs evoke dreamlike images of the fêtes that were staged in the magnificent gardens of the palace on fine summer evenings, giving the whole place the aura of an earthly paradise: 'A stranger on first entering these Elysian gardens appeared as it were bewildered with delight, and as if transported to some fairy scene of enchantment.' These entertainments were carefully choreographed, down to the position of every orange tree and lantern, and the timing of every firework. Thousands of privileged revellers would be entertained, with musicians strategically positioned in bowers, arbours and grottoes, from where their music would mingle with the sound of the fountains. The grounds were brilliantly illuminated, so that every fountain, shrubbery and bed was a kaleidoscope of colour – water and foliage seen in variegated dazzling patterns of light. The effects of sight and sound were blended with the heady scent of hundreds of orange trees and myrtle bushes. It was a long way from the smell of sauerkraut on the stairway. For the young woman who grew up sustained by her mother's casseroles and who spent morning until dusk working for the family enterprise, with the odd foray to watch a puppet show or circus nearby, the most tangible sense Marie conveys to her readers with her account of the luxurious life at court is the taste of success.

But the more one delves into her claims, and compares them with the accounts of other witnesses, the more one can't help but wonder

whether her memories of her life at court are but a gigantic fairy tale, with the believable bits culled from other places, particularly the published memoirs of 'her most intimate friend' Madame Campan. Her reminiscences, if not outright identity theft, do smack of a status upgrade. They are an attempt to pass herself off as a pet of the palace and a trusted noblewoman, as Madame Campan undoubtedly was. It is a persona that would engage much public sympathy for her in Georgian and Regency England, where the French émigré population and horror stories about the Revolution testified to the plight of nobles fallen on hard times.

Marie's eyes are only ever directed upward to the gilded cornices and chandeliers of Versailles. It is as if she is blinded by the glare of the gold and gilt all around her, for she reveals nothing of the filth for which the palace was renowned. Leather umbrellas were advised when walking beneath windows, to avoid the common hazard of chamber pots being emptied without warning, and foreign visitors habitually commented on the sheer amount of human waste. One pictures William Cole holding his nose, horrified by 'people laying their nastiness in such quantities that it was equally offensive to the sight and smell'. Aristocrats accepted this as part of life, as the Marquis de Bombelles observed: 'A palace which lodges twelve thousand persons cannot be tended like the boudoir of a pretty woman.' In fact Versailles was capable of accommodating around twenty thousand people. It was vast, although the scale is not conveyed by Marie, who relates things as though the King and Queen are in the next room. The scale was partly functional – Versailles was the King's home, with an elaborate domestic infrastructure, but it was also the administrative centre for the diplomatic, military and domestic affairs of the entire country, the headquarters of the board of trade, home office, foreign office, and armed forces.

Above all, Marie's account is misleading because the supposed relaxed informality and centrality of her position contravene everything we know about the strict protocol at court. Access to the royal family was governed by a code of privilege and precedent. In addition – and she does make a passing reference to this – the essential attributes for admission to court circles were wit, flattery and bon mots – verbal bullets ready to be fired in the duelling that

passed for conversation. These qualities – essential for men – were also desirable for women, though with a greater premium on grace. As her memoirs state, 'compliment, wit and repartee were considered as indispensable for those admitted within the precincts of the royal saloons'. From what we can gather, via Hervé and from the fragments of information provided by third parties who knew Marie as a hard-nosed businesswoman, the attributes of erudition, wit and articulate banter were not hers; nor was she a natural beauty. Even a regular visitor like Madame de Staël, equipped with the advantages of wit and brains, was mocked by the court cronies at Versailles more than she amused them. Once she was seen with a ripped sleeve, and this and her forgetting the correct form of curtseying scandalized the Versailles set, who spoke of her faux pas for weeks, and stonewalled her.

All outsiders were subjected to vicious criticism – women who visited from Paris were treated like country bumpkins and referred to as 'stragglers'. For interlopers and new faces to survive even a one-off presentation at Versailles seemed to require outstanding diplomatic and social skills; to survive there for eight years, as Marie claims, would have been exceptional. For a girl with Marie's antecedents to earn the approval of the Princess to such a degree that 'she was required by Madame Elizabeth to sleep in the next room to her, in order to be always near her', seems nothing short of miraculous. Given all the available information, the likelihood seems slim that a lowly-born niece of a showman famous for commercial entertainments, and with links to the fair, came to be on first-hand terms with the King and Queen, treated as an equal by a Princess and granted an unusually relaxed degree of access for a commoner.

At the court of Versailles everything was regulated – the length of a dress, the number of curtsies, even how you walked. Madame de La Tour du Pin describes preparing for presentation at Versailles by having curtsey coaching, with rehearsals of the correct moves for four hours at a time without a break. She also had to learn how to walk the walk – practising not taking her feet off the ground, but 'gliding on gleaming parquet'. Marie seems to have taken both feet off the ground in her own presentation of her life at court.

There was a strict protocol for even the most private activities, including the dubiously honorary duties of the royal bottom-wiper. Rank determined proximity to senior royals, and the privilege of taking part in such events as the King and Queen getting dressed was exclusively confined to the highest echelons of old nobility. Stretching away to menial duties to keep the palace lit, heated and so forth there were a vast number of jobs such as clock-mending and clock-winding, each so circumscribed that the man who mended the clocks would not dream of winding them up, and the person who turned over the royal mattress each day would never make the bed.

Complex behind-the-scenes-activity regulated the surface display. The sense of a face and a back was enhanced by the physical layout, whereby behind public corridors and apartments was a warren of private passages that were off limits to all but the chief members of the royal household. It was a change-resistant customary culture, which is why Marie Antoinette was regarded as so dangerous with her desire to modernize the monarchy and her flagrant breaches of etiquette.

The protocol was like a security system. It was designed to preserve a carefully controlled distance between monarch and subject, to exaggerate the otherness of the royal family and thereby increase their power. The enactment of the private in public was a crucial aspect of this system. When Marie Antoinette complained, 'I put on my rouge in front of the whole world' she had reason to grumble. Her daily routine of bathing and getting dressed commonly took place in the presence of forty people, and her apartment was often so crowded that on occasion there were ladies-in-waiting two rows deep at the edge of the room.

Among many accounts that illuminate the minutiae of protocol, Harriet Martineau's 1841 description of how the Queen started her day stands out. Marie Antoinette liked to have breakfast in the bath, and the sole job of two women was to supervise her morning ablutions. A bath was rolled in on castors. Instead of undressing to bathe, the Queen got in wearing an elaborate bathing gown lined with fine linen. Breakfast was served on a tray placed on the cover of the bath. After her bath she returned to bed, where she received those entitled to attend her levee. These were her secretary, the King's messengers, and court physicians and surgeons. Noon was the main

visiting hour. During the few hours spent at her dressing table having her hair arranged, the Queen had formal audiences, but not everyone admitted to her at this time had the right to sit down. Typically, this is where she would receive the ladies of the palace, the governess of the royal children, the princes of the royal family, the secretaries of state, the captains of the guard and, on Tuesdays, the foreign ambassadors. 'According to their rank the Queen either nodded to them as they entered, or bowed her head, or leaned with her arm upon her toilette table as if about to rise. This last salutation was only to the royal princes. She never actually rose because her hairdresser was powdering her hair.'

The rules and honours were so meticulously observed that it was regarded as incredibly serious when, owing to the height of her hairstyle, the particular ceremony of slipping petticoats over the Queen's head became impossible to perform. Martineau writes, 'When her majesty was pleased to have her head dressed so high that no petticoat would go over it, but must be slipped up from her feet, she used to step inside her closet with her favourite milliner and one of her women. This change gave great offence to the ladies who thought that they had a right to the honour of dressing the Queen.'

The admittance of Marie – a talented commercial modeller – to the very centre of court life would have constituted an extraordinary breach in these well-documented and famously rigid rituals. The inflexible hierarchy at Versailles was calculated to insulate the royal family from contact with other classes, and certainly to preclude the level of intimacy that Marie would have us believe she attained. An observation by Mercier is particularly interesting in light of the court credentials that constitute such an important part of Marie's autobiographical claims. He wrote:

> The King, Queen and the royal princes hold no communication save with nobles of the highest rank; so one may say that princes leave this world without having spoken to a plebeian. They never talk, at least only very rarely, with a tradesman, a manufacturer, a labourer, an artist, or with a sensible man of the middle class in Paris, and so there are an infinity of things that they do not know under their own names; for the varnish of a picture will always spoil the truth of it.

But even more compelling as a challenge to Marie's claims is her absence from the official records of staff at Versailles. The Almanac de Versailles, which runs to almost 200 pages, names every spit-mender and commode carrier, but there is no reference to Marie Grosholtz. More telling is her omission in the administrative records relating directly to Madame Elizabeth. Among sixty-six named roles – including that of Léonard, the coiffeur, who came in when required from Paris – there is no mention of Marie.

However, the lack of records should not be regarded as conclusive proof that Marie was never at court. Conceivably she could have had a limited tenure as an art tutor, and if she was employed on a short-term part-time basis – say for a few lessons – this could account for the lack of a record. For example, we know that in 1782 the King acquired the chateau of Montreuil on the Versailles estate as a gift for his eighteen-year-old sister. She was not allowed to sleep there until she was twenty-five, but she spent her days there. It is conceivable that under Elizabeth rules were less stringent than at Versailles and that Marie gave the Princess lessons there – although household records from this time that appear comprehensive, naming every laundress and furnace attendant and giving details of a botany tutor and a drawing teacher, omit to mention the presence of a tutor in wax modelling on the payroll.

Somehow the lack of references to her, taken with the demands of the exhibitions in Paris, especially for frequent new figures, all lead one to conclude that her official involvement at Versailles, if it ever happened, was minimal. Certainly she could have gone to Versailles as a visitor, because royal-watching was a popular spectator sport and the rank and file were actively encouraged to indulge in this reverential form of sightseeing. This admittance of the riff-raff to the palace grounds amazed English visitors, including Arthur Young: 'The whole palace, except the chapel, seems to be open to all the world; we pushed through an amazing crowd of all sorts of people to see the procession, many of them not very well dressed.'

The most popular ritual that the public were permitted to watch, and which was a magnet for tourists and locals alike, was the Grand Couvert. This public dining ritual dated back to the time of Louis XIV. Once a week, surrounded by Swiss Guards and with various staff

in attendance, the King and Queen, sometimes joined by other senior royals, would make a meal into a performance. Given the spectacular performances available in Paris, one would hardly think the sight of human beings eating would have had a sure-fire, drum-roll, gasp-and-grip level of excitement for the crowd. Yet the royals performing in public an ordinary activity that was usually private made it extraordinary, and their subjects loved this sedate spectacle.

Part of the interest the ritual held was in the grandeur of the table, decked with magnificent Sèvres china, fine linen, and solid gold and silver tableware, and the awe-inspiring servility of those in attendance, decked in fine livery. Marie sets the scene:

> The table was in the form of a horse-shoe, the Cent Suisse (or Swiss body-guard), standing nearly close together, formed a circle around it, and through or rather between them, the spectators were permitted to view the august party whilst they were dining. To this spectacle any one had access, provided they were full-dressed, that is, having a bag wig, sword, and silk stockings; even if their clothes were threadbare, they were not turned back; nor were they admitted, if ever so well clad, if without the appendages which the etiquette required.

This public dining was, according to Madame Campan, 'the delight of persons from the country', and, like cramming in as many as possible sightings of rare species on a safari, after a glimpse of the big game that were the King and Queen they would hurry to see the lesser royals' feeding time. The stairs were a veritable stampede as sightseers rushed to view 'the princes eat their bouilli and then ran themselves out of breath to behold Mesdames at their dessert'. Particularly eagerly sought was the sight of Marie Antoinette actually eating, but people often felt disappointed by the Queen's inactivity at the table. Mrs Thrale seems to have been extremely lucky, for she reported in her diary, 'The Queen ate heartily of a pie which the King helped her to.' In most accounts not a morsel passes the Queen's lips, and in the best tradition of married couples' dining habits she and her husband 'did not speak to each other at all'. Mrs Thrale's overall reflection was, 'It is a mighty silent ceremonious business this dining in public, sat like two people stuffed with straw.'

Unlike Louis XVI and Marie Antoinette, who were going through the motions like jaded circus performers, Louis XV had prided

himself on playing to the audience. His star turn was removing the top of an eggshell with one deft flourish of his fork. As Madame Campan recalled, 'He therefore always ate eggs when he dined in public, and the Parisians who came on Sundays to see the King dine returned home less struck with his fine figure than with the dexterity with which he broke his eggs.'

Though much seems counterfeit in Marie's claims about her eight or so years at court, her description of the costumes reeks of authority and authenticity. Her memoir is above all a richly detailed costume history. With fashion-plate clarity she supplies details of texture, cut and cloth for each sartorial layer of court society. Thus we can picture the magnificence of the Swiss Guards, in the same costume 'as that worn by Henry the Fourth, consisting of a hat with three white feathers, short robe, red pantaloons, or long stockings, all in one, slashed at the top with white silk, black shoes with buckles, sash, with a sword and halbert'. She gives us almost stitch-by-stitch detail of outfits for all occasions; you can almost hear the rustle of the panniers and smell the powder as Marie brings court dress to life. A style of dress called *à la polonaise*, in which Marie Antoinette is said to have appeared at her most beautiful, is described as 'light blue velvet, trimmed with black fur, white satin stomacher terminating in a point; sleeves tight to the arm, also trimmed with fur'. The matching headdress was of 'blue velvet, with bird-of-paradise feather, and diamond aigrette, hair turned up, *frisé*, gold lama veil, splendid diamond earrings'. We see the King wrapped up for cold weather in leathers and with a 'grey coat trimmed with dark brown fur with large sleeves lined throughout with fur and called a jura'. She conjures up the glint of diamond shoe buckles on the men, and the women's sparkling bodices, 'often one blaze of jewels'. We can feel the weight of their heavily embroidered formal dresses for the fêtes, where extravagance was most indulged, with 'not only the Queen, but many of her subjects, wearing large fortunes upon their persons, comprised in the value of the diamonds by which they were adorned'. Even dressing down was dressing up at Versailles, with real silver thread adding interest to the Queen's elegant green riding habit.

The emphasis on appearances is not incidental detail. Marie Antoinette's status as fashion icon was a dangerous development.

Though the young Queen – powdered, painted and preened to per-
fection – injected youthful caprice and energy to the court, a more
subversive expression of this was her desire to modernize the monar-
chy by abandoning the stultifying and – to her mind – constraining
formality of the old generation. Her physical attributes won her many
admirers – including Horace Walpole, who swooned, 'It is said that
she cannot dance in time, but time is at fault!' Less positive was that
her good looks primed her for dangerous vanity. Madame de La Tour
du Pin relates how, as a newcomer at court, she was given strict
instructions not to stand near the windows, where the sunlight would
compliment the bloom of her young cheeks, for under no circum-
stances could the Queen be publicly outshone by younger skin. Such
vanity was also in stark contrast with the bearing of the last Queen,
the long-suffering Marie Leszczyńska, who had spent her dowdy days
embroidering altar cloths.

Marie Antoinette's misguided approach to revitalizing the court
would see her condemned for extravagance and excess, but more
importantly it contributed to the destabilizing of the monarchy. Grace
Elliott, mistress of the Duc d'Orléans, described how Marie
Antoinette's behaviour upset the old guard: 'She had imbibed a taste
for fashions and amusements which she could not have enjoyed had
she kept up her etiquette as a great queen. By this means she made
herself many enemies amongst the formal old ladies of the court,
whom she disliked, and attached herself to younger people, whose
taste was more suited to her own.' Fissures started to crack the bedrock
of court society. Older, wiser ministers looked on in dismay.

When Marie Antoinette brought in the couturier Rose Bertin and
the hairdresser Léonard, the introduction of these two Parisian style-
makers to Versailles irrevocably altered the distribution of power at
court. Prince de Montbary lamented the admission of 'people of a
class who were strangers to the court, but who had a reputation for
their talents. Little by little the mixing of the classes became consid-
erable.' Their admission signified the calamitous innovation of the
Queen becoming a style-setter for the masses. Madame Campan wit-
nessed this development: 'The skill of a milliner, who was received
into the household in spite of custom which kept persons of her
description out of it, afforded her the opportunity of introducing

some new fashion every day.' There is a sense of two eras: before and after Bertin. 'Up to this time the Queen had shown very plain taste in dress; she now began to make it a principal occupation, and she was of course imitated by others.'

Most serious was the way in which dress started to function differently. Instead of being an integral aspect of the display of power and encoding unchanging values, it was now contrived to be ephemeral. Whereas traditionally the dress and bearing of the Queen were designed to emphasize her difference from her subjects, suddenly it was desirable to copy her as a fashion icon. She was a model for the new, an originator of trends rather than a dignified reinforcement of the status quo. In this reversal, the power lay with Léonard and Bertin, who became the undisputed rulers of the kingdom of fashion, and the Queen one of their most illustrious subjects. As one courtier who witnessed the hairdresser's reception at court put it, 'Léonard came and he was king.'

Illustrating the new balance of power is an incident that happened when the royal party were en route to Notre-Dame one day in the spring of 1779. The King and Queen's carriage passed up the Rue Saint-Honoré, where the crowds lining the street included Rose Bertin and her staff, who had gone on to their showroom balcony to get a better view. Recognizing her beloved Bertin, Marie Antoinette waved at her and pointed her out to the King, who then doffed his hat and waved, too. This seemingly inconsequential gesture of the King and Queen waving to the leading fashion designer of the day seems to encapsulate the enormity of social change, and the reversal of deference. That Marie was close by is likely, but whether she witnessed the incident we can only guess.

The readiness to copy the Queen should not be underestimated at this time. Sometimes there was a subtext to new trends of which those who followed them were happily oblivious. Notably in 1781, following the birth of the Dauphin, the Queen's hair loss posed a delicate problem for Léonard. At first he tried to convince her that her preferred high headdresses, which required healthy long hair to attach them to, were passé and that 'the middle class has long made them its own and now even humble folk are beginning to wear them.' She took some convincing, because, as the Queen said, 'they suited me so

well.' He therefore marketed a new look as making her look younger; but she was still stubborn. He finally resorted to straight talk: 'Your Majesty was saying that you were attached to your hair, as I can well imagine, but unfortunately your hair is no longer attached to Your Majesty. Before a fortnight is past it will all have fallen out, unless this day we apply the infallible remedy of scissors.' Two weeks later on the streets of Paris and in the fashionable gardens of the Palais-Royal every woman in the know sported a new hair-do – *coiffure à l'enfant* – completely unaware that their new-look shorter style was a testament far more to diplomacy than to design and cutting skill.

The new fashion industry helped by the Queen not only made the fortunes of Léonard and Bertin. The shift in perception of royalty was a vital development for Curtius and Marie, allowing them to take representation of royalty in daring new directions. The royal family was the centrepiece of their Palais-Royal exhibition, and its members the most talked-about figures. The fact that Rose Bertin supplied the costumes for the wax figure of the Queen also added great interest: it gave more women the chance to study every detail of exclusive couture design, and meant they could emulate royal fashion by going off and buying cheaper versions of the trimmings. As well as designing the Queen's wardrobe, Bertin was responsible for dressing one of a number of wax dolls that were sent each month from her workshop. These were used to carry information on the latest designs, fabrics and trimmings to the provinces and abroad. As Mercier described the wax doll's travels, 'The precious mannequin attired in the newest fashion is dispatched from Paris to London, and from thence is sent to shed its graces round the whole of Europe. It travels north and to the south; it goes to St Petersburg and to Constantinople; and all nations, humbly bowing to the taste of the Rue Saint-Honoré, imitate the folds turned by a French hand.' The *poupées* of Saint-Honoré were world famous. It was said that during wars the ships carrying them were granted safe passage. One of the most radical aspects of the waxworks was the way that the full-size model of Marie Antoinette was in effect a giant wax doll, a bigger version of these miniature dolls whose every trimming was vital information in the ever-powerful fashion industry.

Marie – whether from within Versailles or in central Paris we can never be certain – witnessed the waning of deference that

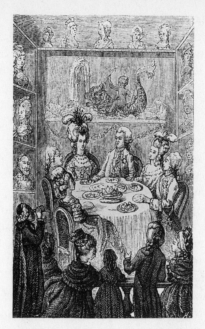

Le Grand Couvert – Curtius's wax replica

accompanied the explosion of consumer interest in fashion, and the occasional absurdities of trends such as baby-poo brown – *caca Dauphin* – as the must-wear colour for a boy, a tribute to Marie Antoinette's son Louis Joseph. These currents of change laid the foundations for Marie's understanding of the role of wax in marketing the monarchy, and its potential as a powerful medium with which to influence public opinion. By exploiting the image of the royal family in different ways, Léonard, Bertin and Curtius, assisted by Marie, anticipate the process whereby the royal family started to become public property, with public interest setting, not following, their agenda. These self-made artists and stylists, with their respective salons in close proximity in Paris, represent the emergence of new media through which interest in royalty can be expressed.

The Palais-Royal Exhibition gave a different perspective to royalty. Here, how the figures of the royal family were seen was vastly different from how we look at royalty at Madame Tussaud's today. The social,

political and religious importance of the royal family was such that although they were the butt of crude ballads and ribald mockery, the sacramental nature of kingship was still potent. Where we see members of the royal family as ordinary people somehow born into a more exalted position and, to a degree, as objects of amusement (the latest figure of Prince William has been made with reinforced cheeks in readiness for the kisses of his fans – more like a pop star than a future king), for Curtius's audience there was a real degree of awe and respect. He provided a second-hand way of getting a peep at something genuinely powerful and significant at this time, in a way that stirred stronger feelings than mere amusement.

In a fascinating way Curtius worked a skilful and daring interplay between private and public realms. In much the same way that he presented Madame Du Barry in an intimate pose, an even more risqué representation was of Marie Antoinette preparing to go to bed. This full-length figure turned the Queen into a fantasy boudoir femme fatale. It was like a regal peep show, putting into the public domain something to which only a very few people would have access given the strict protocol governing the private chambers of the royal household.

If Curtius made the private public, then he also made the formal informal; his most successful tableau was his reconstruction of the Grand Couvert, the ritual of the royal family dining in public. The wax replica royals at this dining table adorned with fruit and crystal required no hushed reverence. People did not have to be on their best behaviour, or conform to a dress code. It was a relaxed experience, and made the ritual more accessible to a wider audience, given that in real life it was possible to witness it only on Sundays. As for the origins of these wax figures, in a single enigmatic sentence Marie implies that they were taken from formal sittings: 'So much did the taste for resemblances in wax prevail during the reign of Louis the Sixteenth that he, the Queen, all the members of the royal family, and most of the eminent characters of the day, submitted to Madame Tussaud, whilst she took models from them.'

The location and tone of the exhibition at the centre of the Palais-Royal leads one to question the likelihood of the royal family co-operating with a process that would put them on public display in a

commercial exhibition that also featured freaks and a ventriloquist. It was the immense popularity of this exhibition that sealed Curtius's reputation and confirmed his success as one of a number of middle-class entrepreneurs who made big fortunes in small workshop set-tings. The period when Marie claims to have been at Versailles coincides with the halcyon days of the exhibition at the centre of the Palais-Royal, an era that many who survived the Revolution, includ-ing Chancellor Pasquier, would recall with nostalgia as a golden period 'when the splendour of Paris reached its zenith'.

4
Courting the Crowds at the People's Palace

A S A MIDDLE-aged woman establishing herself in England, Marie would regale the public with accounts of her time in residential royal service at Versailles. Whereas Léonard and Rose Bertin's involvement at court is well documented, even though they only ever commuted, retaining their day-to-day commercial interests with salons in the city, Marie's own role in the royal household is nowhere acknowledged. She is invisible and unmentioned. This strengthens the assumption that in her twenties she was working hard for Curtius, dividing her time between the Boulevard du Temple exhibition and his salon in the far from regal arcades of the Palais-Royal. Following its controversial conversion as a bold experiment in social engineering offering fun, fashion and shopping to anyone with money in their pocket to spend, the Palais-Royal became the People's Palace, and the waxworks were the jewel in the crown. It combined the amenities of pleasure park, amusement arcade, shopping mall and museum with the glow of a red-light district. The garish glamour was such that the chronicler Bachaumont quipped that 'Le Palais Royal n'est plus Palais, ni Royal.'

The Palais-Royal was a private estate belonging to the Orléans family, who were first cousins of the French monarch, and one of the wealthiest families in France. However, the extravagance endemic among *Ancien Régime* nobility meant they were not always as flush with funds as they might wish, and in 1781, strapped for cash, the old Duc d'Orléans bequeathed this prime slice of Paris real estate to his son, the Duc de Chartres, who decided to redevelop it as a public amenity. Up until this time an air of exclusivity meant that none but the beau monde would dare to set foot there. 'It was a promenade of luxury, gaiety and ceremony,' recalled Baron de Frénilly. 'There were

plumes, diamonds, embroidery and red heels; a chenille, that is to say a frock coat, and a round hat would not have dared appear there. The Palais-Royal was the heart and soul, the centre and core of the Parisian aristocracy. This was what the Duc of Chartres one day undertook to destroy.'

Its most famous feature had been the natural beauty of the vast avenue of ancient horse-chestnut trees that provided a giant canopy under which it was de rigueur to promenade after a trip to the Opéra. Protest songs about chopping down the trees became topical with the ballad singers, and the Duc was booed in public. But to no avail: chestnuts, fountains and parterres were all demolished to make way for arcades lined with boutiques and booths offering assorted entertainments. The property development also included some first-floor penthouse apartments, which offered prime residential addresses for the super-rich. As Baron de Frénilly wistfully recalled, 'Its verdant salon was transformed into a bazaar, and the reign of democracy began in this capital of Paris.'

The Duc de Chartres was one of the most illustrious playboys in Paris. Marie recalls him as 'one of the most dashing characters of the day'. A renowned Anglophile, he had almost single-handedly inspired a craze for all things English, from horse-racing to English afternoon tea – although the interpretation of the latter was a little confused, and English visitors were highly amused at the sight of buttered muffins and steaming tea urns being presented to guests after formal dinners. In her twenties, Marie was in a city with a love–hate relationship to the country that would eventually become her home. Officially England and France were enemies, but unofficially each was in thrall to the other's style. English riding clothes were particularly influential, and in the most elegant boulevards and gardens, amidst a mass of riding crops, leather boots, well-cut hacking jackets and tight breeches, the only accessory missing was the horse.

Marriage into one of the richest families in France (in a society wedding that helped launch the career of Rose Bertin, who made the trousseau) should have eased the Duc's cash-flow problem. But his profligacy meant he was perpetually short of money. Dismissed as a fast-living lightweight, the dilettante Duc confounded his critics by

proving to be an astute businessman. Initially reviled for ruining a green site and axing the ancient trees, thanks to the popularity of the new site he effected a pretty impressive conversion from public enemy number one to the toast of Paris. 'From being as angry as the French can be,' noted Mrs Thrale, 'the public were all happy and content and cried Vive le Duc.'

In 1784 the Duc inherited his father's title to become the new Duc d'Orléans. As one of his first tenants in a main wing facing the garden, Curtius was quick to realize that a wax portrait of his landlord, now the toast of Paris and riding the crest of a wave of public support, was an obvious necessity for his Salon de Cire. Asserting her own credentials as an eyewitness to the Duc's physical characteristics, Marie corrects a 'modern work upon the Revolution' that suggested he was short. He was, she states, five feet nine – and she adds, rather imperiously, that 'she having taken his likeness, and a cast from him, had a better opportunity of judging than most other persons.'

The illustrious Duc was more than an attraction in their wax pantheon. According to Marie, he also was a personal acquaintance and a regular fixture in their social lives. In one of the many striking examples of how she and Curtius managed to bridge the social divide, she describes the fabulously wealthy fast-living aristocrat as 'a constant visitor', and she gives the impression that when he wasn't hobnobbing with his royal relations at Versailles he loved nothing better than to relax chez Curtius.

Sometimes, however, he tested his host's hospitality. Among many English habits, he followed 'what the French considered the most prominent vice of that nation – that of drinking to excess'. Marie relates how when the Duc got roaring drunk Curtius contrived to get him out of the house by persuading him to go to the Cadran Bleu, a tavern opposite, where he would apparently continue carousing and once became so drunk and disorderly that he broke windows. But evidently drunkenness was not his worst vice. With his demise during the Revolution came the revelation of a darker side to the Duc. Marie would have blanched if she had been aware of the discovery in his private quarters within the Palais-Royal of a pervert's playroom, or what official reports described as 'secret apartments containing all the equipment for skilled debauchery'.

Whatever his personal shortcomings, his transformation of a leafy aristocratic enclave into a commercial leisure complex for the general public was a resounding success. His concept of a promenade for the people was also a dramatic physical manifestation of the changing mental landscape of pre-Revolutionary Paris. The significance of people who had formerly been unwelcome gaining access correlated to a growing sense of entitlement more generally. Indicative of this was a famous incident when a lowly clerk took an aristocrat to court after a public fracas at the theatre, when the nobleman had tried to evict him from his seat. At the hearing, much was made of the entitlement of the humble man to his seat: 'His status as a citizen should in itself have protected him from any insult, in a place where money alone put nobility and commoners on the same level, according them equal rights.' The concept of equal entitlement, and the realization that those who could afford to pay for either a ticket or a set of clothes were on an equal footing to those of noble birth, was radical. It meant rethinking all that had ordered society up to now. It meant acknowledging that wealth was the new index of worth, whereas formerly it had been rank. (More radical still was the concept that individuals had equal value as human beings irrespective of material assets – a theme given serious expression in the works of Rousseau.)

Also demoting the significance of rank as the sole indicator of worth were the theme and moral of the biggest box-office hit of the decade, *The Marriage of Figaro* by Beaumarchais, a play in which the servants were superior to their masters. It opened on 27 April 1784 and enjoyed a sell-out run in Paris and the provinces. The key speech was like an axe chipping away at the roots of the *Ancien Régime*: 'Nobility, wealth, rank, position, all that makes you proud. What have you done to deserve so many advantages? You have given yourself the trouble of being born, nothing more.'

Beaumarchais chimed with a rising tide of anti-Establishment feeling. For a comedy his play was taken very seriously, and the Marquise de Bombelles for one had not been amused: 'It is a stain on our century to have permitted the performance of *The Marriage of Figaro*; this condescension has already had the greatest consequences.' What started as a push by the on-the-up sector of Parisian society for

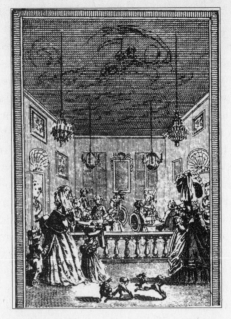

Interior of the Salon de Cire, Palais-Royal

admittance to specific spaces (such as grand theatres, fashionable public gardens, and certain Masonic lodges), and a greater participation in cultural life, fed into a broader quest for political inclusion and representation.

The Palais-Royal represented these changes in a concentrated site-specific way. It glittered with possibilities for self-improvement. This was evident both in the colonnades of chi-chi boutiques selling every frippery and trinket to enhance status and also in a host of intellectual activities, public lectures, clubs and societies, small museums encompassing scientific and artistic subjects, all offering the chance for the expansion of intellectual horizons. The whole place was imbued with a spirit of aspiration, from the luxury-carriage dealerships to an upmarket property club directed at those keen to invest in land in America. Even Curtius's salon adopted a pseudo-educational style and arranged a series of historical artefacts and relics alongside the figures of the most influential people of the day. This lent an air of

worthy instruction to idle curiosity, and gave a higher purpose to the business of having fun. As a French journal recorded some years later, 'There were also to be seen works of art, paintings, sculpture, antiquities, mummies, rarities such as the shirt worn by Henri IV when he was assassinated with the certificate attached to prove its authenticity. In a word all sorts of objects which had caused or had been connected with a sensation in the past.' This formula of history alongside hot news was one that Marie would emulate later on, giving a veneer of gravitas to cheap thrills.

The mingling of the masses here was the ultimate expression of the newly emerging popular culture, in which social differences were being eroded by common interest in fun, fashion and ephemeral pleasures. The class mix was striking: 'All the orders are joined together,' wrote Mayeur de Saint-Paul, 'from the lady of rank to the dissolute, from the soldier of distinction to the smallest supernumerary of farms.' The symbolic significance of the Palais-Royal within the city is evident from contemporaries' references to it from the mid-1780s onwards. Karamzin called it 'the capital of Paris'. For Mercier it was 'the heart, soul, brain and essence of Paris'.

Curtius's wax salon spanned two booths in an arcade which was lined with luxury retailers including confectioners, milliners, jewellers and – the latest innovation – parfumeries. One wonders whether Marie's parsimonious personality in later life was in part a reaction to witnessing daily the recreational spending of the newly moneyed. Karamzin gives us a detailed account of the milieu:

Everything that can be found in Paris (and what cannot be found in Paris?) is in the Palais-Royal. Do you need a fashionable frock coat? Come here and you will find it. Do you wish your rooms magnificently decorated in a few minutes? Come here and it shall be done. Would you like paintings or prints by the finest masters, in frames? Come here and choose. All kinds of precious things, silver, gold, are to be found here for silver and gold. Say the word and suddenly you will find in your study a choice library in all languages, in beautiful bookcases. In short, should an American savage come to the Palais-Royal, in half an hour he would be most beautifully attired and would have a richly furnished house, a carriage, many servants, twenty courses on the table and, if he wished, a beautiful Lais [a

greedy Greek courtesan] who each moment would die for love of him. Here are assembled all the remedies for boredom and all the sweet banes for spiritual and physical health, every method of swindling those with money and tormenting those without it, all means of enjoying and killing time.

The relish with which people flashed their cash does not seem to have struck a chord with Marie except as an indicator of the rich pickings to be had by carefully pandering to consumer interest. For her own part, she was always a model of thrift and economy.

When visitors were dropping from shopping, there were gaming tables, lottery outlets, and a bewildering choice of taverns, cafés and restaurants. The coffee house where Rousseau used to play chess became a place of pilgrimage, and ardent Jean-Jacquists toasted his memory in front of his empty chair, which was preserved as a relic. Another dimension adding to the allure of this location was its racy reputation as a place where both paid and unpaid sexual negotiations spiced the human traffic. Guidebooks testify to the temptations for which the area became famous, for example 'les demoiselles chit chat au Palais Royal'. Here aristocratic wives bored with their husband's dalliances might seek solace with their own assignations. As one noblewoman, Madame de Matignon-Clermont d'Amboise, remarked, 'Our reputations grow again as fast as our hair.' A famous landmark in the Palais-Royal was the solar-powered noonday gun, triggered by the powerful rays of the sun passing through a glass lens. This prompted Abbé Delille's witty observation 'In this garden one may meet with everything, except shade and flowers. In it, if one's morals go wrong, at least one's watch may be set right.'

This licentiousness was largely because private ownership placed the Palais-Royal outside the jurisdiction and policing that applied to the public streets. This was a boon to booksellers, who evaded the censors with a torrent of disrespectful publications about the King and Queen that included explicit pornography. It was also to Curtius's advantage. Always astute in gauging what appealed to his audience, he was able to be more daring in his own depiction of the royal family. His tableau of the Queen going to bed was at the milder end of a range of unflattering representations of Marie Antoinette, tastefully titillating rather than obscene. Even with such fierce competition for their

custom, the crowds of pleasure-seekers who came to the Palais-Royal to shop, to people-watch or to tryst made sure they found the time to visit the waxworks.

Although in her adult life Marie would cultivate a public persona of ardent royalist, becoming watery-eyed at the mere mention of her former employer, Madame Elizabeth, the context of the royal tableaux dating from this time was not that of undiluted respect. In contrast to the mass of racy engravings and such pornographic best-sellers as *Essai historique sur la vie de Marie Antoinette* (in print continuously from 1781 to 1793), which were consumed in the private realm, there is something quite powerful about the collective viewing in public of the Queen going to bed. Given the growing disenchantment with the royals, the wax figures could be a good stimulus to less than flattering opinions.

At this time the King and Queen were to a degree their own worst enemies, and it is not surprising that their subjects were starting to become disillusioned. Marie recalled the optimistic spirit that had greeted the royal couple on their coronation and the longing of the nation for a reign 'divested of the vice and licentiousness which were uncontrollably apparent throughout the reign of their predecessor'. There were high hopes that Louis XVI and his beautiful young Queen would restore the credibility of the Crown, so badly dented by the libido of the old King. A monarch who had once deployed a massive amount of manpower to track down a pre-pubescent young girl who had caught his eye in a vast crowd, resulting in a fiasco of a hunt, did not promise to be a hard act to follow. But from the moment the crown touched his head and he complained it was too tight, and pinched him, there was a foreboding that kingship simply did not fit Louis XVI. This was compounded by rumours of his (rather ironic) impotence ricocheting around the public domain and being given voice to by the ballad singers. When they launched into 'Can the King do it? Can't the King do it?' the gleam of royalty was tainted by public mockery. The odds that the King would recover his dignity, and emerge as a figure commanding respect, lengthened.

His physical bearing was also catastrophic in terms of public relations. Far from blinding his subjects with the iconography of power

and projecting himself brilliantly like Louis XIV, Louis XVI squinted at his subjects and was so short-sighted he could not recognize anyone at more than three paces. Madame de La Tour du Pin conveys his ineptitude: 'He looked like some peasant shambling along behind his plough; there was nothing proud or regal in his appearance. His sword was a continual embarrassment to him, and he never knew what to do with his hat.' Madame Campan reinforces this, and conveys that 'his walk was heavy and unmajestic; his person greatly neglected; his hair, whatever might be the skill of his hairdresser, was soon in disorder.' For his hair-fixated subjects, his permanent bad-hair day would not impress.

The falling away of royal authority started to gather momentum. Rather as erosion eats away at cliffs, rendering a landscape unrecognizable, society in the late 1780s was starting to look radically different from even ten years before. Mercier wrote, 'The word "court" no longer inspires respect among us, as it did during the reign of Louis XIV. The prevailing opinions are no longer supplied by the court; it is not the court which decides reputations these days, no matter in what branch of the arts; now it is only in a derisive way that one says, "The court has decided thus."'

Marie Antoinette's hairdresser, Léonard, described the distance between Paris and Versailles as 'five leagues of mortally wearisome high road'. Even in her childhood this relatively short distance had divided two different worlds; but by the time Marie was in her late twenties the polarity between the ossifying world of the court and the energy electrifying the Palais-Royal was more marked. Paris was effervescent with talk of change. For now, the growing interest of the people in politics was interpreted as a healthy sign of their greater access to information. Speaking far too soon, Mercier wrote:

> Dangerous rioting has become a moral impossibility in Paris. The eternally watchful police, the two regiments of guards, Swiss and French, in barracks near at hand, the King's bodyguard, the fortress which rings the capital round, together with countless individuals whose interests link them to Versailles: all these factors make the chance of any serious uprising seem remote . . . Paris need never fear an outbreak such as Lord George Gordon recently had in London, and which took a course unimaginable by Parisians.

So, while her centrality to events at court seems to have been a distortion of the truth for the purposes of enhancing her image for commercial reasons later in her career, Marie's proximity to the events that ripped Paris apart in 1789 is more feasible. The function of the exhibition as a monitor of popular opinion had put Curtius on the map in public life, and in the wake of this, before she was thirty, Marie was destined to be not a bystander but a participant in and recorder of one of the most momentous periods of history.

5

Marie and the Mob

IN THE FIRST half of her life, in Paris, Madame Tussaud may be said to have lived through 'the best of times, and the worst of times'. Her close identification with the French Revolution functions at two levels. At the personal level her account of all that she had gone through enthralled her audience, and earned her a mixture of respect and sympathy. In her long years on tour in England she was remembered as telling 'many queer tales' of the Revolution, and the Revolutionary relics at the core of her collection reinforced her account of her experiences. In the minds of many, her reminiscences established Madame Tussaud as a plucky survivor of traumatic times. A family friend of her eldest son, Joseph, Mrs Adams-Acton, encapsulates the widely held perception of Madame Tussaud's colourful past at the epicentre of the Revolution:

> It was difficult to realize that Madame Tussaud, clever little artist that she was, had been employed at the French court, teaching modelling in wax. How she, so closely involved in the life of the court, had yet escaped death or imprisonment was incomprehensible till one understood that the sans-culottes had found her of use to take casts of the decapitated. Amongst others, she had held in her own hands the heads of Queen Marie Antoinette, of Madame Elizabeth, and of the Princesse de Lamballe, and had taken casts of them and of many others. Her task in France had been a hard and gruesome one, and her adventures excited our sympathy.

Her first-hand, eyewitness credentials were an integral part of the fascination her artefacts held for the public. More importantly, for the vast numbers of people who saw them, they were interpreted as an authoritative record of the recent past, and were relied upon as an

authentic historical narrative of the French Revolution. In 1904 the man who also propelled Baker Street to fame, the creator of Sherlock Holmes, Sir Arthur Conan Doyle, in a speech at a dinner to commemorate Madame Tussaud's arrival in England, described how the models and relics functioned in this way:

> If you could conceive the position of a person living in the year 1792 – or thereabouts – if you could put yourself back in the streets of Paris in those days; if you could see the King and Queen with the shadow of their dark fate upon their foreheads, see the austere Robespierre looking at them; the murderous Danton muttering. If you could see these historical scenes, and this woman take the heads of these people out of the guillotine basket to frame them in waxwork, from the skill which she had gained, if you can imagine that – and probably you cannot because few of us can imagine scenes apart from our own period – I say if you can imagine that, it would be a most extraordinary and unique and curious thing. Madame Tussaud is responsible for a definite image of one of the most terrible periods of life.

Many of the key images that continue to inform our interpretation of the French Revolution derive from the original exhibition that Curtius and Marie steered through the supremely challenging commercial conditions of Revolutionary Paris. Heads on pikes, death masks, Marat in his bath – for us these are gruesome reconstructions in the Chamber of Horrors, but for those paying a few sous to see them when they were newly moulded they were a valuable source of topical information. What we experience as history was, for the Parisian public, literally headline news.

If the two branches of the wax exhibition – the Palais-Royal salon and its counterpart in the Boulevard du Temple – had originated as innocent entertainments for all classes, in 1789 they started to assume a more serious function. Instead of being an amusing barometer of public interest, they became a register of a rapidly changing political scene. From being an invaluable reference for followers of fashion who loved to scrutinize the hair accessories favoured by the Queen, the exhibitions evolved in response to the mounting interest in current affairs. As a visual reference of the topical, in a largely illiterate society wax had the edge on print, and the adaptability of the model heads and bodies provided a particularly arresting parallel

to the dramatic reversals of fortune that would see the 'heads' of a series of governing bodies rise and fall from power in quick succession. The potential of the medium to serve political ends meant that Marie – by now twenty-eight – found herself not merely a witness but embroiled with the epic events of 1789 that saw a reform movement turn into a revolution, and feudal respect for monarchy descend into anarchy.

In eighteenth-century France the relationship between head and body was a potent metaphor and recurring motif. In 1776 a spokesman at the Parlement of Paris had described the relationship between king and nation as like that of the head to the body. Addressing Louis XVI, he referred to him as 'the head and sovereign administrator of the whole body of the nation'. On the eve of the Revolution the journalist and playwright Louis-Sébastien Mercier used a similar analogy about Paris. He referred to the city as 'a head that had grown too big for its body'. Like the top-heavy hairstyles that characterized the excesses of the *Ancien Régime*, Mercier implied, Paris was teetering, precarious, and unbalanced.

As the relationship between Louis and his subjects became ever more strained, a power struggle was played out between Paris and Versailles. The chisels that Curtius and Marie used to remove the wax heads of those people in public life whose popularity had paled were increasingly busy chipping away at society beauties in their finery to make way for a new species of celebrity. These were men committed to radical reform – men who would translate the theories of Voltaire and Rousseau into action. In 1789, alongside Marie's models of these literary giants, Abbé Sieyès, Mirabeau, Necker and the Duc d'Orléans took up their places as the new subjects of public homage.

Later in the same year a philanthropic doctor, Joseph-Ignace Guillotin, proposed a more humane system for public execution in the form of a machine that 'would separate the head from the body in less time than it takes to wink'. It was not until 1792 that his theoretical proposition was put into practice, being most spectacularly employed in the regicide of 1793, an event emulated by fanatical republicans in the ritual decapitation of royal chess pieces. Decapitation dominates the iconography of the French Revolution. From the straightforward updates of Marie and Curtius's mannequins to the drama of the

tumbril, drum roll and drop as necks were severed like cabbage stalks, for the people of Paris the headless body became a grim reality of everyday life.

The guillotine, the mechanical decapitating machine linked for ever to the unfortunate doctor who had no part in its design or construction (it was largely the invention of a German piano-maker called Tobias Schmidt), was also to become inextricably linked to Marie. In the collective imagination of millions of people all over the world she is best known for modelling the scaffold-fresh heads of the most famous victims of the French Revolution. This association is largely derived from her memoirs, which make much of her first-hand experience of the atrocities of this period. The image of an innocent young woman in a blood-stained apron being forced to mould the brutalized faces of people she had known is central to the identity of Madame Tussaud. But, rather as Dr Guillotin was credited for a machine he did not construct, attribution to Marie of some of the most famous death masks and relics from this period has to date eclipsed the role of Curtius.

On the eve of the momentous events of 1789–95, Curtius deemed it prudent to leave his premises in the Palais-Royal and to consolidate in one large exhibition in the Boulevard du Temple, which remained the family home. In addition to seismographic sensitivity to currents of change – the asset upon which his exhibitions relied – Curtius had the added advantage of a good network of contacts in positions of power. He relied on being in the know in order to be in tune with public interest, and, just as he had a knack of showing the right material at the right time, similarly he made a point of fraternizing with or distancing himself from people in public life to serve his own ends. Marie would have us believe from her memoir that the eve of the Revolution marked her return to Paris from Versailles. She implies that it was because of Curtius's inside knowledge about the impending upheaval that he coerced her into abandoning her position as pet of the palace to return to the fold. But, instead of fond farewells at the palace of Versailles, it seems more likely that the moving she did at this time was rather more mundane.

Either late in 1788 or early in 1789, they gave up the two boutiques they had rented in the arcades besides the famous Café Foy in the area

of the Palais known as the Galérie Montpensier. It was no mean feat packing up all the paraphernalia and installing it all at 20 Boulevard du Temple. It was not going to be an easy fit. The sconces and candel-abras, elaborate rococo looking glasses and pedestals that had been the backdrop to the tableaux of the royal family were at odds with the props used to create the atmosphere of cheap thrills in the Caverne des Grands Voleurs. But from now on the exhibition would comprise two different sections under one roof, anticipating a duality of glitz and gore that has carried through to the present-day exhibitions. The process of moving and adapting to whatever accommodation was available would stand Marie in good stead in the future. Wrapped in cotton shrouds, the dummies that had been reincarnated so many times as men and women, literati and glitterati, courtiers and crimi-nals, according to which heads were affixed to their frames, were all carted back to the bustle of the theatre district.

However, the former happy bustle of street life had assumed a new edginess as privations started to have a corrosive effect on morale. The poor harvest in the summer of 1788 followed by one of the harshest winters in memory had drastically affected the supply of the staples of bread and firewood. The severe weather highlighted privilege and poverty. At the palace of Versailles the weather was largely inconve-nient. Icy winds froze sauces en route to the King's dining table, and the imaginative solutions to keeping warm adopted by some members of the royal household restricted normal interaction with the world. The Marquise de Rambouillet had her servants sew her into a bearskin, while the Maréchale de Luxembourg retired to a sedan chair packed with warming pans. While at court aristocrats could hibernate in comfort, in Paris the poor without fuel died cold and hungry. In spite of this, in December 1788 Louis XVI's oppressed subjects were still loyal royalists. A few streets from her house Marie would have seen the people's monument to their monarch in gratitude for the gift of firewood, a towering snow obelisk 'for our ruler and our friend'. The King's cousin the Duc d'Orléans had also made a generous donation of firewood, funded in part by a sale of fine art. Marie, however, was sceptical about the motivation for his charity: 'By giving away large sums of money he rendered himself very popular with the people, as also by taking the democratic side of the question; his fortune being

so immense that it enabled him to purchase popularity.' But from the spring of 1789, like the snow tower made by hundreds of freezing fingers, regard for royalty was starting to melt away. At the Palais-Royal the political temperature was also starting to rise, and the King's wayward relative was fanning the flames.

Whereas previously people had flocked to the waxworks primarily to see what and who was in or out of fashion, now the buzz was news. The national economy was a universally hot topic as a succession of finance ministers tried and failed to implement reforms that would put the country back in the black, or at least try to haul it out of the red. Finances had been dented first by the Seven Years War (1756–63) and then by French intervention in the American War of Independence (1775–83), and this, in conjunction with the prodigality and change-resistance of the King, presented a monetary and diplomatic nightmare for each of those charged with devising solutions. At the Palais-Royal exhibition the finance minister Calonne had taken up his place. With elaborate lace ruffs and a powdered wig, he was a picture of *Ancien Régime* elegance. In her memoir Marie described him as 'a great favourite with the court and proportionately disliked by the people'. An exceptionally well-groomed gourmet, with a penchant for truffles and expensive pomade, he was not the best role model for belt-tightening. Certainly Marie was no fan, accusing him after his fall from grace not only of stealing 'several objects of vertue that belonged to the nation' but of selling them off 'to defray certain expenses'.

By the time the exhibition had moved back to the Boulevard du Temple, Jacques Necker had replaced Calonne. With no frills and furbelows he was a lower-maintenance model, and no crony of the court. Marie noted that his appearance 'savoured more of the countryman than of one who had been accustomed to fill the highest stations and commune with royalty'. His belief in transparency, demonstrated by his earlier publication of the *Compte Rendu*, a ground-breaking economic exposé of the nation's finances, had paved the way for a popularity which in the challenging climate of the first half of 1789 meant that there was both respect for and confidence in this brilliant Swiss businessman. His conviction that the Crown was accountable to the people particularly endeared him to the public,

and he also advocated tax and electoral reform. However ineffectual his efforts proved, he assumed the status of a favourite and hero.

Marie watched as the same people who patronized the exhibition – the small fry of society such as artisans, hairdressers/wigmakers, craftsmen and shopkeepers – turned into voracious consumers of political pamphlets that championed their cause. In the caste system that characterised *Ancien Régime* France, the Third Estate comprised the vast body of the populace, who had the least political power and who were subjected to the most iniquitous taxes on basic goods such as salt. It was these people who suffered most from the fluctuating price of bread. One of the recurrent complaints of the Third Estate expressed in the *cahiers de doléances*, the formal lists of grievances they were invited to submit to the Estates General at Versailles in March and April 1789, was that 'all goods needed to support life are very dear.' Bread was the big issue. As the price of the four-pound loaf reached a new high, domestic budgets were put under almost intolerable strain. Military convoys for the transportation of grain became a common sight, and bakers were given police protection. On the outskirts of the city, extra troops were mobilized near the customs posts in the wall that encircled it. Built in 1785 to minimize evasion of royal revenue, the high-walled *enceinte* was deeply unpopular. The customs posts were natural flashpoints in the violence that erupted later in the summer, when in just three days nearly all of them were destroyed.

Hollow stomachs were never a problem for the other two Estates – in reverse order of power, the clergy and the nobility. These upper echelons, comprising less than half a million people, owned two-thirds of the land, compared to a tenant class of twenty-five or so million common people. Engravings depicting the plight of the disenfranchised masses used a common imagery of oppression. Typically a peasant was shown giving an uncomfortable double piggyback to a fat noble and a cleric, or, more dramatically, he was being trampled underfoot by them. Men of letters reinforced this theme with grim metaphors. For Abbé Sieyès the nobility and clergy were to the Third Estate 'a malignant disease which preys upon and tortures the body of a sick man'. For the historian Sébastien de Chamfort, the Third Estate were the hare, the nobles and clergy were the hounds, and the King

was the hunter. With a hunting-mad king on the throne, this was particularly apt.

Occupying an expansive space between the fat cats of the old order and the teeth-chattering classes too poor to buy firewood were the rapidly growing ranks of the middle class, who were also part of the Third Estate. These employers and entrepreneurs, of whom Curtius is a prime example, enjoyed the fruits of self-made prosperity. They sent their offspring to expensive private schools, and acquired second homes, which they furnished in expensive imitations of aristocratic grandeur. Mercier marvelled at the middle-class makeovers – bell wires installed in walls for summoning servants, expensive carpets, gilt moulding and superb beds. He wrote, 'The middle classes are better housed today than monarchs were two hundred years ago. I believe an inventory of furniture would greatly astonish our ancestors were they to return to this world.' It is this group in particular who followed with avidity the twists and turns of the political drama that unfolded at Versailles between May and June, and which culminated in the Tennis Court Oath, when the representatives of the Third Estate declared themselves a National Assembly committed to working towards the establishing of a constitutional monarchy and the reducing of *Ancien Régime* privileges. There was mounting concern about the mixed messages from the King who, while seemingly compliant with the pushes for reform, was at the same time sanctioning a greatly increased military presence in Paris. French guards and foreign regiments were mobilized in and around the city.

To keep abreast of these developments, the best place to go was the Palais-Royal, which had become the headquarters of Third Estate propaganda. Here Pierre Choderlos de Laclos was one of the writers employed by the Duc d'Orléans to churn out politically inflammatory tracts. In 1783 his epistolary novel *Les Liaisons dangereuses* had scandalized high society and provoked waves of gossip as people speculated on the real-life identity of the amoral protagonists, and his subversive writings stirred up weighty debates. From noon until night beer flowed at the Café Flammande and brandy at the Café Foy, but it was the intake of news and views that was intoxicating. In a letter to his wife the Marquis de Ferrières, visiting from the provinces, evoked the exhilarating atmosphere:

You really can have no idea of the variety of people who regularly collect at the Palais-Royal. The sight is truly amazing . . . Here a man drafts a reform of the constitution, there a man reads aloud his own pamphlet; at another table someone is castigating a minister; everyone is busy talking each with his own attentive audience. I was there almost ten hours. The paths are swarming with girls and young men. The bookshops are packed with people browsing through books and pamphlets, and not buying anything. In the cafés one is half suffocated by the press of people.

Up until now the most famous orator in the Palais-Royal was a chestnut-seller. On her way to and from the exhibition, Marie would have seen this distinctive figure enthroned on his ebony seat, from where he delivered his legendary sales spiel: 'Sirs, I have gathered to tell you that I have perfected my talent. I may not be the equal in eloquence of all those who occupy the *lycée*, the museums, the clubs of the Palais, but I am as zealous. They stir up the air with vain words; I prove realities. They caress the ear, I delight the *palais* [palate] by means of an exquisite fruit.' But now soapbox speakers drowned out the 'Supérieur des Marronistes' (Chestnut Supremo) with their impassioned appeals to the public to try new political ideas. From every quarter – ballad singers, salesmen, pamphleteers – there was a deluge of words.

With public interest in the political affairs of the day at fever pitch, and the woes of the nation a subject of fierce debate, people flocked to the Palais-Royal, where anti-Establishment rhetoric poured forth. The unbridled ranting amazed Arthur Young; 'The press teems with the most levelling and seditious principles that if put in execution would overturn the monarchy, nothing in reply appears, and not the least step is taken by the court to restrain this extreme licentiousness of publication.' Formerly the Palais-Royal had been a recreational destination, a sensation-seeker's paradise, and time-killer's dream; now it was the natural habitat of a new species of wild-eyed, vein-throbbing fanatic. It was the unofficial news agency, and at any one time the number of people congregating there for the latest updates could be counted in thousands. Arthur Young conjures up a vivid picture:

The coffee houses of the Palais-Royal present yet more singular and astonishing spectacles; they are not only crowded within, but other

expectant crowds are at the doors and windows listening *à gorge déployée* [open-mouthed] to certain orators. The eagerness with which they are heard and the thunder of applause they receive for every sentiment of more than common hardiness or violence against the present government cannot be easily imagined.

Given this edgy atmosphere, it is not surprising that Curtius had decided to remove himself from the crucible of fanaticism. He was not merely an interested observer in the Third Estate cause: his keen interest extended to socializing with many of those involved, and, according to Marie, he was regularly a host to most of the key players who were committed to reshaping the political landscape of France. In her memoirs she describes the new cast of characters at the family dinner table: 'Formerly, philosophers and the amateurs and professors of literature, the arts and sciences ever resorted to the hospitable dwelling of M. Curtius. But they were replaced by fanatic politicians, furious demagogues and wild theorists, for ever thundering forth their anathemas against monarchy, haranguing on the different forms of government, and propounding their extravagant ideas on republicanism.' There is a symbolic contrast between the animated scenes at the wooden dining table upstairs and the sedate tableau immediately below, where the wax figures of Louis and Marie Antoinette were still seated in all their formality at the Grand Couvert, fragile figures oblivious of the growing contempt in which they were held.

Talk eventually tipped into action, and from taking passive interest in the issues of the day the people of Paris started to show their readiness to take a participatory role. The symbolic destruction of primitive effigies of those who had incurred the wrath of the people was an ominous indicator of the potential for violence. In succession, two finance ministers who had failed to implement vital reforms were murdered by proxy: in 1787 a primitive effigy of Calonne was hung, and in 1788 a makeshift Loménie de Brienne was ceremonially burned. More menacing, on account of the scale and force of the associated riots, was the mock murder of the wallpaper manufacturer Réveillon in April 1789. A casual remark by this prosperous man about worker's wages was misinterpreted and blown out of proportion to the extent that it incited an angry mob to go on the rampage. They destroyed the printing machines and stock in his

warehouses, and then moved on to ransack the luxurious Rue Saint-Antoine home of this employer who had only ever had the interests of his employees at heart. The rioters had carried a mock gallows through the streets together with a crude dummy of their foe, inviting those en route to come and witness it being hanged and burned in the Place de Grève. Little could Marie have known that this atavistic energy was but the ominous beginning of violent political activism in which the wax heads that were her and Curtius's livelihood would play a major role, where the symbolic and the real would become interchangeable. Wax heads formerly used to celebrate heroes and decry villains, viewed for a small fee by a good-natured public, were imminently to be borne aloft in protest and in triumph, and were then supplanted by real heads on pikes, displayed as bloody trophies of murderous anger.

The King's sudden sacking of finance minister Necker on Saturday 11 July was the spark in the powder keg. From now on there was a sense of events overwhelming people, rather than people controlling outcomes. On the afternoon of Sunday 12 July the news of Necker's dismissal reached the Palais-Royal. Inside the coffee shops, along the arcades, to the upper levels of the wealthy residents, and down to the busy bookshops, which these days were permanently packed, this sensational piece of news spread. There were ripples of rumour and panic, and a keenness to know more. As the report of a major happening circulated, many of an estimated six thousand people who were present that afternoon migrated to where the crowd seemed to be concentrating. From a tabletop outside the Café Foy, the charismatic Camille Desmoulins had turned the news into a dazzling speech, a rallying cry to take up arms in protest. While he was in full stride there was a panic that the police were on their way to break up the crowd. He seized on this with a flourish of hyperbole as being 'the sounding of the tocsin of a new St Bartholomew's Massacre'. His already keyed-up listeners were agog, hanging on every word. In the course of his oration he picked a leaf from a nearby tree and urged his stunned listeners to follow suit so that collectively they would be displaying the colour of hope. This improvised insignia was a precursor of the tricolour, which shortly afterwards became the approved emblem of patriotism. To emphasize the seriousness of Necker's loss,

Desmoulins urged the crowd to support the proposal of closing the theatres as a sign of mourning. Seizing on this theme, a contingent of the crowd broke away and made for the theatre district in the Boulevard du Temple, leaving in their wake the sorry sight of a tree stripped of any foliage that was within reach, and the ground strewn with broken twigs.

The first Marie knew of the disturbance was when, after invading the Opéra to demand the immediate suspension of the scheduled performance, the crowd surged noisily along the Boulevard du Temple. Chanting 'Vive Necker! Vive le Duc D'Orléans', it came to a halt outside the waxworks. Curtius quickly gave instructions for the gates of the railings in front of their house to be shut. But it soon became apparent that the crowd was not as threatening as it looked. Marie describes the protesters as 'very civil and their general bearing so orderly that she felt no alarm whatever'. At the entrance to the exhibition they entreated Curtius to hand over the wax busts of Necker and the Duc d'Orléans, the people's favourites – the one whose sacking had strengthened his appeal in their eyes, and the other whose blood-line connection to the King seemed to increase their appreciation of his commitment to their cause. Curtius complied with their requests – not least because he recognized the makings of a sensational publicity coup. Ever the showman, as he handed over the first bust he declared, 'Necker, my friends, is ever in my heart but if he were indeed there I would cut open my breast to give him to you. I have only his likeness. It is yours.' There were bows and bravos all round. The 'what if' school of historians may be interested in Marie's assertion in her memoirs that the crowd also demanded the figure of the King, 'which was refused, M. Curtius observing that it was a whole length, and would fall to pieces if carried about; upon which the mob clapped their hands and said, "Bravo Curtius, bravo!"'

With the heads of their heroes in its hands, the crowd restyled itself as a funeral cortège to show the sorrow caused by the loved minister's fall, and the mood became more sombre. The heads, elevated on shallow pedestals, were draped with black crape, the material of mourning, and to the beat of muffled drums and with black banners edged in white the cortège processed through the streets. An eyewitness, Beffroy de Reigny, was in the Boulevard du Temple at the

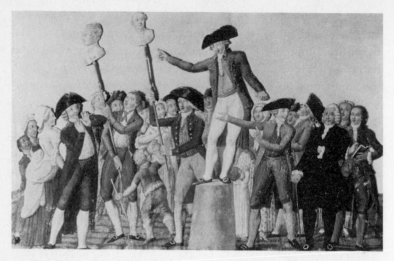

Wax heads of Necker and the Duc d'Orléans held high to celebrate
the people's heroes . . .

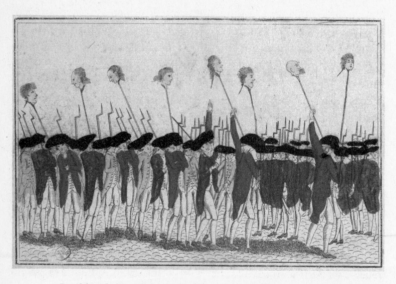

. . . . Real heads brandished on pikes to punish the people's enemies

time. He put the crowd at 'five or six thousand'. He reports that they were 'marching along, quickly and not in any kind of order', and that they had an improvised selection of weapons and were threatening to burn down any theatres which opened, 'saying that French people should not be enjoying themselves at such a moment of misfortune'.

Through the bustling artisan area of the Rue Denis, and the aristocratic enclave of Rue Saint-Honoré, the procession attracted curious bystanders as it went, and by the time it reached the Place Vendôme there was a considerable multitude of 'mourners' rallying around the waxen figureheads. This scene is memorably evoked by Thomas Carlyle:

> The Wax-bust of Necker, the Wax-bust of D'Orléans, helpers of France: these, covered with crape, as in funeral procession, or after the manner of suppliants appealing to Heaven, to Earth, and Tartarus itself, a mixed multitude bears off. For a sign! As indeed man, with his singular imaginative faculties, can do little or nothing without signs: thus Turks look to their Prophet's banner; also Osier *Mannikins* have been burnt, and Necker's Portrait has erewhile figured, aloft on its perch.
>
> In this manner marched they, a mixed, continually increasing multitude; armed with axes, staves and miscellanea, grim, many-sounding, through the streets.

As they poured into the Place Louis XV, they came face to face with a company of the Royal Allemand, who refused to salute the busts. Rather like the unfair competition when dogs and donkeys were pitched against bulls at the Combat au Taureau (a popular animal-fight venue near the waxworks), from the outset it was clear the odds were against the civilians, who found themselves face to face with the crack cavalry of the Prince de Lambesc. First insults flew, next stones, and a number of the dragoons panicked and opened fire before charging into the thick of the crowd. A pedlar called François Pepin, described in contemporary records as 'a hawker of articles of drapery', was carrying the bust of the Duc d'Orléans. He was shot in the ankle, and received a flesh wound to his chest from the tip of a sabre. He got off lightly compared to the man carrying Necker's likeness. As the fracas intensified, with fighting spilling over into the Tuileries gardens this unfortunate man was mortally wounded. What Marie referred to as

the 'sanguinary commencement' of the Revolution had begun, and the waxworks had assumed a crucial place in the historical record. Curtius was later to capitalize on the part his wax artefacts played on this momentous day. In a pamphlet in 1790 he boasted with characteristic aplomb, 'I can therefore say, to my credit, that the first act of the Revolution happened chez moi.'

While protesters struggled to protect his wax likeness, a short carriage drive away, in the calm of Grace Elliott's house, the flesh-and-blood Duc d'Orléans was safe and sound. Here, servants in the household informed him that rumours were rife that he had been sent to the Bastille and beheaded. Similar confusion occurs with reports of the fate of the wax busts. Curtius claims that six days after the protest d'Orléans's head was returned intact. If you reverse the idea of a bull in a china shop, and imagine trying to carry a very breakable object through a stampede, then Pepin's later testimony suggesting the bust was destroyed in the fracas seems more plausible. This corroborates Marie's statement in her memoirs that it was never reclaimed, 'having in all probability been trodden to atoms in the hurry and disorder'. The bust of Necker was returned by a member of the Swiss Guard with singed hair and several sabre wounds to the face, but after careful cosmetic surgery by Curtius it resumed its position in the exhibition. Two days later, in the aftermath of the storming of the Bastille, symbolism gave way to visceral realism when, in full view of a crowd, blunt knives sawed through the necks of real heads, delivering the first bloody totems of mob violence.

For the King, Tuesday 7 July 1789 was a far more eventful day than Tuesday 14 July. On the earlier date his diary entry read, 'Stag hunt at Port-Royal, killed two.' On the day the Bastille was stormed it read, 'Nothing.' While the King's hunting log showed that he had a disappointing day, Curtius by contrast was in the thick of the action. He had been recruited as a district captain in the newly created National Guard, an instant people's army formed in a matter of days as a response to the escalation of public disorder. He took to his new role with gusto, and claimed that on his first day of active service his intervention had prevented a gang of ruffians from burning down the Opéra and other theatres in the boulevard: 'Their torches were all prepared, and without my vigilance they would have destroyed one of

Curtius in National Guard uniform

the finest quarters of Paris.' The success of the stand-off between his troop of forty and the six hundred incendiaries he put down to his personal diplomacy: 'I went out at the head of my troop and spoke to them. By good luck I convinced them. They gave up their wicked ideas and made off.'

As the call went up to procure arms for the new civil militia, Curtius joined the search for weapons. Far from demanding the latest military technology, they even resorted to raiding the museum in the Place Louis XV for any crossbow or sword that might be put into service regardless of its status as historical relic. At the Hôtel des Invalides they raided a considerable cache of muskets. But guns without powder were useless. What the motley militia who made their way to the Bastille had in their sights was the vast quantity of gunpowder that the Swiss Guards had recently stored there, supposedly out of harm's way.

Curtius made much of his role as a *vainqueur de la Bastille*, the title conferred on the band of patriots (whose numbers have been put at between 800 and 900) who made their way to the legendary medieval fortress in pursuit of gunpowder. He used the title in all his

correspondence, displayed the commemorative engraved gun that each *vainqueur* was given later, and in 1790 published a pamphlet entitled *Services du sieur Curtius, vainqueur de la Bastille*. This boastful account reads as if the falling of the Bastille was his personal triumph. As in so many of the testimonies about the event, Curtius exaggerates liberation and downplays the objective of seizing gunpowder. He reinforces the potent symbolism of the ancient medieval fortress as the concrete expression of despotism, which in turn has the effect of dramatizing the significance of its fall. He describes with pride his part in 'the final dangers and glory of a conquest that put a seal on our liberty'.

In reality what happened was anticlimactic. In the first place the Bastille could have swung a sign saying 'Vacancies': there were only seven prisoners. In people's minds it was an impenetrable warren of dungeons and torture chambers, where each cell was a hell of rats and chains in which curling fingernails scratched last words on mouldy walls so thick they muffled even the loudest screams. Incarceration there symbolized a slow, dark death – like being buried alive. In reality it was far less inhospitable. Prisoners could pay for upgrades, and were allowed home furnishings such as fire tongs. In fact room service was so good that one aristocrat described how surprised he was when, after finishing his unexceptional first meal there, a much better one arrived moments later, and he realized he had eaten that intended for his visiting valet. Testimonies by former prisoners feature unlikely references to creature comforts, notably the Bastille's house blend of coffee, which was evidently 'the best Mokka'. Unlike the man-in-the-iron-mask folklore, prisoners were not in chains but, as in some twenty-first-century hotels, were encouraged to make use of the exercise area on the roof with its panoramic views of the city.

As for the prisoners, they were no longer the calibre of the popular heroes of the past, innocent victims of a whim of a king who only had to put a name on a *lettre de cachet* for a lock to be turned and a life to be clanked shut. At the time that Curtius was rallying his men outside the prison gates, the inmates were hardly a magnificent seven. They comprised four forgers, the incestuous Comte de Solages, whose own family wanted him locked up to protect them from him, a deranged Englishman, and an Irish debtor whom Marie identifies in

her memoirs as the extravagantly named 'Clotworthy Skeffington Lord Masareen' and who, she states, 'was not confined in the cells but had an apartment on the first floor'. A week earlier an even bigger public-relations headache for the liberation cause would have been the Marquis de Sade, but he had just been transferred to Charenton. In fact, though this was not common knowledge in July 1789, as part of a general programme to modernize the medieval remnants of Paris the Royal Academy of Architecture already had the Bastille in their sights for demolition. Regarding it as a large dark blot on the urban land-scape, in its place they had in mind a colonnaded atrium with a foun-tain – a light, bright civic oasis of calm. The design for a space with no specific function was rather appropriate to replace a building that had ceased to fulfil its original purpose and was largely redundant, a pre-Enlightenment throwback to darker forms of despotism when kings were cruel. In July 1789 it was what lay on the outside of its walls that was foreboding, as the impregnable fortress was faced with the challenge of keeping people out.

As sieges go, the storming of the Bastille lacks the requisite dura-tion to be one of the great ones. It was over in hours rather than days, and the really big guns that were the cannon on the ramparts were never fired. In terms of blood and thunder it was more whimper than bang. It even started with an invitation by the anxious governor to the leading assailants to join him for what turned out to be a long and inconclusive lunch. It was clear that by temperament poor Bernard-René de Launay was more a white-handkerchief-waver than a nerves-of-steel hero. But the short route to the assailant's victory via weak resistance, capitulation and surrender was not without casualties on both sides. By the time the *vainqueurs* finally got their hands on the barrels of gunpowder, with the almost incidental outcome of the release of the ragtag inmates, their casualties stood at eighty-three, compared to a single victim from the Bastille defence. De Launay's murder shortly afterwards was a brutal addition to this tally. A young journalist, Loustallot, reported the event in the first issue of *Les Révolutions de Paris*, one of a spate of new newspapers that appeared at this time: 'De Launay was pierced by countless blows, his head was cut off and carried on the end of a spear, and his blood ran every-where.' The provost Monsieur de Flesselles met a similar fate, and

impaled on pikes the heads were paraded through the streets. In grizzly imitation, true copycat style, only days later the children of Paris started to play 'let's pretend' by impaling real cats' heads on sticks and staging their own parades.

The fall of the Bastille became epic retrospectively, significant more for the meaning it was given afterwards than for what happened at the time. At the forefront of those shaping interpretations for their own ends were Curtius and Marie. Certainly the acquisition of gunpowder was crucial for a people's army which, only hours before, had had muskets but no ammunition. And this material empowerment was another milestone for the Third Estate, which only months ago had been without electoral representation. The storming of the Bastille served as a brilliant symbol for the transformation of subjects into citizens. It represented the birth of patriotic propaganda – and it was not just politicians who seized the opportunities to capitalize on this.

In the spring of 1789, as bread costs severely stretched domestic budgets, Curtius and Marie had for the first time felt the knock-on effects. Takings dipped and attendance fell away, as even the few sous necessary for a little light relief could not be spared. Cash flow was of sufficient concern to prompt Curtius to start what would be a protracted correspondence to chase a further inheritance claim on his maternal uncle's estate in Mayence, Germany. Legal letters dating from early April show that he had already received a legacy, but was pursuing that of his elder brother Charles, who was also a beneficiary but had been missing for some years. In July, however, the storming of the Bastille meant that prospects were suddenly looking brighter, as the Revolution played into the hands of the commercial entertainers and a wide range of entrepreneurs.

Curtius quickly realized that the events racking France had the potential for malleability, like the wax that was his medium. They could be fashioned in any number of ways to accommodate different markets. In London, in September 1789, the star billing in advertisements for Philip Astley's circus at the Royal Grove, Westminster Bridge, was as follows: 'Finely executed in wax by a celebrated artist in Paris, the heads of Monsieur de Launay, late Governor of the Bastille, and M. de Flesselles, prevôt de marchands (sic) of Paris with

incontestable proofs of their being striking likenesses'. The show promised to exhibit the heads 'in the same manner as they were by the Bourgoisie [sic] and French guards'. Elsewhere it was stressed that these facsimiles had been 'obtained at great expense'. They proved so popular that later advertisements boasted, 'The head of the Governor which Astley has brought from Paris is so finely modelled that almost every artist in London is anxious to take a drawing, for which purpose several of them have been attempting to take sketches as we suppose for magazines, print shops etc.' Evidently Curtius had cottoned on to the role that replica heads could play as valuable visual dispatches from abroad. Marie makes no mention of these heads in her memoirs, and it seems more likely that they were the work of Curtius himself, whose medical background and earlier experience making anatomically correct replicas would have served him well in the manufacture of macabre relics.

Nine days after the fall of the Bastille, the murder of Curtius and Marie's neighbour Foulon became their next grizzly subject. *Révolutions de Paris* reported this beheading with relish: the 'severed head separated far from his body was carried at the end of a pike through all the streets of Paris . . . His body that was dragged through the mud and carried all over the place announced the terrible vengeance of a people rightly angry towards tyrants!' The unfortunate Foulon, a former finance minister, had made an ill-judged remark about food shortages, flippantly suggesting that people eat hay. Marie describes how, by way of revenge, a furious mob tracked him down at his country house and forced him back to the city, where he was subjected to a humiliating parade through the streets. Shamed and cheered with a collar of nettles round his neck, a bunch of thistles in his hand and a truss of hay tied at his back, he was finally dragged to the Hôtel de Ville and hanged. After death his head was hacked off and impaled on a pike cruelly brandished in front of his distraught son-in-law Berthier de Sauvigny, before he too was beheaded. Both heads were paraded on pikes, Foulon's gaping mouth mockingly stuffed with straw and dung. Other accounts of this well-documented double murder highlight the matter-of-fact tone of Marie's own recollection of it. She recalls the actions of the mob with no hint of her own feelings about either their barbarity or her having witnessed the

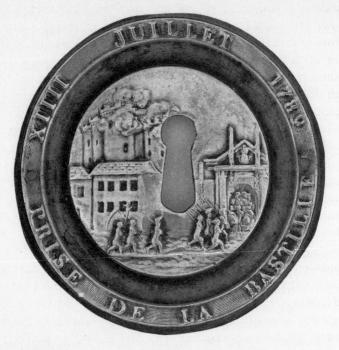

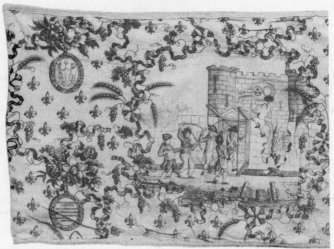

From locks to bed-linen there was a vast range of
Bastille-themed merchandise

murder of a neighbour. There is no trace of revulsion. Even making allowances for the distance from which she recalled events in her memoirs, her impersonal tone is striking. In an understatement which contrasts sharply with other witnesses, she confines herself to the opinion, 'This event was a dreadful shock to all who wished well to their country, as it proved that the mob were too strong for the constitutional authorities.'

Grace Elliott, for example, was a less cool witness to the atrocity. Much of her memoir of the French Revolution reads as an innocently unselfconscious revelation from a privileged perspective. It is the Revolution seen from inside a carriage on the way back from the horse races at Vincennes, or from a private box at the theatre. It is revolution as inconvenience, traffic jam and interruption. Thus Foulon's beheading stops her shopping. She is en route to her jeweller's in the Rue Saint-Honoré when she encounters 'a procession of French guards carrying Monsieur Foulon's head by the light of flambeaux. They thrust the head in my carriage and at the horrid sight I screamed and fainted away.' In his memoirs Chateaubriand describes graphically 'the horrid sight' that caused Grace Elliott to pass out. In the street outside his aristocratic mansion he had a chilling encounter with Foulon's killers, who 'were singing, capering, leaping to bring the pallid heads nearer to my own head. An eye in one head had been pushed from its socket and was dangling on the corpse's face, the pike sticking through the gaping mouth, the teeth clenched on the iron.' The visceral reality of Foulon's mangled body makes Marie's coolness seem even more striking.

Importantly, Chateaubriand's testimony suggests it might be right to challenge the widely held belief that casts were always made from the actual human remains. For maximum impact the wax heads needed to be easily identified – an unrecognizable mush would have no value. For a practised modeller, copying rather than casting from death seems a much more plausible method. Casting from the blood-stained original, while it became an important tool in Marie's marketing initiative later on, was not necessary in order to reproduce a convincingly ghoulish image. The head of Foulon was particularly popular, and promotional material for the exhibition made much of the fact that 'the blood seems to be streaming from it and running on

the ground'. Whereas Curtius and Marie had established their reputation with the allure of glamour, the new market centred on gore, and the voyeuristic lure of the brutalized body – but sufficiently sanitized to appeal as an exhibit that people would pay to see. They controlled sensation rather as the media today edit and airbrush the atrocity pictures that come into the public domain.

Lurid souvenirs of the bloodshed were but one facet of the new souvenir industry that emerged with the fall of the Bastille. There was a vast range of commemorative merchandise. From Bastille bonnets trimmed with fabric towers to Bastille shoe buckles, there were head-to-toe choices. There was even Bastille bed linen, with siege motifs that one would not have thought conducive to aristocrats getting a good night's sleep. And there were also Bastille panoramas, peep shows and plays. In fact there was no escape from the Bastille as a money-spinning theme. Long before its fall, this prison had exerted a great fascination for the public, with former prisoners turning their experiences into best-selling books. Simon Linguet's account of his two-year imprisonment was one of the most popular prison memoirs. First published in 1783, it reinforced the terror the place inspired, and its immense success meant that Linguet had the accolade of being featured in Curtius and Marie's collection. He kept alive preconceptions about the prison that made the public highly receptive to the versions of its fall that were sold in such a compelling variety of forms in July 1789.

The contract for its demolition won by the builder and stonemason Pierre-François Palloy was a significant commercial coup. It is no surprise to learn that this self-styled 'Entrepreneur de la démolition de la Bastille' was a good friend of Curtius. Like him, he exploited every commercial opportunity with panache. Under his guidance the Bastille was broken up and remade into an immense amount of imaginative merchandise. No stone was left unturned. Stone fragments became patriotic front-door steps; they were etched with maps, inscribed with words, and incorporated into mass-produced presentation packs, which also featured a seemingly endless supply of authentic keys. They were carved into busts of Mirabeau, and crafted into jewellery for all budgets. Poorer patriots displayed small chips in rings, but Madame de Genlis probably had difficulty

standing upright, such was the size of her Bastille bling. A large highly polished fragment was studded with the word 'Liberté', spelled in gems, and surrounded by tricolour motifs in rubies, sapphires and diamonds, all entwined with laurels. And relics were also the basis of a 'Liberty' museum which, after exhausting Parisian interest, Palloy sent on tour all over the country, like a portable theme park.

Macabre memorabilia also sold well. Metal fixtures and fittings were melted down and marketed as inkwells made from leg-irons, medallions from manacles. Commercial opportunism extended even to England, where, with an eye to the export market, designers responded rapidly to the dramatic turn of events in France. It was not just Marie and Curtius who profited from heads. The Wedgwood brothers announced, 'We are making Mr Necker's head of a size proper for snuffbox tops.' Elsewhere, the Duc d'Orléans's head was shrunk to fit on to gilt buttons, and both the people's heroes featured on a range of plaques and in endless plaster busts. Adaptability was the key requirement and, eager not to miss their moment with their range of Bastille medals, the Wedgwoods took artistic licence, merely modifying figures they had used the year before to commemorate the American wars of independence. The jasperware medallion advertised as showing the goddess of Liberty holding hands with France was in fact an ingenious bit of recycling, as evidenced in a letter by Josiah Wedgwood dated 29 July: 'The figure of Hope in the Botany Bay medal would come in exceedingly well for the figure of Liberty.'

The public readily subscribed to the idea that in celebrating the storming of the Bastille they were celebrating the symbolic defeat of despotism. Newspapers fed them this angle: as one report put it, 'The dungeons are opened; liberty is given to innocent men, and to venerable old men surprised to see the light. For the first time, august and sacred liberty finally entered this abode of horrors, this dreadful asylum for despotism, monsters and crimes.' A barrage of products reinforced the liberation-propaganda bandwagon. But the most audacious piece of propaganda can be attributed to Marie – the full-length wax figure named as the Comte de Lorges. The Wedgwoods' artistic licence with their Liberty medal pales compared to Marie's with this

composition, which is one of her most famous works. The figure of a wild-eyed, toothless old man with a long white beard is the perfect realization of the mental images that haunted the popular imagination about the victims of the *Ancien Régime*, incarcerated in dark dungeons called *oubliettes*, and forgotten by the outside world. The wax representation of the Comte is the fictional compensation for the factual deficiencies of the sorry cast of inmates who were released by the *vainqueurs*. Given that none of the prisoners was the raw material to inspire public sympathy, a journalist – Carra – did what journalists still do: he abstracted from the facts a human-interest story that would engage. Published in September 1789, and entitled *Le Comte de Lorges prisonnier à la Bastille pendant 32 years enfermé en 1757 et mis en liberté 14 July 1789*, the slim volume was an instant success. This was the blueprint for Marie's reconstruction, the word made wax. Her figure, later seen by Charles Dickens in mid-nineteenth-century London, seems to have percolated in the novelist's imagination until being reborn as Dr Manette in *A Tale of Two Cities* (1859). The long beard and unkempt appearance which emphasize the impact of Manette's long-term isolation in cruel captivity echo very clearly de Lorges.

Marie is emphatic about de Lorges. She makes no mention of her part in the wax likenesses of the first victims of the Revolution, but de Lorges is the first figure since the outbreak of the Revolution for which she takes full credit. She describes how the Comte was discovered with other prisoners in dark dungeons beneath the prison. The 'most remarkable' among them, she says, 'he was brought to her that she might take a cast from his face, which she completed. It is a whole-length resemblance taken from life. He had been thirty years in the Bastille and when liberated from it, having lost all relish for the world, requested to be reconducted to his prison and died a few weeks after his emancipation.' Her earliest posters advertising the exhibition when she came to England also made reference to him, and in catalogues she even tackled those sceptical about the true history of this frail old man by reasserting her personal acquaintance: 'Existence of this unfortunate man in the Bastille has by some been doubted, but Madame Tussaud is herself a witness of his being taken out of that prison July 14, 1789.' There is more than a hint of Manette in her catalogue description of how 'the poor man unused to Liberty for 30

Marie's wax model of the Comte de Lorges

years seemed to be in a new world' and 'frequently with tears he would beg to be restored to his dungeon.' The figure was often singled out for praise in reviews of the exhibition: in Liverpool, for example, the edition of the local paper for 14 April 1821 declared, 'The Count de Lorges is a fine piece of physiognomy.'

To give further veracity to her account of the liberation of the Comte de Lorges, Marie's memoirs invoke Robespierre. Before Palloy's demolition squad reduced it to rubble, the deserted prison became the prime destination for curious sightseers, including Marie. She describes how Robespierre, like a tour guide, conducted the fascinated visitors to the different parts of the prison – including the cell where de Lorges had been confined. Here he burst forth into an energetic declamation against kings, exclaiming, 'Let us for a while reflect on the wretched sufferer who has been just delivered from a living

entombment, a miserable victim to the caprice of royalty.' Her account of her visit is also memorable for her claim that, descending the narrow stairs, she slipped and 'was saved by Robespierre, who catching hold of her, just prevented her from coming to the ground; in the language of compliment observing that it would have been a great pity that so young and pretty a patriot should have broken her neck in such a horrid place'. In a life notable for a preponderance of twists of fate, how ironic that Marie nearly met her own death while visiting the dungeon that later on indirectly contributed to her financial fortune – if indeed she was not simply creating a frisson for her English audience by this account of a notorious murderer saving her neck in such a poignant place.

What is incontrovertible is the widespread credence given to the myths and misleading interpretations of the physical remains of the Bastille. Such was the gullibility of the public that an old printing press was presented to them as a despicable instrument of torture, and human remains from the medieval past unearthed during demolition were given new biographies to better fit the status of recent victims of barbaric kings. Across the board the public subscribed to the symbolism. The son of an English doctor recording his impressions as a sightseer spoke of 'the fallen fortress of the tyrannic power', and in a similar vein Madame de Genlis referred to 'the frightful monument of despotism'. Marie helped propagate this perception. Dungeons had been full of noxious vapours and stench; cells infested 'by rats, lizards, toads and other loathsome reptiles'; airless windowless cells admitted neither light nor fresh air; torture instruments would punish 'those unhappy persons whom the cruelty or jealousy of despotism had determined to destroy'. And, most chilling, there had been 'an iron cage about twelve tons in weight with a skeleton of a man in it who had probably lingered out a great part of his days in that horrid situation'. To read her account of her purportedly first-hand experience in the Bastille is to see a blueprint for the synthetic dungeon that eventually became known as the Chamber of Horrors. Two models of the Bastille, one showing it before the fall, and the other in ruins, were also put on display in the Boulevard du Temple exhibition, and later came to England with her. But

Curtius's show-stopper in the summer of 1789 was a tableau of the siege – a theatrical backdrop to the unambiguously authentic heads of de Launay, Flesselles and Foulon. The collection, formerly a frivolous and fashionable recreation, was fast becoming an indicator of the political climate.

6

Model Citizens

WHILE CURTIUS AND Marie adapted their exhibition, a wave of idealism swelled. In 1790 the anniversary of the storming of the Bastille saw the first epic Revolutionary festival for a mass audience. Choreographed by the painter Jacques-Louis David, it took place on the Champ de Mars, rather than the site of the Bastille, and was designed to emphasize unity and to usher in a new era of classless harmony. Where formerly privilege and tradition had divided, patriotism was presented as a unifying force. In the spirit of equality, a cast of thousands were not just spectators but took a participatory role in the preparations, including site preparation and setting up the enormous amphitheatre and stage. Marie describes taking part in this communal earth-shifting, when both the highest and the lowest wielded the spade and the pick in fraternal harmony, and she herself trundled a barrow in the Champ de Mars. A fellow wheelbarrow-pusher and witness was Madame de La Tour du Pin, who noted, 'Laundresses and Knights of St Louis worked side by side.'

Whereas *Ancien Régime* pageantry was a spectacle of power, reinforced by the sheer force of time and tradition, this revolutionary display was an ephemeral celebration of the present. David conceived everything on a spectacular scale, with dazzling special effects designed to increase the visual impact. Variously featuring in his festivals were fountains gushing from gigantic breasts, processions of children, clouds of white doves, the burning of old symbols, the brandishing of banners bearing new ones, togas and chariots, laurels and cypress, classical imagery recast for a new civic idyll. He also had a mass-choir habit. But it was eventually to become apparent that the new political landscape he was dramatizing was as flimsy and unstable as his plaster-of-Paris models and cardboard mountains. Unity and frater-

nity were not achieved simply by putting on a spectacular show of these virtues. Festivals alone did not instantly inculcate their values in the hundreds of thousands of citizens who saw them, and the hope that patriotism would prove a cohesive force proved to be wildly over-optimistic. The initial sense of *l'année heureuse* quickly gave way to an overwhelming feeling of anticlimax. Equality too was to prove elusive in practice. The festival generated a huge influx of custom from beyond the city for the prostitutes in the Palais-Royal and yet, far from displaying a spirit of unity and equality, the opportunist girls had no qualms about charging young clients six livres, and more mature clients twelve.

As people embraced a patriotism that theoretically dissolved class differences, there was a backlash against the former frivolities of fashion. As well as pushing together to make a public arena, people in a new way pulled together to swell the national coffers. There was a mass meltdown of shoe buckles and silver accessories, as citizens from all classes proffered their valuables to the mint. The zest for patriotic donations and the eagerness to have one's name printed on the thanks-giving lists of the National Assembly meant that patriotism itself became a fashion, and its dictates were taken every bit as seriously as the wildest extravagances that had been so blindly adhered to before. Hairdressers adapted by promoting patriotic hairstyles. In place of wigs and powder, the look was overtly low maintenance, the impli-cation being that, whereas aristocrats devoted hours and fortunes to their high hair, the patriotic mind was on a higher plane. Marie records the changes: 'the hair cut short without powder "à la Titus" and shoes tied with strings', where before 'hair was worn long and powdered and buckles were in use for the shoes.' The new look did not impress the English aristocrat William Wellesley-Pole: 'Men in order to show their democracy have sacrificed their curls and toupees; some of them go about with cropped locks like English farmers without any powder, and others wear little black wigs.'

However, if the former excesses were curbed, they were not com-pletely quashed. Enterprising jewellers produced glass and crystal trin-kets emblazoned with slogans such as 'La Patrie'. Brass shoe buckles were marketed as 'à la nation' and even milliners cottoned on to this ruse, merely renaming their confections in tune with the times. Writing

from Paris to his wife in the country, the Marquis de Mesmon tells her he has bought her a 'terribly pretty hat in the latest fashion which is entitled "To Liberty" – the most *ravissant dernier cri!*' What all this meant for Curtius and Marie was packing away all the frills and finery, and consigning their Bertin creations to dust sheets and trunks, as increasingly they found themselves kitting out their figures in uniforms.

The kaleidoscopic fashion palette of the *Ancien Régime* dried up to three colours: red, white and blue. Florists did well with poppies, daisies and cornflowers, and ribbon-makers profited from a run on tricolour trimmings, which were worn in buttonholes, and as rosettes and cockades. Finery with aristocratic associations was out, and, for those who had depended on the ostentatious consumption associated with feudalism, patriotism was a disaster. 'The embroiderers are going bankrupt; the fashion merchants are closing down; the dressmakers are sacking three-quarters of their workers. Women of quality will soon no longer have chambermaids.' Not generally known for his fashion tips, Marat's fashion forecast was bleak. 'I should not be surprised if in twenty years' time there is not a single worker in Paris who can trim a hat, or make a pair of pumps.'

In contrast, the rag-sellers and ink suppliers and those engaged in papermaking, printing and publishing all flourished. The official records of the new governing bodies and the public appetite for news generated a vast market for paper and print, and with the quickened pace of current affairs journalists thrived as never before. The waxworks were in a unique position to give a visual commentary on the changes. They were able to keep abreast of every development, where other manufacturers struggled to keep up. Topicality was particularly problematic for the producers of politically themed objects. For example, designs for plates with images and slogans for one political phase became quickly obsolete, given the turnover of governing bodies, each with a different agenda. The waxworks, however, were ideally placed to cater to a climate of instability. A nineteenth-century commentator, Audiffret, gives a good summary of Curtius's adaptability. 'Curtius made a display of his patriotism from the start of the Revolution; he offered for the public approval or execration the men of the hour or the whirl of fashion, victors and vanquished, and awarded them a place of honour or infamy according to the

circumstances. He became a weathercock, like so many men who did not boast about it and who had found for themselves a way of making money.'

The weathercock response was not only a sound commercial strategy: it was to become a means of survival. Ill winds were gusting in 1791. The death of Mirabeau – who, in spite of his aristocratic status, had played a prominent part in the first phase of the Revolution and been elected to the Estates General as a representative of the Third Estate – was crushing for the moderate cause. Marie describes his funeral cortège as exceeding anything of the kind she had ever witnessed. His funeral was also significant as the inauguration of the Panthéon as a secular hall of fame for the great and the good. The architect de Quincy extended Soufflot's supremely elegant neoclassical shell of the unfinished church of Saint-Geneviève into a space that signified the symbolic and secular reorientation of social values. The Panthéon was radical in recognizing worth and birth as separate and unrelated criteria for social distinction. In a new way, worth was in the eye of the beholder, and the people, not the Establishment, were ostensibly the arbiters of greatness. As Madame de Staël noted, 'For the first time in France a man celebrated by his writings and his eloquence received honours formerly accorded to great noblemen and warriors.' However, although the Panthéon might have looked more democratic, in a sense it was much less so than a Christian church. At a crucial doctrinal level, whatever the trappings of social hierarchy, all souls were equal before God. Kings and peasants alike knew they would be judged by the same God. In the Panthéon, some people were explicitly more 'worthy' than others, and the entity ascribing worth was the nation/state/Revolutionary government. What mattered was the 'will of the people' – though all too often this turned out to be the whim of some politician. Nevertheless, the Panthéon replicated on a grand scale what the waxworks provided as a popular entertainment, a forum for secular idolatry.

In his diary, Gouverneur Morris, reflecting on Mirabeau's funeral, eloquently conveys the climate of changeability, and questions the honours accorded to the first resident of the Panthéon: 'I have seen this man, in the short space of two years, hissed, honoured, hated and mourned. Enthusiasm has just now presented him gigantic. Time and

reflection will shrink that stature. The busy idleness of the hour must find some other Object to execrate or exalt. Such is Man, and particularly the French Man.' This was to prove true, and when Mirabeau's double-dealing with the royal family was later uncovered, his mortal remains were ignominiously removed from the Panthéon. The installation and subsequent removal of Mirabeau was a grand-scale version of the simple dynamics of the chop-and-change celebrity culture promoted so successfully by Curtius and Marie. Like contemporary celebrity culture, political allegiance to specific people was eternal only while it lasted, an unstable mix of sincerity and fickleness. The waxworks were at the apex of the culture of impermanence, charting the changing allegiances in public life.

The fact that Curtius was politically active, with a role in the National Guard and a member of the Jacobin Club, meant that it fell to Marie to keep the exhibition running smoothly from day to day. As a captain in the newly co-ordinated civic militia called the Chasseurs, Curtius was required to go on anti-smuggling patrols and to supervise food distribution. All this ate into his career as a showman, and in his pamphlet he referred rather resentfully to 'sacrificing the time belonging to my work. This is a loss for an artist.' Although the proliferation of men in uniform on the streets was a reminder of the background tensions, there was an atmosphere of relative calm until the King's abortive flight in the spring of 1791. After this the divisions between royalists and republicans became more serious. Marie notes in her memoirs, 'France was at this period rent by different factions.'

There was an all-pervasive sense of duality, and of people at all levels of society being challenged by conflicting allegiances and divided loyalties – Curtius the artist-businessman negotiating an incredibly politicized environment and torn between show business and civic duties; the members of the French Guard increasingly torn between loyalty to the King and empathy with the National Guard; the general public split between moderate Girondins and extreme Jacobins; the National Assembly pulled between appeasing the people and punishing the King; and the King himself torn between complying with the constitution and fleeing to reassert his power, assisted by foreign allies. In this climate, allegiance started to become

a much more serious matter, and one can begin to understand the origins of Marie's reticence. Her iron will seems to have been forged in these trying times when it was at first prudent and then became vital that she learned not to say how she felt, not to tell what she knew. An extra pressure was that the exhibition was a highly conspicuous public arena, with the stakes set high if the tableaux and figures did not chime perfectly with public opinion.

With the failed escape attempt of the royal family, all vestiges of respect for monarchy vanished. As Grace Elliott noted, 'Even those who some months before would have lain in dust to make a footstool for the Queen passed her and splashed her all over.' There was even more contempt for the King. He was called Louis the Hated and Louis the Fat Pig – Marie certainly blamed the failure of his escape attempt on the legendary Bourbon greed, given that he had insisted on stopping for supper. At the family home she eavesdropped as political talk at the dinner table turned to republicanism:

> Many members of the Jacobins who began about this period to frequent the house of M. Curtius would speak boldly as to the formation of a republic, and the destruction of royalty; and soon the cry of 'No King!' was heard throughout the streets, and was even disseminated through the medium of the public papers, whilst the clubs of the Jacobins and Cordeliers, ever the most furious and daring, echoed the yell of 'Down with the Monarchy' in all their meetings.

Writing on the eve of the Revolution, Mercier had challenged France to remould itself. In a stirring address, he had urged his audience to grasp the potential for change: 'See that you are ruled not by order of nature but by caprices, which your cowardice has allowed to harden into laws. Know yourselves, hate yourselves and in that excellent discontent remould your world!' By 1791 discontent had turned into belief not just that the monarchy should be brought to heel, but that it could be removed. Remoulding was dramatically under way – most especially in the waxworks, where Marie found herself working all hours on an ever-shortening cycle of removals and renewals.

Beyond the waxworks, the quest for change involved the destruction of material objects, such as the burning of aristocratic pews

in churchyards, the painting over of all aristocratic livery and the felling of royal statues by way of a ritual purging of feudal symbols. But rapidly the focus shifted to flesh-and-blood subjects. If in 1790 the number-one hit and national theme song was the optimistic 'Ça Ira' – a pre-Revolutionary version of 'Que Sera Sera': 'Things will work out' – then by 1791 a new second line was ominously violent: 'Let's hang aristocrats from the lanterns!' This was belted out with gusto at every opportunity. Similarly violent was the oratory of Danton and Marat, who supplied a significant amount of the raw material from which the social order was being recast. Marie lets us see them afresh. Danton's mild manners off the podium were greatly at odds with his formidable physical presence – 'His exterior was almost enough to scare a child; his features were large and harsh . . . his head immense.' Marat, in stark contrast, was 'short with very small arms, one which was feeble from some natural defect, and he appeared lame; his complexion was sallow, of a greenish hue, his hair was wild, and raven black; his countenance had a fierce aspect.' She describes his fire-in-the-belly speeches as seeming to come from someone under the influence of some 'demonical possession'.

She had ample opportunity to formulate her impressions of Marat, because on one of the many occasions when his newspaper *L'Ami du peuple* incurred the enmity of the authorities he sought asylum at her home. She relates how he arrived with a carpet bag and stayed for a week. He appears to have been an undemanding house guest, spending most of the time writing – 'almost the whole day in a corner with a small lamp'. On one occasion he subjected her to a private hearing of his political rhetoric, tapping her on the shoulder 'with such roughness as caused her to shudder, saying, "There, Mademoiselle, it is not for ourselves that I and my fellow labourers are working, but it is for you, and your children, and your children's children. As to ourselves we shall in all probability not live to see the fruits of our exertions"; adding that "all the aristocrats must be killed." ' She then describes a chilling postscript to her conversation with him when Marat 'made a calculation of how many people could be killed in one day, and decided that the number might amount to 260,000 [*sic*]'. She described his newspaper as 'one of the most furious, abusive and calumnious productions which ever appeared, its object being to inflame the

minds of the people against the King and his family, and in fact to incite them to revolt and to the destruction of every institution and individual likely to afford support to the tottering monarchy'.

The silence of what Marie omits from these recollections of her fanatical guests, namely the personal feelings they evoked in her, is deafening. Given her supposed eight-year tenure as royal art tutor at the palace of Versailles, and the strong bonds of reciprocal friendship she professed between herself and Madame Elizabeth, she seems to have shown great restraint in withholding any royalist sympathy in the face of Marat's republican rants. Interpretation of her reticence depends on how much credence one gives to the story of her life presented in the memoirs. In the eye of the Revolutionary storm her fence-sitting is the sign not of an unfeeling person, but of a prudent person; restraint at that time would have been understandable. But far away from the dangerous atmosphere of Revolutionary Paris, when recollecting events so many years later, her reticence is baffling. Rather as moths adapt their wing colour as a survival camouflage, perhaps Marie's apparent thick skin was developed as a survival mechanism in dangerous times. Decisions about the content of the exhibition were becoming fraught. Curtius's aristocratic connections were what propelled him into the Parisian limelight in the first place, and Marie made much of her links to the court circle. One surmises that she would have been torn between preserving the *haut ton* of the exhibitions with royals and courtiers, and focusing more on the new wave of activists and agitators. If Curtius was more naturally disposed to the latter course, and jumped on every passing bandwagon, then Marie's strategy was to cultivate the impression of being an innocent victim of circumstances, a reluctant collaborator. (In England she always defended Curtius's reputation, and claimed he too had been a royalist compromised by circumstances. The *London Saturday Journal* in 1839 reiterated the claims in the memoirs: 'Her uncle always persisted in saying, however, even after he had fairly joined the revolutionists, that he was a royalist at heart, and that he had only favoured these visionaries, and entered into their views, to save his family from ruin.')

An important element in the realignment of social values and the secularization of France at this time was the energy that went into demoting the power of tradition by devising new rituals. David

played a major role in masterminding the aesthetic of the Revolution, and according to Marie he was an associate of Curtius and a familiar face at the family home. In what appears as a consistent theme of her own magnetic attraction for powerful men – remember the King's brother tried to kiss her, Voltaire complimented her on her looks, Robespierre called her a pretty patriot – David was always very good-natured towards her, but his originality clearly deserted him in using the old cliché of 'always pressing her to come and see his paintings'. It was an unreciprocated admiration: she calls him a monster, and 'most repulsive'. 'He had a large wen on one side of his face, which contributed to render his mouth crooked; his manners were quite of the rough republican description, certainly rather disagreeable than otherwise.' David was evidently acutely self-conscious about 'the revolting nature of his countenance, manifesting the utmost unwill-ingness to have his likeness taken.' However, Marie evidently per-suaded him and although the likeness did not come with her to England, she states that she produced 'a most accurate resemblance of that eminent artist'.

Whatever Marie's personal relationship with David, he incorpor-ated a wax figure of Voltaire in the festival dedicated to the writer in July 1791. This was the second time that wax figures from the exhibition had played an integral role on the wider stage of the Revolution, but the earlier impromptu use of two busts in July 1789 was very different from the carefully choreographed role that the figure of Voltaire played on this occasion – aboard a magnificent chariot and clad in vermilion robes. It was the centrepiece of a cast-of-thousands production devised by David for the writer's grand entry into the Panthéon. In his diary, Lord Palmerston referred to 'a figure of Voltaire very like him in a gown' and 'a very fine triumphal car drawn by twelve beautiful grey horses, four abreast'. Unfortunately, torrential rain made the colours of the robes bleed, but it was Curtius who had a red face when VIPs roundly blamed him for failing to do justice to the event with the rain-streaked figure. The press, however, were more interested in contrasting Voltaire's glory with the mocking of the King. Engravers had a field day juxtaposing Voltaire being crowned and fêted with adulatory fanfares with the King being insulted by fanfares of farts from the behinds of angels.

Only days after the Panthéonization of Voltaire, a republican rally in the Champ de Mars was quashed by force when Lafayette fired on the crowd. But the zeal of the republican cause was by now bullet-proof, and the dethronement of the King was now not likely but inevitable. Shortly after this, a brave public-relations exercise on the part of the royal family backfired horribly when the Queen, her children and Madame Elizabeth went to the Comédie-Italienne. Incensed by the leading lady, Madame Dugazon, seeming to address one aria directly to the Queen, when she sang the line 'Ah, how I love my mistress!', the Jacobins in the stalls could not contain themselves. Grace Elliott relates how 'some Jacobins who had come into the playhouse leapt upon the stage, and if the actors had not hid Madame Dugazon, they would have murdered her. They hurried the poor Queen and her family out of the house, and it was all the Guards could do to get them safe into their carriages.' This was the last public appearance of the Queen before that engagement that she did not plan and where she would find herself centre stage, drawing the gaze of a vast audience as drums rolled.

From the invasion of a stage and upstaging of a public performance by a few angry Jacobins, in 1792 the boundaries that were breached became more serious. The lines crossed were to involve nations and frontiers, and most dramatically the invasion of the royal family's private quarters in the Tuileries with devastating consequences. On 20 April 1792, when France declared war on Prussia and Austria, there was a sense that what had started as a popular uprising, which it was thought could be contained and directed by new authorities, was becoming increasingly unmanageable. Marie, by now a woman of thirty-one, began to live at the centre of a city where the difficulties of day-to-day life were exacerbated by war. 'La patrie en danger' heightened nationalistic fervour. Whereas the outbreak of the Revolution had provided commercial opportunities for those in show business and consumer goods, now it was the turn of others to profit from the opportunities that came with military action. Seamstresses turned their talents to uniforms, and factories and foundries went into overdrive to supply equipment and arms. Church bells were melted down for cannon. Tanneries could barely keep up with the demand for harnesses.

As hostilities escalated, ordinary civilians became embroiled in the war effort. The wives of Paris were called upon to tear up their trousseaus for bandages. (Total mobilization – *levée en masse* – was officially declared by the Convention in August 1793, after a series of setbacks during the first half of that year.) Marie relates how, in response to a chronic shortage of gunpowder, 'For the purpose of obtaining the quantity of saltpetre [a prime ingredient of explosives] that was required, they were obliged to resort to the most singular measures. It was imagined that it might be procured in considerable quantity from the mouldy substance commonly found on the walls of cellars. Every private house, therefore, underwent an examination to see what might be extracted from their subterranean premises.' The austerity and enterprise of her later years probably originate from her experiences at this time. Like many civilian survivors of wars she had those distinctive badges of fortitude. A persistent shortage of animal tallow in the later years of the war was particularly difficult for the exhibition, as candlelight was crucial to the overall illusory magic of the display of figures.

But it was not just candles that were in short supply. For those in the entertainment business the sheer numbers of the men recruited as soldiers meant a drastic depletion of both customers and performers. Marie reported the enthusiasm with which people joined up, and how the quarter in which she lived 'appeared almost cleared of men'. As Curtius became ever more involved in Jacobin affairs, as well as being involved in the National Guard, and as he stepped up his pursuit of his inheritance claim in Mayence in conditions more difficult by the day, Marie had to keep the exhibition afloat. Later on in England she recalled that, for the first time, in the summer of 1792 it was necessary to reduce admission charges to attract more customers. This year also saw grocery riots when, as well as bread, other foods including coffee and sugar were in short supply.

Marie was living in a city that was like an ideological building site, with drastic demolitions and radical conversions such as churches being declared Temples of Reason. In the course of the next two years, language and traditional systems for measuring time were all revised. New language was supposed to render old concepts obsolete. The King was demoted to Louis Capet, and the Duc d'Orléans

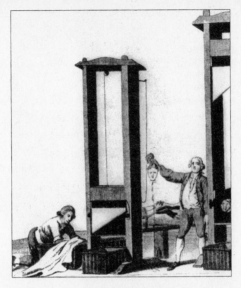

The modern beheading machine

became Philippe Egalité. Many public establishments pasted up posters proclaiming 'The only title recognized here is that of citizen,' but an anecdote from the theatre shows how hard it was to implement these changes. A prima donna at the Comédie-Française called for her lackeys, only to be told, 'There are no more lackeys, we are all equal today.' Unabashed, she replied, 'Well then, call my brother lackeys!' The one-size-fits-all 'commune' replaced the distinctions of hamlet, town and city. Meanwhile, the most ominous manifestation of equality was the newfangled instrument of capital punishment – the gleaming guillotine – which made its first appearance in the Place de Grève in April 1792.

Historically, a protocol of execution meant that the supposed swiftness of beheading was the privilege of the well-bred criminal, while the riff-raff felons were subjected to burning, breaking on the wheel or hanging. Now the guillotine brought democracy to decapitation. As a new invention it captured the public imagination and was the talk of Paris; as a well-worn relic its fascination is undimmed. At the height of her fame in England, Marie allegedly bought the original guillotine blade and installed it in pride of place in the Chamber of Horrors. The

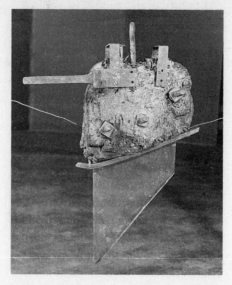

The guillotine blade bought from the Sanson family

catalogue entry read, 'This relic was purchased by Madame Tussaud herself, together with the lunette, which held the victim's head in position and the chopper which the executioner kept at hand for use should the guillotine knife fail – Sanson the original executioner vouching for the authenticity of the articles which were then in possession of his grandson.' The whole was listed under the heading 'The most extraordinary relic in the world'.

In spite of the difficulties and the mounting tensions in the background, the exhibition remained a precise gauge of the mood of the people. The different acts of the unfolding drama were revealed by just a glance at the silent doormen, who were persuasive enough in their realism to entice people to pay up to see more. In the 1780s they had been dressed in the regalia of royal soldiers; in 1789 they had been reclothed in the simpler uniforms of the National Guard; now they had the distinctive uniform of the sans-culottes: long trousers, such as working men wore, rather than the knee-breeches (culottes) favoured by courtiers and professional men, with the all-important *bonnet rouge* on their heads – the red cap which

according to Marie was 'much worn at this time as the symbol of liberty, but proved more correctly the symbol of anarchy and was a great favourite with the vulgar'.

Whereas clothing had once followed the fads of fashion, now it had a more serious function as a political statement, with colour, cut and even degree of cleanliness all loaded with significance. It is not surprising that, as the Revolution progressed, the innovative fashion and lifestyle magazines that had appeared in the heady climate of the late 1780s fizzled out completely. Their ethos was not viable in a city that had lost its sparkle, and where dress was suddenly bound up with ideology. What Marie's memoir omits in feelings and opinions, it supplies in detailed description of dress, like a talking pattern book. She witnessed the emergence of clothing as an integral aspect of political allegiance. The absent-minded who forgot to sport a patriotic cockade or to wear the correct republican accessories were putting themselves in real danger. Being out of date, once social death, would soon become a justification for a death sentence. The weight of importance Marie ascribes to clothing makes more sense in the context of her experiences of living at a time when appearances were judged so harshly, and could be used as evidence against you. An incident concerning her maid related by Madame de La Tour du Pin illustrates this:

> She went out, dressed as always in the clothes normally worn by a maid in a good household, her apron white as snow. She had gone but a few steps along the street when a cook, her basket over her arm, pushed her into an alley and said to her, 'Don't you know, you wretched woman, that you will be arrested and guillotined if you wear an apron like that?' My poor maid was astounded to find that she had risked death by observing a lifetime habit. She thanked the woman for saving her, hid her anti-republican apron, and hurried off to buy several lengths of coarse cloth to disguise herself, as she put it.

Wearing trousers was an overt anti-Establishment statement, and as class war intensified it became common practice for aristocrats to adopt an affected version of working-class dress. Marie relates how the Duc d'Orléans, now Philippe Egalité, in order to ally himself to their cause, donned the outfit of the sans-culottes. 'It consisted of a short jacket, pantaloons and a round hat with a handkerchief worn sailor-fashion loose round the neck, with the ends long and hanging down, the shirt

collar seen above.' Contrived unkemptness was also part of the look. An Englishman in Paris at this time, Dr John Moore, remarked on the 'great affectation of that plainness in dress and simplicity of expression that are supposed to belong to Republicans'. He relates how a well-connected acquaintance from one of the first families in France drew attention to himself at the theatre by his choice of clothes, 'in boots, his hair cropped and his whole dress slovenly'. When this was commented on, he defended himself by saying that 'he was accustoming himself to appear like a Republican.'

As the Revolution progressed, cleanliness was seen as subversive, to the extent that anyone bold enough to appear in a clean shirt was subjected to a barrage of insults. Marie relates how Marat conformed to this dress code, with 'a dingy neglected appearance, not very clean'. Robespierre, however, did not embrace sartorial slovenliness, and was renowned for his high standards of personal grooming. Marie remembers him as 'a perfect contrast to Marat, being fond of dress. He usually wore silk clothes and stockings, with buckles in his shoes; his hair powdered, with a short tail; was remarkably clean in his person, very fond of looking in the glass and arranging his neckcloth and frill.' It seems very surprising that the man directing the Revolution and the strict arbiter of Revolutionary protocol should himself appear in such brazenly counter-Revolutionary garb. It was noted by, among others, the Revolutionary idealist Helen Maria Williams, who in a letter wrote, 'While he called himself the leader of the sans-culottes, he never adopted the costume of this band.'

Named after their style of dress, the sans-culottes were the most important popular movement of the Revolution that surged in power in 1792. As work wear, their clothing defined a set of values and emphasized class difference. A pamphlet from 1793 entitled *What is a Sans-Culotte?* answers the question with a vivid picture and gives a good profile of Marie's audience: 'He's a man who goes everywhere on his own two feet, who has none of the millions you're all after, no mansions, no lackeys to wait on him, and who lives quite simply with his wife and children, if he has any, on the fifth floor. He is useful because he knows how to plough a field, handle a forge, saw a file, tile a roof, how to make shoes and to shed his blood to the last drop to save the republic.' The sans-culottes were the rank-and-file

workers, the legions who lived cheek by jowl in attics and tenements and whose chief concern in daily life was a full breadbin for the family. They were the artisans and craftsmen who worked in the Revolutionary hot spots of the Rue Saint-Antoine and the Rue Saint-Marcel, with their concentration of small workshops. They were the people who rejoiced the most with each blow to the old regime. They were also regulars at the waxworks, which shed its former associations with the court and, in pace with their rise to prominence, reinvented itself as a favourite sans-culotte entertainment.

7

The Shadow of the Guillotine

THE SUMMER OF 1792 found Paris seething with a menacing rabble as thousands of the extreme patriots known as *fédérés*, who came from Marseilles, poured into the city to celebrate the third anniversary of the fall of the Bastille. Their spirited singing of the Marseillaise stirred up patriotic hearts, and adrenalin and alcohol fuelled fraternal feeling with the sans-culottes. En masse they represented people power as an awesome force. In his memoirs, Chateaubriand wrote of this time, 'A popular despotism could be scented, no doubt creative and filled with promise, yet far more powerful than the old rotting monarchical despotism; for, as the sovereign People is everywhere, when it becomes a tyrant, he is likewise – the inescapable presence of a universal Tiberius.'

On the night of 10 August 1792 the combined might of a mob of provincial *fédérés* and Parisian sans-culottes finally brought down the Crown when they invaded the Tuileries and the royal family were forced to flee for their lives. For a suffocating sixteen hours they hid in the cramped space of a booth used as a press box by the Legislative Assembly, but their suffering was as nothing compared to what befell the Swiss Guards, gendarmes and other troops garrisoned at the Tuileries. Loyal to the end, they were massacred by the merciless mob. But it was not only the sunburnt hands of the *fédérés* that were bloodied: a small group of women also committed acts of breathtaking barbarity. Their final outrage was to castrate the corpses and then distribute the severed penises from blood-spattered apron pockets, with smiling faces as if they were pressing posies into the hands of passers-by. One eyewitness to these atrocities who never forgot what he saw was Napoleon Bonaparte. At the end of his career he reflected, 'Never since has any battlefield given me the same

impression of so many corpses as did the sight of the masses of dead Swiss . . . I saw some very well-dressed ladies committing the worst indecencies on their cadavers.'

The eruption of years of pent-up grievances exploded any constraints of civilized humanity. Mercier gives a vivid account of the carnage witnessed by the rubbernecking voyeurs who sought out the site of the atrocity. They saw a jumble of corpses in a stack like a woodpile. 'Weep they did not, they seemed petrified, struck mute. Everywhere they stepped back, horrified by stench and sight of oozing corpses, throats cut, entrails hanging out, and anger still screwing up their faces. The more stoical visitors pointed at the massed flies agog for blood drawn by the heat of the open wounds on corpses, the eyes torn from their sockets.' Marie was one of those who walked through the devastation and saw the gobbets of flesh and shards of glass, scenes of horror heightened for being viewed under bright sun (although ominously, as spectators noticed on that dazzling summer day, even the sun was the colour of blood):

> Wherever the eye turned it fell upon many a mangled corpse. The beautiful gravel walks were stained with gore; the statues, although some were spotted with blood, were uninjured; for such was the extraordinary respect manifested for works of art even by the murderous mob, that when their victims sought refuge by climbing up the statues, the people would not fire at them lest they should damage the beautiful specimens of sculpture; they therefore kept pricking those who clung to them with their pikes, till the unfortunate wretches were forced to descend and despatched by such means as best suited the caprice of their assassins.

An intriguing aspect of Marie's recollection of the aftermath of the massacre is her claim that she was there not as a sightseer, but to look for kinsmen, having 'three brothers and two uncles who were among the combatants at the palace'. This is the first and only reference she makes to them, and when she exclaims, 'How few individuals are there who have experienced so dreadful a blow as that of losing in one day, by the hands of assassins, three brothers and two uncles!', one can't help conjecturing that the odds are against her being one of this minority group. This claim was perhaps no more than the

characteristic embroidery of her victim status by means of which she engaged public sympathy later on in her career.

The Tuileries massacre marked the removal of the King and Queen to the Temple prison. Like the rare animals once displayed in the royal menagerie at Versailles, the royal family in captivity became a prize sight in Paris, a pay-per-view attraction. As Marie related, 'An intense interest existed in the minds of the people respecting them, and in all the houses round the prison, the proprietors were able to let their lodgings at an extremely high rate, numbers of people paying for admission to those rooms from the windows of which they could obtain a view of the King and his family walking in the Temple gardens.' From now on it seemed as if all the mechanisms of restraint had been broken, and the popular uprising marked a turning point to a chill climate of menace and criminality. It is from this period that Marie assumes a starring role in some of the key episodes which defined the Terror of the Revolution. What is not in dispute is the fact that the exhibition remained a leading attraction – it was like the pulse and heart of the public body. But what is worth exploring more carefully is the source of some of the most famous stories and the related exhibits associated with the period of Marie's life when she became Citizen Grosholtz and the shadow of the guillotine fell on the new republic.

On 2 September rumour about the progress of the invading armies sparked panic that turned into drastic retaliatory action against suspected counter-revolutionaries. Danton and Marat have been widely held responsible for inciting the bloodbath that ensued, with the infamous prison massacres that claimed thirteen hundred lives. At La Force prison, one of the most famous victims, who has become the individual embodiment of the horror of a mass slaughter of the innocent, was the Princesse de Lamballe, a loyal and beautiful lady-in-waiting to the Queen, whose official title at Versailles had been Superintendent of the Royal Household. Marie's description of these crimes as being perpetrated by the 'saturnalia of hell' obscures another dimension to the atrocities against this woman, namely that her murderers were ordinary cobblers and cabinetmakers, jewellers and journeymen. The murder of the Princess is widely documented and, while details differ slightly, all sources concur that

the brutality plummeted new depths of depravity. Count Axel von Fersen, the devoted admirer and erroneously suspected lover of the Queen, wrote, 'The Princesse de Lamballe was most fearfully tortured for four hours. My pen jibs at giving details, they tore off her breasts with their teeth and then did all possible for two whole hours to force her back to consciousness to make her death the more agonizing.' After death, her brutalized face was turned into an obscene comic mask with a fake moustache of her pubic hair, and this was brandished on a pike outside the Temple prison to taunt the Queen. As Carlyle put it, 'That fair hindhead is cleft with the axe; the neck is severed. That fair body is cut in fragments; with indignities, and obscene horrors of moustachio *grands-lèvres*, which human nature would fain find incredible.'

This monstrous mutilated relic becomes the first head that Marie claims she was forced to mould. In her memoirs she describes how the head was immediately taken to her, evoking feelings 'easier conceived than described. The savage murderers stood over her, whilst she shrinking with horror, was compelled to take a cast from the features of the unfortunate princess.' This is recounted as a profoundly traumatic experience: 'Alas for Madame Tussaud, to have the severed head of one so lovely in her trembling hands was hard indeed to bear.' It was a trauma that would have been exacerbated by Marie knowing the Princess by sight at Versailles, and being aware of her reputation for having an almost saintly good nature. Yet there is something unconvincing about the spirit of her co-operation with the mob. 'Eager to retain a memento of the hapless princess, Madame Tussaud proceeded to perform her melancholy task, whilst surrounded by the brutal monsters, whose hands were bathed in the blood of the innocent.' As keepsakes go, one feels most people would have settled for a lock of hair. She never showed this gruesome commission in England, though nineteenth-century catalogues record that Marie did display a full-length figure of the Princess, and the press in Liverpool praised 'the extremely beautiful and highly finished incumbent figure of the Princesse de Lamballe'. However, she did not baulk from recounting details of the murder of the Princess to spice up the catalogue. For example, a version of the catalogue printed in 1819, when the exhibition was on tour in Cambridge, after a graphic

description of the mutilation of the body continued, 'The murderers carried the bleeding head to Madame Tussaud, and ordered her to take a model of it which dreadful order more dead than alive she dared not refuse to obey.' It would have been shocking enough to read of the unfortunate end that the beautiful woman met, without having to stomach the sight of her mangled mortal remains. Marie's personal involvement in the immediate aftermath of such a famous murder, however, would have strengthened her claims to have been a 'victim' of the Revolution, and added interest to the other Revolutionary relics on display, reminding the public of her proximity to events.

As Restif de la Bretonne noted, 'August 10 had renewed the Revolution and brought it to its conclusion; 2, 3, 4 September cast a sombre horror over it.' Indeed, the violence of the September killings caused revulsion among all but the most diehard supporters of the Revolution. As Madame Roland wrote, 'You know my enthusiasm for the Revolution, well now I'm ashamed of it. It has been dishonoured. I now find it hideous.' As the sans-culottes' vision spiralled into blood-soaked vengeance against aristocrats and royalists, human viscera would become as familiar a sight as butcher's cuts. The mood was already much darker as a life-and-death game of hide-and-seek began. The rigorous house searches for counter-revolutionaries and royalist sympathizers forced suspects to adopt ever more ingenious methods of evading the authorities. A contemporary called Peletier describes this: 'One man squeezed up behind the wainscot, which had been nailed back on him, seems to form part of the wall; another is suffocated with fear and heat between two mattresses; a third rolled up in a cask loses all sense of his existence by the tension in his sinews.' The embassies closed and, for one of the only times in the Revolution, social life seemed to come to an abrupt halt as people reeled from the impact of the carnival of carnage, of ordinary people stooping to extraordinary acts such as unfurling human entrails like ribbons in public places and forcing people to drink victims' blood.

What for many citizens were life experiences to live through and forget, Marie's steely constitution turned into shrewd exploitation of a market for the macabre. A climate of opportunism that saw racketeering in everything from saltpetre to sugar and soap also had a

darker side, in which the murkiest business was allegedly carried out by the famous executioner Charles-Henri Sanson, and one of the most interesting rumours suggests that Curtius and Marie may have given him their custom. Profiteering from executed criminals was a perk of Sanson's job, and in the early days, when time permitted, he is said to have sold the fat from corpses as an emollient that was 'excellent for the rheumatic pains'. The guillotine presented new opportunities, and it is said that, so that they could add realistic replicas to their exhibition, Curtius and Sanson came to an arrangement whereby Sanson would loan them the severed heads of the most interesting public enemies for a fee, before they were interred with the trunks in the cemetery. Certainly some of the waxwork heads of the executed are astonishingly realistic, and so this does seem plausible, although Marie's own explanation of her most famously grizzly guillotined heads was always that each one had been done under extreme duress 'by orders of the National Assembly'. This casts her in a better light than admitting to a macabre business arrangement with Sanson.

Whatever the truth, we know that all that Marie experienced she profited from, and the chief exhibits with which she later filled her Chamber of Horrors derive from this next, hate-filled phase of the Revolution. Sans-culottes took pleasure in training their pet dogs to growl at the word 'aristocrat'. In poignant contrast, the innocent young Dauphin in his captivity dubbed his pet squirrel 'aristocrat' as a term of endearment. This is reported by the Russian traveller Karamzin: 'It is said when playing with his pet, he [the Dauphin] tweaks its nose and says "You aristocrat! You great aristocrat squirrel!" From continually hearing this word the gentle child has taken to using it.'

In the third week of August a second guillotine was set up, close to the Tuileries in the Place du Carrousel, but the royal family, though so near, were apparently unaware of the execution of the publisher of a newspaper with royalist leanings on the evening of 2 September. Less than three weeks later, on 21 September, the official symbolic death of monarchy was announced and the National Convention started a new rule. The Republic was declared on 22 September. To emphasize the new era, a new calendar transformed 22 September 1792 into Day 1 in the month Vendémiaire in Year 1. But a more dramatic

defining moment between past and present was 21 January 1793, when the oblique blade of the guillotine separated the head from the bloated body of Louis Capet.

The trial of the King had had the air of a theatrical entertainment, with the back of the Assembly hall converted into boxes, and spectators eating ices, and his execution was not to be missed – a one-performance-only production of a tragedy last staged in seventeenth-century England, and never before seen in France. If with the Grand Couvert his subjects had loved to observe the King dining in public, his dying in public was an undreamed-of spectacle. It was symbolically staged in the Place de la Révolution, formerly the Place Louis V (the Place de la Concorde today). This was the site where in 1789 the King's troops had shattered public confidence by firing on civilians, and where in 1791 King-hating had gone up several levels with the mobbing of the captive royal coach after the flight to Varennes. Now, on a cold January morning, the square and the tributary streets on all sides were packed. People had climbed on to the walls of the Tuileries gardens and pressed tightly along the steps. Troops four deep cordoned off spectators. Cannon and armed troops were strategically positioned. Windows en route had been ordered to close their shutters, shops were shut, and, apart from mass drums, there was silence. An unseasonably oppressive fug of humidity seemed to sap the crowds, or perhaps it was just the sheer unreality of what they were awaiting that made them so subdued. In this arena on an elevated scaffold, one man fixed the gaze of twenty thousand people. At 10.20 the blade fell. The executioner's son pulled the head from the basket and held it up by the hair. The sight drew uproarious cries of joy, and shouts of 'Long live the nation! Long live the French Republic!' Those closest to the scaffold surged forward to dip pieces of paper into the royal blood. Some even dipped their fingers and tasted it, reporting that it was 'salty', a reference to the lamb grazed on salt marshes that was a privilege of aristocratic diets.

Even as the executioner staged an instant auction for the King's hat, and did a brisk trade in locks of hair and buttons, the mortal remains were taken with the utmost security to the Madeleine cemetery, the King's head placed between his legs in a wicker basket on a cart that

was escorted by an armed guard. As the official reports emphasized, the body was transported with the utmost 'care and exactitude'. Nothing about the disposal of the body was left to chance. The Commune, which masterminded every detail, even planned the site of the grave as a propaganda exercise. The King was to be interred between the victims who had died on his wedding day, when celebration had turned to tragedy and they had been crushed to death, and the bodies of the Swiss Guard massacred by the people on 10 August. The extra-deep grave was filled with double layers of quicklime. While the scaffold sale of a few material relics was indulged as the executioner's traditional perk, the royal remains were another matter. As Mercier later wrote, the double dose of quicklime was to ensure that 'it would be impossible for all the gold of the potentates of Europe to make the smallest relic of his remains.'

The quest to obliterate any material that could inflame sentiments of martyrdom went further. Keen to avoid anything that might confer on the dead King a posthumous power that would further the counter-revolutionary cause, the General Council ordered the ritual burning of all remaining personal effects at the Temple. The official document decreed, 'The bed, the clothes and everything that served for the housing and clothing of Capet will be burned in the Place de Grève.' Erasing the memory of monarchy was also the motive behind the orders for the ritual desecration of all the royal tombs at Saint-Denis in August, an official orgy of vandalism against royal bones and headstones.

The high-security operation on 21 January evidently did not prevent Marie with her carpet bag of tools rushing to the Madeleine cemetery, where she modelled the royal head before it was consigned to the quicklime. Or so the story goes, backed up by the death head – the ultimate revolutionary relic – which is still on display in the Chamber of Horrors, and which old catalogues describe as 'Taken immediately after his execution by the order of National Assembly of France, by Madame Tussaud's own hands'. Successive generations of the Tussaud family have insisted on its authenticity: for example, John Theodore Tussaud, Marie's great-grandson, writes in his memoirs, published in 1919, 'The casts were undoubtedly taken under compulsion, with the object of pandering to the temper of the

people, or of serving as confirmatory evidence of execution having taken place – perhaps both.'

Quite why the authorities should have made an exception to their campaign of erasing the memory of the monarchy by conserving such a potent reminder is unclear. The death head is never mentioned in other sources, and how likely is it that the authorities would allow someone who (by her own account anyway) had been a member of the royal household to record and potentially replicate the King's image, so as to make him 'special' again? Given that statues of the King were being pulled down by official orders, which is well documented, the modelling of the head seems even less likely. In fact from 1793 until the end of Marie's life, in 1850, there is no record of this relic ever having been displayed. There is also documentary evidence to support the theory that the royal execution was never the subject of a tableau in the original exhibition in Paris. A journalist, Prudhomme, publicly criticized Curtius for not commemorating the execution of the King in his exhibition, but showing instead a tableau of the assassination of the Jacobin deputy Lepeletier, whom a royalist had murdered in revenge for his part in voting for the King's death, on the evening before the King was guillotined.

As the Revolution escalated, Curtius and Marie were ultra-cautious about their royal models, so much so that pretty early on they had diplomatically removed the King and Queen from their places at the Grand Couvert. The first appearance of the King's head was in the Baker Street exhibition in 1865, fifteen years after Marie's death. It is as if, using the past as a resource from which to make new attractions, her heirs constructed from a mould of the living King a mock-up of him in death, creating a convincing decapitated head, and a sensational relic of a regicide. This helped to propagate the by now already well-established myth of Marie as the reluctant recorder of history. As one catalogue put it, 'Thus it was that she was compelled again to work with tear-dimmed eyes and take impressions of the dead features of many who had been her friends in happy Versailles days.' Another was even more melodramatic: 'So again was her art to write history, but to write it in letters of blood!'

In the febrile climate following the execution of Louis XVI, exhibiting an effigy of the King could easily be misconstrued as an

expression of royalist sympathy. Curtius had already had a brush with bad press after Lafayette, formerly the darling of the Third Estate, fled the country as public enemy number one. Yet his figure stayed behind on show, and outstayed its welcome in the eyes of the public. With his charismatic approach to crisis management, Curtius had rectified the situation with a spectacular decapitation of the figure of Lafayette in the street outside the exhibition. But in 1793, with Robespierre the new star in the republican firmament and England and Spain having joined the revolutionary war, the authorities were less forgiving. Now a similar wrong move could result in prison and a death sentence. This was a period of paranoia and surveillance, of informing and spying, of bribery and betrayal. The raised stakes became all too apparent when a German showman, Paul de Philipstal, misjudged his material. Since his arrival in Paris in the winter he had been wowing audiences at the Hôtel de Chartres with his twice-nightly Gothic variety show. Styled as a phantasmagoria, it was a technically brilliant magic-lantern show with a supernatural theme. In a blacked-out chamber with an eerie Halloween-style set with skeletons and tombs, the audience jumped out of their skin when lightning flashes announced the arrival of the undead. In a now-you-see-them-now-you-don't fright-fest of reappearing and disappearing, the audience were seriously spooked.

One of his crowd-pleasing flourishes by way of a grand finale was a risqué satirical allusion to a recognizable public figure. A journalist writing about the show in March 1794 described how variously the faces of Marat and Robespierre were superimposed on to a slide of a cloven-hoofed devil. It is extraordinary that Philipstal got away with such audacious stunts for so long. But his luck ran out when a wrong slide change meant that an image of Louis XVI was shown such that the King seemed to be flying upwards as if ascending to heaven. The audience overreacted, interpreting this as a subversive display of respect for the late King, and Philipstal was duly arrested and incarcerated. It was Citizen Curtius to whom his distraught wife appealed for help. There is something almost Masonic about the kinship of showmen, but Curtius was probably motivated by more than charitable instinct when he agreed to help such a wealthy and successful name on the international circuit, and a respected innovator. It is evidence of Curtius's propensity for having the right friends in the right

position of power at the right time that he knew Robespierre well enough to call upon him to intervene. In the version of this transaction that appears in Marie's memoirs, the reputation of Robespierre as incorruptible is called into doubt. Marie implies that he was not immune to bribery. As her memoirs relate, 'On M. Curtius leaving the room after having obtained an order for setting Philipstal at liberty, he left on the table three hundred Louis, without saying a word to Robespierre about them; as they were never sent back there can be no doubt that the gift was accepted.' The fact that Philipstal was indebted to Curtius would alter the course of Marie's life when he reappeared at a later date, offering what she thought was an opportunity for the favour to be returned.

An iconic image of the Terror is the death of Marat – meeting his ultimate deadline like a true journalist, still clasping his pen in his hand. His final moments after his assassination by Charlotte Corday are immortalized both in the famous painting by David and in the wax tableau attributed to Marie. David's painting is both monumental and poignantly mundane – the vinegar-soaked turban is a reminder of Marat's skin disorder, the bath prosaic when compared to an elegant deathbed or a heroic battlefield. Yet the ignominious circumstances were no bar to the cult of Marat that followed his death, and which the waxwork tableau did much to propagate. Successive catalogues from the time Marie came to England list Marat's image as 'taken immediately from life by order of the National Assembly', and often this particular exhibit was singled out for attention in the press. In the touring years, for example, the *Derby Mercury* of 1 December 1819 referred to 'the very finely modelled figure of the noted French Revolutionary Character Marat' and went on: 'this subject is considered the chef d'œuvre of the ingenious artiste.' On 11 October 1828 the *Lancaster Gazette* invited its readers to 'Shudder at the objects in the Second Room. Behold the bloody revolutionist in the agonies of death.' Marat's death throes evidently didn't move everyone: for Charles Dickens, the most horrific sight in the Chamber of Horrors was a man looking at Marat 'while eating an underdone pork pie'.

The two works, in wax and in oil, are perhaps linked by more than common subject matter. In the heat of a summer night, 13 July 1793

at 7.45, a doctor certified the death of Marat only hours after his assassination by Charlotte Corday. In sympathy with the Girondins, who had fallen from power, she had talked her way into Marat's room and plunged a knife into his chest. The hot weather and the rawness of his skin disorder accelerated the rate of decomposition. This posed an immediate problem for the official-martyrdom theatricals that were an important aspect of Revolutionary propaganda. The body of the assassinated deputy Lepeletier had been displayed in a dramatic nude parade, but that had been in the cold January weather. For four days his naked body, styled in a classical pose, was exposed to the elements on a pedestal that mourners ascended via a staircase. With Marat, the hot weather and state of the corpse meant speed was of the essence, and a fast funeral was in order. Even the embalming went wrong, and the clichéd excuse 'It just came off in my hand' was the macabre truth as an expert team of embalmers tried to put Marat together again, like Humpty-Dumpty. On 14 July the botched and blotched cadaver was arranged with great care on a dais in the Cordeliers Club, and with plenty of artificial lighting, and round-the-clock incense, it passed muster for public view. Also on display were the bath in which he had died and the packing-case writing desk. For two days only, by which time not even copious air freshening could mask the smell, mourners paid their respects. The funeral, brought forward to 16 July, included all David's signature touches: cardboard trees, silver-foil lyres, and young girls in white. Louis Sade (formerly known as the Marquis de Sade) gave the funeral oration.

David's original hope had been to display the body just as he himself had last seen Marat, when he visited him on the evening before he was assassinated and found him working in the bath. As he told the Convention, 'I thought it would be interesting to show him in the attitude in which I found him, writing for the happiness of the people.' As the state of the corpse prevented the accurate reconstruction of this scene, necessitating less exposure of the body, David determined to represent it in the commemorative oil painting he had been commissioned by the National Convention to paint. It took four months for David to complete *Marat Assassiné*, which was presented to the Convention on 14 October 1793.

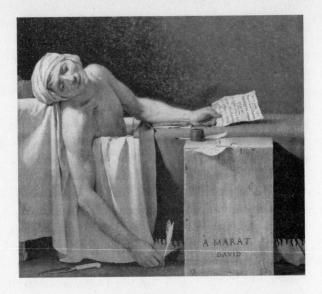

The death of Marat. Was the wax model a source for
David's painting, or the other way round?

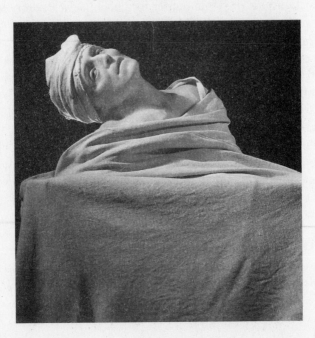

The delay between the death and the completion of the painting, and also the composition of the painting, are a cue for Marie to enter the scene. For she always claimed that a commemorative wax tableau was the visual reference for David's work. As her memoir states, 'It was by his orders that Madame Tussaud took a cast from the face of Marat, as also of Charlotte Corday, after death, from which David made a splendid picture of the scene of the monster's assassination, and had written upon it, "David à Marat", for whom he pretended an extraordinary friendship.' She described being fetched by 'some gens d'armes', who took her to Marat's house expressly to take a cast from the dead man's face. 'He was still warm, and his bleeding body and the cadaverous aspect of his almost diabolical features presented a picture replete with horror, and Madame Tussaud performed the task under the influence of the most painful emotions.' But did she go to the actual scene of the crime? It seems more likely that the public lying-in-state for two days was her chance to observe and replicate the necessary elements for her tableau version of Marat's martyrdom. In pride of place at the Boulevard du Temple exhibition, it was a star attraction in the months after his death, when the cult peaked. (One facet of this hero worship was a boom of baby boys named Marat.) Marie relates how this new exhibit became a focus of public out-pourings of grief, with the crowds 'loud in their lamentations'. She goes on to describe how a further publicity coup happened when Robespierre recommended the new exhibit. As he left, he invited passers-by to follow his example and 'see the image of our departed friend, snatched from us by an assassin's hand', and to weep with him for the bitter loss. Robespierre's approbation was evidently highly effective: as the memoirs testify, the tableau was so popular that 'people poured in to the exhibition to see the likeness of their idolised Marat, and for many successive weeks, twenty-five pounds a day was taken.'

How plausible is the substantial claim that the public display of this tableau served as the principal reference for David's most famous painting? Some art historians have speculated that the links between the two works are more formal, and that David collaborated with Marie on the composition of her tableau, and instructed her on the exact pose of the body in the bath. Unquestionably the two works

are remarkably similar. The art historian Roger Fry, writing on David's style, refers to 'a highly polished Madame Tussaud surface', and there is indeed something waxy about Marat in this painting. In fact the perfect skin is but one aspect of this classically idealized representation of a youthful body that bore no relation to the putrefying green-tinged cadaver of the older Marat that was processed through Paris caked in white make-up in the elaborate funerary celebration orchestrated by David. But an alternative theory is that Curtius and Marie may have copied David's work, and that when his secular pietà was eventually hung in the court of the Louvre its impact was so great that they updated their own earlier Marat 'news story' to emulate his work. Later, in England, the Tussauds were open about copying work by David, specifically his *Coronation of Napoleon*, so this may have been an early example of this practice. Whatever, it is a fascinating chicken-and-egg conundrum, and it is hard to prove or disprove Marie's claims that it was because of the value of her talent as a source for David that she was treated leniently later in the Terror.

As for Charlotte Corday, Marie claims that she made two portraits of her, one 'from life' in the Conciergerie prison, and the second after her execution on 17 July, when 'the remains were conveyed to the Madeleine, where Madame Tussaud took a cast from her face.' Marie recalls her prison visit almost in a spirit of admiration for the assassin, whom she found 'a most interesting personage'. As well as admiring her physical attributes – 'beautiful colour', graceful deportment, clear complexion – she found her engaging. 'She conversed freely with Madame Tussaud, and even cheerfully, and ever with a countenance of the purest serenity.' If Marie was admitted to see Corday in prison, the visit is not recorded. However, the historical record does include details of her portrait being taken by other artists who had formal sittings with the fetching assassin, who captured the imagination of the public both with her looks and with her self-memorializing. She clearly had a grasp of her allure as a murderer, as is evident in a letter to the Committee of Public Safety in which she requested permission for her portrait to be taken: 'Just as one cherishes the image of good citizens, curiosity sometimes seeks out those of great criminals, which serves to perpetrate horror at their crimes.' This would have chimed

with Marie's own views, as it underpinned the voyeuristic appeal of the Caverne des Grand Voleurs and, later, the Chamber of Horrors.

Charlotte Corday's request for a portrait was granted to the painter and draughtsman Pierre-Alexandre Willie. She had spotted another artist, Citizen Hauer, sketching her at her trial, but, although she admired the likeness, the subsequent work by Willie is judged the better. Whether she met Marie is uncertain, but she would no doubt have been gratified by her place in the exhibition, and the praise heaped on her by Marie in early catalogue listings when the exhibition came to England, where Marat's assassin was widely regarded as a heroine.

After the assassination of Marat the political situation deteriorated rapidly. Two weeks later Robespierre was elected to the Committee of Public Safety, a group that combined the role of war cabinet and foreign office. By this time France was at war with most of Europe, and civil war with particularly fierce fighting in the Vendée was a further destabilizing factor. Measures introduced by the Convention became increasingly radical, and citizens found themselves living in a state of hyper-vigilance. A wrong decision by an innocent person could be lethal; even laughing loud or arguing in public was dangerous. After the Law of Suspects was passed in September, the prisons started filling up and the guillotines got busy. On 2 September 1793 Jacques-René Hébert, editor of the inflammatory anti-royalist newspaper Le *Père Duchesne*, announced to the Committee of Public Safety, 'I have promised the head of Antoinette. I will go and cut it off myself if there is any delay in giving it to me.' On 16 October his promise was fulfilled, and the Queen was the star billing at the scaffold. Unlike the King, she was not even permitted a closed carriage, but was fully exposed to public humiliation in an open car and without corset, wig and false teeth – an emaciated and prematurely aged shadow of her former self.

Marie did not witness her execution, for, as related in her memoirs, 'as soon as the dreadful cavalcade came in sight Madame Tussaud fainted and saw no more.' This squeamishness is out of character. It is also at odds with the bizarre legend that she made her way directly to the Madeleine cemetery, where she found the head and body of the Queen lying unattended in the grass, and immediately

made a model. In fact Marie would have had plenty of time to do this, for various versions of the events surrounding the Queen's burial are consistent in maintaining that there was a delay. Unlike the speed and care of her husband's dispatch, there was apparently no hurry to bury her. The time the gravediggers took to get round to it ranges from an unfeasibly long fifteen days to a story that confirms the Continental rule of everything stopping for lunch, which has it that it was during their lunch break that the royal remains were left unattended, giving Marie her chance. Whether a quick hour's handiwork or a more lengthy and leisurely study was involved, the story of Marie modelling in the Madeleine does not stem from the memoirs, but seems to have originated in the London exhibition some time during the nineteenth century. A 1903 catalogue lists the head of Marie Antoinette with the following description: 'Taken immediately after her execution by order of the National Assembly of France, by Madame Tussaud's own hands.' Like the death head of the King, that of Marie Antoinette mysteriously appears in 1865. Compared with her appearance in David's tragic sketches, made en route to the guillotine, the wax Queen looks remarkably well – more like someone catching up with her beauty sleep than someone recently decapitated.

In contrast there does seem to be evidence that Curtius went to cemeteries to source celebrity heads. In December 1793 Palloy, the 'Bastille entrepreneur', was greatly impressed by his friend's death head of Madame Du Barry. The popularity of this exhibit was directly related to the hatred of the former mistress of Louis XV. Her howls of fear at the scaffold had distinguished her from other victims, and one can imagine the sans-culottes voyeurs at the waxworks revelling in replaying her performance as they got up close to her head. Palloy was informed that it was such a good likeness because Curtius had been to the cemetery to inspect the real thing. There seems no reason for Curtius to lie to his friend about this. The writer de Favrolles corroborates the account. He relates how Curtius obtained permission to memorialize the features of Madame Du Barry and 'executed this project in the Madeleine cemetery. You can see this very well-modelled head at his exhibition in the Boulevard du Temple.'

The lack of evidence for Marie's ghoulish pursuits in the Madeleine has not stopped the myths. In the twentieth century a popular tableau in the Chamber of Horrors showed her tiptoeing through the corpses by lantern light, looking for celebrity heads as if she were on a mush-room-picking expedition, but, as with many of her claims, the truth was probably rather different.

8

Hardship and Heartache

IN 1794 MARIE was a woman of thirty-two, but she had already witnessed a spectrum of experience that would have been exceptional in a much longer life. The strictures on commercial entertainment were now even more oppressive than during the *Ancien Régime*. The theatre was in the stranglehold of a patriotic agenda, with censorship every bit as strict as the days of monarchical authority. From 1792 to 1795 the stage was more like a lecture podium than a place of escapism. The propaganda on offer included a disaster-drama-cum-fantasy in which a giant volcano erupted and all the kings of France were lost in the lava, and another box-office hit was a play in which the hero was a husband who grassed on his own wife, who was then sent to the guillotine. As the grip of political correctness tightened, even the business of having fun became deadly serious.

A puppeteer was sent to the guillotine for showing a marionette of Charlotte Corday, and large numbers of actors from the various theatres were imprisoned. One actor from the Comédie-Française called Dazincourt, smarting from the injustice of his incarceration at the Madelonettes, said he could understand why his thespian friends had been locked up, because they had played emperors, marquises, and kings. Yet he had only ever played footmen and valets and poor, simple sans-culottes. But he was lucky: some actors and actresses were beheaded for performing in plays considered anti-republican. In this context most theatres played safe by churning out anodyne patriotic works that could neither enrage nor excite. If the plays were bland, however, the audiences were boisterous. Grace Elliott was unimpressed by the new type of theatregoer: 'The playhouses were filled with none but Jacobins, and the lowest set of common women. The deputies were all in the best boxes, with infamous women in red caps

and dressed as figures of Liberty. In short Paris was a scene of filth and riot.'

Given the restrictions and the increased sense of risk, Curtius – as ever with an eye for an opportunity – sold some of the dated figures of royals and *Ancien Régime* characters for export. Under a showman called Dominick Laurency, they cropped up in Calcutta and Madras. How the wax was conserved in the Indian climate is unclear, but the touring show was of great interest. The *Madras Courier* of 12 August 1795 announced its opening 'in the large commodious airy house and garden of his Highness the Nabob'.

From March until the end of July 1794, under Robespierre's dictatorship, the guillotines in Paris were so busy that Marie relates that there was a perpetual stream of gore running from the Place de la Révolution through the nearby streets. Whereas formerly the papers had printed daily lists of those condemned to death and their crimes, as the victims grew more numerous there was no space for any other details but their names. A wry comment on this was made in one journal, which announced, 'Today a miracle has occurred in Paris.

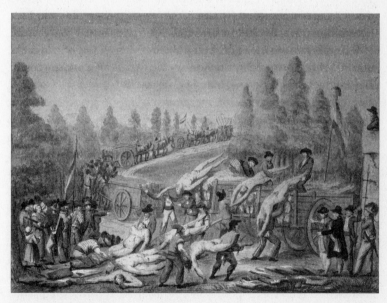

Everyday horrors, carts of corpses became a familiar sight

A man died in his own bed.' In the scorching summer, the smell of baked blood was so offensive to residents in the Rue Saint-Honoré that, on the grounds that it was a health hazard, they persuaded the authorities to relocate the guillotine; but it was soon moved back. In the Champs-Elysées toy guillotines were best-selling items, and behind closed doors in select circles the guillotine became a chic accessory. Miniature mahogany guillotines were placed on the table, and ladies took turns to play executioner by placing under the blade doll-shaped bottles whose heads were portraits of the current enemies. The heads were cut off and red liquid flowed from the neck. This lurid liqueur was then poured into glasses, and the assembled guests could toast the victim. There was also a trend for guillotine jewellery. A Dutch-born resident of Paris, in his *Recollections of a Republican*, recalled how 'women and girls wore golden and silver guillotines in pins and brooches and combs, even in earrings.'

Further guillotines were installed at the Barrière du Trône and the Place Saint-Antoine. But the prime sight remained the Place de la Révolution, where a restaurant with a particularly good vantage point even put the names of the victims on the menus – the daily special and a blood-thirsty splat du jour. So blasé had the public become about blood and butchery that it would not put them off their food. A young shop assistant described how they became so inured to the daily horrors that they didn't even bother raising their heads at the tumbrils taking people to the guillotine, or the carts of corpses and baskets of heads that came back. As heads rolled, the famous *tricoteuses* didn't drop a stitch. But indifference angered the authorities, so to intensify the theatre of cruelty they then insisted that victims be driven through the most busy and highly populated parts of the city, with detours through neighbourhoods where they were known. They also took to cranking up the emotional pain by staging executions in such a way that members of the same family would be compelled to witness their relatives being beheaded before them.

Madame Elizabeth, whom Marie always claimed was her erstwhile employee, friend and pupil, met her end in the same way as her hapless relatives, on 27 May 1794. In her memoirs Marie states only how her attempt to preserve Elizabeth's dignity in death was thwarted when 'her handkerchief, having dropped, left her bosom exposed to the gaze

of the multitude.' Marie fails to mention whether Elizabeth's head was ever salvaged by Curtius and put into their display.

For the bumper crop of heads included some rich pickings for the waxworks. Marie relates how she was summoned, once again by the Assembly, to make a model of Hébert. In one of her catalogues in Georgian England, she describe the extremist journalist as 'friend of the monster Marat' and a man who was 'productive of much mischief and in many respects resembled the character of Tom Paine'. Hébert was followed in quick succession by Danton and Desmoulins. But in a profession where, then as now, novelty was the life-blood of their business, Marie and Curtius must have been starting to worry that their death heads and a model guillotine were old hat, and could not possibly compete with the thrill of real blood spurting into the front rows of a crowd.

Marie relates how at about this time she herself came perilously close to the block and blade of the guillotine. Her memoirs describe how, denounced as royalists by a grimacer from a neighbouring theatre, she, her mother and a mysterious unnamed aunt (whose antecedents and relation to Marie are never clarified, but who is mentioned several times and was presumably part of the household) received the dreaded knock at the door in the middle of the night and were forcibly removed from their home to La Force, one of the most infamous prisons of the Terror. Their plight was worse for the fact that Curtius was out of the country, and so could not come to their aid: Marie states he was at the Rhine with the army. They found themselves crammed in a cell of twenty or so women, including Joséphine Beauharnais and her young daughter. The future empress of France was apparently a paragon of courage: 'Madame Beauharnais did not give way to despondency. On the contrary she did all in her power to infuse life and spirit into her suffering companions, exhorting them to patience and endeavouring to cheer them up.' Just how close to the guillotine Marie came is apparent from her and her cellmates having their hair closely cut every week in preparation for the block. Their turn in the tumbril seemed imminent.

However, the prison episode as remembered by Marie is at odds with other records. In fact Joséphine was never imprisoned in La Force: she was at Les Carmes, a former convent in the Rue de

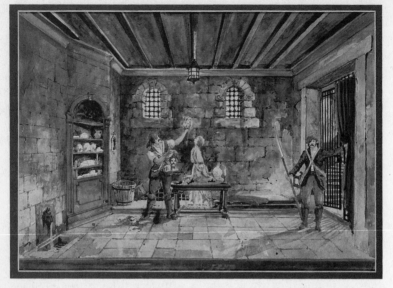

Fact or fiction? Madame Tussaud in prison, watercolour attributed
to John Theodore Tussaud, used as design for popular
wax tableau

Vaugirard, having been admitted there on 19 March 1794. Far from
being stoic in her captivity, she wept copiously and, according to
the account of one of her cellmates, Delphine de Custine, her emo-
tional incontinence made her a total embarrassment. The unisex
arrangements at Les Carmes and perhaps the frisson of imminent
death resulted in bouts of partner swapping. Joséphine's husband fell
madly in lust with Delphine, while Joséphine fell for a general, Lazare
Hoche. No mention is made of Marie Grosholtz. Whether Marie was
ever at La Force is also hard to confirm. She is not in any official
records, but apparently prison officials were often bribed to keep
inmates' names out of the records. Given that Collot d'Herbois,
reportedly one of Curtius's well-connected friends, was by now even
more powerful within the Assembly, it is conceivable that strings could
have been pulled if she had had any sort of trouble with the authori-
ties. However, one can't help feeling that Marie's prison claims are yet
more strands of her embroidery of the truth, furthering the victim

image that was guaranteed to engage public interest and sympathy in her later career.

Certainly, if Marie was ever incarcerated alongside Joséphine, she was on day release on 8 June 1794 for the Festival of the Supreme Being, for her eyewitness accounts of this event conflict with the dates of her alleged incarceration. It was another of David's great republican extravaganzas and, although no one knew it at the time, it was a spectacularly grand finale. Marie relates how Robespierre rose to the occasion. 'He had decorated himself with peculiar attention. His head was adorned with feathers, and like all the representatives, he held in his hand a bunch of flowers, fruit and ears of corn; his countenance assumed a cheerfulness very foreign to its usual expression.' That day there were an estimated three hundred thousand people processing and singing and making their way to the vast Champ de Mars, where a colossal figure of Hercules, as heroic as papier mâché permits, dominated the arena. Standing on the summit of a vast plaster mountain further elevated by a fifty-foot plinth, Hercules held a tiny figure of Liberty in his hand, like Fay Wray in the grip of King Kong. Marie would have seen the ceremonial burning of a succession of symbolic figures: Atheism, Ambition and finally Egoism. The idea was to reveal one final figure left behind, the inflammable and invincible representation of Wisdom, shining clearly for all to see. But the smuts of Egoism besmirched Wisdom and flecked Robespierre's finery, and with a completely different symbolic meaning the smoke of ego got in his eyes. As Marie relates, these unintentionally comic rather than heroic stage effects 'drew upon Robespierre many sneers'. But six weeks later sneers were replaced by jubilant cheers as Robespierre's tyranny of terror ended with his execution on 28 July 1794.

His dramatic death head, the jaw still bandaged from his suicide attempt, is one of the most gruesomely realistic in the collection. It is this head that Marie refers to many times as having been taken immediately after execution by order of the National Assembly. It is one of the few death heads that she claims to have cradled in her lap. In her memoirs, after relating how Robespierre called her a pretty patriot when he broke her fall at the Bastille, she goes on to say, 'How little did she then think that she should, a few years after, have his severed

head in her lap in order to take a cast from it after his execution.' Elsewhere in the memoirs a second reference is made to her 'taking a cast from his mutilated head'. But she also claims to have made a full-length portrait of him from life at his request, and at his suggestion this was dressed in his own clothes, 'to afford additional resemblances'. For maximum effect, in England Marie displayed his death head in isolation. A catalogue for Cambridge in 1818 stated, 'The enemy of the human race we have put by himself as undeserving of a place amongst men.'

On 26 September 1794, Curtius died at his second home, in Ivry-sur-Seine. His death is reported in Marie's memoirs, but there is no revelation of her feelings or any details about the last months of his life. Always one for intrigue, she suggests that the circumstances of his death were suspicious, stating that after a post-mortem 'it was fully ascertained that his death had been occasioned by poison.' (The official death certificate states natural causes, although it does have alterations and crossings-out.) Curtius is never fleshed out in Marie's memoirs. In what is virtually the only reference she makes to him, she tries to excuse his republican leanings by claiming that he was at heart a royalist, affecting his allegiance to the Revolutionary cause so as to ensure the safety of his household. However, his profile in public life as one of the most successful showmen in Paris and his civic duties mean that he does appear in official records, and from these one can form a character sketch.

Like many during the Revolution, he had a dual role – in his case showman and soldier. From the start, he was a keen supporter of the Revolutionary cause and an early member of the Jacobin Club. That he was a consummate self-publicist, name-dropper and string-puller is evident in his claiming to be known to the French legation in Mayence while chasing his claim to his German uncle's estate, in his self-published pamphlet about his National Guard service, and in his toadying to the Jacobin Club by making donations to the war effort and offering patriotic works for public display – such as a bust of the Polish martyr Lazowski, a Commune member who was murdered in April 1793. Apart from some evidence that he was involved in an investigation into the loyalty of General Custine, commander of the army of the Rhine – a mission that took him to Mayence, where his

findings in favour of the general later backfired when Custine publicly denounced *him* – Curtius's military career in the employ of the Jacobins during the Revolution is never anything but obscure. Mysterious missions and mentions of powerful contacts that are filtered through Marie's memoirs also make it hard to formulate an accurate picture of what exactly he did. From the evidence we do have, we can extrapolate a portrait of a man who always tried to keep in with the right people. His mercurial bent was the secret of his success, but as time went on led some people to question his motives. A contemporary, de Bersaucourt, wrote, 'Curtius always takes advantage of the situation. He is wily, this German! He changes all the time according to the wind, the situation, the government, the people in power. He removes the King at Dinner and replaces it with figures of the deputies of the Gironde. He is successively Feuillant, Girondin, Jacobin, Maratiste, Hebertiste, Robespierriste, Thermidorien. He goes with the flow, Curtius.' Perhaps his death was timely, in that he died before the backlash against the Jacobins that came with the fall of Robespierre. This would doubtless have subjected his various dealings to closer scrutiny.

Marie was not with him when he died, but went to the house with two neighbours the following day. Instead of all the friends in high places, it was the grocer Villon and the proprietor of a local theatre called Louis Sallé who rallied round. Curtius had clearly anticipated his own demise, for his will was dated 31 August 1794. In it he is described as a painter and sculptor of Paris, and names as his principal beneficiary 'Citizenness Anne Marie Grosholtz, spinster of full age, my pupil in art who has lived with me under my roof for more than twenty years.' To Marie he left 'everything that the law allows me to give, in view of my not having an heir'.

The strong impression is of a daughter in all but official acknowledgement. In fact a daughter denied, for the will declares, 'I do not have, or know of, any female heir either in France or in a foreign country.' Whether Curtius was her real father or just a father figure – and a very convincing one – Marie found herself with a considerable inheritance that was in the form more of assets than of cash. Curtius left a portfolio of three properties: the house in Ivry-sur-Seine, on which only one instalment had been paid, a rental property

in the Rue des Fosses du Temple, and the family home and exhibition in the Boulevard du Temple. Like many artistic types, Curtius also left a quagmire of administration, unpaid bills and taxes, and a daunting amount of stuff. From floor to ceiling there were literally stacks of possessions that meticulous copperplate inventories detail. Of most significance for Marie's future career were the contents of the exhibition: thirty-six life-size figures, seven half-length and three reclining figures, including those of Madame Du Barry and the Princesse de Lamballe. There were also cases of miniatures, relics and assorted *objets d'art*, including a significant collection of paintings, both framed and unframed. A large proportion of the fixtures and fittings was mirrors, sconces and candelabras, confirming the importance of lighting. The list also includes an item of furniture that was always close to Marie's heart, and where she would spend a great deal of time: a cashier's desk.

Over and above the material inheritance, it was the artistic and business skills that he had taught her from childhood that were the most significant aspects of what Curtius bequeathed to Marie. From the precise blend of bleached beeswax and the secret formula for the in-house colourant for the heads and hands to the art of creating hype and spin, by the time he died Marie was versed in every aspect of showmanship. In the best show-business tradition, since she had been a little girl she had lived and breathed the exhibition. Her family home had been part cabinet of curiosities and part dressing-up box. For all her claims that the great and the good were in constant procession through the house, it seems highly likely that a high proportion of the visitors would be members of the entertainment fraternity – the showmen scientists and theatre people, the wheelers and dealers in artefacts and novelties. Curtius knew who traded in Egyptian artefacts and relics, flea circuses and freaks, and from this pool of contacts he was always able to source additional attractions to spice up his usual bill of fare. At different times in the Palais-Royal, the waxworks were supplemented with a display of living, breathing attractions, great and small, from the giant Paul Butterbrodt, who weighed in at 476 lb, to 'Les Enfans Vivans', a six-year-old boy and girl from Guadeloupe, whose rare skin pigmentation gave them a piebald appearance, and who were advertised as 'an extraordinary phenomenon of nature'.

What Curtius passed on to Marie would stand her in good stead for the rest of her life, and meant that in the immediate aftermath of his death she was able to keep buoyant in turbulent times. It was an especially precarious path that she had to negotiate. The backlash against the Jacobins that came with Robespierre's death was dangerous for an exhibition that had become so closely identified with them, and which had attained the unofficial status of the leading sans-culottes entertainment.

She had weathered the spells when Curtius's various commitments beyond Paris had found her temporarily in charge of the waxworks, but with his death she was unanchored. Her mother was still alive, and looked after the domestic realm, but the burden of keeping the business afloat and financing the family now fell to Marie.

The first initiative she took was to update the doormen's uniforms. Sans-culotte austerity and drabness was replaced in the autumn of 1794 by the more colourful garb of the Gilded Youth. This was the name given to the band of affluent youths whose fine clothes – elaborate cravats at the neck, frock coats and buckled shoes – gave a misleading impression of harmless dandyism. In fact they were fired up with desire for revenge on the terrorists, and the canes that they carried, far from being innocent accessories, were weapons with which they coshed sans-culottes in street fights. Many of the Gilded Youth had lost relatives during the Terror, and so were eligible to attend the 'victim balls' which flourished at this time, admission to which hinged on having lost a close relative to the guillotine. At these balls, often held in the vast halls of defunct monasteries and convents, women wore thin red ribbons at their throats as a further reminder of the guillotine. But such macabre references were not confined to parties. Fashionable men favoured *toilette à la guillotine*, where the hair was long at the sides and either held up with a comb at the back or cut short to imitate the actual preparations for the blade.

The perennial request to hairdressers not to take too much off was in vain for Carrier, an infamously cruel member of the Convention, who was sent to the guillotine on 16 December 1794. Described by a contemporary as 'the bloodiest of the bloody', his notoriety largely hinged on the mass drownings he supervised in Nantes and which were euphemistically described as National Baptisms. Innocent men,

women and children were packed on to boats, with rails to prevent them jumping off. The hulls were then shot at until the vessels sank. His other signature atrocity, which Marie describes in her memoirs, was the Republican Wedding, in which a naked male and female prisoner were tightly bound together facing each other before being drowned. Marie does not mention what other witnesses do, namely how 'in some cases copulation actually occurred and death took them in the very moment that sexual pleasure reached its zenith.' The scale of Carrier's killing was such that human remains were tainting the water of the Loire, and a government directive imposed a temporary ban on its consumption.

Carrier's legendary status as a sadist meant that his death head generated a lot of public interest when it went on display shortly after his execution. In terms of the history of the exhibition it is of particular interest because it was the first head made since Curtius's death, and so there can be no doubt about its attribution to Marie. In her early catalogues in England she referred to it as 'taken immediately after his death by order of the National Assembly'. This too could be plausible, as the ruling Directory were keen to hold up for public execration the most hated terrorists. Marie makes her antipathy for Carrier clear in her catalogue description of him as having taking root in a 'dunghill of corruption'.

The climate of change was such that allegiances veered dramatically. A prisoner of war aboard a battleship called *Marat* described how, after the fall of Robespierre, he noticed a difference in the sailors' shouts. Whereas every day they had habitually shouted 'Long live the Jacobins!', at the end of 1794 they were shouting 'Down with the Jacobins!' By January 1795 the cult of Marat was a sinking ship. The people's favourite was now vilified, and on 21 January – the anniversary of the regicide – an effigy of Marat was ceremonially burned in the Palais-Egalité, formerly the Palais-Royal. In the ensuing months certain groups of the public took to smashing busts of their erstwhile hero wherever they found them, intent on purging the city of his image. Even Marie's iron nerves must have registered some perturbation at the strength of the anti-Marat feeling, given that her tableau of his martyrdom had once been the centrepiece of the exhibition and one of the prime attractions. In the Palais-Egalité she must

have shuddered at the sight of rampaging children offering passers-by fragments of Marat's smashed image with taunts of 'So you want some Marat; here is a little piece of Marat!' The backlash was a mixed blessing for the purveyors of busts: while Marats were two a penny as demand plummeted, there was a boom in Rousseau busts, which were used to replace many of the Marats, and which tripled in price. Such was the climate of hatred that not only were busts of Marat thrown down the sewers of Montmartre, but it was proposed to rename the sewers – 'Montmarat'. The waxing and waning of public opinion was such that Mercier wrote, 'The people of Paris drink, dance, laugh and gossip about a peaceable and responsible government, which in the morning they accuse of being royalist and in the evening terrorist.'

The instability was compounded by the ravages of a cataclysmically hard winter, which like that of 1788 highlighted the divide between haves and have-nots. Yet, whereas before the haves were mainly aristocrats and wealthy clergymen, now they were a more cosmopolitan group of property speculators and profiteers, arrivistes and opportunists. The poor, however, were the same, and inflation meant starvation was rife, as astronomical price rises put even basic foodstuffs well out of reach. Suppliers of flour started to refuse cash, and people were compelled to barter table linen and silver for the odd bushel. Commonly, a six-hour queue outside the baker's would result in the meagre reward of a bit of biscuit. Marie relates how people were reduced to scavenging heaps of rubbish for cabbage stumps and parings of turnips. Disenchantment set in as people started to question the cost of the republic that they had suffered so much to bring into being. As official bread rations became smaller and an attempt to substitute rice flopped because firewood shortages meant there was not enough fuel to cook it with, morale dipped low. As one diarist complained, 'It really seems as if the time has come to die at last of hunger and cold. Lacking everything, Great God what a Republic! And the worst of it is one can't tell when or how it will end. Everybody is dying of hunger.'

The public execution of one of the most loathed of all the revolutionaries was a temporary consolation for the people when Fouquier-Tinville, the public prosecutor, went to the guillotine on 7 May 1795. Marie wryly observed, 'As he ascended the scaffold he

did not appear to derive the same pleasure from viewing preparations for his own death that he had on so many occasions evinced when contemplating the requisite arrangements for the execution of others.' His was the last death head that Marie made, and like those of Carrier and Hébert she describes it as 'taken immediately after his execution by order of the National Assembly'.

But conditions were so tough that it would take more than the novelty of a fresh head to galvanize the public to put their own troubles aside and pay to go and see the exhibition. Another problem was that the candle shortage was still acute, which meant that Marie could not display any of the exhibits to their best advantage. On 16 May she was forced to take out a loan of nearly 60,000 livres to keep the show going; security for this was the rented house in the Rue des Fosses. In the ensuing years Citizen Marie Anne Horry and her brother Didiès, who had lent her this money, proved to be tough creditors. In order to safeguard their loan, they kept on altering their terms, and Marie was eventually forced to put up the family home as security.

In June 1795 the death in captivity of the ten-year-old Dauphin in a cell airless with the stench of his own filth – he had not been allowed a change of clothes for over a year – pricked the hardest republican heart. There was a certain bitter irony to his death from scrofula, a disease that it was formerly thought the kings of France could heal simply by touching the afflicted. Although of great public interest, this was one death that remained in the private realm, the wax image made when he was a little boy remaining safely packed out of public view. In a climate of see-sawing allegiances, it was not prudent to show a member of the royal family, even if defunct. Also, the Dauphin's death resulted in an attempt by the Comte de Provence to press his claim to the throne as Louis XVIII. A hale and hearty male heir to the throne with the might of armed émigrés behind him reawakened the old royalist/republican antagonism, and it was not the right time for Marie to risk anything that could implicate her on either side in the debate.

If she did not capitalize on interest in the Dauphin at the time of his death, she made up for it later. Throughout the nineteenth century the fate of the boy-king captured the public imagination, fuelled by the sheer number of claimants to the French throne, who cropped up in the most unlikely places and in the most improbable guises – for

example, boys who could not speak a word of French. Marie sided with the survivalists, and part of her publicity-stunt repertoire was her claim that she knew that the Dauphin had not died but was alive and well, and living as the Duc de Normandie. Those interested in the legitimacy of this particular claimant set great store by 'the acute perception and accurate memory of Madame Tussaud'. Discussing the case retrospectively, an article in *Notes and Queries* in August 1851 reported how, when asked if she thought the person calling himself the Duc de Normandie was the same individual she had modelled as a child, Madame Tussaud replied with great emphasis, 'I would take my oath of it for he had a peculiar formation on the neck which still remains. Besides something transpired between us which he referred to, which was never likely to be mentioned to anyone.' This enigmatic response whetted people's appetite. This is one case where if Marie had made a death mask of the Dauphin, then the hundreds of escape rumours and flights of fancy that went with the mystery of the 'Orphan in the Temple' would have been nipped in the bud. However, an infinitely more ghoulish memento had been taken from the dead child. The doctor who performed the post-mortem seized the opportunity to obtain a royal relic and removed the boy's heart. The wizened organ, smuggled out under a napkin, eventually discredited all the claimants when twentieth-century forensic science conclusively proved Bourbon DNA.

With so many trials and traumas, personal loss, financial worry, a business to keep afloat, one can imagine feelings of vulnerability could not be indulged. But Marie's innate self-reliance was soon to be challenged more personally.

9

Love and Money

IN OCTOBER 1795 – Vendémiaire Year IV in the Revolutionary calendar – the Place de la Révolution was renamed the Place de la Concorde, but discord was more the order of the day. Inflation and starvation were uppermost in people's minds. Symbolically, the floor beneath the printing press that produced the paper money called the *assignat* collapsed under the weight of paper that it was handling. This physical collapse echoed the fiscal collapse whereby each note was now worth merely 1 per cent of its face value. Marie relates how she papered a room with notes. This same month, twenty-six-year-old Napoleon Bonaparte rose to prominence and became known as General Vendémiaire for his role in quashing a popular uprising on the Right Bank, when armed royalist factions staged a show of strength. The fighting so famously referred to as 'a whiff of grapeshot' was, according to Marie, 'a tremendous hail of grape', with hundreds of casualties, and once again the streets of Paris were splattered with blood. These events in public life were the backdrop to a momentous month in Marie's personal life. On 18 October 1795 Marie married.

The wedding certificate authenticates the marriage of Citizen Marie Grosholtz, aged thirty-four, with François Tussaud, aged twenty-six, described as 'an engineer'. The civil ceremony took place in the prefecture of the Département de la Seine in Paris. Witnessed by an inspector of buildings and a painter on behalf of the groom, and by a theatre proprietor and a merchant on behalf of the bride, the *ton* was hardly *haut*. Certainly for a woman who later made so much of her time at Versailles, and the number of aristocratic and otherwise charismatic men in public life who supposedly took a shine to her, it was a curiously down-to-earth union. It was also not propitious. Tussaud was not a man of substance. It was Marie who had the

assets, and, unusually, a nuptial agreement stipulated that she retained control over the property that she owned. It is as if from the outset, rather than sharing all that she had, she felt it would be prudent to protect her assets from her husband.

All that is known of François is that his family were from the Mâcon area and, going back several generations, had been involved in the metalworking industry. He was the eldest of seven children, and surviving documents record his father as an 'iron merchant'. François had moved to Paris a few years before the Revolution, and, although his stated profession was engineer, circumstantial evidence suggests he may have worked for Curtius for a time. Virtually the only documented insight into the relationship between Marie and her husband surfaces in 1903, in a letter from her grandson Victor Tussaud to his nephew John Theodore Tussaud: 'I have always understood that in addition to incompatibility of temperament, your great-grandfather was a confirmed gambler, which propensity he afterwards however varied by becoming miserly.'

Whether to fund her husband's gambling or to help out the business it is not clear, but within days of her marriage Marie was negotiating a private loan from Madame Salomé Reiss. The terms of the loan were that, in exchange for 20,000 *assignats*, Marie would pay Madame Reiss an annuity of 2,000. In addition to the earlier loans she had negotiated, this meant that, far from a carefree start to married life, the Tussauds had a weight of debt.

Not only were there financial worries; it appears that only a few months after their marriage Marie was left to fend for herself while François took some of the figures on tour in England for several months. From January 1796 the movements of a show billed as Curtius's Grand Cabinet of Curiosities can be traced from posters and newspaper advertisements. The tour included Chester, Cambridge, Norwich and Birmingham, and an advertisement in the *Norfolk Chronicle* of 16 January 1796 implies that it also visited the capital, where it 'gave great satisfaction in New Bond Street, London'. In modest rooms attached to pubs in the smaller venues, and more spacious halls in the larger cities, the exhibits that had thrilled Paris must have been a welcome injection of exotica. The predominantly French Revolutionary subjects included wax busts of the King,

Queen and Dauphin, a model of the Temple where they had been imprisoned, a model of the guillotine – one inch to a foot – and the head of M. de Launay, governor of the Bastille. These were shown alongside assorted curiosities including profiles of the French royal family made of human hair, a three-foot-high crystal-glass warship, and a gunship 'beautifully cut in paper with scissors'. Given the ongoing war with France and hungry interest in the Revolution, these artefacts must have been a fascinating insight into foreign news. The show was highly acclaimed, the *Birmingham Gazette* referring to it as the 'ne plus ultra of the arts' and singling out for praise the representation of the 'Dying Philosopher' Voltaire.

From intriguing fragments it seems plausible then that the affable showman presenting these exhibits and calling himself Curtius was François Tussaud trading under his uncle-in-law's famous name. Later in England Marie would make recriminating references to her husband, about him leaving her all alone, and in this correspondence she also alludes to him having visited London. The evidence is therefore compelling that from the outset the Tussaud union was dogged by separations arising from attempts to keep the business afloat, and François's trip to England in 1796 so soon after their marriage was but a forerunner of a much more prolonged and dramatic separation seven years later. If it was far from propitious for their relationship, this earlier successful tour would augur well for Marie, for it meant that by the time she herself came to England a positive impression had already been made by work associated with Curtius.

With an absent husband and ailing finances, it is unlikely that Marie shared the joie de vivre in her midst. After the strictures of the Revolution and the patriotic dress code that had seen fashion magazines close down for a time, under the Directory, in 1795–9, the city put on its glad rags once again. In spite, or perhaps because, of the hardships imposed by food shortages and currency problems, in these years a carefree, almost decadent spirit started to enliven public life as once again Parisians came out to play. Pleasure gardens, gambling establishments and dance halls were perpetually packed. As a reaction to the earlier restrictions, those who could afford to dressed from head to toe in garments from as many different countries as they could display on one body. As the German traveller

Kotzebue noted, 'The whole world has to pay tribute to the toilette of the Parisian – one wears English cloth, Egyptian shawls, Roman sandals, Indian muslins, Russian riding boots and English waistcoats.' The most gossiped about and gawped at beauties in public life at this time were Madame Tallien and Joséphine Beauharnais, who caused a sensation with their diaphanous dresses that left little to the imagination. Draped like Greek goddesses, their look emulated classical sculpture, but, unlike cold marble statues, the way these flesh-and-blood women flaunted their charms set pulses racing. Blonde hair was all the rage – brunettes wore blonde wigs – and another fashion favourite from this period was the pashmina, after Napoleon sent them to Joséphine by the hundred during his Egyptian campaign. Although they became her signature item, Joséphine was not immediately drawn to the lightweight shawls: she wrote, 'They may be beautiful and expensive with the advantage of lightness, but I very much doubt that they will ever become fashionable.' How wrong she was!

The opulence and air of glamour that had been the hallmarks of the exhibition in the early days now returned, but this time there was no guiding hand from Curtius to determine who was shown. Under the Directory, current affairs were so complicated and factional that it was not obvious which figures the waxworks should focus on. But, attractive women always being of interest, Marie installed an elegant portrait of Joséphine. The preference of the Directory for rich costumes gave scope for sumptuous display, as Marie noted in her memoirs: 'The costume of the directors was most remarkable. A cherry-coloured cloak, white silk pantaloons, turned-down boots, waistcoat of silk, à l'espagnol, the whole richly embroidered with gold, Spanish hat and feathers.'

Once people had kept a respectful distance as they watched the royal family eating in public; now eating in public was egalitarian. Following on from the fraternal feasts of the Revolution, now individual menus, private tables, grand mirrored dining areas and fancy foods were available to anyone who could afford them. What had previously been the privilege of a noble minority had become a democratic experience. The dining table at the waxworks charted this change, as a succession of politicians took their turn as the VIP guests, the young, impassioned

and self-made sitting in the very same place that had formerly been occupied by the royal family. But the greater social mingling in society at large removed some of the magic the exhibition had created in the days of the *Ancien Régime*. In those days the lifestyle of the royal family and other dignitaries gave them the mystique of an exotic species, so removed were they from the ordinary people. But now, as a sans-culottes diarist records, 'Poorly dressed people who would formerly have never dared show themselves in areas frequented by people of fashion were walking among the rich, their heads held high.' Having to persuade people paying to look at wax figures when the new social mobility meant there was much more scope to get up close in public to the glitterati of the day was from Marie's perspective a distinct downside to democracy.

Before her first wedding anniversary, at the age of thirty-four – an age that was more typical of death than of first-time motherhood in this period – Marie gave birth to a daughter, Marie Marguerite Pauline, in September 1796. The baby lived only six months, and at her death Marie cast a tiny mask that she later displayed in the exhibition. Two sons, who were to play such a pivotal role in the future direction of the exhibition, were then born in fairly quick succession for an older mother: Joseph on 16 April 1798 and, when she was thirty-nine, François (later known as Francis) on 2 August 1800. If their adult life would see them basking in their mother's success, their infancy was set against a backdrop of real struggle for her, both in an unhappy relationship but also commercially. In François Tussaud, Marie had more of a drain on her resources than a reliable ally who shared her industrious nature. His speculative streak also meant she was living on a fault line. Even with her mother in the background throughout – a woman who, barring a couple of mentions in the memoirs, is so remote that we have no sense of her relationship with Marie or any clues as to her character – it seems that this was both one of the toughest times for the exhibition and a bleak time personally.

In the social whirl that saw restaurants, gambling venues and dance halls boom, viewing wax figures simply couldn't compete. People were relishing movement and noise, music and laughter. Indicative of the hedonistic spirit was the subject matter of a new wax exhibition that started up at this time, catering to an entirely different audience. Once

Curtius had offered a dazzlingly elegant salon at his rented premises in the arcades of the Palais-Royal; now the Palais-Egalité was home to the Cabinet of Professor Bertrand, a cautionary tale showing 'all the dreadful consequences of libertinism in the most lively manner in wax'. This type of show, which became more common in the nineteenth century, prompted unfavourable comparisons with the modelling maestro. Looking back nostalgically, one contemporary commented, 'Curtius may have committed some blunders, but he never sought to attract his patrons by the exhibition of unpleasant subjects likely to disagree with a delicate stomach.' You needed to be robust for Bertrand's waxes. Directed at a male-only clientele, their depiction of the progressive ravages of venereal disease on the body provided a graphic warning of the price of pleasure: 'At the end of this gallery of the furies lies a youth on his death bed, as large as life, in whose languid eyes and distorted features, pain, shame, repentance and despair are eloquently displayed.' This unhappy ending seemed to be an insufficient damper on the promiscuous mood, as evidenced by the number of times a directory of the prices and specialities of the prostitutes of the Palais-Egalité was reprinted.

In her twenties Marie had watched the rise of Robespierre, who in five years had insinuated himself into a position of power with the whole of France in thrall to him. Nearing middle age, she was poised to witness the more epic scaling of the heights of glory by a young Corsican general with not just a country, but the world in his sights. Just as the earlier dictator helped fill the coffers of the exhibition when it was still managed by Curtius, the cult of Napoleon would substantially benefit Marie in the future when she was making her own success. In the difficult days under the Directory, when he was only just starting to distinguish himself, Marie could have had no idea of the role Napoleon would play in her professional life. She could never have predicted the stature he would attain over the next fifteen years, and how she would exploit the explosion of public interest in the great man.

Napoleon had a split personality sartorially. His preference for the jackboots and uniforms of the field was offset by an awareness of the impact of ceremonial dress in creating the aura of power. Marie recalls him during his triumphal return from his military campaign in Egypt,

'dressed in the costume of a Mamaluke, in large white trousers, red boots, waistcoat richly embroidered, as also the jacket which was of crimson velvet'. With the *coup d'état* of 1799 Napoleon manoeuvred himself into the position of First Consul. In Marie's view this event signified 'the true end to the history of the Revolution, which resolved itself into a government of military despotism under the guidance of a talented but arbitrary dictator'.

She relates how at the personal request of Joséphine she was commissioned to take a life mask of Napoleon. At six o'clock in the morning – the only time he would be free, she was told – she made her way to the Tuileries, where she received a warm reception from Joséphine. Bearing in mind her assertion that the last time they were together was as cellmates, this was presumably an emotionally charged reunion. Apparently 'Joséphine greeted her with kindness, conversed much and with extreme affability.' Napoleon, by contrast, was gruff, and evidently reprimanded Marie when, reassuring him about the procedure of coating his face with liquid plaster with straws for him to breathe through, she said he shouldn't be alarmed. 'Alarmed?' he exclaimed, 'I should not be alarmed if you were to surround my head with loaded pistols!' Even making allowances for Marie's assertion that the portrait was a present for Joséphine, her account of this sitting seems improbable. Napoleon is renowned for his vigilance about his image. He was ultra-controlling about how he was presented to the outside world, in whatever medium. It therefore seems unlikely he would grant access for a sitting with a show-woman and a proprietor of a commercial exhibition – especially as he habitually turned down David's requests for formal sittings. And to permit a process whereby, once she had taken a mould from his face, Marie could manufacture unlimited numbers of models of him would seem to show him in breach of his own meticulously observed protocol for his propaganda machine. Napoleon constructed his identity with what was *not* shown and measured and seen; his image was based on what people believed him to be like – hence all the controversy about how tall he was.

But most persuasive in undermining Marie's claims to have slapped plaster on his features are Napoleon's own words on the subject of likenesses: 'It is not the exactness of traits, a wart on the nose, that makes a likeness. It is the character of the countenance, what animates

a person, that it is necessary to portray. Certainly Alexander never posed for Apelles. No one knows if portraits of great men are likenesses. It is enough that their genius lives.' In her early catalogues, when she states that Napoleon was taken 'from life', it is more likely that she means either from observation or from existing portraits in other media.

An anecdote from this time relating to Marie and the exhibition that does seem to be true concerns David. The painter evidently possessed a Curtius-like capacity to transfer loyalty, slipping seamlessly from being the propagandist of the Revolution to being the official painter of what in effect was the embryonic court of Napoleon, which would in time come to rival the spectacle and pomp of the *Ancien Régime.* Whether he still used the figures as source material for his own work is unclear, but clearly David retained his interest in the exhibition that was now under Marie's management. A vignette recorded by his pupil Etiénne Delecluze describes a visit in 1801, during which they were invited to inspect the contents of a chest that were not on general display. When the lid was opened, they recoiled at the sight of a row of chillingly lifelike decapitated heads, of which those of Hébert and Robespierre were instantly recognizable. David, trying to conceal how disconcerted he was, appraised them with a professional eye and pronounced that they were very convincing and extremely well done. He and his pupil then left, apparently stunned into silence by the contents of the trunk, and did not speak a word to one another as they walked the length of the boulevard.

With some of the prize pieces that had once been the big earners now out of sight, like the hidden heads that David saw, it had become more obvious what Marie should hold back from public view than what she should put on display. Also, there were now many more racy distractions for the public, from busy brothels to the glitz of the gaming tables. Still buffeted by the loss of her first child, with two small boys to care for, and a husband who needed supervision more than he could provide support, she was under considerable pressure. François's unreliability created a sense of instability rather than security, which was exacerbated by her creditors' constant revisions of the terms of their loan. Adversity was the theme of her life when, in August 1802, Philipstal, the showman whom Curtius had spoken up

for and saved from the guillotine back in 1793, returned to Paris. He had come to source some attractions to beef up his own bill of entertainment, which, having been the talk of Georgian London, was starting to suffer from widespread imitation. A victim of his own success, he had announced on his departure from England that he was closing 'for a short time, to make way for an entire new set of amusements', and had Marie's wax figures in his sights. For Marie, his reappearance at this time must have seemed as if real life was mimicking the *deus ex machina* devices that were the grand finale of Philipstal's own magic shows.

Philipstal proposed a professional partnership whereby Marie would display a series of wax figures relating to the turbulent events in the recent history of France as a supplementary attraction to his main entertainment. But his terms were tough. She was to pay her own transport costs and expenses, and he would take half of her gross earnings. It seems likely that he used the showman's knack of persuasion and talked up how profitable his run at the Lyceum Theatre had been. One can imagine a compelling description of packed houses and glowing newspaper testimonials, and the energy of a showman who was making a success must have forced her to draw a very unfavourable comparison with François's ineptitude. How much acceptance of Philipstal's proposition was motivated by the chance to restore the fortunes of the ailing exhibition in the Boulevard du Temple and how much by the prospect of a legitimate escape route from her husband we can never know. What is clear is that it cannot have been a decision taken lightly. Marie must have been fairly desperate to contemplate leaving all that she had known for an uncertain period of time in a country that until recently had been the enemy of France, especially as she spoke not a word of English. It would entail abandoning the core of her inheritance, but most poignantly her two-year-old son and her elderly mother – Joseph was to go with her to London – without presumably much confidence in committing them to François's care. It was a far cry from the circumstances in which her mentor, Curtius, had been persuaded by a kindly rich patron to leave all that was familiar to him behind in Berne to embark on a new life in Paris. The world had changed dramatically from the days of aristocratic patronage, cosseting and

private commissions. Now every man was out for himself, and, as Marie would discover to her cost in leaving her husband, a personal predicament with a weak man was about to turn into a professional predicament with an unscrupulous one. Philipstal cast a dark shadow on her new life in England, and it would be a very long time before she could see herself reflected clearly for the talented woman she was in her own right, and not merely a reflection of Curtius's genius.

10

Vide et Crede! The Lyceum Theatre, London

ONE OF PHILIPSTAL'S programmes of entertainment in London was entitled 'A Magical Deception'. But unfortunately it was not just on stage that he deceived. Given that there seems to have been not a trace of the ingénue about Marie, and that guile rather than gullibility was her nature, it is surprising that she failed to detect the all-too-real flaws in Philipstal's business proposal. But an ailing exhibition in Paris and a lacklustre relationship with François must have made her susceptible to what had appeared to be a persuasive option to improve her lot both personally and professionally.

She knew that in London she could capitalize on the intense interest there was in France. This was not confined to the horrors of the Revolution. Three successive attempts at invasion by the forces of Revolutionary France – in 1793, 1797 and 1798 – had instilled a hyper-vigilance in the British people about their vulnerability to the ambition of Napoleon. Since his appointment as First Consul, respect for his military brio had turned into fear of him as a ruthless tyrant, which fuelled fascination. As she carefully packed crates of moulds – some thirty figures and busts – Marie must have felt confident that the two figures of Napoleon and Joséphine would serve her well in the months ahead.

Bonaparte's fame was legendary yet his physical appearance was only a subject of speculation for all but a tiny minority of Englishmen. Joséphine, as the woman who had turned the head of the most powerful man in the world, was similarly of great interest. As a high-maintenance, style-setting adulteress, she had usurped the late Queen as the focus of gossip, and the public of both sexes were hungry to know more of her. Marie's confidence in the earning potential of such crowd-pulling material that she was bringing to London tempered

what must have been the painful emotions of leaving her two-year-old son, her elderly mother, her aunt and the ancillary assistants involved with the exhibition.

Although the Treaty of Amiens, ratified in March 1802, had officially ended hostilities between England and France, many regarded it as a comma in the conflict rather than a full stop. The statesman Lord Cornwallis voiced a commonly held cynicism when he referred to the peace as 'experimental', and celebration was tinged with caution. The continuing sensitivity of Anglo-French relations was evident on the streets of London when a misunderstanding over the celebratory illuminations outside the French ambassador's residence nearly caused a riot. The crowd reacted violently when they misread the coloured lights as spelling out 'Conquered' rather than 'Concord'. This slur on John Bull almost made the war resume again, until a diplomatic solution was reached. The poet Robert Southey watched the fracas from the top of a garden wall nearby. He describes how a large number of soldiers in the crowd were incensed by the perceived insult and 'insisted upon it that they were not conquered and no Frenchman should say so; and so the word "Amity" which can hardly be regarded as English was substituted'.

But patriotic sensibility was not sufficiently piqued to stop streams of the well-to-do from indulging their curiosity about recent history by crossing the Channel for a spot of Terror tourism. They longed to see for themselves the blood-stained block of the guillotine and the still scarlet stones of massacre sites, and to take an envious look at the loot in the Louvre. But the most coveted sight was a glimpse of Napoleon in person. To this end, regular receptions at the consular court at the Tuileries and numerous military parades became objects of pilgrimage for the thousands of Napoleon-worshippers who crossed to France at this time.

For those who could not afford to travel to Paris, there was no shortage of French-themed entertainments in London. The capital was cluttered with improvised models of the guillotine, sometimes billed as 'The French Beheading Machine'. For only 6d. one exhibition in the Strand was more explicit, with a 'Grand Exhibition of La Guillotine' that included a demonstration of a decapitation: 'The execution is performed on a figure as large as life; the head is severed

from the body by the tremendous fall of the axe and the illusion is complete.' At Mrs Salmon's waxworks in Fleet Street, the public could see 'the horrible cells of the Bastille with the man in the iron mask, the Queen of France and the Dauphin in distress'. It was a competitive market that Marie was about to enter, but the first-hand credentials she would claim and the sensational details of the coercion behind the making of many of her gruesome relics would confer an extra dimension of interest on her own figures, and give her the edge on her rivals.

While packet ships plied the Channel taking well-heeled English tourists to the shores of France, Marie and her fragile cargo were among the busy return traffic that brought an influx of foreign show-people to Dover, all keen to conquer the peacetime market with novelties as yet unseen in England. Monsieur Moritz was one of the early arrivals. His version of a phantasmagoria featured a terrifying image of the late King of France as a skeleton. Philipstal's optical illusion of the King, shown in the wrong place at the wrong time, had got him imprisoned, but English audiences loved this royal phantom.

A rapturous reception was also given to the Frenchman who launched his cabaret of performing poodles on the London circuit. They were a smash hit for several seasons, and were fondly recalled by all who witnessed their anthropomorphic antics. In a glowing tribute, *Chambers's Edinburgh Journal* described their talents:

> From puppyhood upwards they had been taught to walk on their hind legs and maintain their footing with surprising ease in that unnatural position; they had likewise been drilled into the best possible behaviour towards each other. No snarling, barking or indecorous conduct took place when they were assembled in company. But what was most surprising of all, they were able to perform in various theatrical pieces representing transactions in heroic and familiar life with wonderful fidelity.

A military siege, complete with cannonfire, and smoke, saw dogs storming ramparts on ladders and charging about in military uniforms in the heat of a live-action battle. In the second part of their performance the dogs enacted an elegant pastiche of court society. In ludicrous contrast to their canine characteristics, poodles depicting

grandes dames wore the powdered wigs of the *Ancien Régime*; others wore the ruffs and dress swords of noblemen. The sight of the wet-nosed gentlemen bowing to the wet-nosed ladies brought the house down. As the review said, 'The frequent bow and return of curtsy produced great mirth in the audience, but when the noses of the animals neared each other, it produced a shriek of delight from the youthful spectators.'

A fellow showman whose presence in England was going to prove a great source of solace to Marie was Monsieur Henri-Louis Charles. Less famous than his brother the eminent physicist Professor Jacques Charles, who had acted as technical adviser to the pioneering aeronauts, Monsieur Charles was a ventriloquist. He came from the same close-knit show-business community as Marie in the Boulevard du Temple. Circumstantial evidence suggests that he knew both Marie and François (in one of her letters to her husband she says that Monsieur Charles sends his regards). It is known that Curtius employed a ventriloquist at the Palais-Royal salon to inject some variety and action into the sedate surroundings, and it is entirely plausible that this was Monsieur Charles.

While Philipstal was in Paris inveigling Marie to join him at the Lyceum, Monsieur Charles was already installed in the upper room there, baffling Georgian audiences with his splendidly named show 'The Auricular Communications of the Invisible Girl'. This was no ordinary ventriloquist act of marionette and showman, rather a blend of science and showmanship whereby an elaborate metalwork pavilion with apparatus for hearing the communications of the ethereal star dominated the stage. Heard but not seen, his unusual leading lady was, as his publicity proclaimed, 'invisible to the most penetrating eye', yet this was no bar to her engaging in lively dialogue with members of the audience and answering any questions put to her in English, French or German. Even more astounding was her deity-like skill of being all-seeing: nothing that happened in the auditorium escaped her notice. As the posters pronounced, 'In short everything is as completely visible to her as she is invisible to the assembly, near whom she seems to sigh close to their ears, so that her breath may not only be heard but also felt; she follows all their motions and seems even to guess their thoughts.'

Whereas Monsieur Charles impressed audiences with a deception based on mechanical ingenuity, Marie was reliant on the quality of her artistic imitation of life. But this type of deception was not new to the city. She and Curtius had enjoyed a virtual monopoly with their wax exhibition in Paris, but she was going to have to work much harder to distinguish herself in England. Although many of the foreign entertainers could genuinely claim to be innovative in London, there was no novelty value to waxworks per se. Long before Madame Tussaud's arrival, wax figures had been a familiar part of the visual culture in different forms for different audiences across the class divide. Moreover, the waxworks exhibitions that were up and running in London in some cases comprised collections extending to hundreds of full-length figures. If Marie could not compete on quantity with her collection of around thirty figures, her artistry meant she could hold her own with quality.

The most familiar associations with her medium were the fairground-booth waxworks, where the lack of resemblance to the intended subject was almost part of the pleasure of viewing them. In early September 1802, a couple of months before Marie arrived in London, Bartholomew Fair, the biggest and longest running fair, on the site of the later Smithfield Market, was in full swing. Wordsworth went along, and was moved to record what he had seen in a poem:

All moveables of wonder, from all parts,
Are here – Albinos, painted Indians, Dwarfs,
The Horse of Knowledge, and the learned Pig,
The Stone-eater, the Man that swallows fire,
Giants, Ventriloquists, the Invisible Girl,
The Bust that speaks, and moves its goggling eyes,
The Wax-work, Clock-work, all the marvellous craft
Of modern Merlins, wild Beasts, Puppet-shows,
All out-o'-the-way, far-fetch'd perverted things,
All freaks of Nature, all Promethean thoughts
Of Man; his dullness, madness, and their feats
All jumbled up together, to make up
This Parliament of Monsters.

Marie would spend her life trying to dissociate her own exhibition from the pejorative associations of the waxworks that had

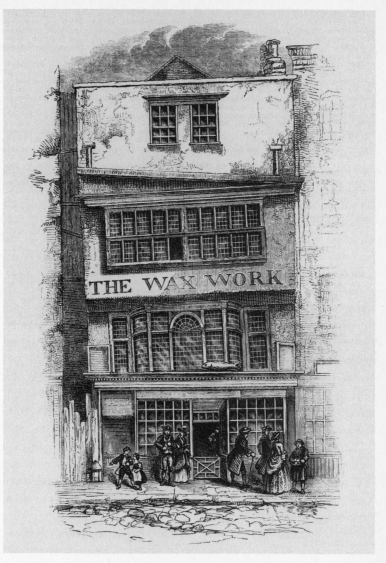

Mrs Salmon's waxworks, Fleet Street – advertised by symbol of fish –
an eighteenth-century Madame Tussaud's

traditionally been part of this tier of entertainment. To promote her preferred image of a refined version of this art, her early advertisements studiously avoided any reference to 'waxwork'. She substituted a series of phrases such as 'accurate models in composition'.

In a different league from the fair were Mrs Salmon's waxworks, with permanent premises in Fleet Street. Although the late Mrs Salmon had been justly renowned for her talent, she had also had a reputation for eccentricity, mixed with a dark sense of humour. She used to wear a bonnet accessorized by coffin trimmings, and is said to have slept on a winding sheet with a shroud for a nightdress and a pall for a coverlet. Her trademark practical joke was a spring-activated booby trap beside a figure depicting a character from English folklore called Mother Shipton, which was positioned near the exit of the exhibition. When punters stepped on the trap, the part-mechanized Mother Shipton kicked out at them, giving them a memorable send-off.

Mrs Salmon was to eighteenth-century popular culture what Marie would become in the nineteenth. After her death in 1760, aged ninety, the exhibition continued to flourish, with successors trading under her name. Early enthusiasts of her amusement-arcade brand of fun included both Hogarth and Boswell, and Dickens later made reference to her show in *David Copperfield*. Mrs Salmon's waxworks was thus an established London landmark that provided the chief point of reference for assessing the comparative achievement of Madame Tussaud.

The subject matter at Mrs Salmon's spanned history and horror – anticipating the market that Madame Tussaud would cultivate so successfully with her Chamber of Horrors. But whereas Madame Tussaud tended to focus on the trial-and-execution aspect of crime, the Salmon waxworks were more sensational and showed the crimes being perpetrated. A visitor at the end of the eighteenth century recalled tableaux depicting criminals in the act of their crimes, including a notorious bodice-ripper who scandalized society by 'maliciously tearing, cutting and spoiling the garments' of a Miss Porter as she strolled in St James's.

Rather as Marie would attempt to attract a higher calibre of patron than the indiscriminate public, it seems that there were similar efforts

to market Mrs Salmon's enterprise as an upmarket concern, as is evident from the tip in a publicity poster that its location was 'convenient for the quality's coaches to stand unmolested'.

A neighbouring attraction and rival to Mrs Salmon was Rackstrow's museum at 197 Fleet Street. Founded in 1787, this mind-boggling display of crazy curating challenged the constitutions of visitors until around 1808. An eclectic selection of natural curiosities – animal, vegetable and mineral – camouflaged the main attractions, which were explicit anatomical models in wax of the female pelvic organs and 'anatomical representation (in wax) of the urinary bladder and penis of a man'. These were arranged alongside pathological specimens that would have done Damien Hirst proud: endless pickled human organs, including 'a penis injected to the state of erection', and stomach-turning aberrations of nature, all preserved in spirits. What is particularly striking is the juxtaposition of items – a bust of George III and death masks of Oliver Cromwell and Sir Isaac Newton alongside 'a bone of the penis of the sea bull'. And all this was presented in the guise of an educational experience. The only concession to sensibility was that female visitors were offered the opportunity to view the exhibits without men being present, with the assurance that 'a gentlewoman would attend them separately.' This pathological-peep-show style of waxworks proliferated in the nineteenth century, in contrast to Madame Tussaud's version of respectable family entertainment.

Another waxworks that had long been a feature of London life was within Westminster Abbey. The core of the collection of wax figures here was the remains of effigies crafted for ceremonial purposes. These relics of ancient funerary ritual related to royalty and people of noble birth. A wax double of the deceased dignitary was positioned on a hearse – historically, a platform on which the wax figure was attached, and draped with hangings and laudatory verses. From the fourteenth century onward these likenesses had been the focal point of solemn processions that ended in the Abbey. The decrepitude of the collection spawned the nickname 'the ragged regiment'. A description in a guidebook published in 1708 hints at the aptness of the name, describing Edward III as 'a broken piece of wax-work, a battered head, and a straw-stuffed body not one-quarter

covered with rags'. In the mid eighteenth century attention was deflected from the sorry remnants of the regiment that included bashed-up Edward III, Charles II and Elizabeth I when a series of new full-length wax figures was installed with commercial, not ceremonial, intent – as Horace Walpole complained, 'to draw visits and money from the mob'. To install full-length wax figures with seemingly no other purpose than to satisfy and profit from public curiosity stands out as a daring and dubious use of the consecrated space of a place of worship. It also hints at the potency of lifelike representations of historical characters and people in public life in a culture where there was no collective visual frame of reference. The new figures included Queen Anne, William and Mary, a made-over Elizabeth I and Lord Chatham (Pitt the Elder), with an admission charge of 6d. The figure of Chatham was commissioned from Patience Wright, an intriguing American artist who moved in the upper echelons of late-eighteenth-century English society.

This charismatic woman represented the more rarefied and elitist genre of wax modelling. Like a society portrait painter, she largely fulfilled private commissions for her privileged circle of contacts. While Marie was coming to England yoked to a commercial showman, Patience Wright, who came from Philadelphia, had been introduced into English society by Benjamin Franklin. The doors of the smartest addresses had been opened to her, and she once caused a sensation in an aristocratic drawing room by placing there a brilliantly executed likeness of a housemaid which it did not take long for someone to be duped into addressing, much to the delight of those present. But, beyond her parlour pranks, her work received the highest encomiums. The *London Magazine* regarded her as a prodigy, 'reserved by the hand of nature to produce a new style of picturing superior to statuary and peculiar to herself and the honour of America, for her compositions in likeness to the originals surpass paint or any other method of delineation; they live with such a perfect animation, that we are more surprised than charmed, for we see art perfect as nature.' Her figure of the Earl of Chatham, which can still be seen at Westminster Abbey, was immensely popular.

However, Mrs Wright got one thing wrong in the eyes of her English hosts. Her relaxed American familiarity clashed with stiff

English formality, and those who witnessed it almost melted with embarrassment when, as if they were her new best friends, she addressed the King and Queen as 'George' and 'Charlotte'. This puts Marie's supposed chumminess with Louis and Marie Antoinette in the shade. She controlled access to her work by exhibiting by appointment only at her residence in Cockspur Street.

Patience Wright died in 1786. Although Marie therefore had only the legacy of the talented American's reputation to contend with when she came to London, there had in one sense already been rivalry between them. Evidently Patience had identified the potential for wax in the decadent days of *Ancien Régime* Paris, and in 1779 she wrote to Benjamin Franklin asking for his help to set her up in business in the French capital. He deterred her, because he felt the wax-portraiture market was already well supplied. Presumably his direct experience of Curtius's talent was the basis on which he made his assessment.

The closest anyone in England came to Curtius was the Irish-born Samuel Percy, who set a new standard of excellence for wax portraiture. He confined his work to miniatures and half-figures, and like Curtius he enjoyed aristocratic patronage, in his case from the Earl of Shaftesbury. Appealing to the aesthetic taste and vanity of 'the nobility and gentry', his exquisitely detailed portraits displayed in dust-proof boxes, gilt frames, and on convex glass mounts represented the top end of the consumer market. Hand-tinted and occasionally embellished with seed pearls and glass beads, they were of exceptional intricacy. His facility for texture also put him in the Curtius class, but whereas Curtius excelled in mimicking the human complexion, Percy's signature skill was the intricacy of his chiselling of wax accessories such as lace ruffs. His wax-medallion portraits graced stately homes and even royal residences: the collection of HM the Queen at Windsor Castle includes historical character studies by Percy. Whereas Marie catered to the shilling-a-pop general public, Percy drew those with guineas to spend. His distinguished clientele often ordered copies, made by an assistant from Percy's mould, and these unsigned inferior reproductions were distributed to friends and relatives. Those who baulked at the guinea-and-a-half fee for a coloured miniature portrait could opt for the less expensive plain-white relief

style, 'after the manner of Roman coins'. Percy's career represented the medium of wax as fine art, for the privileged consumption of the private collector or those who frequented the Royal Academy, where at various times between 1786 and 1804 Percy's works were on display.

There was a polarity in Georgian London between waxworks as general entertainment and waxworks as a small, respectable seam of Establishment culture. This dichotomy echoed a more general chasm between entertainment and education. Marie quickly recognized the potential to plug this gap by using the medium to promote her unique and innovative blend of 'infotainment'. When she first arrived in London there was no National Gallery, and the British Museum was interested more in protecting its collections from the general public than in making them accessible. Endless draconian rules such as no browsing and the presence of bossy guides watching visitors' every move were the Establishment equivalent of a 'trespassers will be prosecuted' notice.

Prejudice against the general public was deeply engrained. In the early days of the Royal Academy, for example, a concern of artists was the prospect that on general display their work ran the risk of appraisal 'by kitchen maids and stable boys'. To prevent such insufferable indignity, admission fees were devised 'to prevent the room from being filled by improper persons'.

The commercial entertainment sector, by contrast, wooed the public with a constantly changing programme of mechanical inventions, menageries, 'mathemagicians', strongmen, pig-faced ladies, and every conceivable sleight-of-hand illusion. Marie was one of the first to appreciate the value of a printed catalogue as an important part of customer care, and of course an additional source of income. Given so many rival attractions, advertising was essential, and the first indication that Marie was not on safe ground with Philipstal came on arrival, when she learned that he had not included her exhibition in any of the advertisements for his own entertainment. The exception was a token mention on a poster of 7 December 1802 of 'A Cabinet of Wonders'.

Aware that pre-publicity was a crucial part of creating the hype on which opening days depended, this must have been very

demoralizing. Moreover, since she did not speak English, she was completely reliant on Philipstal to help promote her. She could not have had clearer proof that he regarded her very much as the supporting act, and not an equal. Undaunted, she set up her thirty or so exhibits, interspersed with the model of the Bastille, the model of the guillotine, the blood-stained shirt of Henry IV and an Egyptian mummy.

In assessing the plight of a forty-one-year-old woman in a foreign country, with no money, no fallback, a small boy in tow, and a show about which the public were largely unaware, the minuses were daunting. But there were some pluses, chiefly her pluck and enterprise. After a presumably lonely Christmas in modest lodgings in Surrey Street, near the Strand, Marie showed her mettle early in the new year, when she seized the opportunity to add a topic of hot news to her exhibition. Her coup was to display a post-mortem likeness of the traitor Colonel Despard, whose trial and subsequent execution in February 1803 enthralled the nation.

Since Ireland had been formally annexed to Great Britain, by the 1800 Act of Union, becoming, as one historian put it, 'a half-alien dependency', it had seethed and hissed with dissent. Vehemently opposed to the merger, Despard had for years fought with the United Irishmen for the freedom of his country. This organization had secretly sided with the French during the Revolutionary wars, and had given backing to the invasion plans of 1798. These allegiances were the background to Despard's audacious plot to bring down the English Establishment.

Despard was seen as a despicable traitor of such daring he made Guy Fawkes look timid. Not only had he set his sights on seizing the Houses of Parliament, but he was also plotting to take the Bank of England and the Tower of London, with the help of his thirty-two accomplices. Most dramatically, he was planning to assassinate the King – or, as the *St James's Chronicle* with palpable outrage reported it, 'The leading feature of the conspiracy is of so shocking a description that we cannot mention it without pain and horror. The life of our beloved Sovereign it appears was to be attempted on Tuesday next by a division of the conspirators, while the remainder were to attack the Tower and other places.' The

dastardly ambitions of the would-be King-killers were punctured in the prosaic setting of the Oakley Arms, a pub in Lambeth, where they were apprehended by a party of Bow Street Runners.

The trial transfixed the nation, and courtroom drama quickly turned into sensational melodrama when Lord Nelson was subpoenaed as a character witness, on the basis of shared military service abroad some twenty years earlier. Not even a glowing testimony from Nelson could sway the jury to spare Despard the sentence of being hanged, drawn and quartered. However, after what our press would call an 'emotional appeal' from his widow to intervene, Nelson succeeded in getting the sentence reduced to hanging and decapitation after death. Thousands of people watched the prolonged and ritualistic degradation of Despard's body, and broadside presses spewed accounts of his death. Executions were a staple subject of mass-produced and inexpensive woodcuts that enjoyed huge sales. These primitive representations, many of which relied on modifying existing stock blocks, were poor in quality, and early on Marie realized she could capitalize on the hunger to see better likenesses.

In the context of the precarious peace with France, the wax head of Colonel Despard was a good talking point. It was also much easier to view close up than from among the suffocating crowds at Newgate. Although of course it was a talking point on which Marie could not as yet converse, as she gratefully pocketed the shillings at the entrance. If she had been able to engage her customers in conversation, it would have been interesting to hear what she told them about modelling this macabre exhibit, for unlike with the French death heads and Revolutionary relics, that were the blood-thirsty core of her exhibition, she could not claim coercion as the reason for dabbling her lady-like hands in this sanguinary business.

In stark contrast to the calm atmosphere of Marie's cabinet was the spectral extravaganza offered by Philipstal in the upper room of the Lyceum. Since his earlier experimentation with the magic-lantern genre in Paris, his show had evolved to an altogether more sophisticated technical level. This was in no small measure down to the refinements to the magic lantern that had been made by a star pupil of Monsieur Charles's brother the professor, a man called Etienne Robert. It was the fun of fear that Philipstal was providing for his

audiences. The biggest thrill that he pioneered was sitting people in pitch darkness, for in eighteenth-century London congregating in the dark with strangers gave a frisson of daring to the experience of going to the theatre. Rivals tried to market this as a negative and announced on their publicity that at their shows 'total extinction of light in the theatre is unnecessary', but they were rather missing the point.

Sir David Brewster (writing in 1832) gives a blow-by-blow, or rather flash-by-flash, account of fright night at the Lyceum in 1803:

> The curtain rose and displayed a cave with skeletons and other terrific figures in relief upon its walls. The flickering light was then drawn up beneath its shroud and the spectators in total darkness found themselves in the middle of thunder and lightning. This was followed by the figures of ghosts, skeletons and known individuals whose eyes and mouth were made to move by the shifting of combined sliders. After the first figure had been exhibited for a short time, it grew less and less, as if removed to a great distance, and at last vanished in a small cloud of light. Out of this same cloud the germ of another figure began to appear, and gradually grew larger and larger, and approached the spectators till it attained its perfect development. In this manner, the head of Dr Franklin was transformed into a skull; figures which retired with the freshness of life, came back in the form of skeletons, and the retiring skeletons returned in the drapery of flesh and blood.

In a terrifying climax, instead of advancing and receding in front of the audience, the spooks and spectres suddenly charged towards them. The startled spectators shrank closer together, fingernails were dug into hands, and screams were shrill in the air, though the less timorous reached up to try and touch the menacing mirages.

Sometimes Philipstal undertook private performances in the homes of the wealthy. On one occasion he was engaged by 'a man of fortune' in Portman Square, off Baker Street, to entertain a group of friends including a number of young ladies. Unfortunately although the finale was supposed to be the hair-raising, heart-stopping highlight of the show, on this occasion things did not go as planned. As a newspaper reported, 'On the very first appearance of the spectre the ladies were thrown into fits and . . . it was in consequence of this circumstance that he thought it proper to stop the exhibition.' The

report is an account of the ensuing legal action brought by the showman against the gentleman who had booked him, the latter having refused to pay the full fee for such an abbreviated performance. Although the parties are not named, circumstantial evidence indicates very strongly that the showman concerned – described as an expert in the 'deception of the spectrological arts' – was Philipstal. In one of the letters in the scant correspondence with her family in France that miraculously have survived, Marie makes mention of his involvement in a legal dispute that could well be the one outlined here. This incident also fits a picture that can be pieced together from disparate fragments of information about him as a difficult, contentious man. The evidence is of a career studded with litigation, lies and let-downs, and a tendency to disappear and reappear in other people's lives with the unpredictability of one of his own creations. Yet, redeeming his reputation, the dislikeable magic-lantern maestro must take credit for importing Marie's talent to London, thereby helping to lay the foundation for the future national and international entertainment empire.

Though Philipstal and Marie offered seemingly unrelated entertainments, they both catered to a burgeoning interest in likenesses of the famous. A contemporary account of Philipstal's performances by a man called Nicholson, who seems to have attended them regularly, describes how they featured 'semblances of several great heroes and other distinguished characters'. He writes, 'Mr Philipstal's performances are not wholly confined to "men that were"; he occasionally introduces great and distinguished characters of the present day; the compliment paid to our gallant Lord Nelson in crowning him with laurels being particularly well conceived.'

This experimentation with animated likenesses of living and dead heroes and celebrities could be seen as the distant ancestor of cinema. The low-tech images projected by Philipstal were an embryonic form of the sophistication achieved in movies with actors and actresses in different roles. In each case a large part of the pleasure for the audience lies in the interplay between representation and reality. But whereas today the stars of the big screen are generally rated for their ability to play many different characters in a convincing manner, making us forget their 'real' identities, in Georgian England what was

so utterly compelling was simply the evocation of the actual person. It is hard, in the twenty-first century, constantly bombarded with photographic images, to recapture the sheer magic of any representation. For us, jaded as we are with seeing reality reproduced, it is the quality of the reproduction that matters. For Philipstal's audiences, in contrast, likeness itself was the buzz.

As manufacturers of likeness, Philipstal and Marie were lauded for their ingenuity. Some thirty years before Daguerre used light to capture likeness, becoming a pioneer of photography, with his magic lantern upstairs at the Lyceum and with her wax figures downstairs Philipstal and Marie were tapping into the thrill of the mimetic. In using their talents for this form of replication of the famous and infamous, they were continuing what Curtius had done so successfully in Paris some twenty years earlier, exploiting and profiting from the nascent cult of celebrity. 'Vide et Crede' – 'See and Believe' – was a popular slogan among showmen – Marie herself used it – and this challenge to come and behold their wonders was often a tag line on handbills. For those who went to the Lyceum in the season that Marie and Philipstal were there, their first experience of the moving and static facsimiles of real people was incredible, and they could not believe their eyes.

11

Scotland and Ireland 1803–1808

THE HIT THAT Marie had with her likeness of Despard should have pleased Philipstal, confirming his hunch that the fashionable fun-seekers of London would love her work. But just as she was getting into her stride he decided unilaterally that they should move north, to Edinburgh. How much petty jealousy played a part in his insistence in moving Marie on is unclear. He was a man who easily felt threatened. In January 1802, in an attempt to assert his superiority in the magic-lantern market, he registered a patent for his equipment. He was keen to distinguish his own entertainment as the original and best phantasmagoria in the midst of a crop of imitators. Emblazoned on his handbills were the words:

Under the Sanction of His Majesty's Royal Letters Patent
PHANTASMAGORIA
This and every evening till further notice
At the
Lyceum, Strand
As the advertisement of various exhibitions under the above Title, may possibly mislead the unsuspecting part of the public (and particularly strangers from the country) in their opinion of the Original Phantasmagoria, M de PHILIPSTHAL, the Inventor begs leave to state that they have no connexion whatever with his performances. The *utmost efforts* of Imitators have not been able to produce the Effect intended, and he is too grateful for the liberal encouragement he has received in the Metropolis, not to caution the Public against those spurious copies, which, failing of the perfection they assume, can only disgust and disappoint the spectators.

Magnanimous though this may sound, it was not only to protect the public from disappointment that he was registering a patent: he was

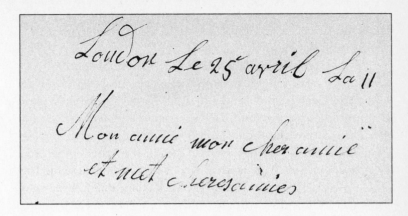

Writing home – 25 April 1803

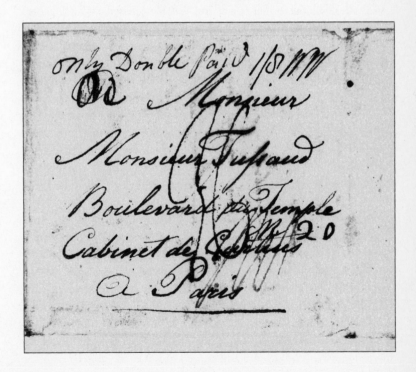

increasingly alarmed about the competition. A growing concern was that phantasmagoria fever was leading to phantasmagoria fatigue – another reason to head north.

The unforeseen disruption of the move from London may have been tinged with some relief for Marie once she heard about the imminent opening in the upper theatre of a Mr Frederick Winsor, a German showman-scientist. His 'act' comprised a demonstration of gas for the purposes of illumination. This form of light entertainment entailed not just gas-lit chandeliers in the upper theatre – or what he described as 'aeroperic branches' – but a dramatic illumination of the whole building. It was dazzlingly obvious to Marie that fiery bursts of flame and furnaces in proximity to her wax figures would be a perilous arrangement. So, while Winsor was installing his gas lighting, Marie was presumably happy to be packing up her crates in the lower theatre in readiness for her departure. What happened on Mr Winsor's opening night confirmed her worst fears. The auditorium quickly became a fug of noxious-smelling fumes which made the audience run – in some alarm – for the exits. 'It will be the last GAS-p,' mocked the press. But they would eat their words, for Mr Winsor withdrew to his workshop in Hyde Park and, with patience and evangelical commitment, eventually developed a system of metropolitan gas lighting that transformed the lives of Londoners. By the time Marie revisited London, in 1816, twenty-six miles of gas mains had been laid, and the novelty of gas lamps was such that people pursued the lamplighters on their rounds – more interested in looking at the lamps themselves than in seeing by them.

The date for Marie's departure for Scotland was set as 27 April 1803. In her final days in London, with the contents of her exhibition safely boxed, she seems to have had a pang of homesickness, judging from the contents of a letter to François dated 25 April. In this, the earliest of the surviving correspondence between them, she is writing to him at the Cabinet de Curtius, 20 Boulevard du Temple, from her lodgings at 2 Surrey Street. She tells him how receiving his letters gave her great pleasure, but also made her miss him – 'Nini [nickname for Joseph] and I cried with joy and sadness at not being able to embrace you' – and later in the same letter she promises that as soon as she has a new address in Edinburgh she will let him know it. 'I implore you

my love to reply to me at once as your letters are the only consolation in a place where I know no one. I will end by embracing you a thousand times.' Feelings of loneliness are exacerbated by being in transit, but also compounded by a lack of support from Philipstal. 'He treats me as you do, he has left me all alone. It is better so, as he is angry about everything.' There were evidently wrangles about the transport arrangements for the exhibition. Adding to Marie's burden, Philipstal was not going to be travelling with her: he had unfinished business in London and would come on later. Reiterating isolation, she says plaintively, 'I must travel all alone.'

Her letters are extremely rare opportunities to hear Marie's own voice. But they reveal more – notably that she was uneducated. The writing, with loopy lettering, is often illegible, and words wobble over the page in slopes not lines. The language seems to be almost a patois of French and German, and spelling and grammar are similarly inconsistent. Perhaps the reason she tends to write in effect a round robin – most of her letters open 'My friend, My dear friend, and My dear friends' – is because of the sheer difficulty that expressing herself on paper entailed. Another possibility, borne out by the way she lapses into third-person references to her aunt and mother even though she is supposedly addressing them directly, is that they could not read and she relied on François to read out to them her news. This would also account for the inclusion of more intimate expressions of affection to him that he could read to himself.

This correspondence is tantalizing for being one-sided: none of the letters from François survives. However, from her letters and legal documents, it is possible to deduce that back in Paris he was mired in financial difficulties. The day before Marie embarked for Edinburgh she visited Mr George Wright, a solicitor at 41 Duke Street, Manchester Square, to draw up legal documents assigning to François full power of attorney and authority 'to borrow what seems good on the best terms he can, all the money he requires and to compel his said wife to join with him completely in paying the capital interest laid down in any transaction'. With this document she was putting in jeopardy all that remained of her inheritance from Curtius. What induced her to such rash relegation of power to a man who she knew was an unreliable bungler is unclear. Presumably she was complying

with a request from him to assist in obtaining further loans – a compliance no doubt influenced by her young son, Francis, and her mother being in his care, and for their sakes she could not refuse him. With this significant piece of administration behind her, she left London, a city she would not return to for fourteen years.

As she made her way to the busy wharves to embark on a boat that would chart a slow course along the east coast of England, she was leaving a city that was straining with growth. London was the first British city with a million inhabitants. The river was the place to sense the expansion. It was a building site of warehouses, and an inadequate number of docks were congested with cranes and a forest of masts belonging to ships trading in every conceivable cargo and commodity. Mooring space was permanently short, and before they set sail some ships were so heavily laden that they lay low in the water and the passengers had to board them by descending ladders. Livestock were lowered with ropes, winched aboard in canvas cradles, and a strange sight was airborne horses, ungainly bundles with sprawling legs, swivel-eyed with panic as they were lowered on to the deck. But before Marie reached the warehouses and the tidal road that was the Thames there was the clatter and hubbub of wheels and hooves, with every jolt and lurch reminding her of the fragility of her exhibits. The streets of Georgian London were a constant turmoil of traffic – carts, chaises and coaches. Wheelwrights, saddlers and farriers and the smell of manure reinforced the impression of a city reliant on horsepower. Given that her original purpose was to remain abroad only long enough to generate sufficient funds to restore the financial health of the family business, she probably believed she was leaving London for good. She could not have the faintest inkling at this stage that this city, not Paris, would be her home.

The timing of her departure proved fortunate. In a popular contemporary cartoon, the illustrator Gilray satirized the precarious Peace of Amiens as an illusory phantasmagoria, and its flimsiness was finally proved when, just two weeks after Marie left London, after much diplomatic wrangling the treaty finally collapsed. On 17 May England declared war on France, resuming a conflict that would last for another twelve years. As a citizen of the enemy country, it could have been compromising for Marie to reside in London. New legislation imposed

travel restrictions on 'foreign aliens', and vilification of all things French was the principal theme of a vast propaganda offensive at this time.

As it was, after a queasy journey with collective *mal de mer*, by 10 May she was acclimatizing to Edinburgh, a city where there were plenty of compatriots. Well-connected émigrés who had fled France in fear of their lives had colonized this gracious city, the most illustrious of them being the youngest brother of the late King Louis XVI, the Comte d'Artois (later Charles X). But, while he weathered his exile in the grandeur of Holyrood Palace, Marie settled into the humbler surroundings of rented accommodation in the city centre. It appears that not heeding the famously sentimental advice penned by the Scottish bard Robbie Burns, 'Should Auld Acquaintance be forgot', Marie had forgotten her erstwhile court connections, or they had forgotten her, for her time in Edinburgh shows no fraternizing in émigré circles using her links with Versailles as an entrée. There is no hobnobbing at Holyrood, but rather a woman entirely committed to the hard graft of making her mark with a travelling show, and overly grateful for any encounter beyond the community of showpeople. There was, however, one old acquaintance in her midst who came through for her – Monsieur Charles.

A month before Marie arrived, Monsieur Charles was bestowing upon the people of Edinburgh the great privilege of an opportunity for an audience with the Invisible Girl. He whetted their appetite with elaborate hyperbole (or one might just say hype) in the *Edinburgh Evening Courant*. This was no ordinary entertainment, but 'The Only True Original and the Most Incomprehensible Experiment that has ever been witnessed in the World'. His ethereal leading lady was variously described as a 'Living aerostat' and a 'Mysterious incognita'. The extravagant claims are a match for the list of patrons. The people of Edinburgh, in extending their patronage, would be joining vertiginously elevated ranks of cultural cognoscenti, for Monsieur Charles assured the public of the presence of 'His Royal Highness the Prince of Wales, distinguished personages and philosophers in England and Scotland' at previous performances. Perhaps most extraordinary of all was that a world-class act with such a prestigious clientele should be available at so modest a location as 63 South Bridge Street. But such dichotomies and anomalies never seemed to deter the public.

Still rocking from the motion of the boat – 'with a bad head as though I was on board' – on 11 May Marie wrote home. She describes a rough voyage, with even seasoned sailors succumbing to seasickness, made worse by the necessity of keeping below deck because of the swell. There are rare glimpses of maternal feeling and pride at her small son's plucky behaviour on rough seas that earned him the nickname 'Little Bonaparte'. 'The boat rolled in the most terrifying manner and the captain who has made this voyage a hundred times said he had never seen anything like it. But Monsieur Nini was not afraid. He made friends with the captain and everyone else. In fact the captain wished he had a child like him.'

In the same letter we learn the extent of Monsieur Charles's friendship to Marie in adversity. The spat with Philipstal over transport costs had evidently escalated to such a pitch before her departure that she nearly abandoned their partnership. 'I threatened to return to Paris and when he saw I meant business he gave me £10. One has to be wary of Philipstal.' On arrival it transpired that his grudging handout had been insufficient to cover the travel expenses of £18. 'If I had not found Mr Charles we should have been obliged to lose all. Monsieur Charles has lent me £30.' He gallantly assured Marie that he would extend the run of his own show for as long as it took for her own exhibition to be safely installed. She discovered that the pitching of the boat had resulted in thirty-six breakages to her precious cargo, and the necessary repairs added a considerable pressure to the already onerous workload of settling in and setting up. She lost no time. In two days she had rented rooms suitable for the exhibition – 'a nice salon well furnished and decorated for £2 a month'. She intended to lodge on the same premises – Bernard Rooms, Thistle Street. The bonus of her landlady, Mrs Laurie, being able to speak French and the fact that she had found an interpreter fluent in German, French and English who could help with marketing – wording advertisements and copy for catalogues – and most importantly who could act as a guide, contribute to a buoyant tone. These new contacts and her growing friendship with Monsieur Charles alleviated the isolation that had tipped into loneliness in London.

As she familiarizes herself with her new surroundings, her impressions are favourable: 'a beautiful little city from which one can see

snow-covered mountains'. True to form, it is not long before she is surveying another summit – in the form of Edinburgh Castle, where she was soon in the lower foothills of the social mountaineering that gave her so much pleasure. 'I have discovered some compatriots at the castle and one lady-in-waiting has spent all her life in France. She is friendly and we spend a lot of time together.' She had also turned Little Bonaparte into Little Lord Fauntleroy: 'Monsieur Nini is dressed like a prince and spends all day at the castle playing with a little French boy.'

But there was not much time for relaxing. An advertisement in the *Edinburgh Evening Courant* on 7 May 1803 announced the forthcoming opening of the exhibition on Wednesday 18 May. The resumption of war gave topicality to the relevant French protagonists, advertised as 'Accurate models from life of Bonaparte First Consul of the French Republic, Madame Bonaparte, Cambacérès, le Brun, Moreau and Kleber plus numerous other distinguished characters of the French Revolution, accurately modelled from life by the Great Curtius of Paris'. The steep entrance fee of two shillings was an effective invisible cordon to keep out those who favoured the waxworks of the fair. Madame Tussaud aimed for a more exclusive ambience: she was determinedly not in the business of providing cheap thrills for hard-working labourers who paid for their pleasures in pennies.

The exhibition duly opened on 18 May, and on the 26th Marie wrote home. The earlier expressions of affection for her husband are now replaced by admonishment for not answering her letters. 'This is the hundredth letter I have written to you without reply. Why have you not written? Remember that I am your wife and that you are the father of my children.' Presumably the fact that the Channel was closed constituted extenuating circumstances, but to prevent him from using this as an excuse in the future she advises him from now on to direct letters to her via Hamburg. Her main news, however, is the resounding success of the opening. Takings had risen from £3 14s. on the first day to £13 6s. by the eighth – a sum that signified a healthy headcount of 133 visitors. She was clearly encouraged by the reception: 'Everyone is astonished by my figures, the equal of which no one has seen here.' However, Philipstal, who had only just arrived,

was piqued by her good reception, even though he was a beneficiary of it: 'Philipstal is worrying about my success, and wondering how to get more money out of me.' What the scribbled script here also conveys is the physical labour of running the exhibition: 'Sometimes we are too tired for supper.' The pleasures interspersing the daily grind are small, and involve no outlay of money, such as going to the countryside (her idiosyncratic style has *kambain* for *campagne*) on a Sunday afternoon to collect wild honey.

A few days later a rare non-collective letter to Paris, directed to a Madame Allemand, whose relationship to Marie is not clear, gives a further glowing progress report. The exhibition is permanently packed in both the morning and evening hours (11 until 4, 6 until 8). She confides her mounting concern about her contractual ties to Philipstal. 'I think I shall stay in Edinburgh for three months and if all goes well pay off Monsieur Philipstal . . . I have good friends, and if he thinks that I am afraid of him he is mistaken. According to our dreadful arrangement I alone have had to pay all expenses and buy materials out of my half of the receipts . . . I do hope to be finished with him.' In a characteristic flash of the social insecurity that made her prone to delusions of grandeur she adds, 'I am regarded as a great lady here and have everyone on my side.'

Her deteriorating faith in Philipstal and eagerness to escape from his financial clutches − what she terms 'his insupportable domination' − is the principal theme of her next long letter to her husband, dated 9 June. Interestingly, perhaps because François was exasperated by the illegibility of her own handwriting, she dictates this letter to the interpreter. In a further twist, this interpreter seems to have been an old hand in the entertainment business, and there is a reference in the letter to his having met Marie's husband when the latter was in London: 'You know him − he is the Swiss with whom you once went to the opera in London. He wishes to send you his best wishes.' This casual reference can be interpreted as further evidence that François may well have toured with Curtius's cabinet on its earlier visit to London and a number of other towns in 1795–6. If, as her earlier letter claimed, she had been left alone this would explain her resentment of her husband and shows the conflict between their livelihood and their relationship.

After two weeks the takings stood at an impressive £190. This raised Marie's hopes for the forthcoming horse fair in July, when she hoped the influx of country people would boost takings to an ambitious £20 a day. In a manner reminiscent of Curtius, she is clearly making an effort to network and to make friends in high places: 'I have had the good fortune to become acquainted with the governor of Edinburgh Castle.' But it is her lowly friend Monsieur Charles (also remembered to her husband in this letter) who is the stalwart of her daily life, and a source of reliable support. Their rapport is evident from the fact that he wanted to go into partnership with her once she had managed to extricate herself from Philipstal: 'Monsieur Charles has done very well here and he has suggested joining with me – but once I have got away from Philipstal, I don't want any more joint ventures.' The unequivocal message is 'Once bitten twice shy.'

This letter also provides a psychological sketch of the Tussauds' marriage, with several interesting insights. We learn that François had bid his wife to return to Paris. Her response is baffled indignation: 'I am not ready to return yet, and can't help being surprised that you suggest it before my business is cleared up, and when all the ports are closed.' She goes on, 'I will not return without a well-filled purse.' This reinforces the impression of a marriage of reversed roles, with the financial responsibility and reliability resting with Marie. François comes across as her dependant, reliant on her to be bailed out and funded as each of his half-hearted ventures comes to nothing. One can't help but speculate whether his desire for her to come back was motivated less by love than by money. Power of attorney meant he could whittle away at what was already there, but the goose was ultimately a more valuable asset than a finite number of golden eggs, and François probably knew that Marie's work ethic combined with her talent would be a good vehicle on which to travel through life, and a means of subsidizing his schemes. To date she had indulged him. Bucking all norms at the time, she was the main provider, and perhaps the combination of the eight-year age difference and his perception of her status as an heiress from the outset weighted the relationship unequally. This sense of vocational cross-dressing continues when she asks him if he has 'taken a turn at the cooking', and she entreats him to take care of her mother,

two aunts and little Francis. 'I do urge you to take my place at home – and work hard and change the exhibition as you like while I'm not there to argue with you.' There is no doubting who wore the trousers at the Boulevard du Temple.

The earliest surviving catalogue for Marie's version of the exhibition dates from this time. Entitled *Biographical Sketches of the Characters Composing the Cabinet of Composition Figures Executed by the Celebrated Curtius of Paris and his Successors*, it points to the pedagogic packaging of Marie's exhibition. The provision of a catalogue in itself elevates the tone of her enterprise, and shows her commitment from the outset to distinguishing her exhibition from those of her rivals by marketing its educational value. For example, when the gruesome spectacle of Marat in the agonies of death is accompanied by a brief account of his life, what would otherwise be a horror show turns into a history lesson. But it is accessible history – gossipy, opinionated and at times waspish. For example, Madame Du Barry is described as 'elevated by accident from a brothel to a partnership in the throne', and Joséphine is described as a woman of great abilities of mind and body. The core of the catalogue is the recent history of the Revolution, and there is nothing impartial about Marie's perspective. Napoleon is condemned for his despotism, 'for whether the ruler be called a monarch or a consul, it is of little consequence to the people, if their liberties must be sacrificed for his aggrandisement'. But of course Napoleon is also the main theme of current affairs, and she condemns his ambition to invade England and to 'overthrow . . . her people, their laws and their liberties'.

While Marie was basking in her success, Philipstal was baulking at it. It is evident from the pre-publicity for his show that in conjunction with the phantasmagoria he was also featuring mechanical automata on the bill. The *Edinburgh Evening Courant* gave a taste of these. Again appealing to public fascination with likenesses, there were a pair of life-size automatic figures 'as large as nature'. One was a small boy, the other a six-foot-tall Spanish rope dancer 'that seems almost endowed with human faculties, the power of respiration which the mechanism here demonstrates is incredible – he will smoke a pipe and mark the time of the music with a small whistle besides exhibiting the other feats of a rope dancer in exact imitation of life.'

But his first night was nothing short of disastrous. The automata worked satisfactorily, but they were the supporting act for his signature phantasmagoria, and here a succession of technical hitches resulted in a farce for the audience and a horror show of public derision for Philipstal. Not even an apology in the *Edinburgh Evening Courant* on 18 June, when he expressed regret that the apparatus 'was not completely in order and failed of producing the effect intended', could restore the public's confidence, and they stayed away. Another factor working against him was that the citizens of Edinburgh, far from being terrified by these Gothic slide shows, were tiring of them. In the past eighteen months there had been so many spooky exhibitions haunting the city it had been like a permanent Halloween. Philipstal had not taken into account the critical factor of novelty, and contrast between the lack of enthusiasm for his show and the critical acclaim of Marie's must have been galling. While the public continued to stream to her exhibition, his audiences dwindled. His Scottish hosts were in effect shooing him away, and on 23 July, under Philipstal's orders, both his and her exhibitions closed.

Rueing her decision to enter into partnership with him, Marie was desperate to extricate herself from the arrangement. Although her takings had been good (box-office receipts for the period 18 May to 23 July totalled £420), she realized to her dismay that she still could not afford to buy him out. Her expenses were £118, and from the remaining £302 she had to pay Philipstal £150 16s. Her expectations of bumper takings during the horse fair had not been met, and disappointing numbers had prompted her to halve the admission fee to one shilling, a rate that became the standard admission charge. She shared her predicament with François in a letter dated 28 July. With talk of lawyers and litigation, rows and recriminations with Philipstal, it is a portrait of a person feeling horribly trapped. As she says, she is a woman 'bowed down with anxiety and fear':

> I have been forced to accept his accounts as he placed them before me
> . . . He treats me like a slave. I have made all possible efforts to break
> the association. I have shown our agreement to different lawyers
> who concur that there is no chance of it being broken legally. The
> agreement is entirely in his favour. The only possible solution is to

separate and he will have none of it . . . He holds my nose to the grind-
stone seeking only to flout and ruin me so he can take all.

'Slave', 'grindstone' – the words are like the bars of Marie's prison. Yet,
down but not defeated, she rallied, and in October she opened the
exhibition in Glasgow. Unlike in Edinburgh, she lodged away from the
exhibition. Her new landlord was a pastrycook, in Wilson Street, and
she hired the New Assembly Hall, in Ingram Street, to display the
figures. With her usual aplomb, she orchestrated a carefully prepared
pre-publicity campaign, with handbills and notices in the local press,
and she took great care over set design and all the touches which put
her waxworks into a different league. This last point is shown by her
studiously avoiding the W-word: her advertisements refer to 'Accurate
models from life in Composition by the Great Curtius of Paris'. They
are tailed by the intriguing small-print announcement: 'Ladies and
gentlemen may have their portraits taken in the most perfect imitation
of life; Models are also produced from PERSONS DECEASED, with
the most correct appearance of animation.'

At the New Assembly Hall she had the luxury of much larger
premises than in Edinburgh and could arrange her figures in two
rooms, setting what would become her trademark style of dividing
gore and glitz. A letter home to Madame Allemand dated 10 October
points to precocious success at the box office. After barely two weeks
she had taken £40 – more than enough to cover expenses.

Philipstal is conspicuous by his absence. Like a pimp, he was happy
to exploit Marie's earnings; but, unlike a pimp, he didn't hover in the
background. Confident that the law upheld his position of power in
their 'partnership', and that Marie couldn't afford to pay him off, he
disappeared – refusing to let her know his whereabouts. They had no
contact with one another until December, when out of the blue he
summoned her to join him in Dublin. Still legally obligated to him by
the terms of the cursed contract, she had no option but to obey.

With a naval convoy flanking the packet that took her across to
Ireland – a powerful reminder of the state of war – she was eventu-
ally reunited with Philipstal in Dublin. He had opened his phantas-
magoria on 23 January at the Little Theatre, Capel Street. In early
February she took premises at the Shakespeare Gallery, near the

fashionable area of Grafton Street. Advertisements she placed during her season in Dublin show her capitalizing on the lure of likeness. 'Figures executed from life consisting of accurate models in wax, of the invention of the celebrated Curtius, than which nothing can be a closer resemblance of Nature – the Figures being elegantly dressed in their proper costume, are scarcely distinguishable from life.' The reference to wax is a very rare case of her mentioning the medium in publicity material.

Once again she enjoyed healthy returns, while Philipstal floundered. In May he was forced to concede defeat and put his magic-lantern apparatus up for sale, His advertisement suggested that 'any gentleman of a scientific and mechanical turn will find this an object worth his attention: either for gratification of private society or, in its present successful connection with the public, as a source of profit.' His short-fuse personality is even evident in his sale notice: 'No person applying either from idle curiosity or a view to making improper discoveries can possibly be attended to.' Covering his professional dignity with the pretext that important business in England was calling him away, he made his excuses and left.

Marie never heard from Philipstal again. During their overlapping months in Dublin in early 1804 she was finally able to pay him off, and buy her artistic freedom. She communicated this news to her family in early March. Letters from this period have a cool, formal inflection. They are studded with boasts about the daily crowds and public acclaim. Instead of the former endearments and sentimental affection, there is a new sense of confidence bordering on defiant self-reliance: 'My son and I are very well indeed. Have no doubts I shall do very well for the time and I hope to succeed seeing that I now work only for myself and my children.' She talks about working hard in order to give her children a good start in life. But most dramatically – perhaps emboldened by public approbation, long queues and ledgers record-ing day after day of good takings – she reveals that commitment to her professional path has eclipsed her personal ties to her husband and any joint ventures in Paris as her priority. 'The day I finished with M. Philipstal my enterprise became more important to me than returning to you.' Yet although she bid him a melodramatic adieu, in reality it was more *au revoir*, because this was not her last contact with François.

In his final weeks in Dublin, one of Philipstal's automata that he was exhibiting as a supporting act was called the Self-Defending Money Chest:

> The mechanism of this piece is ingeniously disposed so that it may with justice be termed the Miser's Life Guardsman – for upon a stranger attempting to force it open by a master key or otherwise, a battery of 4 small pieces of artillery concealed from even the nicest scrutiny will instantly appear and discharge themselves. The very superior excellence of this chest is that the proprietor has always a safeguard against depredations.

This exhibit is a good mechanical metaphor for Marie's newly hardened mercenary bent, and sense of self-protection. Her experience at the hands of Philipstal had been a harsh lesson about unscrupulous exploitation of her earning power, and that and the slow-drain dependency of her husband on her financial resources seem to have led to a hardening resolve to be autonomous.

One of her early letters from Edinburgh had highlighted her disadvantaged position in her partnership with Philipstal: 'His business is in a bad way, and he has only my Cabinet on which to rely.' Resentment had crystallized into outright animosity, and this seems also to have tainted her perception of her husband. By the time she reached Ireland she had discovered her own capability, and she realized she wanted to be accountable to no one, but to make enough money so that her children could count on her for their future security. This feeling was reinforced by the realization that, in François, her children were missing a reliable provider. She would take on this responsibility. Like the Self-Defending Money Chest, from here on she would fiercely protect her assets, and no one and no circumstances would sway her resolve or deplete her reserves.

In Ireland Marie's trail becomes obscured. There is a hiatus in correspondence, and the irregularity of her letters precludes precise calibration of her fluctuating feelings towards her husband. But the significance of the backdrop of war should not be underestimated. Post took far longer, putting even more strain on long-distance communication, and ports were closed. In this context, what appear to be inconsistencies in Marie's intentions expressed to her family in

sporadic bulletins make more sense. After what had sounded like a declaration of intent to secure her children's future financial position by remaining abroad and touring with the exhibition, a later letter from Dublin dated 27 June 1804 makes a non-specific reference to her return to Paris: 'When I return let there be no reproaches.' Her vagueness is not straightforward ambivalence: to a large degree the decision to return to Paris was out of her hands – she was stranded by the conflict. In the same letter Marie advises her husband of her new address in Dublin, and yet, while this suggests open lines of communication, this is the last letter she is known to have written to him.

The four years she was to spend in Ireland were an important watershed. This period (1804–8) sees her shedding all vestiges of victimhood, getting even with Philipstal, asserting her authority from afar with her husband, and asserting her own credibility as a commercial artist. Like someone whose life is changed by religion, in Ireland Marie's fervour is directed to self-sufficiency and independence, which from now on would be the tenets of her life.

Marie is a regular presence in the Dublin press for much of 1804, amid the advertisements for malt whiskey and horse hospitals, and patriotic notices such as that assuring the King that the Wicklow Sea Defensibles 'wish to express our great willingness to march at any moment to meet our enemies wherever they shall dare to invade our coast'. Any frustrations about being marooned by the war were tempered by her exhibition coming into its own in the context of the conflict. She had a great advantage with her core French theme, and now, with unprecedented interest in him, she could capitalize on her figure of Napoleon as never before. In an advertisement in the *Freeman's Journal* of May 1804 she announced, 'In order to gratify a very general curiosity at the present crisis, the Proprietor submits to the Public of these kingdoms a most correct portrait of the present despot of France BONAPARTE with those of his consular colleagues M. Cambecérès and Lebrun.'

The crisis to which she refers is fear of invasion, which peaked to paranoia in the pre-Trafalgar period. For the British public in England, Scotland and Ireland, Napoleon personified the enemy. The British people were not fighting France: they were fighting 'Boney'. Anti-Napoleon propaganda was pasted to tavern walls, pinned on

trees, left on pews in churches; there was a glut of broadsides and handbills, prints and caricatures. There were even mock posters styling the invasion as a production coming soon to the 'Theatre Royal of the United Kingdom'. Napoleon was a tyrant, a despot, a Corsican upstart, a megalomaniac monster hell bent on renaming London 'Bonapartopolis'. Most alarming of all, he was attacking the British people where it hurt them most, by threatening their national dish. It was claimed that under his rule beef would be banned in favour of roasted frogs. This was the ultimate punch in the stomach. While the fathers of Britain feared he would alter what they ate, children were threatened that unless they behaved he would eat them. A popular nursery rhyme at this time went:

> Baby, baby, he's a giant,
> Tall and black as Rouen steeple,
> And he dines and sups, rely on't,
> Every day on naughty people.

In the glut of imagery, Napoleon was morphed into every conceivable manifestation of menace, and in the torrent of print every imaginable character defect was conveyed, including accusations that he was a devilish incubus with his birth chart analysed in the light of the Book of Revelation. The might of this vast propaganda machine, like a juggernaut that rumbled for years, was directed to making Napoleon larger than life. Marie's trump was that in her cabinet he was utterly lifelike. The allure of this was at its highest in a cultural context where, so great was the longing for physical information about him, many cartoonists were reluctant to caricature his face.

Another selling point for Marie was that, while the mass-produced propaganda fed a diet of atrocities and sensational stories to the public, she satisfied curiosity within a more genteel format. If her own English was still not very fluent, no doubt she could get the interpreter to regale visitors with her reminiscences of how Joséphine, her former cellmate and friend, had asked her to make Napoleon's likeness, and how she had been summoned early in the morning to the Tuileries to undertake the task. They would then have heard about the straws put in the great man's nostrils as liquid plaster hardened on his features.

Such enthralling stories became a vital part of her self-propaganda. Like the liquid plaster that was the start of her modelling process, so it was with the truth, which she sculpted for her public in the touring years. From it a convincing story of her life was set that has lasted for years.

The country where Marie found herself in temporary exile was a febrile mix of factions and pockets of disaffection. Its status as Napoleon's potential back door to England and the residual tension following the controversial Act of Union meant there was a current of pro-French feeling pulsating beneath the surface. But these circumstances also meant that the country was overrun with troops, and it is from this vast audience of soldiers, garrisoned in towns all over Ireland, that Marie sought her custom in the years following her separation from Philipstal. In a climate of curfews and caution, and jittery landowners who habitually asked their servants to hand them their guns with their hats when they went out, she brought a welcome diversion, a relaxing and sociable entertainment that cast a new light on current affairs. Having once been a favourite sans-culottes entertainment, she was now bringing light relief to British troops billeted in towns the length and breadth of Ireland, proving herself very much her mentor's protégé in her capacity to adapt according to commercial opportunities.

Throughout 1805 the progress of the exhibition can be tracked in the dense small print of provincial newspapers – like *Finn's Leinster Journal* in Kilkenny, and the *New Cork Evening Post*. As she moves around the country, she introduces new attractions. At Kilkenny, for example, there is an intriguing addition: 'curious and eccentric models that are drawn by a Flea' – for the first time a flea circus, which is dangerously close to the folksy stuff of the fairground. For two years, 1806 and 1807, no documentation is available to support a clear picture of her travels, but she may well have been on a prolonged tour, for she reappears in Belfast in May 1808 and for the first time is advertising under her own name:

Madame Tussaud
Artist of the grand European
Cabinet of Figures
Modelled from life

Which has been exhibited with great applause in London and Dublin may now be seen at 92 High Street Belfast.

In almost five years to the day she had progressed from being seasick, homesick and helpless as a victim of Philipstal to commercial success in her own right. She had given birth to herself as a brand.

12

'Much Genteel Company'

MARIE'S DECISION IN the spring of 1808 to drop the Curtius connection and to trade under her own name had been born out of positive circumstances, chiefly a growing confidence in her own credibility as the proprietor of a popular entertainment. Local papers were fêting the 'celebrated artiste Madame Tussaud'. The rebranding was a symbolic separation from the past, signifying that she was no longer merely the protégé of the great Curtius of Paris, preserving his fame: she was making her own. But by the end of the year she had to endure a much crueller cutting off from the original exhibition, which was as painful to her as it was unplanned.

It transpired that, while the provincial newspapers of Ireland were singing her praises, back in Paris François was sinking her assets. He had been slipping deeper and deeper into debt and was falling behind with loan repayments. Eventually he had no recourse but to sign over the entire Salon de Cire to his principal creditor, Madame Reiss. In the legalese that makes a precision instrument of words, a document dated 18 September 1808 details the settlement: 'François Tussaud cedes to Mademoiselle Salome Reiss all the objects comprising the salon of figures known as the Cabinet of Curtius. These objects include all the wax figures, all the costumes, all of the moulds, all the mirrors, lustres and glass, which she may deem fitting. M. Tussaud hereby renounces any right in this regard.' These few short sentences would have long-term consequences. It is not an exaggeration to say that they reoriented Marie's life.

For a second time, while still savouring her hard-won freedom from contractual chains to Philipstal, she found herself a victim of legal process. It is hardly surprising that, as a white-haired grandmother, she cautioned her successors against the legal profession. Her

great-grandsons recalled her favourite axiom: 'Beware the three crows, the doctor, the lawyer and the priest.'

Precisely when Marie heard about her husband's financial crisis is hard to establish. But the disposal, presumably without consulting her, of what had been her core asset, and in its heyday a leading attraction in Paris, seems to have been a point of no return for her marriage. And the loss of the family home magnified the emotional cost of her husband's financial folly, for with the power of attorney that she had conferred on him he also downsized the household to the smaller rental property in the Rue des Fosses, which meant losing what had been a modest source of regular income. But almost outweighing emotional ramifications was the fact that his action deprived her of prime-location premises to which she could return to resume the family business. If this had been her original hope, then it was irredeemably dashed.

In one of her early letters home Marie had stated that the initial objective of her travels in England was to procure 'a well-filled purse'. This implies that she had intended to return to Paris to reinvigorate the business with fresh funds. Yet it is interesting that, while she sent François bulletins about her takings, she never sent him any cash. She regaled him with impressive figures, but there is no record of her ever having sent anything back home from the day she left to the day she died. Perhaps his action was in part retaliation for a perceived lack of trust in his ability to handle money and a dwindling sense of pulling together as partners. Given his track record, though, her actions seem sensible more than selfish. Her one lapse of judgement was in granting him power of attorney. But, whatever their individual culpability in this turn of events, there was never a reconciliation. Marie never returned to Paris; she saw neither her mother nor her husband again, and little Francis – the son she had left aged two – would be a man of twenty-two before they were reunited in England.

At the age of forty-seven, then, with Joseph (Nini) now a boy of ten by her side, Marie's quest for autonomy took on a different dimension. From 1808 onward she had new determination to secure the future of her sons, over and beyond her personal success. To this end she committed herself to the punishing lifestyle that was the lot of travelling showpeople. Although her fame peaked in the years when

she settled in London, her twenty-seven years on tour, visiting and revisiting Scottish cities and significant market towns and large cities throughout the length and breadth of England, established her as a regular fixture in the cultural landscape. The future format of the exhibition evolved during this time, when she assumed her part in the constant colourful cavalcade of entertainers who lurched and lumbered on bad Georgian roads, bringing welcome bursts of entertainment to communities lacking the amenities of London. Importantly, this period marks Marie's development as a doughty matriarch, and the emergence of 'Madame Tussaud and Sons' as a family business.

Her years on tour happened against a backdrop of social unrest. Popular discontent was exacerbated by the vanity and extravagance of the Prince Regent and his brothers, who inspired ridicule rather than respect. This played into the worst fears of those who felt the reverberations of the French Revolution were in danger of toppling the pedestal on which kingship was now perceived as being rather precariously placed. This insecurity resulted in a hard-line response to crowd control, of which the St Peter's Field incident in Manchester in 1819 was a notoriously dramatic example. Some fifty thousand people had assembled to hear a radical speaker airing views on workers' rights, and democracy. The sheer size of the crowd had alarmed the authorities, and troops were sent in. Their heavy-handed approach resulted in several fatalities and many more horrific injuries. A local paper called the debacle 'The Peterloo Massacre', a term which spread into wider circulation, and the name has stuck.

The crowd that might become a mob was a source of almost paranoid anxiety for many at this time, and even spontaneous gatherings fuelled anxieties. The small news stories of everyday life illustrate these fears, for example when a rumour that a house was haunted drew a fascinated crowd of would-be Georgian ghost-busters special constables were deployed to break it up, an event reported as 'A great number of people assemble about a ghost.' Caution prevailed, and that trouble was expected was evident in the standard announcement whenever a fair or public gathering had taken place without incident of 'Perfect order was maintained' – like a sigh of relief. The British Museum, like many other institutions, took no chances: from 1780,

when the Gordon rioters went on the rampage in Bloomsbury and razed Lord Mansfield's house to the ground, until as late as 1863 there was a military presence at the gates.

Fear of the crowd was especially evident in attitudes to traditional entertainments, and a killjoy movement to suppress fairs, spearheaded by the Society for the Suppression of Vice, started to gather momentum. (In an article in the *Edinburgh Review* Sydney Smith, a friend of Charles Dickens, suggested that this society would be more aptly called the Society for Suppressing Vices of Those Whose Incomes Don't Exceed £500.) The perceived danger was that the unbridled fun of workers en masse might erupt into civil disorder. The form that people's pleasures should take was further complicated by the radical change in how people lived. The quickening pace of industrialization, concentrating vast numbers of workers in cities, also undermined the customary rural entertainments.

Imperceptibly, a great grey smog of earnestness starts billowing through these decades, turning entertainment more and more into an educational experience, engulfing the free spirit and pure fun of the traditional fairground pleasures. Creeping legislation, policing and finally calls for the suppression of fairs altogether signified a middle-class crusade. The battle cry was 'rational recreation', and those championing this cause became more numerous and more vociferous throughout the first half of the nineteenth century.

Marie's own version of 'utility and amusement' was in perfect sync with the growing middle-class concern that pleasure should have a purpose beyond its own reward. She built her fortune on this belief as, in the Victorian era, it gradually developed from a preoccupation into an obsession. Rather as Curtius had been in the right place at the right time in pre-Revolutionary Paris, Marie shaped her own business in accordance with the gentrification of pleasure that was happening in Georgian and Regency England. With her carefully targeted marketing, there was no danger that her visitors would encounter anyone other than people like themselves. Her assurance of segregation and protection from the rowdy mob endeared her to the middle-class market that she was aiming at.

The England she toured was the land that William Cobbett, an acerbic commentator and critic of the existing social order, portrayed

in *Rural Rides*: a place where corruption in politics was rife and reform deeply contentious. The oligarchic ethos was such that even public interest in the political process was regarded with suspicion, let alone the idea that ordinary people had the right to a participatory role. Of an adult population in England and Wales of around 7 million, fewer than 450,000 could vote. The inequality of the electoral system was taken up by writers. Whereas Cobbett used the *Political Register* to vent his spleen, Thomas Love Peacock used satire. His novel *Melincourt* described two types of borough: the city of No-Vote, a manufacturing town of over fifty thousand with no parliamentary representative, and the tiny community of One-Vote, 'a solitary farm, of which the land was so poor and untractable, that it would not have been worth the while of any human being to cultivate it, had not the Duke of Rottenburgh found it very well worth his to pay his tenant for living there, to keep the honourable borough in existence'.

The reform issue sharpened political debate, and as and when the key opponents and supporters were in the spotlight they took up their places in Marie's exhibition. For the second time in her life, the figures were indirectly contributing to debates about democracy. Her model of Cobbett had the rare distinction of a moving head, and the biographical description that went with the nodding figure summarized his self-made success: 'Born of humble parents and by his own unaided genius raised himself to the highest station as a political character'. One feels that Marie would approve of that.

Her early years on the road were comparatively tranquil, yet physically testing. Her travels around Georgian England spanned the heyday of stagecoaches, inns and milestones, but the reality of transport at this time was markedly different from the nostalgic idyll which, with the addition of snow, has inspired endless Christmas cards and place mats. Most roads were slow and badly maintained. Turnpikes regulated only a small percentage of the total mileage, and mismanagement of cross-country roads was a constant gripe of the public. The improvements on major roads introduced by John McAdam from around 1816 were a catalyst for more efficient stagecoach services, but even these were uncomfortable and expensive, and the fact that rival companies took to dangerous racing on certain routes also made them hazardous. Marie and Joseph had to endure long cold journeys in

winter, and dusty ones in summer. They sped ahead to be in time to take delivery of the figures, which were transported under canvas tarpaulins on sturdy freight wagons by the private carrier companies, who charged by weight, and transported such diverse cargo as flour, tallow, blacking and bones, and even the occasional painting dispatched by John Constable. Given the demands of nomadic existence and the rigours of setting up and publicizing the exhibition and producing new figures, as well as maintaining the existing ones, often damaged in transit, Marie's sheer stamina seems to have been the underpinning of her success.

Notwithstanding the increased number of stagecoach services between London and major cities in the first thirty years of the nineteenth century, England before the steam age was a country characterized by communities more cut off from each other than connected. Journeys between the principal cities took days, when in the railway era they would take hours. The mail coach speeding through a town was often the main source of news from London. For most of the population, the capital felt as faraway and unfamiliar as a foreign city, existing in their minds as somewhere as exotic as it was remote.

For most people in the provinces news was old, unreliable and in short supply, and in this context Marie's topical exhibition was a welcome arrival. To understand quite how prized news was, one only has to consider the circulation of newspapers. There were no daily newspapers published outside London until as late as 1855. The trade in second-hand newspapers was brisk, and many in the provinces paid to have old copies of the London papers sent to them. Subscription clubs were another resource for newshounds, and families would club together and share readership. These clubs ranged from ad-hoc affairs to more formal arrangements with proper reading rooms where subscribers could go to get their news fix for a guinea or so a year. W. H. Smith has its origins as a subscription club in the Strand. This thirst for the topical was a boon for Marie. Her colourful cast of people making the news was an immensely popular visual supplement to eyesight-challenging black print in a newspaper. It was also an enjoyable first-hand experience, as opposed to reading a newspaper that was not second-hand but more commonly twelfth-hand by the time it got to you.

The physical and cultural isolation in the provinces created a market for all manner of travelling shows. Their seemingly inexhaustible supply of wonders was a welcome respite from humdrum everyday life, and for a few days or weeks they brought colour and vibrancy, spectacle and novelty to communities starved of the types of entertainment that were in such rich supply in the capital. Londoners might relish the jewel in the crown of commercial entertainment that was William Bullock's Egyptian Hall in Piccadilly, but there was nothing comparable to this Georgian equivalent of a multiplex outside the capital. Small market towns with limited facilities were reliant on the more rudimentary and less varied diversions that passed through, setting up in the marketplace. A doctor in a small town in Essex gives a flavour of what came round: 'An exhibition on our right of a Giant, a Giantess, an Alibiness [sic], a native of Baffin's Bay and a Dwarf very respectable. We had a Learned Pig and Punch on our left and in front some theatrical exhibition. All in very good order.' There was clearly scope for enterprising showmen to supply more sophisticated entertainments. By prioritizing towns, Marie and the other commercial entertainers exploited the gradual shift of focus away from the rural communities, which had been the hub of the great fairs, to a growing urban audience with money to spend and time to spare.

Her travelling years coincided with those of some other famous itinerant showmen, some of whom also built lasting family fortunes. Astley's circus continued to draw huge crowds wherever it went. Of heart-throb status was the stunt rider Andrew Ducrow, who quickened female pulses with his somewhat racy flesh-coloured bodysuit. His fans paid tribute not just with flowers, but also by presenting him with whips, silver spurs and other equestrian tokens of their esteem. Another big name on the same circuit at the same time as Marie was the clown Grimaldi. A large part of his appeal was the way he chronicled the news of the day in a comic format. One of the most successful of her contemporary fellow commercial entertainments was George Wombwell's menagerie. Just as one facet of Marie's appeal was the way she popularized history by proving herself a judicious curator of relics and characters, George Wombwell's menagerie enthralled by making natural history accessible. He boasted that his collection had as great a variety as Noah's ark, and like Marie he maintained a punishing

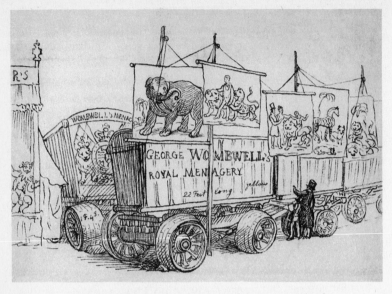

Wombwell's Menagerie, drawing by George Scharf

touring schedule, often overlapping with her – for example in Bath and Bristol. Records for his returns at Bartholomew Fair show just how popular his menagerie was. In just three days his takings were £1,800, which at sixpence a time means an impressive headcount. Wombwell had the showman's knack of turning adversity into opportunity, and when his elephant died, prompting a rival circus to puff their elephant as 'The Only Living Elephant in England', his immediate response was to print posters offering the public the chance to see 'The Only Dead Elephant in England'.

It was not only men who made money in show business. Another contemporary of Marie's was Sarah Beffen. She was similarly famous in her own lifetime, and similarly immortalized in the works of Charles Dickens – and in three novels (*Nicholas Nickleby*, *The Old Curiosity Shop* and *Little Dorrit*) compared to Marie's sole mention in *The Old Curiosity Shop*. She was born without arms and legs, yet her dexterity as a miniaturist, a skill she perfected using her mouth and shoulder to control the paintbrush, won her such critical acclaim that she was for many years one of the biggest names on the fairs circuit.

She even won royal recognition, and was granted a pension by George IV, who, mixing bad taste with bon mots, commented, 'We cannot reward this lady for her handy-work, I will not give her alms, but I request she is paid for her industry.'

However, for the very few names who rose to national fame on this circuit, there were vast legions of entertainers who sank without trace. These peripheral people endured lives of real hardship living hand to mouth as they went from one town to the next, following the calendar of fairs, markets and race meetings. They constitute a shadowy underclass. A large number of them were open-air entertainers who moved among the crowds. Not enough pennies in the hat meant sleeping under the stars or in vermin-ridden lodgings where the calibre of patrons was such that the proprietors deemed it prudent to chain cutlery to the dining table. Of this number were the puppeteers, among whom Punch and Judy men were very well represented, the stilt-walkers and the knife-swallowers. There were even people with the skill to regurgitate live rats, who presumably took a crumb of comfort from the fact that if their acts went wrong, they could always restock rodents from their digs.

Marie knew that at any one time she had only the favour of the public between her and a swift descent to the destitution and oblivion that befell so many showpeople. She had no troupe or company to help to dilute disappointments, to give advice and to provide companionship: for many years it was just her and Joseph. But she had ambition, and this, iron will and artistic talent were her assets. She honed various survival strategies on tour, and flexibility about how long she stayed at any one place was key. Her pre-publicity wherever she opened was always carefully orchestrated, but she never committed herself to a set length of time for any specific visit. How long she stayed was always open-ended, and her publicity materials show how she often drummed up numbers by dramatically announcing imminent departure, only to defer it as required. In this way she kept her public hungry for her, and was never humiliated by their dwindling interest. It was a technique that served her well.

As far as we can establish from an early and battered ledger with columns of largely indecipherable entries, she managed to maintain a lifestyle of modest comfort. Her early letters hinted at respectable

lodgings and these seem to have set a level that she maintained. Her assiduous record-keeping, with every penny of outgoings listed alongside takings, suggests that expenditure on presentation was a priority, as one would expect. Outlay on candles was considerable, to create the requisite ambience. Attention to the details of costumes and jewellery was always a source of personal pride, and the ledger hints at this too. She never compromised her high standards, and the wear and tear of touring did not prevent her from exhibiting immaculate figures in freshly laundered outfits – 'washerwoman' and 'soap' are frequently listed in her costs. As for her own dress, austerity and sober respectability disposed her to a matronly style: there were no personal fripperies. A pint of porter, a pinch of snuff, the odd lottery ticket and theatre outing for sure – but in the main the evidence is of exemplary dedication to the exhibition, and her accounts are a record of frugality and practicality.

Along the way there were music lessons and a smart set of clothes for Joseph, for, much as her own childhood had been an apprenticeship for showmanship, so it was with her son. For a time Marie placed his wax likeness at the door, and encouraged visitors to compare the model to the young man in person. With fluent English (as reported home in early letters) and an engaging personality (again mentioned in letters), he was a good guide and assistant. A peripatetic life meant he had had limited opportunities for a proper schoolroom routine, but, given that they stayed in some places for months at a time, he may have dipped in to the 'hedge' schools – the informal, ad-hoc assemblies of juveniles co-ordinated in local communities by philanthropic clergy. We know he learned English very quickly, so he seems to have been a bright little boy, and most probably he was more literate than his mother. By 1814, when they were in Bath, he was even accorded the honour of being introduced as 'J. Tussaud Proprietor' in their publicity, as if at the age of sixteen this was a rite of passage in the life of a budding showman, although his mother, as 'Madame Tussaud, Artist', still topped the bill in bigger letters. As he grew up he became more active on the artistic side – the music and staging – and in 1815 he was put in charge of making silhouette portraits of the public, which at one shilling and sixpence proved to be a lucrative and popular sideline.

Whatever their individual specialities, and the differences in the size of their shows, the itinerant showfolk specialized in hyperbole, hoax and spectacle. The picture of the bloody-jowled wild beast on the outside of the van often bore no relation to the superannuated mangy creature within. The 'Black Giantesses' announced on posters were often impostors on platform heels with cork-blackened faces; the 'Pig-faced Ladies' were dogs or bears with shaved faces, draped in poke bonnets and voluminous clothes to complete the disguise. Some acts left spectators completely flummoxed, such as the feats of Chabert, the Fire King, whose seemingly fireproof constitution made him a household name. His star turn took the celebrity chef concept to a whole new level when he made himself the chief ingredient of his recipe for entertainment. In front of packed audiences, he entered a hot oven in which slabs of steak and mutton were simultaneously cooking. The oven had an aperture through which he conversed with the audience, and at the end, to prove the heat that he had endured, he shared the meat – cooked to perfection. *The Times* laconically noted that the joints were devoured with such avidity by the spectators that 'had Monsieur Chabert himself been sufficiently baked, they would have proceeded to a Caribbean banquet'.

Whether on a formal stage or in an informal caravan or booth, the exoticism and escapism on offer elicited a wide range of emotions. There were gasps of wonder, disgust and delight, and occasionally disappointment – as memorably recorded by one of the spectators of the Living Skeleton. As well known in his day as Chabert, the Living Skeleton did not live up to his reputation as far as Prince Pückler-Muskau was concerned: 'The Living Skeleton was a very ordinary sized man, not much thinner than I. As an excuse for our disappointment, we were assured that when he arrived from France he was a skeleton, but that since he had eaten good English beefsteaks it had been impossible to curb his tendency to corpulence.'

Gradually the rich array of variety acts that had been the back-cloth to Marie's early years on tour started to be overlaid by educational entertainments, as spectacle alone started to be regarded as too frivolous. As audiences became more discriminating, some of Marie's touring companions could not count on the full houses they had once enjoyed – the man who played his chin could not

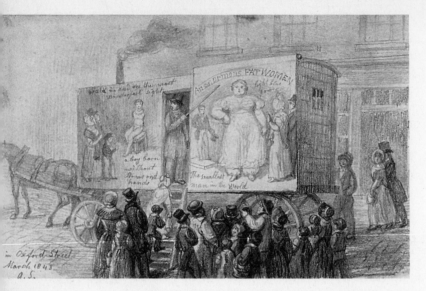

Freakshow caravan, drawing by George Scharf

really compete with the mechanical genius of Mr Haddock's Androides. 'Philosophical experiments, rational, fashionable and entertaining selections', as one showman described his more cerebral programme. Such learned fare started to eclipse the interest in Siamese twins and learned geese. The days of The Wonderful American Hen were numbered, but, with three wings and four legs, at least the bird billed in her heyday as 'The Greatest Living Curiosity in the World' could make a comeback as the star turn on a dining table. For some fifteen years Signor Capelli's Learned Cats had enchanted audiences by imitating human actions – roasting coffee, grinding knives and turning a spit – but now they were damned as being more 'industrious than intellectual'. By the time Marie stops touring there are almost signs of freak fatigue, in favour of educational content. She exemplifies the transition from the traditional innocent fun of the fair to a more elevated style of recreation centred on the town, not the country, and tapping into the new sensibility of aspiration.

Although she followed the circuit established by the fairs, many of which kept to a seasonal calendar and were often linked to race meetings, livestock auctions or specialized markets, she kept herself well apart from the open-air temporary set-up of the booth and tent. She hired premises attached to public houses, hotels, and theatres, and where they were available she customized many of the comparatively new assembly rooms, which from the late eighteenth century were an innovative civic amenity in provincial towns. Some assembly rooms had separate function rooms, and sometimes Marie was able to maintain her exhibition in one part of the rooms while the ball season was ongoing. On one occasion, in York, she turned this shared-premises arrangement into a public-relations opportunity. When the distinguished guests attending the ball stopped their quadrilles and waltzes to retire for tea, Joseph drew back the canvas screen concealing the space dedicated to their exhibition, and before resuming dancing the guests were able to enjoy the interlude by inspecting the figures. The proceeds of their private view were donated to the Fund for Distressed Manufacturers – a charitable act which was reported in the press, thereby generating a very favourable impression of Madame Tussaud as a woman with a social conscience, an impression that one conjectures was part of her calculated publicity campaign, in which everything she did worked towards creating a very particular impression of herself in the public eye.

Of all the premises where she exhibited, assembly rooms were the perfect milieu for Madame Tussaud. They were a bricks and mortar, or rather gilded-cornice and chandelier-bedecked, manifestation of her ethos. They were the parade grounds of polite society, a forum for elegant recreation. Their value as a venue for social mixing, a place to see and be seen, was captured by Jane Austen. When Mr Darcy makes his entrance in the assembly room at Meryton, the room crackles with 'the report which was in general circulation within five minutes after his entrance, of his having ten thousand a year'. Designed in part for balls, they were equipped to accommodate orchestras, and a high standard of lighting was also a feature. The overarching aim was to create a congenial environment in which to display the dash and dazzle of provincial society at play. These amenities lent themselves particularly well to Marie's personal style of promenade, which she developed in

the 1820s, making music a crucial component of the experience. She cultivated an environment where people-watching was a legitimate part of the pleasure. After a pleasant perambulation around her wax figures, visitors could avail themselves of strategically placed ottomans and chairs and appraise those still inspecting the exhibits. Just as the study of human nature informs her fiction, in life Jane Austen was a compulsive people-watcher, and she testifies to the attraction of exhibitions as a social experience, confessing, 'My preference for men and women always inclines me to pay more attention to the company than the sight.'

From a faded and fragmented paper trail of handbills, exhibition ephemera and provincial newspapers, an impression of Marie's progress can be assembled. Her itinerary encompasses the fashionable resorts of Cheltenham, Bath and Brighton – cities whose fortunes were founded on the leisure industry – and significant trading ports such as Bristol, Portsmouth and Yarmouth. It covers the burgeoning manufacturing conurbations like Birmingham, and the industrial engines of urban growth that were Liverpool and Manchester. Outside London, Manchester was the city to which she returned most often, visiting it six times between 1812 and 1829. But her success was not confined to the smoke-choked industrial north. In Oxford in 1832, as she moved ever closer to London, her exhibition was 'visited by thousands' and, as if describing works at the Villa Borghese rather than wax mannequins, *Jackson's Oxford Journal* enthused about her stylish presentation and the overall impact of her skilful design that combined 'beautiful freshness of painting, bold relief of statuary and the actual effect of dress and ornament united'.

The elements common to the different-sized communities that Marie visited were an affluent middle class and the presence of a local press through which she could communicate with her target audience. Marie was clear about her audience, and it is evident from her publicity that it was the queen bees, not the worker bees, she wanted to attract. 'No improper persons will be admitted' was her cautionary warning in the *Bristol Mercury* in the summer of 1823. Her preferred clientele was that which she evidently attracted in Chelmsford in 1825, when, reviewing her newly opened exhibition there, the local paper reported the attendance of 'much genteel company'.

LAST WEEK BUT ONE

Exhibition and Promenade,

NOW OPEN WITH GENERAL APPROBATION,

In the Assembly Room, Green Row, Portsmouth.

MADAME TUSSAUD and SONS return their thanks for the support their Exhibition has met with, and they respectfully announce, that it must FINALLY CLOSE IN A FEW DAYS; at the same time considering that a large class of persons are unavoidably excluded from viewing the Collection, in consequence of the pressure of the times, they have made arrangements to admit

THE WORKING CLASS

During the time the Exhibition remains

For Half Price,

From a QUARTER BEFORE NINE TILL TEN in the Evening; by this arrangement, sufficient time will be given for both classes to view the Collection without interfering with each other, and they hope that none but those so situated, will take advantage of it, as, if known, they will be refused.

٭٭٭ *Admittance 1s.; Children under Eight 6d.; Half price for the Working Class at a Quarter before Nine; no Half-price for Children.*

MADAME TUSSAUD AND SONS

Portsmouth, 1830

'Madame Tussaud respectfully acquaints the gentry' became the standard opening in her publicity notices that announced the arrival of her exhibition. A notice in Newcastle-upon-Tyne in June 1811 went one rung higher up the social ladder: 'Madame Tussaud Artist respectfully informs the nobility and gentry of Newcastle and its vicinity that the Grand Cabinet of Sixty Figures, which was lately exhibited in Edinburgh with universal approbation, is now open for inspection at the White Hart Inn, Old Flesh Market.' She showed almost no interest in wooing the working class. One notable exception is evident on a poster that she had pasted around Portsmouth towards the end of her touring years in 1830:

> Considering that a large class of persons are unavoidably excluded from viewing the Collection, in consequence of the pressure of the time, Madame Tussaud and Sons have made arrangements to admit THE WORKING CLASS during the time the exhibition remains for half price, from a quarter before nine till ten in the evening. By this arrangement sufficient time will be given for both classes to view the collection without interfering with each other, and they hope that

none but those so situated will take advantage of it, as if known, they will be refused.

This rare notice hints at a norm of social segregation that is incomprehensible today when mass-market interest is the focus of popular culture. It also betrays a certain cynicism on Marie's part in thinking that the 'gentry', so dear to her, would be inclined to pass themselves off as workers and cheat their way into her exhibition like cheapskates. For the workers, even the reduced rate of sixpence was still prohibitive in the context of the standard penny charges at fairs for everything from topical peep shows that were a prized form of news for the illiterate to the unconvincing waxworks that were a staple of the 'raree-show' scene.

In the small print of local papers, the growth of the exhibition can also be monitored. The core collection of around thirty figures with which she arrived in 1802 had already doubled by 1805, when the *Waterford Mirror* commended her 'sixty capital figures' and 'several uncommon objects' to 'all admirers of real genius and talent'. In 1815, when she was weaving her way around the coast of Cornwall, the *Taunton Courier* and the *Western Advertiser* were advertising her 'unrivalled collection of figures as large as life', comprising '83 public characters lately exhibited in Paris, London, Dublin and Edinburgh' and now – something of a comedown – at 'Mr Knight's Lower Rooms, North Street, Taunton'. By the spring of 1819 the *Norwich Mercury* was alerting the public to their chance to see 'Ninety Public Characters' at the Large Room in the Angel Inn. In the winter of the same year the *Derby Mercury* referred to 'one hundred figures of personages of different periods and nations, illustrious for their rank, talents or virtues; remarkable for their personal appearance, misfortunes or sufferings, or of notorious celebrity for their crimes and vices'.

As the wax figures multiplied, an impressive growth spurt was also evident in the number of illustrious patrons. Whereas before she announced her own exhibition, now on her publicity material there was a fanfare of royal connections preceding her arrival. In Taunton, in 1815, her handbills boast the patronage of 'their Royal Highnesses the Duke and Duchess of York and Monsieur Comte D'Artois'. In

January 1819 she trumpets the arrival of her collection in Norwich by highlighting the patronage it has received from 'his most Christian majesty Louis XVIII, the late Royal Family of France, their Royal Highnesses the Duke and Duchess of York and Her Grace the Duchess of Wellington'. By the spring of 1826, when she opens in the assembly room in Lincoln, she is styling herself as Madame Tussaud, Artist, niece to the celebrated Curtius of Paris, and artiste to her late Royal Highness Madame Elizabeth. (The degree to which she capitalized on her early life in France is evident in a poster from 1816 in which she announces herself as 'Madame Tussaud, lately arrived from the Continent', even though, having been in the country for thirteen years, she was hardly packet-ship fresh.) By giving herself an air of social superiority, she adds another dimension of interest to her collection that helps to distinguish her from rival touring waxworks. In fact later on there is legitimacy to her claims of distinguished patrons, but on tour the alleged noble connections and associations that feature in her publicity are all part of the licence with the truth that is the showman's prerogative.

Following the same wheel ruts as Marie's wagons were numerous entertainments whose proprietors similarly puffed up the credentials of their exhibits. The proud presenter of the Scientific Java Sparrows challenged all prejudices about the brain power of birds:

> Having finished their education at the University of Oxford, where they met with the greatest approbation from the Vice-Chancellor, the Collegians, and the Mayor and Inhabitants of that learned city, the birds now presented to the particular notice of the nobility and public have required no less than three years to complete their education. They are now perfect in the following seven languages: Chinese, English, French, German, Italian, Russian and Spanish.

Often it was the singularity of the size of an animal or human that was the bait to customers. Aged fifteen and allegedly 'eight feet around', Miss Holmes, a native of Prescot, Lancashire, was billed as 'the most extraordinary phenomenon of nature, a Gigantic Fat Girl'. Working people and servants could see her for threepence, tradespeople sixpence, and ladies and gentlemen a shilling. Double bills highlighting contrast were also popular. The Devonshire Giant Ox and Tom

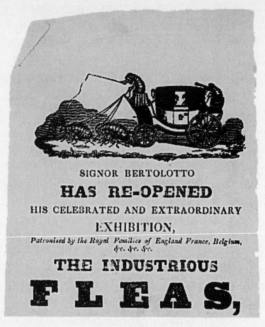

SIGNOR BERTOLOTTO

HAS RE-OPENED

HIS CELEBRATED AND EXTRAORDINARY

EXHIBITION,

*Patronised by the Royal Families of England France, Belgium,
&c. &c. &c.*

THE INDUSTRIOUS

FLEAS,

Flea Mail – Signor Bertolotto's Flea-drawn Mail Coach

Thumb's Fairy Cow were a popular pair, and Miss Hales the Norfolk Giantess went down well alongside the 'smallest person in creation'. Of course, lest punters feel discomfort in gawping at their fellow creatures, a growing trend was to couch voyeurism in terms of educational value. In the case of Miss Hales, her proprietor resorted to verse:

Exhibitions like this may to us be of use –
What a contrast of creatures this world can produce!
From such wonders eccentric presented to view
We now may our study of Nature pursue.

The smallest performers on the circuit were the those in the flea circuses, whose popularity moved one reviewer to poetry:

No more from our blankets with hop, step and jump
With bloodthirsty purpose you dart on our . . .
With other performances now you delight us,
And prove you can do summat better than bite us.

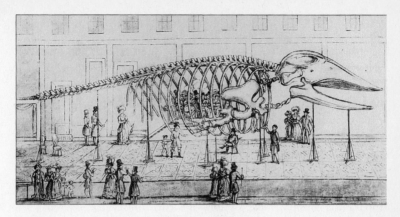

The Whale Lounge

These tiny stars were one of the oldest traditional attractions. Flea-circus purists made a distinction between flea performers that were actually wired together in intricate metal harnesses and those that were an optical illusion.

It is unclear which of these categories Marie's flea circus fell into, but, before her upward mobility meant such frivolities were anathema to her, her fleas had had their fans. The *Worcester Herald* had enjoyed seeing the French imperial coach 'pulled by one of those sable-coloured blanket harlequins commonly called fleas'. But her troupe was outclassed by a rival's rendition of 'Flea Mail – an accurate representation of England's Pride, her dashing Mail featuring a Flea Coachman who handles his whip in the most approved style and a flea-guard who flourishes his horn.'

At the other end of the scale was an immensely popular touring show that gave a novel literalness to the concept of a whale of a time. The skeleton of a giant whale was the basis of a hands-on entertainment which packed in people of all ages. It was arranged in such a way as to form a series of carriages, which created an extensive gallery 'through which hundreds can pass beneath the massive vertebrae and between the giant ribs of this once mighty inhabitant of the Northern deep'. In Liverpool a party of junior Jonahs entered the whale. The local paper marvelled at how many of them could be fitted into the mouth cavity alone – 'the capacious maw . . . could fit in with ease

one hundred and fifty-two human beings in the shape of tender juveniles of the infant school standing within its mouth at one time.'

This was the richly textured world of popular entertainment that Marie inhabited, and the passing of which Dickens mourned in *The Old Curiosity Shop*. In the time that Marie toured, she was witnessing the twilight years of the traditional travelling shows, and she herself was germinating the new style of recreation for a different generation. The longer she toured, the more her exhibition grew in size and scope, attracting bigger crowds. Her return visits with new material were an important facet of her marketing initiative, which was designed to cement her reputation as a reliable purveyor of educational entertainment, like a public-information service, on what was an increasingly competitive circuit. Impressive attendance figures start to appear in her publicity. For example, in advance of her arrival in Liverpool in the spring of 1821 she states in her publicity that 30,020 people have just visited her in Manchester. In the *Bristol Mercury* of 18 August 1823 the numbers are even more impressive: 'Her celebrated collection of figures [was] lately viewed in Manchester, Liverpool and Birmingham by upwards of 100,000 people.' In January 1826, her advance publicity before opening in Bury St Edmunds alludes to earlier success on tour by stating that in the cities of Oxford and Cambridge alone 18,000 people had visited her collection.

As she expanded the exhibition, the drawbacks of life on the move started to become more apparent, specifically the need for space. It became difficult both to transport the figures and props from place to place and to locate premises of the right size to set them up for maximum effect. While the assembly rooms tended to be ideally proportioned for the purposes of creating a theatrical backdrop, with still enough space between the figures to permit the public to walk around, not every town she visited had one, and in those that did it was not always free for her to hire. This meant that sometimes she had to make do with constricted accommodation that cramped her style. During her visit to Norwich in February 1819 the local paper opined that the figures would have benefited greatly from being displayed in larger premises, then commenting:

On women, kings, generals and statesmen you stumble,
And of characters here meet a very strange jumble.

In Liverpool, in 1821, another facet of the space problem was taken up by the press. Transport charges for the network of carrier services that criss-crossed the country were generally based on bulk and weight. There was therefore an incentive to try to keep the figures as compact as possible. But while reducing dimensions was an effective strategy for transport purposes, it was detrimental to display. An article in *The Kaleidoscope*, a local periodical, criticized the way that, in order to fit more figures into the exhibition, Madame Tussaud had scaled down the bodies, resulting in an 'anatomical want of proportion'. This lessened the impact of the finely executed heads, and obviously affected the overall illusion of lifelikeness. This charge of 'deficiency of appropriate attitude' was obviously taken to heart by Marie, and by the end of the year, on a return visit, the local press remarked on the improvement, noting 'the major part of figures are now as correct in expression and formation of limbs and attitudes as they are in the faces.' Her commitment to improving her collection appears in her publicity when revisiting Liverpool and Manchester, which announces, '80 great and astonishing changes since it has been absent'.

As she develops a relationship with the public and a reputation for excellence, she becomes more mindful of not risking anything that would damage the good opinion of her show. Rather than cramming her figures into rooms, she adopts a more sophisticated approach to display. Ledgers show bills for glaziers, carpenters and gilding. Lengths of material are also listed, and one can sense her developing the panache for presentation that would reach its fullest expression when she acquired permanent premises. The effort she put into set design was evident in 1822 when, for a Christmas season, she redecorated the theatre in Preston especially for her exhibition, and put a platform across the pit so that she had ample space on which to make a suitably dramatic backdrop for her representation of the previous year's coronation of George IV. Similarly in 1824, when she reached Northampton and found that the town hall was not sufficiently large to do justice to her display, she went to considerable effort to customize the local theatre. The theatre pit was again boarded over, so that, in conjunction with the area of the stage, she boasted that she had created 'one of the largest rooms in Northampton'.

A recurrent theme, both in the critical acclaim she gets from the public and in her own publicity material, is the lifelike illusion of her figures, and their interest as accurate likenesses of specific people. Evaluating the figures of the French royal family, for example, the local paper in Worcester in 1814 remarks, 'The resemblances are allowed to be most accurate.' With the French material, an extra frisson of interest was generated by Marie's claims that the faces were cast directly from the flesh-and-blood subjects – something that she emphasized in all forms of publicity. This immediacy was especially powerful in the death-like authenticity of her human relics of the Revolution and the macabre exhibits that were her signature pieces. In Norwich in 1819, for example, Marat is billed as her star attraction, 'in this figure represented immediately after receiving the mortal wound'. She goes on to state, 'The model was taken from his body on the spot, by Madame Tussaud, by order of the National Assembly, and was universally allowed to be a most exact resemblance, both to the person and physiognomy of the above-mentioned celebrated but atrocious character.' This sense of eyewitness proximity to people of both historical and current interest was particularly compelling. The patina of authenticity, from the tint of the flesh to the colour of the hair and the disarming glint of glass eyes, exerted a great fascination at a time when information about people tended to be disseminated through print, monochrome engravings or the formal aesthetic of fine art. Her convincing replicas gave those who saw them that uncanny sensation of optical trickery that, even in an age when we are saturated with images of the famous, makes you stop in your tracks in front of a life-size likeness. For as *Chambers's Journal* pointed out in 1881 a wax mannequin exerts a particular sensation that affords a greater depth of intimacy than either a photograph or a statue. 'One can fearlessly criticise the crowned kings of England' and, conversely and even more compelling, 'one can enter securely into a lair of thieves and murderers and feel with a chill that they are shockingly like commonplace mortals.' One can stare and scrutinise at close quarters without redress, 'a popular luxury never possible among the *convenances* of real life.'

The impact was the same whether in experiencing the past in the present by getting close to the dead subjects of recent history or in

having the thrill of standing next to the human subjects of the news stories of the day. In this way her wax figures anticipate the function that would eventually be fulfilled by photographs, capturing likeness in a way that transcends temporal and physical boundaries. During her touring years Madame Tussaud began a process that would evolve dramatically in the 1840s, as advances in the technology for reproducing images were a catalyst for culture becoming progressively more pictorial, ephemeral and celebrity-oriented. Long before this, she had turned a visual medium into a collective cultural frame of reference, and in so doing had established a prototype of the network by means of which celebrity culture would take off. Familiarity breeds fame, and, at a time when the norm was unfamiliarity with what people in public life looked like, her likenesses of the famous and infamous provided a large segment of the population with a pool of visual images that had an impact on how they interpreted both history and current affairs. She enabled the public in the provinces to visualize the people they were hearing about in the limited flow of information that other media supplied. This shared information in turn affected how they related to each other, as common interest in the famous and infamous started to become a cohesive element in society, closing up a gap between the urban metropolitan culture focused on London and the rest of the country. In this way with communality of interest, and her appeal to middle-class values, Marie can truly be said to have been a pioneer of a form of popular culture that burgeoned in the Victorian era. She bridged the demographic divide with her earnestly respectable form of entertainment – closing the gap between the vastly different cultural milieux of curators, collectors and formal display and the caravans, barkers and booths.

A selling point that she developed was giving glimpses of the great and the good on occasions to which the public did not have access, but which were of great topical and national interest – notably coronations. This opportunity for presence by proxy, being able to get close to three-dimensional replicas of people in public life on state occasions, was an integral part of the market Marie exploited. She also capitalized on public interest in significant deaths, in which regard her quick response worked rather like the commemorative supplements rushed out today by newspapers. Before improved

communications carried news quickly to the provinces, Marie took the news of the day on tour in an engaging visual format. Unlike reading a report in private, the public could satisfy their curiosity by means of a civilized and sociable experience, a participatory form of becoming up to date and au fait.

It is worth noting that Marie was not the sole purveyor of such material. At the same time that she was touring, other waxworks were presenting similar subject matter. For example, the national outpourings of grief first at the death of Nelson in 1805 and then later at that of Princess Charlotte, created a fertile market for funerary wax facsimiles, and an almost perpetual cortège of sombre entertainments took to the roads. Rather as Nelson's mortal remains had been pickled to preserve them so that he was in good shape for his funeral, after death he was preserved in wax. A full-size portrait officially commissioned from the celebrated society modeller Catherine Andras was installed in Westminster Abbey, and his likeness was an immensely popular subject in travelling exhibitions. Mr Bradley's star attraction for some time was his tableau of the Death of the Immortal Nelson in the hour of victory. Bradley assured his public, 'The big sorrow of the mournful sight of the dying hero is so powerfully and pathetically expressed that the most insensible human being cannot look upon it without in some sort sharing in the grief.'

The death in childbirth of Princess Charlotte, daughter of the future George IV, in 1817 was an enduringly popular wax weepie for years afterwards. Churchman's grand exhibition went all over the country, presenting the 'splendid and solemn spectacle, of her royal and serene highness the Princess Charlotte and her infant child lying in state as in the lower lodge Windsor. All the splendid arrangements have been faithfully copied.' Coffins covered in crimson velvet and the sombre drapery of death were all part of the mournful theatricality. The appeal to the wider public was obvious. 'To the thousands who were disappointed in obtaining admission at Windsor, this facsimile will be seen with avidity and the sorrowing millions of the empire will be peculiarly interested in beholding so august a ceremonial of respect to the presumptive heiress of the British throne.' Echoing the enthusiasm for taking part in mourning rituals for Diana Princess of Wales, the appeal to the public of grieving by proxy for

'England's Rose' by going to see commemorative wax displays was a boon to waxwork shows.

Marie also faced rivalry from one of her own sex. Madame Hoyo, while more downmarket with her threepenny tariff for the working classes, carved out a good living on the same circuit. Her most famous work was tantamount to a wax autopsy of Samson, depicting his exposed interior and the muscles, veins and arteries of the left arm. She too offered The Great Immortal Nelson, who appeared as large as life with Fame crowning him with a wreath of laurels, and in 1821 she was able to create a double bill which also showed Napoleon Bonaparte in his last moments.

Considering the competition Marie faced during the touring years, with some of it showing almost identical subject matter, her lasting success is even more impressive. For example, when Mr Bradley's waxwork exhibition opened in Manchester in 1818 after a successful run in London it displayed seventy-seven public characters modelled from life to form 'the most brilliant, splendid and striking assembly of the most illustrious personages in Europe'. Alongside the English royal family were figures of Napoleon, Voltaire and the statutory grizzly exhibit of a contemporary criminal – in this case the head of Jeremiah Brandreth as it appeared after his execution at Derby for high treason. Offering topicality and sensation, the pageantry of royalty and the thrills of real-life crime, these shows were the travelling tabloids of their day. Many of them occupied the same price band as Marie, one shilling entrance and a catalogue for sixpence, while some, like Ewing's, offered similar fare for half the price, with admission set at threepence for working people and children.

One of the factors that helped to set the seal on Marie's success was her considerable ability as a sculptor, directed and developed by Curtius under the mantle of his own reputation. Her outstanding artistic ability, coupled with the unique credentials of her French figures and relics and their status as autobiographical material, distinguished her from more run-of-the mill waxwork shows. She herself was not shy of trumpeting her pre-eminence. In advertisements she often describes her collection as 'unrivalled' and cites her unique 'composition', meaning the particular blend of waxes that Curtius had passed on to her, as the reason that her own

portraits are 'very superior to any figures in wax that can possibly be made'. The *Taunton Courier* in 1815 was but one of a number of papers that asserted the superiority of a good collection of wax figures over the 'faint resemblance' afforded by medals, engravings and paintings, which 'are generally deficient in character of contemporary greatness'. It favoured the realism whereby 'the characters of the past and present day are brought before the eye with all the force of the actual, exact and almost speaking figure in its proper costume.' (The costume had been an integral part of the overall effect in Paris, and Marie did not skimp on it now.) Typical of the good reception she received on tour was a comment in the Portsmouth local paper in 1816: 'We never met with deception so complete, nor did we think it possible to give to inanimate substance so perfect an appearance of life and nature.'

The *Manchester Mercury* in 1820 conveys the disorientation that, then as now, is part of the attraction of viewing a convincing collection of waxworks: 'The effect of the whole is highly imposing, indeed, so admirably are they executed, and the arrangement of them so natural and judicious, that the visitor cannot for some time divest himself of the idea that he is in the midst of a brilliant assemblage of animated beings; and he is not unfrequently on the point of expressing his admiration, and addressing himself to some one or other of them as a fellow spectator.'

The standard faux pas of mistaking models for people and vice versa was incorporated into Marie's publicity repertoire. A case of mistaken identity that happened in Rochester in 1818 was widely reported. During a tour of the exhibition a young woman who had made vocal observations on several figures apparently came to a model of an officer in uniform. Not recognizing his identity, and speaking to herself as she thought, she said, 'Pray who are you?' The report continued, 'To her great surprise and confusion the supposed model bowed very politely and replied "My name, madam, is Captain . . . of the . . . Regiment, and very much at your service." On recovering herself, the lady observed "I beg your pardon, captain, for my mistake, and must confess that in the involuntary compliment I paid to the exhibition I cut a rather sorry figure myself." '

Similar anecdotes centre on the self-portrait of Marie. One of her stock stories was that a well-to-do woman was offered a catalogue at the entrance by Madame Tussaud but declined. She then changed her mind, and spotting Madame Tussaud in the centre of the room approached her and asked for a catalogue. As the Lincoln paper reported it, 'Receiving no answer [she] turned away highly chagrined at the supposed rudeness of MT.' Of course the mistake was then revealed when the visitor discovered that 'It was nothing more than the representative of Madame that she had been addressing, and she now readily excused her want of politeness.' A characteristic of Marie's marketing prowess was the way she played the press. She proved herself extremely efficient in the art of self-propaganda, and her own fingerprints can be seen on some publicity that is presented as being independent. It is clear that she 'planted' stories in the press in the style of 'advertorial' – not only amusing anecdotes, but also reports of her charitable donations.

A distinction worth mentioning is between 'lifelike', the effect of the illusion she created with her figures, and 'from life', which is the standard description of the method of modelling. There is a disparity between the illusion of first-hand authenticity that so impressed the visitors and the fact that most likenesses were derived from second-hand sources. In the punishing schedule that Marie adopted during her touring years, it would have been unfeasible for her to travel to take formal sittings with the famous as and when they were of topical interest. Not only that, one wonders whether she would have been granted sittings with many of the distinguished people she portrayed, given that she was going to profit from the display of their image, and that she could reproduce it ad infinitum in a commercial context. This makes her skill and productivity even more impressive, working on the road without a dedicated studio and relying on such secondary sources as engravings, busts and reproductions of portraits. Her contemporaries were under no illusions about this practice. In 1819 the *Derby Mercury*, writing about her exhibition, commented on 'Features represented with the utmost accuracy, most of the models and living subjects being modelled from life, and the rest copied from the finest statues, and the most faithful portraits are displayed at full length in their proper costume.'

Although she makes much of her French material being produced by direct from-the-flesh casting, or modelling from first-hand observation of living subjects, and emphasizes this with autobiographical anecdotes and reminiscences, she is less insistent upon this with the figures she makes in her travelling years. For example, she states in her catalogue that her popular figure of Princess Charlotte was 'taken by kind permission of P. Turnerelli from the beautiful and celebrated model'. As Sculptor in Ordinary to the royal family, Peter Turnerelli produced a succession of royal likenesses in plaster for the mass market that would have been an easily accessible and useful source for Marie when she was on the move. She also acknowledged his bust of the Irish patriot Daniel O'Connell, 'for which Mr O'Connell gave sittings in Dublin'. A figure of George IV, in honour of his coronation, is described as 'taken from a bust recently modelled from life'. Later, more information is given on the pose of the King, which is described as 'an attitude copied from a picture by Sir Thomas Lawrence'. The Duke of Wellington is described as 'taken from a bust executed by a celebrated artist in 1812'. During one of her return visits to Edinburgh, in 1828, a portrait likeness of Lord Byron, described as 'taken from life in Italy', was displayed beside a likeness of Sir Walter Scott, described as 'taken from life by Madame Tussaud', when in fact it has all the signs of having been copied from a bust of the great novelist by Sir Francis Chantrey. This literary duo have extra interest because they afford a rare recorded example of the way in which Marie produced figures in response to public demand. As the local paper reported, she was 'anxious to meet the wishes of her visitors who pressed her to model a likeness of Lord Byron in order that they might see together two of the greatest living poets of modern times'.

'From life' was therefore an elastic term. Sometimes, indeed, it meant from death, and again in this context it was not necessarily Marie's own hands that had coated the features of a dead criminal with liquid plaster. There is some evidence that Marie bought a collection of death masks of executed felons from a surgeon in Bristol called Richard Smith. This may have been the basis of some of her own wax representations of criminals of public interest. For example, the *Liverpool Mercury* announced in 1829 that she had added to her

collection 'a likeness of the Monster Burke said to be taken from a mask from his face. As this is known to be the only certain method of producing a perfect resemblance, we have no doubt that it will cause her exhibition to be crowded by persons anxious to see the features of a wretch whose crimes have hardly any parallel.'

The basis of Marie's popularity was the demand to know what famous people looked like in real life – especially Napoleon, whose changing fortunes did nothing to dim his allure. He remained a giant in the public imagination, and Marie capitalized on the limitations of caricatures to satisfy intense curiosity about his likeness. A month after the Battle of Waterloo, Napoleon had surrendered to the British, handing himself over to Captain Maitland of the *Bellerophon*. When in August 1815 the most feared and fascinating figure in contemporary life finally came in sight of the shores of the country he had for so long threatened to invade there was a national sensation. His status as a captive on board a British naval frigate merely enhanced his appeal. Improvised flotillas of sightseers swamped Plymouth harbour, and anyone with a watertight vessel charged up to twenty guineas to row the curious alongside the ship for a glimpse of the fallen enemy. An eyewitness estimated that there were not less than ten thousand bobbing up and down in boats with their eyes fixed on the frigate's deck, where from time to time Napoleon indulged them by presenting himself. The overcrowded harbour even claimed casualties, as a handful of sightseers drowned in their eagerness to get a look. Newspaper columns were crammed with details of the captive's physical appearance, noting that he was now very corpulent.

Marie transferred Napoleon's in-the-flesh allure to an in-the-wax opportunity, offering a more accessible and less hazardous chance to gawp. With Marie's figure of the fallen Emperor, the public were also guaranteed an unrestricted view, which they could scrutinize and talk about in an unhurried and uninhibited way. A catalogue dating from 1818 describes a full-length portrait of Napoleon 'taken when he was on board the *Bellerophon* off Torbay 1815', and comments, 'He who once could make the mightiest monarchs tremble at his frown, at last is himself become an object of pity.' This is an example of Marie relying on a secondary source to make a topical crowd-pleaser, for none of the

public were permitted to board the boat. Whether she used her pre-existing image of the Emperor from the days of the Directory is unclear, but another possibility is that she based an updated model on the famous portrait by Sir Charles Eastlake, which he made from sketches taken alongside the *Bellerophon*. This painting was exhibited in London with several certificates testifying to its likeness to the ex-Emperor, and it was so popular that it made the fortune of the painter.

Marie did well with her own representation, and in the years after Waterloo she would have been keenly aware of the burgeoning market for Napoleon memorabilia. When she was on tour she would have noted the extraordinary success of Napoleon's carriage that was cap-tured at Waterloo – after a sell-out run in London, where it was dis-played by William Bullock at the Egyptian Hall, it went on a national tour drawing huge crowds. She probably even saw the newspaper reports, in 1818, that the famous carriage and camp equipage had netted upwards of £35,000 on their successful campaign around the country. She later acquired them for her own exhibition.

On tour, Marie realized that royal news was a big draw, and the British royal family started to become a useful source of revenue for her, through her illustrated news service. Her touring years coincided with a prolonged public-relations crisis for the Crown that she now turned to her advantage. Although the heart of her exhibi-tion was the French material, and the French royal family, from 1809 she started to incorporate the British royals. The Hanoverians provided her with plenty of scope. Madness, adultery and corruption all tarnished the sceptre of monarchy. While George III, regarded as the 'father of his people', was an increasingly sad, frail figure – the Lear-like ranting having quietened in his final decade to a more docile detachment from reality – the love and pity he inspired in his frail old age were in direct opposition to the derision in which his sons were held. The Duke of Wellington described George IV and his brothers as 'the damnedest millstones about the neck of any government that can ever be imagined'.

The heir to the throne was held in particularly strong con-tempt. Gluttonous, adulterous, envious and slothful, the Prince Regent indulged in almost the full quota of deadly sins. The Tsar of Russia's sister described his wandering eyes as having 'a brazen way

of looking where eyes should not go'. And with sex went shopping: he didn't blink at splurging £33 on milk of roses and scented powder for his toilette. Though his profligacy disgusted his subjects, the British people loved his wife, Caroline, Princess of Wales – who many, especially her husband, wished would spend both more money and more time on personal grooming. The Princess, who skimped on washing and changing her clothes, quite simply stank, and badly needed a dab of her husband's expensive colognes. A diplomatic aide of the Prince had taken her aside: 'I observed that a long toilette was necessary and gave her no credit for boasting that hers was a short one.' If there was plenty of dirty linen in the royal household, there were vast quantities of dirty laundry in the public domain. The private life of Princess Caroline and the misdemeanours of Mary Anne Clark, the mistress of the Regent's brother, the Duke of York, were but two of the most popular topics of royal gossip, and Marie's figures turned both women into a new form of talking point.

Mary Anne Clark topped the bill in Marie's exhibition when she was catapulted to national interest by claims that she had been using her position to advance the military career of any ambitious soldier who would pay her enough to further his cause. Corruption in the corridors of power is always of public interest, but when it moves to the bedrooms of power it takes on a different piquancy. The love letters between the Duke and his mistress were produced in the public inquiry held at the House of Commons, and as the investigation unfolded the nation was transfixed. As well as their printed intimacies, lovey-dovey exchanges overheard by their domestic staff were all considered as evidence of the Duke's collaboration in his lover's scheme. It was said that, while the case continued, children in the streets took to shouting 'Duke' or 'Darling' instead of 'Heads' or 'Tails' when they flipped coins. Although cleared, the grand old Duke of York's military career, immortalized in the nursery rhyme, came to an abrupt end. The professional credibility of the man who had famously commanded ten thousand men was irreparably damaged by his middle-aged mercenary mistress, who, over and above the promotions she traded in on behalf of others, through fast-track self-promotion had graduated from marriage to a stonemason to the bedroom of the second in line to the throne.

The second major scandal from which Marie profited was the sensational inquiry into the alleged adultery of Princess Caroline, the estranged wife of the Prince Regent (later George IV), with a flamboyant Italian called Bergami. When George III finally died, the problem for his son and heir was that the wife he loathed was legitimately the Queen and officially entitled to be at his side. The so-called Milan Commission arose from his hopes that she would be deemed unfit for queenly office. From her enforced exile abroad, bulletins about Caroline and Bergami shocked and amused in equal measure. There were stories of them canoodling in a pink seashell chariot pulled by horses through the streets of Milan, with her by now a fleshy fifty-something in a low-cut gown, her acres of pink satin billowing and bulging in the arms of her svelte suitor. But not even the news of their absurd entry on donkeys into Jerusalem, where she had founded an honorary order of knights in Bergami's name, diminished her in the affections of the English people. A big headache for the King was that the public preferred his wife. They booed him and cheered her. It was in part the fear of the crowd that informed the decision to abandon the inquiry and simply to sideline the Queen, albeit unofficially. The strength of public regard for her was perceived as potentially inflammatory.

The findings of the Milan Commission were fed to a Secret Committee of the House of Lords, and under the terms of a private bill the Queen was put on trial. Talk of the contents of a green bag containing the most incriminating evidence against her gripped the nation and inspired cartoons and lampoons ad infinitum. This sensational marital showdown dominated 1820, and while it did Marie ensured her figure of Bergami was in pride of place in her exhibition. For example, in July 1820 the *Manchester Herald* reported on the inclusion of 'Bartholemew Bergami – a figure of this so much talked about character, who was so suddenly raised from the situation of a menial to the rank of Noble, by the partiality of a Princess, is now added to the splendid and interesting collection of Madame Tussaud.' In October the public were still fascinated: 'Bergami – as this celebrated Italian will this day become the subject of the House of Lords, so we suppose that on this day, and every day and night this week, the crowds will resort to the Exchange dining room to see his astonishing accurate

likeness.' Eventually the case against the Queen was abandoned, but she was banned from attending the coronation. The King never could see what the public saw in his wife. It is said that when an equerry informing him of Napoleon's death said, 'Sire, your greatest enemy is dead,' the King replied, 'By gad, is she!'

There was an interesting duality to Marie's presentation of royal material. She catered to public interest by giving pride of place to the most talked-about protagonists in each new royal scandal as and when it became of national interest. But she also started to manipulate public opinion by replacing the flawed reality of the royal family as individuals by a bigger image of sovereignty that tapped into notions of national identity, the displayed scarlet and ermine of state evoking the dignified grandeur of heritage and history. Marie did George IV a particularly good service: her wax image was far more regal than the unmajestic figure he cut in real life – stout and gouty, and increasingly reliant on greasepaint and false whiskers to disguise his ruddy, hung-over face. The English-born Irish novelist Maria Edgeworth said that even when the King was well 'He looked like a great sausage, stuffed into the covering.'

The coronation tableaux that Marie developed on tour were particularly popular, and became the basis of a segment of the exhibition that would enjoy lasting success in London. The tableau she introduced in 1821 was but one form of representation of the coronation, for there were also competing models, panoramas and, most striking, theatrical performances. In Liverpool, in December 1821, Marie was in direct competition with Mr Coleman's nightly performance of 'the superb spectacle', which was on such a scale that in addition to the regular theatre troupe there were 200 extras. That an event which represented a solemn sacrament in the eyes of the Church was re-enacted as a play, and in Marie's case was depicted on the same premises as the heads of criminals, highlights a hunger for information that is today satisfied by extensive reporting and television coverage. Bearing in mind the controversy surrounding the televising of the coronation of Queen Elizabeth II, when eminent figures argued that the ceremony ran the risk of being demeaned by being watched in a public house, it is interesting to consider whether these mock-ups succeeded in bringing the public closer to a solemn rite or whether they trivialized

it. In fact Marie and Mr Coleman's versions were probably more dignified than the real thing, for according to some of those who had a bird's-eye view of the real coronation the King himself trivialized the occasion. Mrs Arbuthnot complained that he behaved 'very indecently', and the Duke of Wellington noted, 'soft eyes, kisses given on rings which everyone observed'. A year later Messrs Rundell, Bridge & Co. were still owed £33,000 for the regalia they had supplied. Marie's own throne-fitters, Messrs Petrie and Walker of St Ann's Street, had long since been paid.

Marie's advertisements in the Liverpool and Manchester press chart the development of her coronation crowd-puller. The earliest version, in Liverpool in July 1821 (the same week as the real event), focused on 'the superb figure of His Majesty, on which no exertions have been spared to render it worthy of being considered a correct representation of the Illustrious Person on whom the crown now sits'. In the evenings the King's subjects could admire his likeness while a full military band played in the background. A few months later, in Manchester, she placed the King in a more elaborate setting and 'completely transformed the Golden Lion Assembly Room into a representation of the magnificent throne room in Carlton-Palace'. The reviews were ecstatic: 'The coronation group which is now exhibited to the public in the Exchange Room, exceeds anything of the kind ever exhibited in this town,' gushed the *Manchester Guardian*. Another paper enthused, 'It gives such an air of reality to the scene that respect and deference is conjured up the moment the eye rests upon this imposing spectacle.'

This splendid *coup d'œil* proved so popular that Marie, knowing she was on to a good thing, continued to expand and adapt it, adding allegorical figures of Britannia, Hibernia and Caledonia. The public loved it. 'He nearly looks a king; we felt not a little proud, when we looked at our sovereign,' the *Blackburn Mail* declared in April 1822. Spurred by such acclaim, Marie introduced a new dimension of piquancy by creating a dramatic double bill in which the 'august coronation of his most gracious majesty George IV' was juxtaposed with the coronation of Bonaparte. The spice of legitimacy versus illegitimacy in claimants to a throne was a brilliant piece of showmanship.

Always mindful of the need for change, in order to maintain interest and justify return visits, she then introduced historical figures of the Kings and Queens of England, allowing the public 'to walk along the plank of time' as one review put it. This duality of hot news and history that she tried out on the road, blending the sensational in the present with the pageantry of the past, was a prototype of a format that she was able to expand upon greatly when her show finally came to a halt in fixed premises. By the time it did, the life of the third English king whose reign she had lived under, and whose features she had cast, was coming to a close.

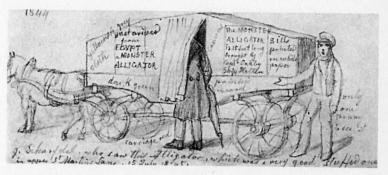

Man inspecting 'Monster Alligator', drawing by George Scharf

13

Dramas and Dangers 1822–1831

LIFE ON THE road was always demanding, but routine hardships paled compared to some of the dramatic incidents that befell Marie in her later touring years. If 1822 saw a series of significant commercial breakthroughs, it also marked a near-miss with death. A private family memoir offers circumstantial evidence that Marie and Joseph were survivors of a disaster at sea that claimed many lives when a boat bound for Dublin was shipwrecked just outside Liverpool. The accident happened on 8 August 1822, and coincided with the King's visit to Ireland. Marie had advised the public at the end of June that she was closing owing to 'a particular engagement in Dublin'. It is possible that, riding high on the success of the coronation tableau, she saw a good commercial opportunity to present it in Ireland with a new peg of topicality given the King's presence there. No passenger lists name Marie and Joseph as among the fifty or so people who survived the tragedy, which claimed around the same number of lives. The only evidence linking Marie to this misfortune is a reference in the ffarington family history.

The story has it that dinner at the imposing family home near Preston was interrupted by sounds of the staff answering the door and speaking to unannounced guests. 'Mrs ffarington's curiosity was aroused and she went to the door herself, where she found the butler was being addressed in voluble French by a party of people outside. She brought them in and found them to be a little company of foreigners who had suffered shipwreck on their way to Dublin. The leader of the party was Madame Tussaud.' Bedraggled, besmirched by mud and carrying one surviving box, they apparently stayed for several days recovering. If this did happen then Marie must have been storing the moulds elsewhere and must have been travelling light, for there is no evidence

of her exhibition being diminished in any way when she returned to Liverpool. Either that or she worked extra hard to replace lost figures.

The story holds more interest for how it delayed reunion with her younger son. Marie's great-grandson told the story that has gained credence by repetition over the years that Francis, by now a man of twenty-two, came over to England at this time and, hearing a rumour that his mother had perished in a shipwreck, returned forthwith to France. The poor communications of the time were such that it took months for news to reach him that his mother and brother were alive and well, and based in Manchester. No details of the reunion remain, but Tussaud family tradition has it that the brothers and their mother met up in Liverpool and from henceforth the course was set fair for Madame Tussaud and Sons to make their mark.

Personal details are tantalizingly scarce: instead of letters and private papers there are just rumours and whispers, ever fainter over time, of strained relations between the brothers, and of François, still in Paris, continuing to be a disappointment to his family, both professionally and paternally. As for Francis, jealous of his mother's long-term relationship with her elder son and unable to establish himself securely as his equal in her eyes, one can understand the friction between him and Joseph, for ever little 'Nini', who had been Marie's helper and the linchpin of her life in the lean years. Of Marie's mother there is no word, but, given that she would have been nearly eighty in 1822, perhaps it was her death that prompted the family reunion. A bad husband, François was no better a father. Apparently he resented paying for his second son to train to be an architect, so Francis was forced to work first for a grocer and then for a billiard-table maker. This unpromising employment actually served him well, for his skills at carving wood were later directed to making the legs and arms of the waxwork figures.

What we do know is that the sons were loyal to their mother, and whether voluntarily or by coercion they devoted their lives to the family business. They both married in the touring years – Joseph in 1822, when the exhibition was in Birmingham. He seems to have fallen for a local girl, Elizabeth Babbington, with whom he went on to have three children, the first of whom, a son, was born in 1829. Francis married later, to Rebecca Smallpage, and their first child, also

a son, was born in 1831. The younger son left in France must always have felt that his brother was their mother's favourite so perhaps in the interests of fraternal diplomacy Joseph and Elizabeth called their first son Francis, and Francis and Rebecca called their first son Joseph. By the time the exhibition was established in London there were eight new members of the dynasty, and Marie had twelve grandchildren. They would all work for the exhibition, and until as recently as 1967 there was always a Tussaud directly involved in the business.

Something that emerges clearly from ephemera relating to the exhibition is its increasingly 'genteel' style. The long opening hours, from eleven to six and then from seven to ten, were ideal for leisurely viewing – and specifically for the promenade so beloved by middle-class respectable families. To create a pleasant mood, music became increasingly important, and over the years the number of musicians increased, from Mr Fisher on the flute to a full orchestra, with musical performers being named in the publicity. In York, in 1826, the papers were happy to report: 'Miss Bradbury and Mr Bellamy are much improved since they came to York, the lady sings with more ease, the gentleman with more spirit.' By the time they got to Durham in 1827 there were fifteen musicians. Of many innovations, Marie seems to have pioneered background music. The strains of the instruments encouraged people to relax. The music created enough noise to encourage private conversations, and was conducive to people lingering. This novelty captured the imagination of the public and the press. In September 1833 the *Maidstone Journal* declared, 'It is hardly possible to conceive a more interesting spot for an evening lounge, aided as the principal attraction is, by a select band of musical performers who play in a style seldom heard at an exhibition of this nature.' In 1834, when the show had triumphantly returned to London and was then in the Gray's Inn Road, *The Times* urged readers 'to lose no time in paying an early visit to the promenade and lounge, where they will not only have their eyes delighted with faithful representation of the great and the good of times gone by; but will hear much pleasing modern music, well executed, and enjoy a high intellectual treat for half an hour.'

Encouraged by such appreciation, Marie introduced a regular programme of singing and, for five months at this site near King's

Cross, praise was heaped on this addition: 'Excellent music and very pleasing singing (for this new feature has been added to the exhibition) render a two hours lounge here exceedingly delightful to the visitor, and forms an agreeable change to the monotony of the theatre.'

The smooth running of the exhibition was rudely interrupted in the autumn of 1831 when Marie was again ambushed by an event that jeopardized both her livelihood and her life. Nine years after her dramatic survival of the shipwreck, it was now fire that nearly finished her off on one of her return visits to Bristol. There, for the second time in her life, Marie, by now an elderly woman of seventy, experienced the full force of the mob when she found herself in the very thick of the riots that erupted at the end of October in the wake of the House of Lords' rejection of the Reform Bill some three weeks earlier.

Bristol in 1831 reflected in microcosm the widening social divisions that were evident in any sizeable city at this time. Over the next decade the rich–poor divide was documented in a spate of social-conscience novels, most powerfully by Disraeli, who described England as 'two nations' alienated 'as if they were dwellers in different zones, or inhabitants of different planets'. The local papers – *Felix Farley's Journal* and the *Bristol Gazette*, in which Marie announced her arrival and then waged her standard publicity campaign – reveal the two worlds of prosperity and poverty.

The tier of the prosperous, from which she drew her custom, was the target of advertisements for dancing academies and sculpture exhibitions. The insecurity of aspiration resonates in earnest entertainments exemplified by the inaugural event of the Bristol Institution's autumn programme: 'The first of the Evening Conversazioni took place on Thursday last and was attended by a brilliant assemblage of about 600 individuals, members of the principal families in Bristol and its vicinity. The gallery of pictures and museum were splendidly lighted up for the occasion. Among the company we noticed the mayor and mayoress, the sheriffs and their ladies, the Bishop of Bristol and family etc.'

Similarly sedate and civilized was the recreation that Marie and her entourage were setting up in the assembly room, where, to the strains of a band, the well-heeled residents of the Clifton area could pass a pleasant hour or two surveying the waxen heroes, foes, royals and

renegades of both the past and the present. This was a world away from the subsistence living that was the lot of Bristol's growing underclass. Their plight was evident in sad snippets in the press, the brevity of which hid a magnitude of suffering.

While Marie's well-to-do customers could safely scrutinize the murderers Burke and Hare and look at guillotined heads in what Marie advertised here as 'the Chamber of the Revolution', the disadvantaged in their midst – poor and hungry – were experiencing crime and punishment more directly. Shortly after Marie opened, for example, Henry Hicks, twelve, was sentenced to twelve months' imprisonment with hard labour for stealing a cheese. In the same week another juvenile offender was sentenced to fourteen years' transportation for stealing a silk bag from 'a respectable woman' on her way to Queen Square.

While Marie's gilt-and-stucco splendour was packed to capacity, the poorhouse of the city was evidently pressed for space as the local labour market was experiencing a dip. Pauperism was on the increase, and 'poor relief' was not exactly philanthropic balm to the oppressed, being meted out in exchange for stone-breaking shifts of up to eight hours daily. But during Madame Tussaud's stay the comfortable insulation of the well-off was violently shattered. In the space of a week the local press went from reporting the enjoyment in Mr Muller's pleasure garden of a firework display for 600 people, 'with splendid rockets crimson and variegated stars', to harrowing accounts of the whole city ablaze in three days of arson and anarchy.

In *Rural Rides*, published only the year before, William Cobbett had described Bristol as 'a good and solid and wealthy city; a people of plain and good manners; private virtue and public spirit united; no empty noise, no insolence'. This was not how Marie and her sons experienced it. The scenes of violence and destruction that they witnessed were traumatic, and for Marie painfully familiar. As Sir Charles Greville recorded, 'The business at Bristol . . . for brutal ferocity and wanton, unprovoked violence may vie with some of the worst scenes of the French Revolution.'

Marie had arrived in Bristol in early September. With a good local press and a spine of commercial affluence, it perfectly suited her business, and it was a city where she had found that repeat visits paid

off. She was not alone in identifying its profitability, and two of her stalwart companions on the travelling-show circuit, George Wombwell and his Menagerie and Andrew Ducrow with his equestrian stunt show, were vying with her for the custom of the well-heeled residents. Ever mindful of the topical, Marie was intending to present the figure of the Reform Bill champion Lord Brougham alongside the effigies of Burke and Hare, in whom public interest showed no sign of abating. Her competitors were no pushover – not merely a menagerie and a circus, they marketed themselves with considerable aplomb. Wombwell always made an impact when he arrived in town, not least because of his sixty-strong cavalcade of wagons. The elephant's mobile home was a free show in itself, being thirty feet long, nearly fourteen feet high and pulled by twelve horses. Not merely wild-beast merchants, Wombwell and his associates were 'the wandering teachers of natural history'. Ducrow, with his superb stud, promised 'a unique classical historical mythological entertainment of the arts and the sciences'. More precisely, he was bringing to the provinces the smash-hit bareback-riding version of Lord Byron's poem *Mazeppa* which had played to full houses for 150 consecutive nights during its London run. The elan and expense of these touring professional shows exuded superiority.

Their educational wrapping and level of professionalism were in marked contrast to the more affordable fun of the fair which had set up in the city at the same time, as was customary during the autumn assize. Marie capitalized on this distinction, and pointed out in her advertisements that her own exhibition was 'free from the bustle and confusion of the throng of the Leather fair'. But the perceived threat of a boisterous crowd at play was insignificant compared to the violent protest that Sir Charles Wetherell's visit provoked among a group of disenfranchised young people.

Sir Charles – a much caricatured figure with a reputation for drunkenness, and no sympathy with the plight of the common people – was in Bristol to preside over the assizes, at which certain local troublemakers agitating for reform were to be tried. His arrival did not augur well. During one of his speeches in the House of Commons, the speaker commented that the only lucid interval Wetherell had was the one between his waistcoat and his breeches.

The Bristol Riots, 1831

But, more than inspiring mockery, he was a highly controversial figure for his stance on parliamentary reform, to which he was vehemently opposed. Though he had held the office of recorder in Bristol for four years, he was out of touch with local opinion, reporting to the House of Commons that in Bristol 'Reform fever had a good deal abated.' Aware that he was loathed in the West Country and a potentially provocative presence, the Bristol magistracy asked for the assize to be postponed, but their request was denied; instead troops were sent to protect Sir Charles, which merely added to the tension. Feelings were running high, and unluckily for Marie the assembly rooms that she had hired for her exhibition were perilously close to where Wetherell was being formally welcomed at a civic reception.

The trouble broke out on the evening of Saturday 29 October, when Sir Charles was at dinner in the Mansion House. Rioters broke in and ran amok, looting the cellars, causing an affray, and then

making off over the rooftops. During the next few days an orgy of looting and destruction ensued, with the administrative buildings of the city as prime targets. The jail was stormed, and many private homes were ransacked and set on fire. Signs of official retaliation were slow to materialize, as fear seemed to paralyse the authorities.

One can all too easily imagine the horrors that particular incidents recalled for Marie: the siege of the local prison; the scaling of the equestrian statue of King William by a man waving a tricolour and shouting for liberty; flaming torches; drunken gangs; the threat and menace of rioters at her door. The past was suddenly storming the present, and her immediate fears were magnified by powerful memories. Marie's ordeal was later reported in the *Bristol Gazette*. As gangs of rioters worked their way along Princes Street, warning residents of their intention to set their premises ablaze, it was clear that the exhibition was in jeopardy. 'During this awful state of suspense, Madame Tussaud and her family experienced the most painful anxiety. It was stated among other places that the assembly rooms were marked out for destruction containing at that time, their invaluable collection of figures. These, at an imminent risk of injury, were partly removed as hastily as circumstances would permit.' This dramatic salvaging was captured by an eyewitness, the young artist William Muller, whose sketch made on the spot shows the vulnerable wax figures being carried to safety amid lashing flames and a chaos of smoke, water-carriers and people in panic. Marie's lodgings were also affected. As the paper reported, 'The house in which Madame Tussaud lodged on the opposite side of the street was among the number which became ignited from the firing of the West side of the square and we regret to hear that the lady's constitution has received a very severe shock.'

If the wax figures were saved, many humans were less fortunate. There were stomach-churning reports of charred heads without bodies, trunks without limbs, dismembered remains, and entire bodies reduced to cinders being 'successively exposed to the public gaze'. Some rioters died horribly slow deaths on the molten-lead roofs of blazing buildings. Although accurate casualty figures were difficult to gauge, apparently when the 11th Infantry Regiment eventually arrived it was ferocious and merciless, sabreing incendiaries to death and mutilating many more.

Charles Kingsley, who was twelve at the time, witnessed the riots from his boarding school on St Michael's Hill, and later likened the sight to Dante's *Inferno*. He was haunted by the noise, the moaning and wailing, and 'dull explosions down below mingled with the roar of the mob, and the infernal hiss and crackle of flame'. Press reports of the riots were a shocking compendium of carnage and anarchy that fixed in the minds of the anti-reform movement enduring images of the hellraiser lurking within Everyman. Rather than sympathy for the rioters, there was widespread indignation. Marie upheld the show-business axiom, though her show did not go on in Bristol but moved on to Bath, ten miles away.

The chaos of the aftermath, while looters buried their spoils and the smell of smoke hung heavy, was hardly a conducive time for people to venture out and have fun. But the Tussauds opened in the Masonic Hall in Bath to good reviews, and a semblance of normality helped them to put their traumas behind them. While Bristol burned, in Bath the quadrille band played on.

They stayed in Bath until December, and then in the new year began a slow drift back to London, via Oxford and Reading in 1832, with four months in Brighton in 1833 followed by an extensive tour of Kent encompassing Canterbury, Dover, Maidstone and Rochester. En route they maintained their topicality, responding quickly to the biggest news stories, such as the 'assassination attempt' on William IV in the spring of 1833. In reality Dennis Collins was an old sailor fallen on hard times, and the stone he threw at the King was much more of an insult than an injury, but the supposed near-death of the monarch was a good news tag and pretext for airing his likeness.

During their 1833 run in Brighton, another triumph for their publicity was a visit by the King's sister Princess Augusta, along with her nephew Prince George of Cambridge. Writing to Marie via her lady-in-waiting, the Princess conveyed her enjoyment of the show: 'Lady Mary Taylor is commanded by her Royal Highness the Princess Augusta to acquaint Madame Tussaud with her Royal Highness's approbation of her exhibition, which is well worthy of admiration and the view of which afforded her Royal Highness much amusement and gratification.' After her early days on the road, when she had resorted to embellishing her advertisements with self-generated lists of royal

patrons, Marie must have savoured the unsolicited approval of a member of the royal family. Before she had even reached the capital, in another sense she felt she had arrived.

The year 1833 ended with the exhibition's return to the centre of London, where Marie hired a large room attached to a bazaar in Gray's Inn Road. She lost no time in capitalizing on her royal endorsement: 'Patronised by the Princess Augusta and Prince George' was emblazoned on her publicity announcements. Apart from a visit in 1816, when she had set up the exhibition near the West End, in premises that sounded more like the name of a showman – the Magnificent Mercatura – Marie had favoured the custom of the provinces to the greater competitive challenges of the capital.

Both London and her exhibition had changed immeasurably in the intervening years. The latter was evolving in size and scope into something more substantial than a travelling show supplying colourful flashes of topicality in improvised surroundings. Display was becoming more sophisticated, with elaborate mirrors, rich costumes and lavish use of gilding, and her sons – by now in their mid-thirties and established showmen – were starting to invest in *objets d'art*, paintings and relics. Gradually their exhibition was assuming the character of a museum and gallery, topicality being anchored in history, with material objects lending weight. Some of the early reviews in London reflect this leaning towards learning. 'A high intellectual treat' was how one described it; another declared, 'We recommend those who have young persons to take them to see this exhibition, as the view of so many famous characters must make them desirous to open the pages of history.'

Between 1833 and 1835 the radius of travel for the exhibition shortened. Movements within London were interspersed with forays to Blackheath, Camberwell and Hackney, where in 1834 the Mermaid tavern's rooms were filled to overflowing. The local paper proudly reported, 'This is as it should be as it plainly shows that the inhabitants of Hackney can appreciate merit and reward it.' In spite of healthy returns and profitability, the policy of temporary stays determined by attendance figures and takings was relentlessly maintained. Not even Marie's age and the arduous lifestyle prompted them to settle. Even in the spring of 1835, when they hired a particularly

well-proportioned room on the upper floor of a handsome building known as the Bazaar in Baker Street, near Portman Square, they negotiated a short-term lease.

If assembly rooms had provided the perfect milieu for the exhibition in the country, then the bazaars that had proliferated in London since 1816 were similarly suitable. The forerunners of arcades, they mixed retail with recreational facilities, but their chief attraction was as sanctuaries of respectability. They had originated as a philanthropic employment scheme for widows of the Napoleonic wars, who were encouraged to run retail outlets. Character references and strict supervision were all part of creating the right tone. The combination of propriety and a great diversity of hand-made and high-quality merchandise, from haberdashery to household items, was a spur to browsing, and passages were permanently thronged with an affluent, elegant crowd. Catering to a captive audience, recreational attractions were installed in suites of rooms on the same sites. (Before Marie's wax figures, a display of automata had been shown.)

The site chosen by the Tussauds had originally belonged to a regiment of the Royal Life Guards, and from here, in a clatter of hooves and with shiny uniforms and stout resolve, troops had set out to play their part in the Battle of Waterloo. Now the mess room was a pantheon for a wax homage to the heroes of that conflict, and the tableau of the Great Men of the Late War was one of Marie's first installations. While there was no visible sign of the earlier military connections, the equine links were still strong, for the vast ground-floor area still had stabling for 400 horses. There were still occasional horse sales, but when Marie and her family arrived the main trade was in carriages and harnesses, together with the products of the Panklibanon ironworks – a well-known ironmonger's whose range of merchandise included the newly fashionable domestic innovation of a bath (an 'absurd new-fangled dandified folly' in the minds of detractors, who felt that they could manage without water as well as had their ancestors). Rather than a disadvantage, the commercial stature of her neighbours and their extensive advertising was a boon for Marie's own business.

To help register their arrival, the Tussaud brothers deployed considerable monetary and imaginative effort to rig up their new

site. A team of specialists was commissioned to design what was trumpeted to the public as a Golden Corinthian Saloon, at a cost exceeding £1,100, with 'walls hung with the richest crimson velvet; papier-mâché ornaments by Mr Bielefield; gilding by Mr Jennings; the truly superb and unique Imperial crown, sceptre, orb and orders by Mr Bellefontaine; the carpentry by Mr Hine, designed and got up under the direction of Messrs J. and F. Tussaud. The whole of British manufacture, being the only display of the kind and may in all probability be the only one.' The press was impressed: 'There is a profusion of rich drapery, the sides of the apartment are decorated with pilasters with Corinthian capitals gilt in burnished gold and the whole appearance on entering, more especially in the evening when the whole is brilliantly illuminated, is peculiarly imposing and splendid.'

Madame Tussaud and Sons rapidly distinguished themselves as an oasis of civilized calm. The musical accompaniment, which now included a harp, enhanced the viewing pleasure. Successive improvements and additions were enthusiastically reported, and their status received a great boost when they achieved the considerable accolade of visits by some of the most famous dignitaries in the country. Even Marie's inscrutable features must have registered some satisfaction when the *Morning Herald* of 31 August 1835 reported, 'HRH the Duke of Sussex has honoured Mrs Tussaud's exhibition at the Bazaar, Baker Street, with a visit on Friday in addition to the Duke of Wellington on Wednesday.' To have this in-person vote of approval (particularly the patronage of the Duke of Wellington) reported by the press trumped Princess Augusta's fanmail by proxy.

14

'An Inventive Genius': Mrs Jarley, Madame Tussaud and Charles Dickens

MARIE SHOWED NO sign of slowing down or handing over the reins to her sons. Neither acts of God nor man-made dramas had daunted her. Though savage seas and lashing flames had tested her nerves and threatened to destroy her work, she treated all such events with equanimity – as interruptions to business, but no more. It was never her dwindling stamina that redirected the exhibition.

The eventual decision to commit to permanent premises came at the end of 1836, and was influenced by a celebrity death that proved a particularly valuable business opportunity. The sudden tragic demise of the popular opera singer Maria Malibran, while she was in Manchester, elicited a great wave of sadness. Rather as the wax likeness of Princess Charlotte had served as a focus of public sorrow, in December 1836 the Malibran figure was a mourner's magnet, and people queued to pay their respects to the pretty diva. Family correspondence between Victor Tussaud and Marie's great-grandson John Theodore Tussaud relates the impact of the tragedy, which touched the public all the more because the singer's husband, a famous violinist, was so traumatized that he fled, leaving others to arrange a funeral. 'The sensation created was immense and the newspapers in England and on the continent were full of various accounts and for a time little else was talked about. It was then that your grandfather modelled a most excellent likeness of the cantatrice, I think in the character of Lucia di Lammermoor. The attraction was so great that the rooms were thronged for many months.' The ledgers show that takings doubled during this time, and this perhaps was the spur for Marie and her sons finally to draw their caravans to a halt.

For over thirty years Marie had never allowed herself to be complacent about public interest and, no matter what the laurels and

triumphs, money was always put back into the exhibition. Now a combination of circumstances persuaded them to commit to London. The valuable acquisitions the sons were making (notably Waterloo spoils, including the personal standard and carved eagles of Napoleon) were reason enough to remain in one place. Beyond logistical concerns that made touring less appealing than formerly, proof of the power of public interest that they could generate where they were and recognition from the Establishment both helped them decide that London, and the Baker Street site in particular, represented the perfect conditions for them to thrive. The coming of the railway had made London a very different place from the city in which Marie had arrived from Paris. The hay market at Paddington, once a vital food supply for the horses of the capital, was becoming a distant memory, as the first generation of Victorians associated the same place with the new railway terminus, and the thrill of the locomotive that fed their appetite for travel.

At the age of seventy-five, Marie installed herself as it were over the shop, in an adjoining house that faced Baker Street. Echoing her childhood, she was in a prime position at the very heart of a city pulsating with change and teeming with comfortably well-off customers hungry for her palatable blend of culture and current affairs. The rigours of the road were over and from now on, instead of conveying her wax figures to her customers, she would let carriages, horse-drawn omnibuses and the new trains bring the customers to her.

In the wider social arena as well there were signs of one era coming to a close and another beginning. The youth and girlish vitality of Princess Victoria was in contrast to her aged uncle King William IV, and brought the buzz of novelty to the prospect of her reign. The clearing of land for the railways was so dramatic, in both physical and psychological impact, that Thackeray among others would refer to a demarcation point between the pre-railroad world and the start of a 'new era'. The sound of the navvies at work was like the death knell of the coaching age. By 1836 the rise in newspaper production was a matter of note, and in that year John Stuart Mill wrote about the growing power of an 'instrument that has but lately become universally accessible – the newspaper. The newspaper carries the voice of the many home to every individual among them.' In 1836 too the

printer George Baxter perfected the colour printing process that would transform commercial illustration and bring a new pictorial element to the Victorian home. If the Victorians would be the first generation with greater scope to visualize the world around them, at a more profound level their world view also changed. For 1836 was also the year in which Charles Darwin returned from the voyage of the *Beagle*, and the subsequent publication of his findings, twenty-three years later, would shatter the Victorian perception of how the world worked.

But long before the bombshell of evolution precipitated a crisis in theology, advances in geology were chipping away at core beliefs, challenging existing views of time and history. The preoccupation with the composition of the physical world happened in tandem with the realization that social strata were unstable, and that, by either a dynamic or a gradual process, the landscape of society could be radically recast. Marie had not only weathered the violent upheavals of revolution in France, but on tour in England she had lived through the eruptions of Peterloo and the violence of the Bristol riots. During this time she had also witnessed the cumulative quieter build-up of people power. The passage of the Reform Bill marked a time of mounting tension, with democracy challenging the status quo politically, socially and culturally. In her old age in London she would witness a further destabilizing of traditional thought patterns as the growth of scientific inquiry began to challenge traditional religious beliefs.

In 1836 all branches of science were still bound up with religion, and election to the chair of geology at the newly established King's College, London, was in the hands of theologians, including an archbishop, two bishops and a couple of doctors of divinity. Even the Zoological Gardens in Regent's Park were promoted as a place to observe God's purpose. But old certainties were under threat from new interests. Not far from the zoo, Marie's exhibition was a place to see a vision of worldly achievement and a compelling representation of the enticements of renown.

She and her sons were establishing themselves at a time when there was a premium on visual information. A plethora of pictorial entertainments – gigantic paintings and endless panoramas and dioramas, which used immense scale and light respectively to produce realistic

representations of battles and other dramatic events from recent history – enjoyed impressive audiences. Two of the most popular were on Marie's doorstep. At the Colosseum down the road in Regent's Park spectacular panoramas were shown in a building designed by Decimus Burton, and in Park Square East Daguerre's diorama was housed in a building designed by Pugin, where throughout the 1830s what one might term 'disasteramas' were extremely popular, including representations of an avalanche that had buried a Swiss village in 1820 and a fire that had razed a Roman church in 1823. Instead of watching flat screens there was a through-the-looking-glass dimension to how people experienced representations of events. Optical illusion took on a different dimension at the waxworks, where proximity to people rather than drama was the draw, and the public were enthralled. Not that Marie had this market to herself, although none of her rivals posed a real threat. For example, unlike Marie's salon, Dubourg's Saloon of Arts in Great Windmill Street promised to 'repay the visit of that numerous class that hunger and thirst after the horrible' with its 'effigies of giants, dwarfs, murderers, patriots, and pirates', and emulating the Chamber of Horrors was a 'select crypt or den for more than usual villains'.

Marie's rise to national fame coincided with that of the precociously talented young man who did so much to propagate her renown. The publication of *Sketches by Boz* and the simultaneously produced *Pickwick Papers* catapulted Charles Dickens to being one of the most famous figures of the day. In many ways Madame Tussaud and Dickens complement each other. If Dickens enabled people to see the contemporary world afresh via his work, Marie enabled people to learn about the contemporary scene and to feel in the know when they saw her creations. They were both accurate thermometers of public feeling, enabling one to gauge the psychological temperature of their times, to understand people's preoccupations. They were both marketing family entertainment, and in their different media they shared the relatively new phenomenon of cross-class appeal.

Tussaud and Dickens were both self-made and, allying hard work to talent, were immensely productive. They attained a level of recognition for their achievements that was unprecedented: household names at home, their fame rapidly became international and enduring. The

familiarity of their work also seeped into the national consciousness in such a way that each of them came to characterize a particular vision of Englishness that crystallized the topical interests and tastes of their Victorian audience.

The trajectories of their respective rises to fame have more in common than is generally supposed. Published as a part-work between April 1836 and November 1837, the Pickwick series became a publishing phenomenon, rising from 4,000 to 40,000 circulation by part 15. Marie was among those who climbed aboard the bandwagon and, like those plugging Pickwick polkas and chintzes, she capitalized on the opportunities for promotion. Her exhibition soon appeared in the *Pickwick Advertiser*, the advertising leaves that were sewn into each issue.

Towards the end of Pickwick's run, in June 1837, King William IV died – a king who had not ascended the throne until the age of sixty-four. His death, while mourned, ushered in the promise of youth in the shape of his niece Victoria. In the pages of the *Pickwick Advertiser*, among the notices promoting india-rubber canvases as endorsed by John Constable, the virtues of 'Kirby's ne plus ultra pins for the hair' were endorsed by the soon-to-be-crowned Princess Victoria. ('With immovable solid head' – one feels that that is how the nation liked its monarchs as well as its hairgrips.) The new Queen also topped the bill in the advertisement for Madame Tussaud's exhibition: 'Her Majesty Queen Victoria the First, Her August Mother the Duchess of Kent, His late Majesty King William IV, the Dowager Queen Adelaide, the King of Hanover, the Duke of Sussex and the Duke of Wellington, with all the leading characters of the day – the whole taken from life – are now added to Madame Tussaud and Sons' Exhibition.' The name of the mysterious and innocuous-sounding 'Second Room' gave no clue to the darker treats in store for an extra sixpence – such as the heads of murderers, the shirt in which Henry IV was stabbed, and the Revolutionary relics. But their common audience in print is but one facet of the intersection between Madame Tussaud and Charles Dickens.

Dickens happened to shadow the exhibition where he lived – first of all when he lived in Furnival's Inn and Doughty Street he was but a stone's throw from the Gray's Inn Road site the Tussauds first rented when they came back to London. Then when he settled in Devonshire Terrace he was on the doorstep of their Baker Street site.

It was here that he wrote *The Old Curiosity Shop*. In this novel the character of Mrs Jarley, the socially ambitious proprietor of a wax-works, is one of his most fully realized portraits of an entertainer. It is also a thinly disguised caricature of his famous neighbour.

Through the output of the ageing Madame Tussaud and the thrusting man of letters we can watch the Georgian era turning into the Victorian one, with a quickening pace and louder volume. We can sense the growth of the mercantile classes made rich by the Industrial Revolution, and can feel a confidence that is almost a swagger as the spirit of Empire fuels patriotism. The anticipation is palpable in the preparations for the coronation of Victoria in 1838. The columns of *The Times* reflect mounting excitement. It became a commercial free for all. There were Royal Victoria pianofortes, coronation medals, facsimiles of the first autograph of Victoria R., and even coronation bonnets. The closer to the day, the greater the number of advertisements offering rooms with views along the route: three windows in Pall Mall were twenty guineas, which made Marie's wax alternative a snip at a shilling. There was an appeal for a Fine Fat Ox weighing not less than 150 stone for a celebratory coronation roast, but the spirit of fatted calf and festivity was apparent in many guises. The Bayswater Hippodrome racecourse – the poor man's Goodwood – invited showpeople to take up booths during coronation week, and a large fair at Hyde Park would bring the usual line-up of gingerbread stalls, giants, Punch and Judys, stilt-walkers and waxworks. There was to be a new crown, which *The Times* described as 'much more tasty [i.e. in good taste] than that of George IV and William IV which has been broken up', and also bigger and better fireworks.

Besides the standard advertisements for her exhibition was the announcement of the publication of Marie's memoirs on 7 May 1838. Over the years she had told visitors 'queer tales' of her time in France, but now, perhaps as part of a ploy to generate more interest in her exhibition – all publicity for the book stated it was available there – Marie launched her official biography, containing, as the advertisement in *The Times* stated,

an account of her long residence in the Palace of Versailles with PRINCESS ELIZABETH (sister to Louis the Sixteenth); likewise a

description of the Manners, Etiquette and Costumes adopted at the court of Versailles, and an accurate delineature of the most distinguished personages who formed its brightest ornaments. Also records of conversations in which Madame Tussaud was personally engaged with NAPOLEON, and most of the remarkable characters who figured in the FRENCH REVOLUTION; all of whom were more or less known to her, and with whom she was required to communicate during that eventful period.

Given Marie's aversion to writing, her mouthpiece was a family friend and fellow émigré, Francis Hervé, who in the preface hinted that depending on the reception of this book Madame Tussaud might be encouraged to produce a sequel about her life in England. Entitled

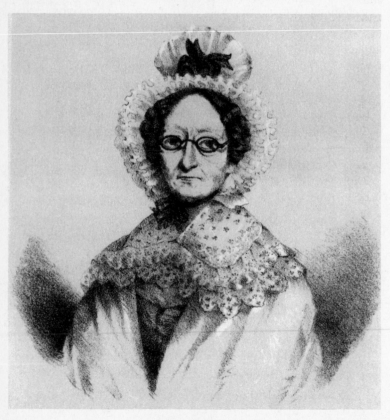

Marie in 1838

Madame Tussaud's Memoirs and Reminiscences of France, Forming an Abridged History of the French Revolution, it promised a detailed autobiographical account of both the last days of the Ancien Regime and the blood-drenched days of the Terror. Pre-publicity in different forms all repeatedly trumpeted her credentials as an authority on the Revolution: 'There are few persons perhaps now existing who can give a more accurate account of all that transpired during the Revolution'.

It came out in a climate of great interest about the French Revolution, which was a consistently popular subject – Carlyle's monumental history of 1837 was enjoying great critical acclaim. But Marie's unique selling point was her first-hand, eyewitness credentials and her proximity to the key characters. This appeal is evident in an article in the *London Saturday Journal*: 'Having read her memoirs, we were much interested in seeing a person who had been on habits of intimacy with so many celebrated characters of bygone times; and we could hardly imagine this lady to be the same little girl who was patted on the head by Voltaire, receiving at the same time a commendation of her beautiful black eyes'.

The Spectator was more circumspect in its appraisal.

> Had her powers of observation been equal to her opportunities, the reminiscences of such a woman must have been highly valuable; but the minds of those persons – as artists, actors, and musicians – whose calling takes them among the great in their familiar moments, are, luckily for greatness, so narrowed, by the demands of their respective arts, that, like Justice Shallow, they only look to 'the limb, the thewes, the stature, bulk and big assemblance of a man', without regard to the 'spirit'. In Madame Tussaud these points are extended by a professional and womanly regard for the costume; and to those who are curious in this way, these Memoirs will furnish forth a pretty tolerable inventory of the dresses of French worthies.

Both she and Hervé are taken to task for accuracy:

> Mr Hervé the editor as he calls himself seems rather a compiler or manufacturer, who has taken down Madame's personal reminiscences and intermingled them with a curt and superficial narrative of the revolution, gathered from the most obvious sources, and not always with the most scrupulous care. Madame Tussaud herself too sometimes

runs counter to general opinions in her gossip, as when she charges Robespierre with being very libidinous and personally corrupt.

Whether as a result of this review or not, it is interesting that subsequent advertisements for the book focus more on the costumes and court protocol than on the personal experiences and history.

The book certainly fuelled the myth of Madame Tussaud as a survivor and witness of the French Revolution, and imbued her with an exoticism that distinguished her from the competition. But self-propaganda was but one aspect of the vast amount of publicity that she generated.

A mark of the exhibition's status as a popular destination was its inclusion in a series of London Fashion Plates by the artist and cartoonist George Cruikshank. The aquatint was captioned 'View in honour of the Coronation. Bazaar, Baker Street, Madame Tussaud's.' Public interest in the thriving exhibition was to be expected, especially given the spectacular stucco splendour of its rooms and the overall effect of chandeliers, glass and gilt. What it looked like is vividly conveyed in a letter from a 'Lady in London' to her 'Niece in the Country' that appeared in *Chambers's Edinburgh Journal*:

> Imagine a room about a hundred feet long (perhaps more), and lofty in proportion, the walls hung with scarlet cloth, which, before reaching the ceiling, is terminated by a ledge running round the whole room; on this ledge are placed, at regular intervals, elegant vases, gilt, with a thick garland of gilt flowers festooned from vase to vase. Over the doorway is a gallery splendidly gilt, filled with musicians who play on various instruments. All the pillars and doors are of white and gilt, which lightens the effect produced by the scarlet walls. The whole place is brilliantly illuminated with gas, issuing from numerous lustres depending from the roof. With all this grandeur, take into account the crowd of figures, animate and inanimate, with which the apartment was filled – some in groups, some standing as if in doubt whether the objects before them were flesh and blood, or merely artificial; every countenance impressed with the feeling of gratified wonder, and looking as if under the influence of a dream.

For Charles Dickens the dreamy splendour of chandeliers and finery exerted less of a fascination than the nightmarish Chamber of Horrors, which he advised entering as if jumping 'headlong into

the sea from a bathing-machine', instead of gradually from the ankle up. He gives us a vivid impression of the melodrama once inside: 'There is Horror in the inflated smiling heads, cast after death by hanging. There is Horror in the basket by the side of the guillotine – a basket just the length of a body without a head, and filled with blood-drinking sawdust. There is Horror in the straps and buckles which hold the victim on the plank till the broad edge descends and does its work.' When he entreats visitors to 'thoroughly master all the circumstances of the Count de Lorges's imprisonment, the serge dress, the rats, the brown loaf – let him then hasten up the steps of the guillotine and saturate his mind with the blood upon the decapitated heads of the sufferers in the French Revolution', one feels that the time he spent in his neighbour's chamber may have helped creative musings that later came together in *A Tale of Two Cities*, as we have seen.

Whether Dickens's proximity to Madame Tussaud's was the main spur for his patronage we cannot know, but certainly we are indebted to him for many allusions to her and her exhibition in both his non-fiction and his fictional writing. His column 'Our Eye-Witness in Baker Street' provides a wonderfully immediate evocation of Madame Tussaud's, and we can sense her signature touches. He describes Marie's meticulous attention to detail of costume, with no-expense-spared accuracy and 'ermine right to a tuft'. 'The bitter disappointment we all feel, at seeing a queen in a Paris bonnet, or an emperor in a glossy hat, does not await us here, where sceptres, and maces, and gold sticks, and state swords, are in every hand that has a right to hold them.' He gives amusing vignettes of country visitors squabbling about the historical facts of the figures they stand before, and through his eyes we see the Bath-bun depot near the Hall of Kings, and sense the anticipation of entering the Chamber of Horrors. His nostrils also register the 'tallowy smell' hanging in the air near the entrance to the waxworks – generated not from within, but from the livestock beneath. Marie was compelled to share premises with the annual Smithfield cattle show, which relocated here in 1841 and became the 'Walhalla of the British agriculturalist'. Never one to miss a commercial opportunity, instead of objecting to her bovine neighbours she realized the rich pickings an annual influx of country visitors

could mean for takings. (More elegant spin-off trade came her way from the Glaciarium. This prototype of an artificial ice rink was set up as a very well-publicized experiment immediately beneath her exhibition. Skaters were promised 'a social and almost festive' experience with not just frozen water, but painted vistas of alpine Lucerne and a band.)

It was not just her exhibition that inspired Dickens: the wily wax-worker herself clearly captured his interest, and sparked his imagination. In 1840–41 the focus of his attention shifted to the personality of the enigmatic foundress when the publication of *The Old Curiosity Shop* put before a mass audience a portrait of a waxworks proprietor that owed much to Madame Tussaud. The 'stout and comfortable' show-woman is introduced in a tone that is part affectionate and part tease, and from the moment she appears her superiority to the other travelling entertainers is stressed. Mrs Jarley is 'discomposed by the degrading supposition' that she knows the Punch and Judy puppeteers. She also dissociates her 'calm and classical' exhibition from the 'jokings and squeakings' and knockabout frivolity of the Punch and Judy show, and later clarifies the precise nature of her upmarket entertainment: 'The exhibition takes place in assembly rooms, town halls, large rooms at inns, or auction galleries. There is none of your open-air vagrancy at Jarley's, recollect; there is no tarpaulin and sawdust at Jarley's, remember. Every expectation held out in the handbills is realised to the utmost and the whole forms an effect of imposing brilliancy hitherto unrivalled in this kingdom.' One feels Madame Tussaud's pretensions are being pricked.

In part 22, that came out on Saturday 29 August 1840, Dickens opens with the observation that 'Unquestionably, Mrs Jarley had an inventive genius.' This sentence is a fair assessment of Madame Tussaud's marketing skills. The Mrs Jarley storyline hangs on her publicity methods, and the description of her attitude to marketing resounds with accuracy when compared with the authentic 'leviathans of public announcement' (posters and handbills) with which Marie broadcast her name. Dickens's readers' familiarity with Madame Tussaud's own advertisements trumpeting royal connections and banning 'improper persons' must have added piquancy to their enjoyment of Mrs Jarley. At

one point Mrs Jarley unfurls various posters and handbills designed for different target audiences. Her arsenal includes such inscriptions as 'One hundred figures the full size of life', 'The only stupendous collection of real wax-work in the world', and 'The genuine and only Jarley'. The most impressive are posters proclaiming, 'Jarley is the delight of the Nobility and Gentry' and 'The Royal Family are the patrons of Jarley'. Mrs Jarley also publicizes her exhibition with verse advertisements, for which she negotiates a hard bargain with Mr Slum, a copywriter whose clients include the ubiquitous Warren's Blacking. Although Marie tended to stick to prose, there were one or two exceptions, such as

Tis a common opinion, and justly believed
That sight, of all senses is soonest deceived.
If a doubt should exist, the most obstinate mind
A perfect conviction might easily find,
While Tussaud's collection of figures remains,
Which from all ranks and ages due praises obtains.
Its merits elude all the force of the pen,
Gives beauty to women, true spirit to men.

and

Her Exhibition still attractive!
Crowded still her promenade!
All resort, or weak, or active
Old or young, or wives or maids.

The ruse of threatening imminent departure, regularly employed by Marie to drum up interest, was not lost on Dickens, and in part 33 Mrs Jarley orders an announcement to be prepared to the effect that the stupendous collection will remain in its present quarters only one day longer. Then when Nell, the heroine, takes this as read, Mrs Jarley immediately shows her another pre-written poster stating that in consequence of numerous inquiries at the waxwork door, and crowds having been disappointed in obtaining admission, the exhibition will be continued for one week longer, and will reopen the next day.

The standard blurb in Marie's catalogue emphasized her aim to 'blend utility with amusement', and to 'convey to the minds of

young persons much biographical knowledge – a branch of education universally allowed to be of the highest importance'. Her interest in the juvenile market was also evident in advertisements which described her memoirs as highly interesting to youth and instructive to the rising generation. Mrs Jarley similarly extols the educational merits of waxwork in her handbills targeting boarding schools, which claim that it was 'distinctly proved that wax-work refined the mind, cultivated the taste and enlarged the sphere of human understanding'. Their objectives and claims are almost identical.

In comparing their practices, the gap between fiction and fact is hardly present. The attention to display, for example, and 'a highly ornamented table for Mrs Jarley herself, at which she was to preside and take the money'. Then the wax figures: 'divers, sprightly effigies of celebrated characters, singly and in groups, clad in glittering dresses of various climes and times, and standing more or less unsteadily upon their legs, with their eyes very wide open, and their nostrils very much inflated, and the muscles of their legs and arms very strongly developed, and all their countenances expressing great surprise . . . and all the ladies and gentlemen . . . looking intensely nowhere, and staring with extraordinary earnestness at nothing.' The vivid and recognizable reality of all these observations suggests Dickens strolling the short distance from Devonshire Terrace to the Baker Street Bazaar, paying his shilling, simply watching a while, taking it all in, and later recalling it to mind with pen in hand.

Dickens gives us enough material to infer what he thought of Madame Tussaud: enterprising certainly, astute for sure, pretentious undoubtedly. There is even a hint of duplicity suggested in his account of how Mrs Jarley recycles certain figures: 'Mary Queen of Scots, in a dark wig, white shirt collar and male attire, was such a complete image of Lord Byron that the young ladies quite screamed when they saw it.' Yet the overall tone is of wit and warmth rather than waspish character assassination. What Marie and her family made of Dickens's character of Mrs Jarley is another matter. Given their rigorous attention to including the leading figures of the day, his omission from their wax gallery when he was unquestionably the

most talked about and widely influential mass-market author is telling. It was not until his death, in 1870, that the man who in different ways had done so much to publicize the exhibition became an effigy in it. He would never know about the honour – and more to the point, long dead, nor would Marie.

15

'The Leading Exhibition in the Metropolis'

IN THE 1840S public interest in the royal family was not dis-
similar to the avid following of the various part-works that
were the nineteenth-century equivalent of soaps, and in which
Charles Dickens was the market leader. Madame Tussaud and Sons
were quick to capitalize. Queen Victoria's marriage to Prince Albert
in 1840 led to a climate of growing affection for the royal couple,
and each event in their lives became a popular tableau. Royalty was
good for takings. The Queen's face graced a catalogue, her wedding
dress of Honiton point lace was copied, and, as a nursery-full of royal
progeny came along, cradles with wax princes and princesses were
cooed over. Then there were the unscripted dramas of assassination
attempts. Advertisements reflect every twist and turn of what would
be a long-running storyline, their abbreviated format a succinct
summary of royal reportage. 'MARRIAGE GROUP – HER
MAJESTY, with the Archbishop of Canterbury performing the
august ceremony', March 1840. 'The Monster Oxford – a full-length
model (taken from life) representing him in the act of attempting
the life of Her Majesty Queen Victoria', 23 July 1840. 'The Prince
of Wales and Princess Royal in their splendid cot', 30 May 1842.
This was royalty as rallying point for fellow feeling, and the Tussauds
developed a type of theme-park patriotism in which they came
to excel.

The annual Smithfield cattle show which took place below
Madame Tussaud's every December literally beefed up their vision of
patriotism. This national event was no mere stroll through a farmyard,
but a display of the very best of British livestock from some of the
finest estates in the land – Earl Spencer's short-horns, Prince Albert's
bulls. It was all about breeding, and the publicity it attracted and the

style of reporting exuded patriotic pride, with an underlying emphasis on the desirability of preserving pedigree, the finest specimens being awarded prestigious prizes. This assertion of the superiority of long lines and skilful husbandry, although referring to animals, correlated with a growing concern in wider society at this time, as an altogether new breed was making its presence felt and causing consternation: the self-made middle classes. The bovine stock downstairs, within smell range of the genteel vision of civility upstairs, was emblematic of separate worlds encroaching on one another. While Madame Tussaud probably didn't much care for the smell of the cattle stall, the dukes and earls certainly found the whiff of new money offensive.

Thackeray coined the present-day usage of the word 'snob' at this time, and in so doing he gave a name to a force that was gathering strength, and which influenced the trajectory of the Tussauds' own success. Snobbery smacks of insecurity, but it is not surprising that the newly wealthy were insecure. With each rung they ascended on the ladder their fear of sliding down increased, and there was also a sense that the ladder was only ever precariously perched against the impenetrable wall of the old order. This insecurity instilled an inferiority complex which powered a quest for acceptance. Self-improvement and material acquisitions were the perceived routes to achieving this, and these were the preoccupations of the vast majority of people who helped Marie and her family to increase their fortune in the 1840s. Her customers were precisely the sort of people Dickens would give life to as the Veneerings in *Our Mutual Friend*, 'bran-new people in a bran-new house in a bran-new quarter of town'. In a world where ostensibly many more doors were open, the Establishment would never be 'at home' to receive them. They were somehow shut out, no matter how much their money.

By contrast, at the waxworks they were always welcome and would meet people like themselves. More potent still was the way that this gleaming salon encouraged them by supplying proof of the power of individuals to rise in the world through their own efforts. If in classical history a pantheon signified a hallowed space for the worship of immortal gods, then Marie's version operated on a secular rather than a sacred plane, and in the last decade of her life the criteria for

inclusion started to change. The contents – always biased in favour of public opinion, not Establishment values – reflected an infiltration by men who had made money, singers and showmen. Military heroes could be found in perturbing proximity to assassins and serial killers. Anticipating the exhibition's future format was the prominence of personalities whose success was self-made, and entertainers enjoying commercial success. By the time Marie died, public taste was moving away from bishops to actresses.

Madame Tussaud and Sons was a place that helped one get one's bearings in a society that was in flux. The railways were but one facet of accelerated living that gave a new consciousness of time. *Past and Present*, a highly influential work by Thomas Carlyle, described a split between nostalgia and novelty that was central to the wax-works, as well as being a preoccupation in wider society. The Tussauds' tableaux of the Kings and Queens of England and noble bards were a reassuring interpretation of English history, but other

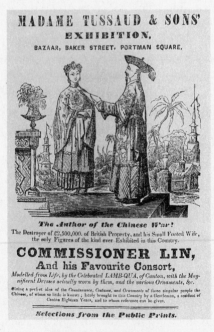

Topical attraction 1841

of their beeswax figures catered to the buzz of novelty, providing brand-new attractions for the likes of the Veneerings. *The Times* described the mix:

> Here are monarchs, nobles, ignobles, the pious and impious, the glorious and inglorious, mingled and mixed together in most strange yet not altogether discordant community. There are the Queen, Prince Albert, and the rest of the Royal Family. The predecessors of her Majesty, Kings George I, II, III and IV and King William IV – here are the Kings of the Stuart line; Oliver Cromwell and the great men of his time; the great, the middle and the little men of modern times . . .

The diverse line-up of contemporaries of interest included some who enjoyed only a relatively short time in the limelight. These included Commissioner Lin and his wife, who came over on a diplomatic visit concerning the Opium Wars and whose elaborate costumes and jewels enthralled their English hosts; Father Matthew, a temperance-movement pioneer; and George Hudson, the railway magnate. As visitors queued, it was less in the spirit of respectful pilgrims, or loyal

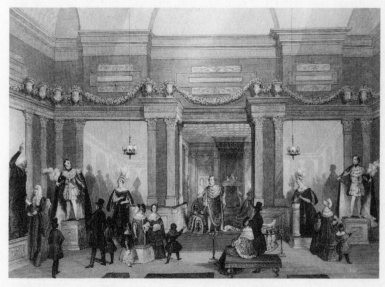

Wax tableau of George IV in coronation robes, steel engraving, from Joseph Mead's *London Interiors*, 1841

subjects, and more as curious fans. Instead of feeling humility before their idols, and awe, they were in many cases looking on them as role models for the power of ambition. But most of all they were simply sight-seeing.

Between 1840 and 1845 Marie, ever astute in gauging what her public wanted, oversaw the restyling of the exhibition with fine art works on a scale that would lend the gravitas of a gallery. Getting away from synthetic pageantry, the Tussauds established themselves as serious collectors, investing in museum-quality pieces of genuine historical interest. Just four words in their ledger, 'Set up George IV', describe their largest investment, though the acquisition of his original corona-tion robes generated a torrent of words from the press. In May 1841 the *Morning Herald* vividly conveyed the splendour of the set:

> The liberality of Madame Tussaud has been largely shown in this add-ition, for she has not only contented herself with costuming the figure in mere mimic apparel, but has actually possessed herself – and she must have done so at no mean cost – of the identical robes worn by that monarch at his coronation festival, robes which cost a generous nation upwards of £18,000! And truly they are vestitures fit for royal shoulders. The figure of the king is exceedingly well modelled. . . . the effect of the sweeping robes about the figure, the ermine and velvet alternating in large masses, is very striking and combined with the other brilliant furniture of the recess, presents a coup d'œil not easily to be matched. In addition to the procession robes there are two others – the purple and parliamentary – lying in careless and graceful heaps on a pair of settees, and beside them may be seen superb models of the regalia and of various other insignia of royalty. The walls of the apartment are decorated with sumptuous hangings and a profusion of gilt devices and richly chased tripods support candelabra, which trans-mit a mellow tinted light over the scene. The general effect is grand and lustrous and embodies to the eye the dreamy impression we have of eastern luxury and magnificence.

But some regarded the way Marie marketed the monarchy as dubious. Dickens for one questioned whether her coronation tableaux did not demean: 'Is there not something compromising to the dignity of royalty in the sale of such wares, and their exhibition in this place?' Thackeray was similarly underwhelmed: 'Madame Tussaud has got King George's

Coronation robes: is there a man now alive who would kiss the hem of that trumpery?' *Punch* objected to the Tussaud acquisition of important royal portraits. As 'part and parcel of a shilling show' they felt the context degraded the image of royalty to the level of pub-sign vulgarity, showing 'no more reverence than the daub of any King's Head that swings and creaks in the doorway of an ale-house'.

Another contentious point was that Marie was not shy about mentioning money: the cost of certain prize exhibits was cited in banner headlines on handbills. To many this confirmed their prejudices that a preoccupation with cost was a proof of her coarseness and inability to gauge the true cultural and esoteric value of an object.

In-house Anglo-French rivalry became more intense in the early 1840s with a concentrated spree of buying Napoleonic relics. A substantial number of these were sourced from the Emperor's brother, Prince Lucien, culminating in the opening of a dedicated room at the exhibition. The memorabilia on show ranged from the mundane, such as the Emperor's underwaistcoat, drawers and Madras handkerchief, to the magnificent, such as a bust by Canova and the Jacobe cradle made for Napoleon's son. Highlighting the difference between a conventional display of *objets d'art* and the human-interest spectacle that Marie knew wowed the crowds, a wax model of Napoleon's infant son copied from a portrait by Gérard was placed in the cradle. The Napoleonic nativity was complete. Reviewers singled out for praise the cloak worn by the Emperor at Marengo and which had served as his shroud, on St Helena. Others were prompted to comment on the relic phenomenon: 'Behold little more than twenty years after the wearer's death the cloak of Marengo becomes a curiosity in a show!' And the opportunity was taken for a jibe: 'The first impression of the visitor is how plain and even rude most of the furnishings are, showing how far the French workman of thirty years ago was behind the English one in such matters, as we believe he is still.' Rather than knocking the French, Marie and her sons published some posters in French advertising the Napoleon collection, in a spirit less of entente cordiale than of astute marketing of an attraction that was likely to be of great interest.

The addition of *objets d'art* and relics and the emulation of a museum setting were a calculated move upmarket, helping to assert the Tussauds' authority as leaders of that tier of entertainment that

bridged the gap between the stuffy formality of glass-case culture and the frivolity of the fair. Exemplifying the difference was their prize exhibit in the Napoleon rooms, the coach that had been captured at Waterloo. It was a comeback career for this carriage, which had been so phenomenally successful when William Bullock had taken it on a national tour. Happily it had lost none of its appeal, and Dickens was one of those who took the chance to test-drive it at the Tussauds'. He conveyed the great appeal of climbing into Napoleon's travelling carriage to 'plant one's own humble posterior in the seat of greatness'. 'It is a noisy jingling process though, the getting into this conveyance – and is not done without attracting the attention of everybody in the room; so let all modest and embarrassed persons think twice before they attempt it.' This hands-on element was a key part of the Tussauds' magic, and one of the most striking things about their rooms was how lively they were – a far cry from the hushed, hands-off culture of dusty and dismal museums, with officious guides making visitors feel small.

It was a successful strategy, and it shows the Tussauds spanning a gap that was becoming more serious in the minds of the moral crusaders on both sides. On the one hand the British Museum had for years showed a stubborn reluctance to admit the general public at all, but when it did it was adamant that it was not going to cater to their comfort. On the other, the moral crusaders had become more evangelical throughout the 1840s in their efforts to suppress the fairs. Unbridled pleasure such as Dickens found at Greenwich Fair and described as 'primitive, unreserved and unstudied' was in his mind part of fairs' appeal. But his view of the fun of the fair was a minority one. Killjoy propaganda escalated at this time. On one poster, the answers to the rhetorical question 'What harm is there in going to the fair?' leave the reader in no doubt of the moral and physical dangers: 'Ask at the workhouse – fairs promote idleness. Ask at the hospital – fairs are the haunts of vice: vice produces disease. Ask at the penitentiary or any other asylum where poor girls with ruined characters find a shelter from reproach and shame. Ask at the madhouse – drunkenness is a common vice at the fair. Ask at the prison – for fairs lead to felony.'

Marie instilled into her sons the importance of catering not just for the interests of customers, but also for their comfort. Their attention to giving visitors an enjoyable experience helped to cement their

reputation. Cultivating the public's regard in this way may seem obvious, but it was not to the National Gallery, the British Museum, Westminster Abbey and St Paul's. The idea of public relations was anathema to these national institutions. For years, even getting into the Zoological Gardens in Regent's Park meant a rigmarole of advance planning, requiring the backing of a member of the Zoological Society, and people joked that going to see a boa constrictor on a Sunday was almost as difficult as getting a box at the opera. The snooty stance of the learned fellows paved the way for some commercial competition in the form of the resoundingly successful Surrey Zoological Gardens. Here the general public could roam freely in expansive surroundings, and were fed and watered and given plenty of stimulating activity besides the very real pleasure of looking at the animals. Entertainments included regular pyrotechnic displays and such sensational acts as the wonderful Russian air voyagers, performing daredevil aerobatics while strapped on to the sails of a windmill.

The proliferation of these sorts of enterprise was in no small measure due to the obstructive attitude of the previous decade. Sir Humphry Davy had fired a warning shot in a letter to the *Literary Gazette* in 1836 about the woefully inadequate management of the British Museum. He urged a rethink in everything to do with 'this ancient, misapplied and I may almost say useless institution. In every part of the metropolis people are crying out for knowledge, they are searching for her even in corners and byways and such is their desire for her that they are disposed to seize her by illegitimate means if they cannot obtain her by fair and just ones.' Before the word existed, and the concept had been properly grasped, one can see the germination of the market for educational tourism, or infotainment as the trade term it. Marie showed a visionary understanding of the dynamics of mass-market entertainment that continues to keep the exhibition she founded one of the most famous tourist destinations in the world.

Her nineteenth-century rivals were not so enlightened, and class prejudice was rife. The title of an article in the *Literary Gazette* in 1819 exemplified deeply engrained prejudice: 'Admission of the Lower Orders to Public Exhibitions'. Cultural apartheid prevailed until the 1840s, and Marie and her sons may be said to have been enlightened trail-blazers. At one point the National Gallery even proposed that

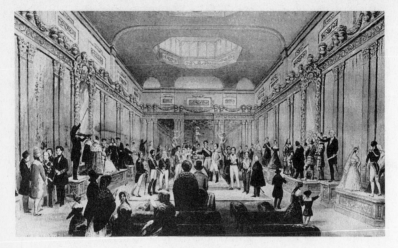

Ottomans, an orchestra, and unrivalled customer comforts, interior,
Madame Tussauds

admission of the public should be contingent upon literacy, with
tickets given on proof of visitors' ability to write their name – 'It may
safely be affirmed that fine pictures can afford no instruction to those
who cannot.' At the British Museum, admission in the pre-reform
dark ages was determined by dress, the dress code being, one
imagines, a highly subjective interpretation of 'decent appearance'. In
a debate about whether to admit the general public on national holi-
days, one member of the British Museum committee objected that
'People of a higher grade would hardly wish to come to the museum
at the same time with sailors from the dockyards and girls whom they
might bring along with them.'

Even post-reform, although it no longer restricted visitor intake
to 120 a day, the Museum was almost defiant in the degree to which it
refused to consider the comfort of its customers, and it almost prided
itself on the lack of facilities. No indoor water closets or refreshments,
no browsing without an official guide, an insistence on Latin
classification – all were part of the mantle of obscurity and elitism seen
as necessary to protect its assets from philistines. These deficiencies were
all absent at Madame Tussaud's exhibition, where an informative cata-
logue, refreshments, plentiful ottomans to rest on, and background

music all enhanced the visitor's experience and encouraged repeat visits. Although the British Museum was free, visitors felt short-changed – which was seldom the case at Tussaud's. She also compared favourably to Westminster Abbey and St Paul's, which came under fire for taking a commercial and exploitative approach to visitors, hustling them around at great speed, and charging fees for all the separate historical sights within. In fact Madame Tussaud was invoked in an article which expressed violent objection to the rip-off that was a trip to St Paul's.

> This tariff [twopence admission, but with successive fees throughout a tour adding up considerably] it is manifest has been arranged with a shrewdness that would not discredit Madame Tussaud, nor any other adroit manager of an exhibition, the entire spectacle being distributed into parts none of which affords the visitor too much amusement for his money, whilst each decoys him onward from the previous sight to fresh wonders and expenditure.

To have become a byword for commercialism was a back-handed compliment. But Marie did not really do compliments. When requested to use her considerable talent to restore some of the more decrepit wax figures of historical interest at Westminster Abbey, which many would have regarded as an honour, she was quite huffy. Her great-grandson had it that a favourite family anecdote of their famous forebear was her tart reply when approached by a crusty cleric with this request for renovation: 'Sir, I have a shop of my own to look after and I do not look after other people's shops.'

In the first half of the 1840s, while the exhibition went from strength to strength, Marie was ambushed by a communication from her seventy-two-year-old husband. Age had not curbed his opportunism, and evidently the phenomenal success of his wife's exhibition in London had filtered back to him. So far as we know she had had no news of him since 1808, and he wrote to Marie using a London-based French colleague, a widow called Madame Castile, as a courier to get the letter to her. His pretext was breathtakingly audacious, given the silence between them, for he wanted to pursue the legitimacy of his claim, as Marie's legal husband, to the inheritance that Curtius had been chasing all that time ago and which had never been resolved. In order to pursue this claim, he needed from Marie a

renewed power of attorney. Madame Castile made it clear that his suit had not been well received: 'She appears to hold against you certain very grave reasons for dissatisfaction since in the first place she seemed not at all pleased to hear from you and told me that she had transferred all her possessions to her sons.'

To say that Marie was not pleased to hear from her husband must have been an understatement, for presumably his approach raised the much more worrying threat of other claims he might make in the future, the most alarming being his potential claim on the profits of the London exhibition. If he had not already thought about this, then he was given an indication of the sheer scale of his wife's success when Madame Castile informed him, 'You can write to her at this very short address – Madame Tussaud's, as your wife is very well known in London. It is impossible to describe the beauty and richness of this exhibition – in all my life I have never seen anything more magnificent.'

Joseph and Francis – by now whiskery middle-aged gentlemen – rallied to their mother's defence and gave their father short shrift. In a curt reply, they jointly informed him that any further correspondence would be unwelcome, and to deter him from future badgering they asserted their ownership of the exhibition. They were all too aware that if Marie predeceased François (which was fairly likely, given her eight-year seniority to her husband) there would be legitimacy in any claim he made to inherit the London exhibition. To secure their position, Marie resorted to the legal profession she loathed and signed articles of partnership between herself and her two sons.

In December 1844 the family friction is all too evident:

> You left mother in debt and difficulty in London, all of which she over-
> came by hard work and perseverance, without asking from you one sou
> from your own pocket. Up to the present time you have not sent any
> money to help her. On the contrary you have sent her no details of her
> business, and the profits from that business, of which you alone have
> had the benefits for many years. We believe, with mother, that she has
> no reason to have any regard for you, who have treated her in such a
> way. I can assure you that every time you write, mother becomes ill
> and above all when you write that you will come and see her. It is too
> ridiculous for words.

But there was no graceful retreat from François: he remained a thorn in the family flesh until his death. Until then, letters continued to cross the Channel with requests and pathetic demands for money – all being met with stern refusal.

Anger at François was tempered with filial concern, however, and before his death, in 1848, they relented and loaned him some money. They also visited him in Paris – much to Marie's irritation. According to family history, Marie's opposition was so great that Joseph dared not venture into the same room as his father, and satisfied himself with a furtive glimpse of the frail old man from behind a screen. Marie's apron strings were long, but it was also with her purse strings that she attached her two sons.

Behind-the-scenes family feuding did not interrupt the prodigious productivity at the exhibition. In *Lectures on Heroes and Hero Worship*, Thomas Carlyle had in 1841 described history as 'but the biography of great men'. Proving that they were ever attuned to the Zeitgeist, the Tussauds had launched one of their most ambitious historical displays. Topping the bill for Christmas 1845 was the 'House of Brunswick at one view', a chronological pageant of monarchs and historical figures from George I to William IV, as a sumptuous context for the coronation robes of George IV. Adding a further dimension to the pageantry of the past were the insignia of 'The British orders of the Garter, Bath, Thistle, St Patrick'. While the House of Brunswick boomed, however, the House of Tussaud was feeling the strain, especially the materfamilias.

Her sons' contact with their father had exacerbated Marie's distress at hearing from him again. There was new pain in old wounds. One of the most revealing likenesses of her is a powerful portrait in chalks from this period. Owned now by the National Portrait Gallery, it stands out from other portraits commissioned for public display for its unflinching and unflattering portrayal of an old woman's face. She has a fierce frown. Her mouth is downturned; her cap droops around her ears; her top lip has disappeared like a sulk. It is all downbeat. These are not the glass eyes of Madame Tussaud's wax self-portrait, but expressive eyes. Unlike the bespectacled matriarch at her desk in the famous Paul Fischer work of 1845, this face feels private. This is not a formal composition but an unguarded study, and seems to capture

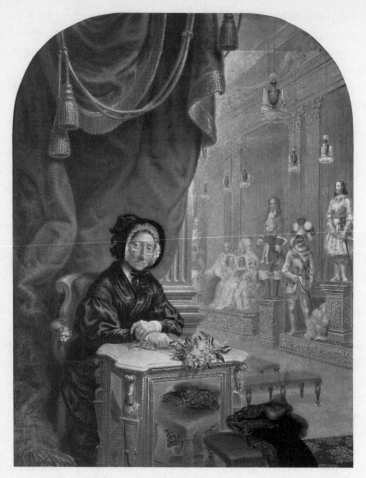

Her public image: Formal portrait of Madame Tussaud by
Paul Fischer, 1845

the vulnerability behind the tough exterior. The beady-eyed money-
counter, the brilliant eye of the artist are not here; instead there is dis-
appointment. The eyes convey lack and loss. Interpreted in light of
what we know about Marie's life, this single image is a stark reminder
that she was a woman who never knew who her father was, a moth-
erless woman who never saw and never mentioned her mother from
the moment she left France, a woman who lost a daughter and left

A private view: Marie Tussaud by Francis Tussaud

behind an infant son. Most telling is that this portrait is by the man that the abandoned child became – as a character study of his mother, it is tough matron, not soft mother, and reminds us of the pain behind her professional success, of pain she caused and suffered. Possibly exploited by Curtius, who had relied on her more and more in running the exhibition, she was certainly exploited by her husband and by Philipstal. Her sons' visit to their father who had treated her so shabbily must have felt like disloyalty that was all the more painful for someone unused to loyalty inspired by love. In fact the overarching feeling is that Madame Tussaud, having been deprived of experiences of loving and giving, was probably not very loving or forgiving herself. And she had been soured by exposure to the worst depravity of man, having experienced the slip-slop of human carnage beneath her feet during the Revolution, and in Bristol having witnessed wild-eyed anarchy and arson. Though the work of love seems not to have come easily to her, the impersonal hard graft that led to a long-standing and successful rapport with her public seems to have been different.

It never seemed to be for herself but always for the fruits of her hard labour that she attracted the attention of a man. For, as well as there being an avaricious husband circling around her success, Marie's exhibition came into the sights of the American showman Phineas Taylor Barnum, whose beady eye for hits quickly fell on her gem. Barnum had made his English debut in Liverpool, where he caused a sensation with Tom Thumb (aka Charles Sherwood Stratton), a young boy whose restricted growth gave him the appearance of a perfectly proportioned miniature man. Tom Thumb was launched in London in 1844, and he captivated all who saw him – including the Queen and members of the royal family when, in what was one of his biggest coups, Barnum took him to Buckingham Palace. The Queen's enchantment was such that they were invited to return, and as a regular visitor Barnum invested in a court suit for Tom. But not everyone approved. There was a disturbing undertow to the presence at Buckingham Palace of a court dwarf, and even the Prime Minister, Robert Peel, was concerned. Thomas Hood was 'revolted by the royal running after the American mite', and Dickens, in a satirical reply, declared that the royal patronage of the diminutive star was a threat to the constitution. He joked that the Queen was so taken with Tom that, 'soon in the two little porticoes at the Horse Guards, two Tom Thumbs will be daily seen, doing duty mounted on a pair of Shetland ponies.'

The serious underlying message was the stigma of philistinism in the Queen. Her enthusiasm for Tom Thumb and various popular entertainments was at odds with the increasing concern of the middle-class core of her subjects that pleasure should be allied to learning. Of course, at Madame Tussaud's the agenda was never in doubt. Marie's loyal public subscribed pretty much wholeheartedly to her professed educational aims. The *Pictorial Times* in 1844 wrote, 'Madame Tussaud's great merit and strongest claim consist in the fact that, aware of the influence which exhibitions exercise upon the public taste, her arrangements have always been made with a view to refine the mind, extend the knowledge and exalt the sentiments of her visitors.' Her pedagogical packaging was so artful that it successfully disguised the contents. With her usual foresight, Marie ensured that Tom Thumb took up his place in her exhibition, so that she too could

make money from the public fixation with the quick-witted little boy with the huge talent for impersonation and amusing patter.

Tom Thumb unintentionally caused one of the biggest culture shocks of the century. The historical painter Benjamin Robert Haydon was actually unhinged by the constant crowds for Tom Thumb compared to the cavernous emptiness of his own exhibition in the next-door room at the Egyptian Hall. On 21 April 1846, he took out an advertisement in *The Times*. Headed 'The exquisite feeling of the English people for high art', it noted that 'General Tom Thumb last week received 12,000 people who paid him £600; B. R. Haydon who has devoted 42 years to elevate their taste was honoured by the visits of 133 and a half (child) producing just £5 13 and 6.' In private he poured his pain into his diary: 'They push, they scream, they faint, they cry help and murder and oh and ah! They see my bills and my boards and don't read them. Their eyes are open, their sense is shut. It is an insanity, a rabies, a madness, a furore, a dream.' Shortly afterwards he cut his throat and shot himself.

This tragedy exposed a dichotomy that was becoming more pronounced and a matter of public debate – a growing conflict between commercial culture and its more orthodox forms. Could instruction and amusement be mixed? Were crowds compatible with culture? Were the barbarians getting too close to the gate? The debate touched Marie and all those who were part of a growing phalanx of entertainers making fortunes from middle-class taste. They trod a precarious path between being taken seriously for their educational aims and being dismissed as tacky money-grubbers.

You could not be in London long before realizing the popularity of Madame Tussaud, and Barnum clearly recognized a fellow genius for publicity. His facility for hype and spin matched hers. He similarly played the press, and always dressed up his entertainments for maximum appeal to an increasingly discriminating middle-class market. His exhibition was not a museum but 'a Cyclopaedical Synopsis of everything worth seeing and knowing'. A club of uncertain provenance became the weapon that killed Captain Cook, and so on. In his autobiography Barnum refers only *en passant* to his failed attempt to buy Madame Tussaud's, but the Tussaud family history corroborates his interest. In 1890 Barnum sat for Joseph Theodore Tussaud, a great-grandson of

Will most Positively Close on Wednesday,
Sept. 10th, 1845.

RICHARDSONS'

ORIGINAL MONSTRE

ROCK BAND

EGYPTIAN HALL,
PICCADILLY.

PERFORMING DAILY,

FROM 12 TILL 5, AND FROM 7 TILL 9 IN THE EVENING.

THE INVENTOR'S APPEAL TO THE PUBLIC:

I have employed thirteen years in completing this production. Men of
science have proved that the greatest pleasure we are capable of attaining
is, that our being sensible that we are of some use to society.

A Victorian rock group

Marie's. Apparently, at this sitting Barnum related how, many years
before, he had tried to induce his grandfather to transport Madame
Tussaud's exhibition to New York, but the negotiations had fallen
through at the last minute. One imagines that Marie, after all her expe-
riences with Philipstal and with her husband, would have been
immensely resistant to relinquishing her life's work to a fast-talking,
fast-thinking American showman whose flash-trash philosophy was so
very different from her own more refined style.

Marie and her family's success in distinguishing their own attrac-
tion was all the more remarkable given the competition they faced
from a burgeoning sector of commercial entertainments catering to
middle-class consumers in search self-improvement. London boasted
an impressive array of purpose-built pleasure resorts, and at this time
one can see cranking into being the prototypes of the amusement park
and the tourist attraction. At the Colosseum a novelty was London's

first ever passenger lift, or 'ascending room', described as a 'small covered room which will contain from 10–20 persons and may be raised by secret machinery with its company to the first gallery'. If this was the height of sophistication at the Polytechnic Institution, which took a theme park approach to science, a ride in a diving bell offered a new depth of learning. But the Egyptian Hall remained unbeatable for sheer variety under one roof. Featuring in one programme were a group of Obijawa Indians, who enjoyed immense success, and Richardson's Rock Band, 'the instruments of which are cut from solid rock'. The rock group comprised the mason, who had spent thirteen years making the instruments, and his three sons. The Egyptian Hall took pride in presentation, and created special effects with great panache. A contemporary sets the scene: 'The astonished visitor is transported in an instant from the crowded streets of the metropolis to the centre of a tropical forest in which are seen as in real life all its various inhabitants from the huge elephant and rhino to the most diminutive quadruped.' Of course, lest there be any suspicion that this is just fun, he continues, 'Juvenile minds will be taught a lesson beyond calculation valuable; they will behold in the great volume of creation, the works of an all-wise providence and the lesson will be indelibly impressed on their minds.'

Another element in the appeal of these pleasure domes was social. Although Marie had pioneered the promenade concert, others were beginning to cotton on to the concept. Dickens described a gala night at the Colosseum which could have been choreographed by Marie: 'The band was stationed in the Egyptian tent; the hall of mirrors superbly ornamented and illuminated served for the principal promenade.' His account of the paying guests is almost pure Jane Austen: 'Matchmaking mammas in abundance – sleepy papas in proportion – unmarried daughters in scores – marriageable men in rather smaller numbers – greedy dowagers in the refreshment room – flirting daughters in the corners and envious old maids everywhere.'

Madame Tussaud was not always the subject of positive publicity. The advent of two new illustrated periodicals in the early 1840s, the *Illustrated London News* and *Punch*, extended her publicity network. But whereas the former tended to be positive towards her exhibition – it once likened her wax doubles to getting a personal introduction to

the famous – the latter was relentlessly critical, and throughout the final decade of her life she was a constant target for amusing jibes.

A persistent erroneous belief is that *Punch* coined the name of the Chamber of Horrors. In fact the name was generated in-house, and was first used in advertisements in the *Illustrated London News* in July 1843. The price of admission to 'Napoleon and the Chamber of Horrors' was listed as sixpence. *Punch* took up the name much later, in 1846, when it mentioned it in an article on a newly launched tableau. It had taken offence at a poster advertising 'a magnificent display of court dresses of surpassing richness, comprising 25 ladies and gentlemen's costumes intended to convey to the MIDDLE CLASSES an idea of the ROYAL SPLENDOUR, a most splendid novelty and calculated to display to young persons much necessary instruction'. Given the economic slump that was affecting much of the country, with a large proportion of the population suffering real hardship, *Punch* felt this new exhibition was jarring. Such superficial pretensions were especially inappropriate given the great influence of the exhibition, and a misguided application of the educational function in which the Tussauds took such pride – it was this that formed the thrust of *Punch's* objection. Under the heading 'Great moral lesson at Madame Tussaud's' it launched its tirade. 'Know all men, that Madame Tussaud has come out as a great public teacher. She has converted her exhibition in Baker Street into an educational institution, and has resolved herself and her sons into a Society for the Diffusion of Useful and Entertaining Knowledge.' It then quoted ver-batim her advertisement, before going on, 'If we were in the place of Madame Tussaud we would superadd to our collection some twice twenty-five of more shabby old working dresses, of surpassing uncouthness, intended to amuse and instruct the superior classes by giving them an idea of laborious indigence.'

The article's last paragraph was the one that fixed the Chamber of Horrors in the national phrase book. The phrase had been used without irony by the Tussauds, but here the context was entirely sarcastic:

> The collection should include specimens of the Irish peasantry, the hand loom weavers, and other starving portions of the population all in their characteristic tatters; and also inmates of the various work-houses in the ignominious garb presented for them by the Poor Law.

But this department of the exhibition should be contained in a sepa-
rate Chamber of Horrors and half a guinea entrance fee should be
charged for the benefit of living originals.

Over the years, allusions to Madame Tussaud – some mean, some
affectionate – peppered the pages of *Punch*. The constant references
were as much as anything a sign of the exhibition's status in public life,
for by the mid-1840s it was regularly being referred to in the press as
'the leading exhibition of the metropolis'. Today at Baker Street
Underground station there is a pre-recorded announcement: 'Alight
here for Madame Tussauds' – the only commercial attraction so hon-
oured. But even in Dickens's time its status as a landmark was firmly
established:

> Visitors from the country go to see these waxworks if they go nowhere
> else; tradesmen living in the neighbourhood put 'Near Madame
> Tussaud's' on their cards; the omnibuses which run down Baker Street
> announce that they pass that deceased lady's door, as a means of getting
> customers; and there is scarcely a cab horse in London but would make
> an instinctive offer to stop as he went by the well known entrance to
> 'Tissards' [*sic*].

It was a much-loved institution, so closely identified with London that
it defined tourist itineraries. To 'do' London was to visit Madame
Tussaud's. A charming story is told of a first-time Russian visitor to
Victorian London whose entire stock of English comprised nine
words: 'St Paul; Evans, chop, song, supper; Thames Tunnel; Tussaud'.
(Evans was a famous music hall, as renowned for robust English food
like chops and kidneys as for songs.) Of these attractions, only St Paul's
and Madame Tussaud's remain. Madame Tussaud's exhibition had
become cultural wallpaper.

16

Bringing the Gods Down to Earth

MARIE DID NOT merely chart the fame of others: in the final phase of her life she herself attained a new level of recognition in the public arena. Publication of her memoirs, immortalization by Dickens, the commissioning of her portrait by Paul Fischer (whose other subjects included members of the royal family) and a famous Cruikshank cartoon, 'I dreamt that I slept at Madame Tussaud's', helped to increase her public stature. References to her on the London stage, songs such as 'Madame Tussaud's, or a Row Amongst the Figures', and an almost perpetual presence in the pages of the press – most frequently in the new generation of illustrated periodicals – all paved the path to her becoming a national institution.

She herself was the focus of public interest and increasingly identified with the exhibition, while her large family unobtrusively assumed their place in the wealthy middle class. They dwelt in self-consciously impressive suburban splendour, but lived for their work. Joseph and Francis provided their children with expensive educations in unquestioned preparation for them to join the family business, with the aim of furthering the fortunes of an entrepreneurial dynasty that was already outstandingly successful by the time Marie died. They were upright members of society and supporters of good causes – including the temperance movement – and they inspired loyalty in the few employees who were not family members. How proud Marie must have been when in 1847 her sons became naturalized British citizens, with the sponsorship of Admiral Napier, the MP for Marylebone, a distinguished naval officer whose wax figure was on display. This was a ringing endorsement of the family's respectability.

An undated family group in silhouette, made by Joseph, has them standing apart in a formal arrangement, with Elizabeth, his wife, in

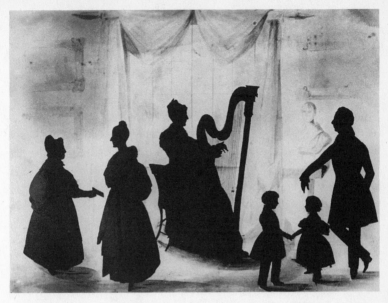

Before the family photograph album: silhouettes by Joseph Tussaud

the centre playing a harp, as Francis looks on, the tailoring of his frock coat lending him elegance. But it is not him as the paterfamilias figure who is the kingpin of the piece: it is the redoubtable matriarch on the left-hand side, a small well-rounded figure in her trademark bonnet and lace collars, her hand extending an exhibition catalogue to a graceful woman – possibly her other daughter-in-law, Rebecca. Silhouettes use darkness for definition, and so it is with the family. There is virtually no material that allows us to penetrate their private lives. Even in this picture the background drapery, pedestals and bust of Napoleon suggest the interior of the exhibition; even this is not the family at home. We only ever see them in the outline of their public achievement – especially Marie, who, approaching her eighties, showed no sign of relinquishing her control of the business.

Fortunately we have a good eyewitness description of what she looked like in her London years from Joseph Mead, author/publisher of *London Interiors*: 'She possesses a small and delicate person, neat and well-developed features; eyes apparently superior to the use of a pair

of lazy spectacles, which enjoy a graceful sinecure upon her nose's tip. Line upon line, faintly, but clearly drawn, display upon her forehead all the parallels of life. Her manner is easy and self possessed and were she motionless, you would take her to be a waxwork.' Age did not dim her eye for business, and, from improvements and additions to advertising, nothing in the day-to-day running of the exhibition happened without her sanction. Her sprightly manner was remarked on by the *London Saturday Journal*: 'Though nearly 80 years of age, being born in 1760 [Marie, whether forgetfully or not, always gave the wrong year for her birth], she does not look more than 65 and bids fair in this respect to rival her maternal ancestors who she tells us were remarkable for their longevity.'

She made a lasting impression on visitors. Enveloped in what one of them called 'her veritable black silk cloak and bonnet', bespectacled and sitting from dawn until dusk at the cash desk with a pile of catalogues by her side, she became part of the exhibition, a permanent display. She was the first person whom people encountered when they came to the anteroom at the top of the stairs.

An American visitor whose recollections were published in a memoir, *What I Saw in London*, wrote:

> We entered the saloon in Baker Street through a beautiful hall richly adorned with antique casts and modern sculptures, passed up a flight of stairs magnificent with arabesques, artificial flowers and large mirrors and halted at the entrance door to deposit our fee into the hands of the veritable Madame Tussaud herself, who sat in an armchair by the entrance as motionless as one of her own wax figures. It was well worth the shilling just to see her.

Another visitor reported, 'Here sat the venerable Madame Tussaud herself, at the receipt of custom. Having paid our shilling she beckoned to a door of a looking glass and on opening it what a sight presented itself. Figures of the size of life, of all ages and of all countries were grouped about the room – some of them of such intense resemblance to life as to be quite startling.' Another visitor recalled her 'bowing to the company as they came in and out'.

Elsewhere it was her conversation that was remembered, accented in a distinctive Germanic-Gallic mix. She never spoke more than

broken English. Before her memoirs came out, many people commented on the fact that 'Madame Tussaud often talked about her life in France.' The stories of her life at Versailles, teaching Madame Elizabeth, her time in the Terror and meeting Napoleon were all trotted out. The claims she made in conversations with visitors to the exhibition percolated into the papers. A *Times* reporter recalled her account of how Curtius and she had been resident in Paris during the horror of the Revolution and, 'as the lady herself declares, employed by the authorities of those days to make many of the likenesses now exhibited'.

The London where Marie was nearing the end of her life was frantic with change and unrecognizable from the city she had left to embark on her travels all those years ago. Gaslight and gilding, acres of glass, particularly in the showrooms of shops, all vied to attract consumers. These changes did not go unremarked by the press. In 'A Paper on Puffing [i.e. advertising]', an anonymous writer for *Ainsworth's Magazine* of July 1842 asked, 'Is the transition from the barber's pole to the revolving bust of the perruquier, nothing? – The leap from the bare counter-traversed shop to the carpeted and mirrored saloon of trade nothing? Are they not, one and all, practical puffs intended to invest commerce with elegance and to throw a halo round extravagance?'

In *Past and Present*, in 1843, Thomas Carlyle railed against the rise of advertising:

> The Hatter in the Strand of London, instead of making better felt-hats than another, mounts a huge lath-and-plaster Hat, seven-feet high, upon wheels; sends a man to drive it through the streets; hoping to be saved *thereby*. He has not attempted to *make* better hats, as he was appointed by the Universe to do, and as with this ingenuity of his he could very probably have done; but his whole industry is turned to persuade us that he has made such. He too knows that the Quack has become God.

As the art of selling became more sophisticated, Victorian advertisers rose to the challenge. The tailors Moses and Sons took copywriting to new heights: 'When ever I'm in want of dress, I always buy at M&S.' Others took a more literary approach:

To eat or not to eat,
That is the Question.
Whether 'tis better to be unprovided at routs,
Assemblies or pleasure parties,
Or to obtain Hickson's Prepared Anchovies
And have the choicest sandwich.

If culverts and cuttings for the railway were disfiguring great chunks of London, other defacements were to be found on walls. Because taxes on newspaper advertising were still prohibitively high, handbills and posters were the preferred medium for those wanting to promote their wares. Advertising mania became a pet topic in *Punch*: 'They are covering all the bridges now with bills and placards. They will be turning the bed of the river next into a series of four-posters.' It was as if Marie was being caught up with, for she had always advertised heavily. Her advertisements were among the first to adorn the sides of London's first mass-transit service, Shillibeer's horse-drawn

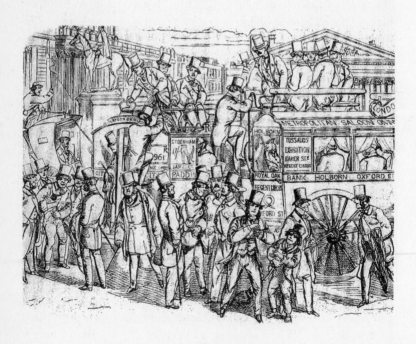

Omnibus with advertising

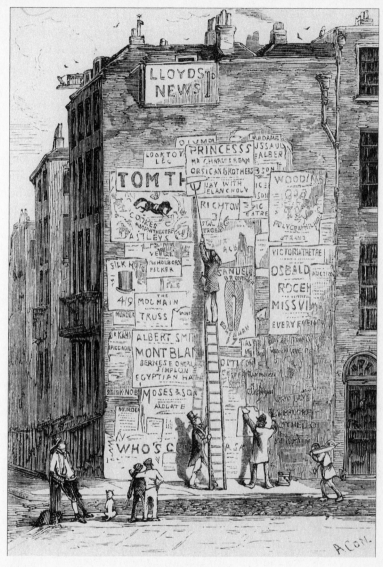

An Old Bill Station

'The Ambulatory Advertiser', drawing by George Scharf

omnibuses, and a sign of her prolific publicity is that in prints of the streets of London from this period you can nearly always discern her name on heavily covered walls. From giant hats and balloon bombardment of flyers to sandwich men and bill-stickers, more attention than ever was being paid to publicity, and London in particular was in the grip of an aggressive advertising boom.

As Marie was slowing down, life around her seemed to be speeding up. Society seemed to be hurtling towards the future. The accelerated rate of technological innovations affected the mobility of people, things, information and ideas, and all these developments were a catalyst for radical developments in how people enjoyed themselves, and the forms their pleasures took. With the penny post, penny-a-mile travel by third-class rail, and the proliferation of affordable reading matter, there was a growing bank of shared information.

Regional differences began to dwindle, traditional class barriers weakened, and a common cultural frame of reference emerged – substantially as a result of the rise of the press, but also influenced by popular fiction, the most influential mass medium of the Victorian age.

Dickens had blazed the trail in this regard. In 1847, writing on Dickens's fame, a contemporary noted, 'It started into a celebrity, which for its extraordinary influence upon social feelings and even political institutions and for the strength of regard and even warm personal attachment by which it has been accompanied all over the world, we believe is without parallel in the history of letters.' Thackeray also enjoyed the fruits of fame, writing to Lady Blessington, 'I reel from dinner party to dinner party. I wallow in turtle and swim in claret and shampang [sic]'.

Paradoxically, the more homogenised culture became, the more the cult of admiration for specific individuals grew, and there was also a more effective network through which to share the communal abhorrence of and fascination with murderers. Marie harnessed these currents of change to her own advantage and, pandering to an emerging mass market, rose in old age to the heights of her renown.

The cult of admiration was a by-product of an increasingly self-conscious society in which preoccupation with how one appeared in public was accompanied by a new interest in the status achieved by others. People held in high regard began to play a role in consumerism. To start with, aristocrats and clergy were the unlikely promoters of products in the pages of periodicals. The long list of named patrons recommending Mr Cockle's Antibilious Pills included ten dukes, five marquises and an archbishop; the 'many persons of rank and fortune' who corroborated the benefits of the British Antisyphilis treatment understandably preferred to remain anonymous. Gradually, from the nobility and gentry being the principal endorsers, other notable people became a source of personal recommendations.

In 1845 Marie herself featured in a celebrity endorsement of a health-giving tonic, promoted as curing an impressive list of ailments, including Indigestion, Flatulence, Head Ache produced by Indigestion, Sickness, Dropsy, Fits and Spasms (a sure cure in three minutes): 'Madame Tussaud of Baker Street, Portman Square, has much pleasure in giving testimony to the great benefit she has received by taking the Elixir Sans Pareil during the last seven years.' Elsewhere she endorsed a firm of dyers.

The greater use of famous people to sell a vast range of consumer goods is reflected in Marie's own catalogue, which by 1844 had a circulation of 8,000 copies a quarter, rising to 10,000 three years later.

Her 'biographical sketches' are flanked by advertisements. Amid the endless ads for Ventilating Hats and Invisible Hair are notices for Nelson's Gelatine, Royal Victoria Carpet Felting, Albert Cravats and the Wellington Surtout, a 'new, light, repellent overcoat for all seasons'. Elsewhere, Napoleon was being used to promote various products including shoe blacking and ink, and the showman–strong-man–explorer Belzoni, endorsed hair dye (perhaps exploiting the link between Samson and hair). Less flattering product association was that posthumously foisted on William Cobbett: 'In his *Register* for June 1832 the late William Cobbett MP described the suffering he had endured for 22 years from the use of imperfect trusses.' Relief could have been supplied by Mr Cole's patented improved product. Technological advances in printing meant that for the first time celebrity likenesses were used on pre-packaged foods for the mass market, on pot lids for such products as relish, meat paste and sauces. The Duke of Wellington and Sir Robert Peel were all used in this way, and even Prince Albert's face appeared on tubs of shaving cream.

One can see very clearly the scaffolding of celebrity culture in the midst of which Marie was proving herself a talented architect. The dissemination of information about public figures in print was the first step, followed by dissemination of their pictorial likenesses. *Carte de visite* mania, the craze for collecting small photographic portraits of the famous, happened after Marie's death, but in her lifetime photo-graphy – or 'drawing by light' – was in fits and starts attempting to close the gap between original and copy. In an 1842 trade magazine an advertisement for Madame Tussaud's exhibition appears beside one promoting photography – at this time still being marketed as an aid for artists: 'By this process the artist will derive great advantage in having a perfectly accurate likeness, from which he can paint a por-trait, saving much of his own time and trouble as well as the time of his sitter.' While the photographic process was much improved during her lifetime, it was not until the decade immediately after her death that the commercial scope of the genre was realized.

Last but not least in the nascent cult of celebrity was the impact of mass-produced figurines. From 1843 to 1850 the growing popularity of non-royal civilian likenesses at the waxworks was mirrored by figurines of people from all walks of life – entertainers, certain popular

clergymen, and statesmen such as Wellington and Peel – becoming the must-have home accessory to place on the pianoforte, somewhere near the aspidistra. The Staffordshire potteries were but one producer which profited from this boom, and one of their best-sellers was Jenny Lind. Known as the 'Swedish Nightingale', she was one of the first entertainers to experience a mob of fans. She made her London debut in 1847, and became a favourite with the Queen. She exemplifies the advent of the celebrity as a mass-market phenomenon crossing the class divide, and naturally her likeness was installed at Baker Street. As a magazine called *The Era* put it, 'The queen in her palace, the lady in her boudoir, the men at their clubs, the merchant on the change, the clerk in his office, and indeed all sorts of people from the most exalted to the lowest members of society spoke of Jenny Lind.' Naturally her name was used by opportunist advertisers to promote goods – plausibly in the case of street ballads, but less so when it came to men's clothes. Lind hinted at a new star power that would eventually drive the aristocrats out of the ads.

One of many lessons learned at Curtius's knee was that crime paid, and the dividends for Marie and her family were particularly good in 1849 when two murder stories were national sensations. On 21 April James Blomfield Rush was executed at Norwich for the triple murder of his landlord and two members of his landlord's family. Public interest was so intense that special trains were laid on for visitors to the crime scene. Later that year, on 13 November, an estimated 50,000 people attended the public execution in London of Maria Manning and her husband, George, for the murder of her lover, Patrick O'Connor, a retired customs officer. The sexual frisson of a *ménage à trois* was enhanced by titillating reports of Maria Manning's tight-fitting black-satin dress – one paper said that the attention given to this ruined the satin industry for the next twenty years. But for Marie, watching from the wings, this was a boon. The wax figures took up their place in the Chamber of Horrors, which was permanently packed as a result of the voyeuristic interest. *Punch* once again launched a hostile attack on Madame Tussaud, who 'displays the names of the Mannings and Rush as the manager of a theatre would parade the combination of two or three stars on the same evening'. The *Art Journal* also inveighed against the glamorization of crime: 'Should such indecent additions continue

to be made to this exhibition, the horrors of the collection will assuredly preponderate. It is painful to reflect that although there are noble and worthy characters really deserving of being immortalised in wax, these would have no chance in the scale of attention with a thrice-dyed miscreant.' By way of defence, the Tussauds took to publishing the following apologia: 'They assure the public that so far from the exhibition of the likenesses of criminals creating a desire to imitate them, Experience teaches them that it has a direct tendency to the contrary.' They also decided on the back of the Mannings to expand their aversion therapy: 'The sensation created by the crimes of Rush and the Mannings was so great that thousands were unable to satisfy their curiosity.' The most telling aspect of the Victorian fascination with murder was the popularity of figurines of murderers and ceramic models of the crime scenes, at a time when Victoria's brood of rosy-cheeked princes and princesses inspired no Staffordshire portraits and comparatively few prints. Cheap accounts of murders also enjoyed a circulation of millions when national newspaper circulation was still hovering around a hundred thousand.

By questioning the status of kings as divine rulers, in the Paris of her early life the philosophers whom Marie described as family friends had set in train a process that would see the world transformed before she died. As kings and queens were demystified, they became more like the servants, not the rulers, of their subjects. Marie's wax exhibition documents a power shift from the subservience of the subject to the dominance of the fan. The last major tableau of the royal family that Marie herself lived to see installed was entitled 'Sweet Home', after 'Home, Sweet Home', a song that had greatest-hit status in the nineteenth century, selling over 100,000 copies in sheet-music form in its first year alone. It was like a theme song for an era that celebrated domesticity. It was also a suitable caption for the wax group that represented Prince Albert and Victoria at home, 'sitting on a magnificent sofa' and 'caressing their lovely children'. This image of family harmony was striking for its simple depiction of the royals as ordinary people – 'the whole intended to convey an idea of that sweet home for which every Englishman feels that love and respect which can but end with their lives'. For visitors, it was as if they had just been announced and entered the royal drawing room.

This family group was a radical view of monarchy, for it played on ideas of the royals' similarity to those viewing them, not the distance which had been so forceful in, for example, that first crowd-pleasing wax tableau of the Grand Couvert of Louis XVI and Marie Antoinette. The ceremonial at Versailles had been intended to emphasize the distance between monarch and subject – as Sénac de Meilhan had said in *Ancien Régime* France, 'It is good for the monarch to come close to his subject, but this needs to be through the exercise of sovereignty and not by the familiarity of social life. This familiarity allows too much to be seen of the man, and reduces respect for the monarch.'

It was as if very gradually the royal family were becoming an entertainment, like a family saga in one of the new mass-market inexpensive novels, of interest for their private life and personalities, and access to them in the private realm was increasingly regarded as a right. There was also a sense in which, as the royals became less regal, the middle classes subscribed with gusto to delusions of grandeur. While Victoria displayed her bourgeois taste in the style of her royal residences and convinced the public that her castles and palaces were primarily homes, the newly affluent sector of her subjects went on a frenzied buying spree to assert that the Englishman's home was his castle.

The 'Sweet Home' tableau of the Royal Family was in sharp contrast to the other major installation that people continued to flock to see, which was the shrine of Napoleon. This juxtaposition highlights the forces of change that had coursed through Marie's long life. For as the royal family seemed to become more ordinary, and were seen as similar to the public who were their subjects, individual achievers were increasingly seen as superior and different from the public who were their fans. This elevation of ordinary men into almost superhuman beings was exemplified by the cult of Napoleon. If deference for the royals was diminished, then there were quasi-religious connotations to the reverence with which the public filed past Napoleon's toothbrush and blood-stained counterpane, and stood before one of his teeth (the catalogue said that during the extraction 'the Emperor suffered much'). For Marie, Napoleon was one man who never let her down, and with whom she had a blissfully happy partnership that saw her through good times and bad, for richer and richer and richer until death did them part.

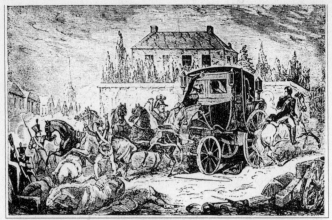

SEASON OF 1846.

M^{ADAME} TUSSAUD & SONS

Have the high gratification to state that THE GROUP of the

ROYAL FAMILY AT HOME !

CONSISTING OF

Her Gracious Majesty, Prince Albert, and their Four Lovely Children, the Prince of Wales, the Princess Royal, the Princess Alice, and Prince Alfred,
HAVE GIVEN COMPLETE SATISFACTION TO THOUSANDS. The novelties for the present season consist of a

Magnificent Display of Court Dresses,

OF SURPASSING RICHNESS,
Comprising TWENTY-FIVE LADIES' AND GENTLEMEN'S COSTUMES, intended to convey to the **MIDDLE CLASSES** an idea of **REGAL SPLENDOUR**, a most pleasing novelty, and calculated to convey to young persons much necessary instruction. Amongst them will be noticed the FULL DRESS of His Majesty

LOUIS PHILIPPE, AS LIEUT. GEN. OF FRANCE

As King of the French, worn by himself on all public occasions, with the Grand Star, Cordon, &c., of the Legion of Honour.
The truly beautiful

GREEK WARRIOR COSTUME,

Of surpassing workmanship, conveying an idea of a GREEK OFFICER in full Costume, of matchless beauty, and a curiosity for the ladies, as a specimen of NEEDLEWORK. The Ladies' Dresses comprise such as are Worn at Court by the Highest Classes. The Collection now contains upwards of ONE HUNDRED AND TWENTY PUBLIC CHARACTERS. Also,
THE MAGNIFICENT

CORONATION ROBES of GEORGE IV.

Worn and designed by himself, and which cost upwards of £18,000.

THE RELICS OF NAPOLEON,

OF SURPASSING INTEREST. The GOLDEN CHAMBER containing the Camp-bed on which he Died, the Coronation Robes, the Cloak of Marengo, and the highly celebrated MILITARY CARRIAGE, taken at Waterloo. The magnificent Rooms fitted up for the purpose, at a great expense. The recent Novelties are

THE NATIONAL GROUP OF EIGHTEEN FIGURES,

IN HONOUR OF THE DUKE OF WELLINGTON,

The Group of the House of Brunswick,

CONSISTING OF FOURTEEN CHARACTERS;
Showing the whole of the British Orders of Chivalry, never before attempted : consisting of the Robes of the Garter, Bath, St. Patrick, Thistle, and Guelph, with their Orders, &c. ; the whole producing an effect hitherto unattempted.

"THIS IS ONE OF THE BEST EXHIBITIONS IN THE METROPOLIS."—*Times.*

Bazaar, Baker-street, Portman-square.

Admission, **1s.** Children under Eight Years, **6d.** Napoleon Rooms and Chamber of Horrors, **6d.**
OPEN FROM ELEVEN IN THE MORNING TILL DUSK, AND FROM SEVEN TO TEN.
G. COLE, Printer, Carteret Street, Westminster

Napoleon's carriage illustrates poster describing the collection in its prime, 1846

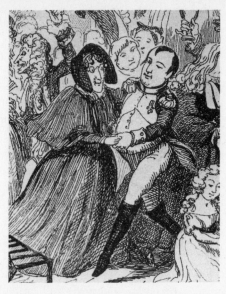

'I dreamt that Napo-le-on Bo-onaparte was dancing with
Madame Tee'
Marie's perfect partner, cartoon by George Cruikshank, 1847

Napoleon was resurrected from death by the sheer volume of com-
mercial entertainments that he featured in. Even his cancerous
stomach, preserved like a saint's relic and labelled as historical evidence
of the cause of the great man's death, could be seen at the Hunterian
Museum of the Royal College of Surgeons, until a French visitor's
protest restored it to anonymity when the card identifying the con-
troversial specimen was removed. Dickens reported the fracas when
the imperial relic was spotted: ' "Perfide Albion!" shrieked a wild Gaul
whose enthusiasm seemed as though it had been fed on Cognac.
"Perfide Albion!" again and more loudly rang through the usually
quiet hall. "Not sufficient to have your Vaterloo Bridge, your Vaterloo
Place, your Vaterloo boots, but you put violent hands on the grand
Emperor himself." . . . From that time the pathological record
of Napoleon's fatal malady has been unnumbered and – to the mil-
lions – unrecognisable.' Doing the rounds elsewhere was a wax like-
ness of the emperor with mechanical lungs. The publicity posters

screamed, 'Napoleon is not Dead! You may see and hear the phenomenon of respiration, feel the softness of the skin and the elasticity of the flesh, the existence of the bones, and the entire structure of the body.'

Increasingly there was a sense of entitlement to access to information about figures in public life. How telling that in the final years of Marie's life Victoria and Albert took legal action in an unprecedented way as a result of infringement of their privacy when family etchings were reproduced without their knowledge for the commercial market. That was a whisper of what would become amplified many times over in the next century, when there would be virtually no escape from the lens and the click that could make a million copies of a private moment. The press that Dickens satirized in *Martin Chuzzlewit* – 'Here's this morning's New York Sewer! . . . Here's this morning's New York Stabber! Here's the New York Family Spy! Here's the New York Private Listener! . . . Here's the New York Keyhole Reporter' – was both a nightmare and a prophesy.

A pertinent comment on our present-day relationship to the stars was made in a book about American cinema by Margaret Thorp, who said, '[The] desire to bring the stars down to earth is one of the trends of the times.' If gods are substituted for stars, then the statement fits Marie's achievement: she helped to bring the gods of her day down to earth. These gods were first of all the royals, and Establishment figures: then they diversified to include entertainers and performers, anticipating current attitudes. Now we don't want merely to bring the stars down to earth, but to wear the same trainers as they do. Some fans treat their bodies as temples to the various stars they revere, eating and drinking the same foods, carrying the same bags. The first stirrings of consumer imitation were happening in Marie's last years.

Her primitive form of virtual reality has entertained without pause for a great many years, and for this alone she deserves far more credit than she has received to date. In so much of what she did can be seen the faint outlines of phenomena that are immense today, and her life remains highly relevant to how we live now, illuminating and reflecting aspects of human nature that are unchanged. In the twenty-first century it is said that if you ask the average teenager

what they want to be the reply is 'Famous.' But the craving for renown was evident as early as 1843, an article in the *Edinburgh Review* makes clear:

> In short there is no disguising it, the grand principle of modern existence is notoriety; we live and move and have our being in print. What Curran said of Byron, that 'he wept for the press and wiped his eyes with the public,' may now be predicated of everyone who is striving for any sort of distinction. He must not only weep, but eat, drink, walk, talk, hunt, shoot, give parties and travel in the newspapers. The universal inference is that if a man be not known he cannot be worth knowing. In this state of things it is useless to swim against the stream, and folly to differ from our contemporaries; a prudent youth will purchase the last edition of 'The Art of Rising in the World', or 'Every Man his own Fortune-maker', and sedulously practise the main precept it enjoys – never to omit an opportunity of placing your name in printed characters before the world.

But Marie's life also shows us how we have changed. Hers was a labour-intensive as well as artistically complex way of rendering likeness. People enjoyed the results communally, in person. Today ubiquitous camera lenses make instant likenesses for consumption by a global anonymous audience. She lived on the cusp of the coming of photography that Baudelaire felt was sacrilegious, as he witnessed society 'rushing as one Narcissus to contemplate its own trivial image in the plate'. Fascination with our own likeness became bound up with changes in the expression and focus of our regard for others. Instead of the solidity of bronze and marble, wax, print and photographs are more fitting media for our more ephemeral allegiances. On two days in 1843, 100,000 people queued to see Nelson's colossal statue when it was on the ground, before it was erected on its giant plinth in Trafalgar Square and that is the biggest difference. Marie's audience still lived in the shade of heroes, whereas we live dazzled by the glare of celebrities, and measure fame in column inches.

Until shortly before she died, in her ninetieth year, Marie was frail but healthy. She had a remarkable constitution. Well into her eighties, she was described as 'as hale to appearance as when at the command of the National Convention she took the portraits in wax from the faces of Hébert, Robespierre and the other heroes of the

Reign of Terror which now figure in what she calls her Chamber of Horrors'. As meticulous a housekeeper as she was accountant, she would often personally inspect the linen and lace on the figures to ensure that they were well turned out. She remained, if not a front-of-house presence, an important force backstage, and was certainly party to the proposed expansion of the exhibition in readiness for the Great Exhibition of 1851, for which planning had already begun in earnest. Asthma had been a weakness, but old age was the reason her lungs finally stopped breathing on Monday 15 April 1850. A perfect copperplate hand recorded in the ledger, 'Madame Died.'

When she was still a novice with a lot to learn, she had been so excited when in Edinburgh, with the ambitious entry fee of two shillings, she had taken £3 14s on her first day. Advertising then was mainly a matter of handbills. In the week that she died, 800 copies of the catalogue were sold, and takings were £199 9s., despite the exhibition being closed on the day of her funeral, the Friday. Advertising now spanned twelve newspapers and – indicative of interest in train tourists – railway guides. Marie's own journey from the Boulevard du Temple to the comfortable surroundings of 58 Baker Street (the address given on her death certificate) had been pretty epic: two countries, hundreds of towns and cities, the drama of near-death, human disappointments. The woman who had arrived with a few packing cases and moulds nearly fifty years earlier, and fretted about her young sons' security, was leaving a priceless collection, a world-famous landmark that meant Messrs Tussaud were set fair for the future.

Beyond her material legacy, prestigious proof of her achievement was evident in numerous obituaries in the national press, including *The Times*, the *Pall Mall Gazette* and the *Illustrated London News*, which also published an engraving. Given the taint of institutional prejudices at this time these were notable laurels. The pages of the *Illustrated London News* tended to be stiff with titled men, people whose family trees had long and royal roots – *les vieilles riches* – and dusty clerics like Reverend Casaubon. That a waxwork proprietor, let alone a woman with a French background and a long history of travelling with a commercial exhibition, and all without a husband, should be included in the pages entitled Eminent Persons Recently Deceased was a substantial form of acknowledgement.

Many tributes, including that in the *Annual Register*, reproduced the biographical details that Marie had always fed her public. But as well as Madame Elizabeth, her class of pupils now included 'the children of Louis and Marie Antoinette'. Apart from this, there were the usual repertoire of *Ancien Régime* and Revolutionary anecdotes, including her imprisonment with Joséphine and, of course, the heads: readers were told how 'she had been employed to cast or model the guillotined heads of those she had known or loved, or those whom she had detested.'

But somehow, notwithstanding all the attention she received, acceptance of her exhibition was never quite there. While money had given her muscle, which she had flexed with serious investments and acquisitions for the business, her mass-market success had mired her for cultural purists. The rising tide of information from print, pictures and travel was for many people a peril. Packaging knowledge into forms that were particularly popular with the expanding middle class had been Madame Tussaud's aim and achievement, but many were dismissive. She still suffers from the snob's sneer. This prejudice is evident in 'a visit to Madame Tussaud's' as written for the *Illustrated Family Newspaper* in 1854: 'During a late sojourn in London, one of my first expeditions was to Madame Tussaud's, a place that everybody sees, or has seen, but which nevertheless it is the fashion in London to laugh at, as being the delight and resort of all the wonder-seeking, horror-loving country bumpkins who visit town.'

Something of the same ambivalence resonates in the initial response to one of the greatest hits for the Tussauds, a painting they commissioned from Sir George Hayter in 1852: *The Duke of Wellington Visiting the Effigy and Personal Relics of Napoleon*. This representation of the greatest living Englishman contemplating up close the greatest dead Frenchman (whom many Victorians thought the greatest man the world has ever seen) was a sensational success. But the *Illustrated London News* qualified its praise:

> At first the notion of associating the greatest living man of his age with an exhibition of waxwork may savour of somewhat questionable taste; but when we recollect that it was the only mode by which the two generals, historically connected as they were, could be brought together upon canvas, and when we know that the incident

so embodied was one of actual occurrence, the force of prejudice on this point is weakened.

The longer Madame Tussaud's was around, and the more popular it became, the more the gulf between a worthy gallery visit and fun at Tussaud;s widened in people's minds. Thackeray conveys this succinctly in his novel *The Newcomes*, describing his visitors' reaction to the sights of London: 'For pictures they do not seem to care much; they thought the National Gallery a dreary exhibition, and in the Royal Academy could be got to admire nothing but the picture of 'M'collop of M'collop' by our friend of the like name; but Madame Tussaud's interesting exhibition of waxwork they thought to be the most delightful in London.'

But off the pages of novels, in life, Madame Tussaud's left some people cold. The American visitor Benjamin Moran was unimpressed: 'So much for Madam Tussaud's exhibition of wax figures, the resort of the curious, and a sham to please or alarm. It is without misrepresentation, the most abominable abomination in the great city, and the very audience hall of humbugs. Barnum ought to have it.'

It seems more than a little ironic that on Marie's death certificate, dated 18 April 1850, under 'Occupation' is stated, 'Widow of François Tussaud'. Even in death she was shadowed by a man whose sole contribution to her signified no real giving at all. The funeral took place a few days later at the Roman Catholic chapel at the corner of Cadogan Gardens and Pavilion Road in Chelsea. One imagines plumed horses and a sufficient display of black bombazine and sombre trappings to convey just the right amount of respect, neither too ostentatious nor too frugal to put in question the family's solid middle-class propriety. It is somehow fitting with this maddeningly elusive dynasty that missing from the public domain are any references at all to Marie's passing other than funeral costs. Figures not feelings. Sixty-three pounds, four shillings and sixpence covered mourning dress for staff, six black suits for male staff, four black silk bonnets and six grey straw ('for domestics'), and an allowance for a cab for servants on the day of the funeral – all being itemised.

When Marie died, instead of their standard hangman's harvest, it was their mother's sunken features that Joseph and Francis had fixed

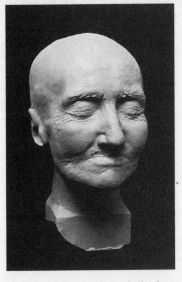

Madame Tussaud's death mask, by her sons

in white plaster. The death mask survives. There is also an unobtrusive memorial tablet on the wall of St Mary's Church near Sloane Square, the new Roman Catholic church to which her bones were removed, into a vault, when the old church was demolished: 'Of your charity pray for the repose of the soul of Madame Marie Tussaud who departed this life April XV MDCCCL aged XC years, Requiescat in pace. Amen.' But to get beneath the surface to the loves and hates, the foibles and fears of Madame Tussaud is another matter. All we have is fragments of character. But these reveal a strong one. According to a family anecdote told by her grandson Victor, Marie was persistently entreated by a neighbour in Portman Square to come and admire his own valuable art collection. Many people would have indulged an elderly man's pride and even appreciated the opportunity for aesthetic reasons, but Marie is said to have dismissed him by saying that she never visited gentlemen, and when they visited her they always paid a shilling. More telling, she is also said to have rebuked Joseph for his tears when she was on her deathbed, and asked him if he was afraid to see an old woman die. Her aversion to lawyers

was evident in the fact that she left no will, but instructed her sons to share everything. They had, of course, a formal partnership arrangement for the business.

In some ways they were liberated when she died. She had apparently been a hard taskmistress, and, irrespective of the money coming in, practised life-long frugality. Victor Tussaud once wrote to his nephew about the fiscal rules that she insisted the family lived by:

It had been a veritable living from hand to mouth. Their system of business was peculiar, but sagacious. Such items for rent, gas, insurance were placed in reserve and accumulated weekly until due, and after paying wages and incidental expenses the balance if any, for sometimes there was none to divide, was divided by two, half being devoted towards improving attractions of their exhibition, however large their receipts, and consequent temptation to add to their private purses, and then the remainder to themselves in equal shares, which sometimes had been small indeed.

Striking in the different views that we do have of Madame Tussaud is the imagery of time and money. Victor recalled her daily ritual of winding and regulating 'a dozen or more large silver watches'. Charles Dickens wrote, 'The present writer remembers her well sitting at the entrance of her own show, and receiving the shillings which poured into her exchequer. She was evidently a person of a shrewd and strong character.' This fed his portrayal of Mrs Jarley sitting 'in the pay-place, chinking silver moneys from noon till night' and entreating the crowd not to miss their chance to see her show before its imminent departure on a short tour among the crowned heads of Europe, positively fixed for the next week. ' "So be in time, be in time!" said Mrs Jarley at the close of every such address. "Remember that this is Jarley's stupendous collection of upwards of One Hundred Figures, and that it is the only collection in the world; all others being impostors and deceptions. Be in time, be in time, be in time!" '

This imagery is apt, because time and money were crucial to the might of the middle classes in Victorian England. The increase of these commodities was what determined the growth of the commercial entertainment sector that Madame Tussaud did so much to shape, and which was entering a new era when she died.

Epilogue

At the time of Marie's death, in 1850, plans were already afoot for the Great Exhibition of the Works of Industry of All Nations, which was due to open in Hyde Park in May 1851. In anticipation of the vast influx of visitors her sons decided to expand the Baker Street exhibition. A staircase was widened, and the Chamber of Horrors was enlarged. This proved to be an astute move. London swarmed with sightseers. At peak times Westminster Abbey reported a record 6,000 visitors an hour. A return visitor was amazed by the sheer numbers of people descending on Madame Tussaud's – his (not entirely credible) estimate 'belonged not to the upper ten thousand but to the lower million'. In some ways these crowds signified a vindication of the arduous years on the road, when Marie had established herself as a familiar fixture with her popular touring exhibition that blended high-minded educational value with spectacle and entertainment. At the same time, at Baker Street, 1851 marked a changing of the guard as the old generation gave way to the new. In a letter to his nephew John Theodore Tussaud, Victor Tussaud (Marie's grandson) confirmed that the Great Exhibition marked a turning point for Marie's sons. Freed from their mother's tight regulation of the accounts they could deploy profits more freely. 'I have often heard your grandfather say that it was not until then that he and his brother had any money to call their own,' Victor declared.

On the bigger stage the Great Exhibition also symbolized one era coming to an end and a new one beginning. The mass use of trains to get there and the concept of the excursion were indicative of the altered landscape in which travelling shows were fast falling out of favour. In contrast to the waning fortunes of the bawdy, gaudy entertainments always threatening to spin out of control, that had for

centuries characterized the people's pleasures in the pre-industrial age was the rise of commercial entertainments centred on cities and shaped by the prosperous middle class. The Great Exhibition signified a shift from a rural to an urban social axis and in some ways was a coming of age for Britain's increasingly confident middle-classes. In the ensuing years, civic bodies and local worthies followed in the footsteps of a generation of commercial entrepreneurs by establishing more museums, galleries, libraries and a host of amenities, calculated in part to raise the moral and cultural standards of the broader public through exposure to the highest artistic and literary achievements, both past and present. The Great Exhibition is therefore a useful vantage point from which to survey Marie's life and assess her legacy.

From the outset the event was controversial. 'The glass is very thin,' the Duke of Wellington observed, viewing Joseph Paxton's Crystal Palace that housed the exhibits as a giant greenhouse just begging for seditionaries' flying stones. Others were worried about the weight of bird droppings that might fall through the glass. These anxieties, however, masked the real fear surrounding the event, which was the prospect of the people en masse – nothing short of a vision of apocalypse in the minds of those vehemently opposed to the event. At the planning stages a proprietary stance was evident in fierce opposition to the proposed Hyde Park site. As the natural habitat of the wealthy and fashionable, the upper echelons of society, this was thought to deserve preservation from the proletariat, and there was a digging in of well-shod heels. The pages of *Punch* chronicled such fears. In a letter of appeal to the architect Sir Joseph Paxton, 'Mob' defended himself:

> Sir, My name is Mob, that is Young Mob – son of Old Mob – and the better behaved son of a wild and ignorant father. For I do assure you that I am very much reformed, and altogether better behaved than my relations of the good old times, who used to kick up a rumpus, going about like a swinish multitude.
>
> If I know how to behave myself in the British Museum shall I become a brute and a savage under your walls of crystal?

It was signed 'Your humble and obliged servant, Mr Paxton, Young Mob, alias the Masses, alias the Million'.

For the first twenty days of the Great Exhibition, the admission charge of five shillings was an effective screen. When it was reduced to one shilling *The Times* urged readers to 'make good use of the two days which remain before King Mob enters into possession'. Reports reek of prejudice. The *Illustrated London News* wrote, 'The crowd of the wealthy to whom money is no object of concern, has been succeeded by the crowd of respectable people to whom shillings are a matter of importance.' There was almost a measure of surprise that 'the rich have not abandoned the Crystal Palace because the comparatively poor have been allowed access to its treasures'. Yet the odd thing is that they did not. Even the young Queen herself freely mingled with the humbler crowds that thronged there once the price was reduced.

Odder still, however, at least in the minds of the critics, the precautions originally thought necessary to handle the masses, and to protect their social superiors from them, turned out to be unnecessary:

> Though preparations as to barricades and police were made for a crush, they were not needed. In a short time after the quiet and peaceable entrance of the few well dressed and intelligent members of the middle classes who had assembled at the doors, these ominous looking erections were with singular good taste at once removed, and the stream allowed to flow regularly without being met at the entrance with preparations for a siege.

Not far from the Great Exhibition, in Leicester Square, the enterprising Mr Wyld had attempted to capitalize on the crowds by erecting a gigantic walk-in globe – a scale model of the world, with land and sea represented in relief on its concave surfaces. If Mr Wyld showed the world turned inside out, then at the Great Exhibition it was the inversion of the social world that was on display. In fact for many people the most impressive feature of the exhibition was neither the exhibits nor the size of the crowd, but the mix of all classes and conditions. A cartoon in *Punch* entitled 'The Pound and the Shilling – whoever thought of meeting you here?' underscored this novelty. In October *The Times* noted, 'The people have now become the Exhibition.' The *Illustrated London News* reported that not only were

mistresses of households giving their maids the day off to visit the exhibition, but they were talking to them about what they had seen there:

> It has often been a matter of severe and we fear not altogether unmerited reproach that the upper and middle classes know little of their domestic servants; that they are harsh towards them for their slight faults, and that they are careless of their mental and moral improvement; and that they too often hold themselves as much aloof from them as if they were beings from another species. The Great Exhibition, if there were any real foundation for these charges, has been the means of breaking down the barriers between the employers and employed.

Yet despite the novelty of this situation, which everyone noted, common in all the reviews and retrospective interpretation of the exhibition's significance was amazement that there had been no public disorder. *Fraser's Magazine* noted, 'In the event we escaped all the horrors . . . that had been predicted for us. London was not eaten up, the Thames was not set on fire.' It concluded, 'We are led to the consideration of the order and decorum that reigned throughout over the largest congregation of sightseers ever brought together.'

The Economist devoted an entire issue to 'The multitude at the exhibition' and concluded, 'we can say that no more orderly people ever existed than the multitude of London.' This is not something, that anyone would have said a generation or two previously.

In retrospect we can now see that the Great Exhibition was a cultural crossroads, ushering in an era when leisure was more formally allied to learning. It highlighted what Marie had in fact been demonstrating for decades: the levelling effect of curiosity, and the binding elements of human interest as the basis of popular culture. In an increasingly killjoy climate, obsessed with self-improvement and worthy enterprises, entertainment was no longer simply about having fun. Rather it turned into 'recreation' – a purposeful way of using one's time. 'Recreation,' thundered one clergyman, 'is the creation anew of fresh strength for tomorrow's work.' The idea that fun could be an end in itself was becoming increasingly unacceptable. The demise of non-productive pleasures, and the didactic agenda redirected traditional entertainments as can be seen in the publicity

material for Signor Sarti's anatomical waxworks, which took a more explicitly educational approach than did Madame Tussaud's. 'The possession of Health is all the capital that the operative classes have to depend upon their maintenance; then how necessary it becomes that they should learn all they can on this important subject. The evil effects of Tight Lacing, Excessive Use of Tobacco and Immoderate Drinking are here shown.'

In many ways, Marie's exhibition was uniquely well suited to this changed climate. For decades she had offered an educational and elevating experience, directed towards her customers' nobler interests and higher aspirations – crowned heads and their robes and regalia; statesmen; military heroes; great cultural figures. Yet at the same time, with some of the more macabre relics and gruesome displays, she had acknowledged the darker side of human curiosity. And as the figures changed, with today's celebrity replacing the forgotten celebrities of yesterday, she had also paid homage to the public desire for novelty, stimulation and distraction. With her use of elegant settings, careful lighting and musical accompaniment by Messrs Tussauds and the Fishers, she had ensured that her exhibition was the sort of place that genteel, respectable people would feel pleased to frequent – a world away from the grubby scrum of the fairs, and increasingly downmarket pleasure-grounds. She recognized a tension between popular appeal and genuine cultural value that was already a subject of concern when she was a young woman in Paris: 'It is certain the Revolution has harmed letters and arts a great deal, and for a long time to come – one sees torrents of bad taste spilling over into this prodigious multitude of productions in every genre . . . Popular appeal which has at least the merit of novelty takes precedence over everything and destroys everything,' declared *La Harpe* in 1791.

Yet, whatever tension contemporaries may have detected between gentrified entertainment and mass-market interest, Marie's strategy paid off. At her death her exhibition was the height of fashion. Aristocrats and senior political and cultural figures had passed through its doors. It was an elegant resort with a museum-quality collection of *objets d'art* and a particularly strong collection of French paintings, including originals by David and Boucher. And the formula was durable. Long after the demise of its plucky founder, through the

efforts of her sons Madame Tussaud's retained its status as the first port of call for a tourist in London. The vast numbers of visitors included many famous faces. Not all were impressed, however. 'Unspeakable and overpriced' was Verlaine's verdict when he went there with Rimbaud. Their compatriot the elder Alexandre Dumas was more generous: 'Every personage who basks in the sunshine of fame can knock on Madame Tussaud's door and demand entry; her hospitality is practised on a most lavish scale . . . She exhibits not only persons but things.' As the creator of *The Three Musketeers*, Dumas was particularly interested in the Revolutionary relics. 'Having sent so many of my heroes to the scaffold,' he wrote, 'I feel it is the least I can do to study it at first hand. I have seen pictures of it, of course, but that is far from being the real thing. I therefore found my way to the famous guillotine of Madame Tussaud, or rather of Monsieur Sanson, as the inscription on the wall informed us.' Over the years, literary allusions to the exhibition occurred in the works of, among others, Thomas Hardy, William Makepeace Thackeray and Henry James, who refers to it in *The Golden Bowl*.

The longevity of Madame Tussaud's as an institution spotlights the paradox inherent in the international renown of her name compared with her comparative personal obscurity. The story that Marie told about her life – and in particular the remarkable shift from court modeller to unwilling handmaiden of the Revolution, and thence to cultural entrepreneur – indulged her audiences' very human craving for closeness to famous historical figures, played out through the wax likenesses that Marie displayed in her exhibition. It mattered to her early audiences that the wax on show had somehow been in contact with the world-famous figures depicted there, just as it mattered that the woman who was responsible for displaying these relics had been close to the individuals whom the relics recalled. Such closeness conferred an aura of authenticity on what might otherwise have looked like crass showmanship. The displays were not simply about history – as Dumas's reference to 'the real thing' suggests – they were themselves part of history and valued as such by those who flocked to see them.

Today it is possible to look back on those early days with a more critical eye. In a sense, Marie's legacy speaks for itself. Yet her fame masks an even more fascinating tale. Of far more interest than her

claims to have known virtually the entire cast of the French Revolution is why she made such claims and why she told her story as she did. There is in fact no evidence to support most of her assertions about her early life. Many of them may not be true. Yet this hardly matters. The creation of the myth is an achievement in itself, just as the success of her exhibition is incontestable evidence of her commercial acumen, her understanding of the market for her work, and her brilliance as a cultural innovator.

If history is about fabricating the past in the present then it is plausible that Marie artfully crafted a story with a cast and plot that would be guaranteed to woo her audience and moreover complement the relics and figures in the exhibition. Her exhibits and her story mutually reinforced themselves. She let people get close to the famous both physically and also via her personal narrative, which, rich with anecdote, was a form of celebrity gossip – inside information about clothes, hairstyles and private moments. This particular narrative also set her apart from the competition. It was her unique selling point and an inspired marketing tool – a much more sophisticated form of the showman's spiel. In her flair for publicity she really did rival Mrs Jarley's 'inventive genius'. The personal achievement this reflects matters more than the obscurity and improbability of aspects of her early years.

If we have scant evidence to corroborate Marie's tales of her life in France, her life in England was played out in public and presents us with a story every bit as compelling if less often told. Her success is all the more impressive for having been achieved in a time of female semi-serfdom exemplified by these lines of Tennyson:

> Man for the field and woman for the hearth:
> Man for the sword and for the needle she:
> Man with the head and woman with the heart:
> Man to command and woman to obey;
> All else confusion.

As far as we can tell, head not heart governed her life. Hers is a story not about love, but about money – and more money than most Victorian men dreamed of making. It is the story of a woman who was not a pale, domestic creature swooning with delicate sensibilities,

but rather a hard-nosed, hard-working artist who in another life might have earned a different type of recognition in the world of fine art but who, as it was, made an unparalleled career for herself in business. It is a story where the woman is not a performer, a beauty or a dutiful wife, but rather an astute career woman who ultimately triumphed over all competition. It is, as we know today, the story of a woman who founded an entertainment empire that continues to expand. (Madame Tussaud's, Shanghai, is scheduled to open in 2006; branches already exist in Amsterdam, New York, Las Vegas and Hong Kong.) It is ultimately a grand-scale success story – of how with nothing more than entrepreneurial flair, commitment and sheer graft a woman born in 1761 to an eighteen-year-old cook built the first and most enduring worldwide brand to be identified simply by reference to its founder's name: Madame Tussaud's. It is a story that, through her exhibition, continues. The longest queue in history is a fitting monument to her achievement.

There once was a Madame called Tussaud
Who loved the grand folk in Who's Who, *so*
That she made them in wax,
Both their fronts and their backs,
And asked no permission to do so.

Punch, 1919

Acknowledgements

For the privilege of being able to pursue my interest in Madame Tussaud I extend warm thanks to Roland Philipps. For extending the reach of my enthusiasm I thank Claire Wachtel and Iris Tupholme. For negotiation and navigation, cajoling and consoling as appropriate I am greatly indebted to Natasha Fairweather. For efficient steering of production I thank Rowan Yapp. For all her efforts on my behalf including many helpful leads I am immensely grateful to Undine Concannon. For generosity of spirit in response to enquiries, Patrick Crabbe, Michael Herbert, Graham Jackson and Michael and Curzon Tussaud must all take credit for the contribution they made – as must William Doyle, who in the dark, daunting days before the first words were written whetted my appetite for eighteenth-century French history and suggested a reading list which set me on a good course for understanding the context of my subject's early life. For creative mid-wifery and incisive criticism Bunny Smedley has no equal. For helping me to mine the rich seams of the John Johnson Collection of Printed Ephemera at the Bodleian Library I am especially grateful to Julie Ann Lambert. I also tip my hat to Guy Penman and John Huggett at the London Library and to Rosie Broadley for specialist digging on my behalf, to Susanna Lamb at Madame Tussauds, London, for generous help in sourcing pictures, and likewise to Jeremy Smith and Geremy Butler at the Guildhall Library, Georgina French at the Bridgeman Art Library, Helen Trompeteler at the National Portrait Gallery, Stephanie Fawcett at the Victoria & Albert Museum, and Ian Kerslake at the British Museum. Finally, for patience and perspective that were bright beams throughout, to Sebastian my heartfelt gratitude.

Sources

FRANCE 1761–1802

On Marie's early life in France

Madame Tussaud's Memoirs and Reminiscences of France, Forming an Abridged History of the French Revolution, ed. Francis Hervé (Saunders & Otley, 1838)

On the sights, smells, fads, fashions and feel of the Paris Marie knew

Louis-Sébastien Mercier, *Tableau de Paris* (12 vols., Amsterdam, 1782–8) – an invaluable resource: vivid and vibrant, it was described by a contemporary as having been 'composed on the street and written on a doorstep'; selections have been published in English as
—— *The Panorama of Paris*, trans. Helen Simpson, with a new preface and translation of additional articles by Jeremy Popkin (Pennsylvania State University Press, 1999)
—— *The Picture of Paris before and after the Revolution*, trans. Wilfrid and Emilie Jackson (Routledge, 1929)
—— *The Waiting City: Paris 1782–1788*, trans. Helen Simpson (Harrap, 1933)

On domestic life, lighting, food, water supply

Annik Pardaihlé-Galabrun, *The Birth of Intimacy: Privacy and Domestic Life in Early Modern Paris* (Polity Press, 1991)

On shopping, fashion and trends

Christopher Todd, 'French Advertising in the Eighteenth Century', *Studies on Voltaire and the Eighteenth Century* 266 (1989), 513–47

Robert Darnton, *The Great Cat Massacre and Other Episodes in French Cultural History* (Basic Books, 1984) – excellent on responses to Rousseau

Carolyn Sargentson, *Merchants and Luxury Markets: The Marchands Merciers of Eighteenth-Century Paris* (Victoria & Albert Museum, 1996)

Anny Latour, *Kings of Fashion*, trans. Mervyn Savill (Weidenfeld & Nicolson, 1958)

Leo Braudy, *The Frenzy of Renown* (Oxford University Press, 1986) – this classic text on the history of fame was an important resource for the changing marketplace of fame

Rebecca Sprang, *The Invention of the Restaurant* (Harvard University Press, 2000)

On celebrity hairdresser Léonard, and celebrity milliner/stylist Rose Bertin

Emile Langlade, *Rose Bertin the Creator of Fashion at the Court of Marie-Antoinette*, trans. Angelo S. Rappoport (Long, 1913)

Madge Garland, 'Rose Bertin Minister of Fashion', *Apollo* 87, January 1968, 40–44

Jean Léonard Autié, *Recollections of Léonard, Hairdresser to Queen Marie-Antoinette*, trans. E. Jules Meras (Greening & Co.,1912)

On having fun – fairs and popular entertainment

R. Laffont (ed.), *Paris and its People: An Illustrated History* (Methuen, 1958)

Robert Isherwood, 'Entertainment in Eighteenth Century Paris Fairs', *Journal of Modern History* 53 (March 1981), 24–48

—— *Farce and Fantasy: Popular Entertainment in Eighteenth-Century Paris* (Oxford University Press, 1991) – this and the following title are scholarly and accessible classics, invaluable for putting Curtius in context

Michèle Root-Bernstein, *Boulevard Theater and Revolution in Eighteenth Century Paris* (UMI Research Press, 1984)

John Lough, *Paris Theatre Audiences in the Seventeenth and Eighteenth Centuries* (Oxford University Press, 1957)

On life at the palace of Versailles

Cecilia Hill, *Versailles Life and History* (Methuen, 1925)

Jacques Levron, *Daily Life at Versailles in the Seventeenth and Eighteenth Centuries*, trans. Claire Elaine Engel (Allen & Unwin, 1968)

Norbert Elias, *The Court Society*, trans. Edmund Jephcott (Blackwell, 1983) – a classic study of court protocol and the private being performed in public

Antonia Fraser, *Marie Antoinette: The Journey* (Phoenix, 2000)

Margaret Trouncer, *Madame Elisabeth: Days at Versailles and in Prison with Marie Antoinette and her Family* (Hutchinson, 1955)

Memoirs, eyewitnesses, first-hand flavour

Madame Campan, *Memoirs of the Private Life of Marie Antoinette Queen of France and Navarre* (2 vols., 3rd edn, Colburn, 1823)

Madame de La Tour du Pin, *Escape From the Terror: The Journal of Madame de La Tour du Pin* (Folio Society, 1979)

John Lough (ed.), *France on the Eve of the Revolution: British Travellers' Observations 1763–1788* (Croom Helm, 1987)

Arthur Young, *Travels in France and Italy During the Years 1787, 1788, 1789* (Bell, 1900)

Hester Lynch Thrale, *The French Journals of Mrs Thrale and Dr Johnson*, ed. Moses Tyson and Henry Guppy (Manchester University Press, 1932)

Letters of Jefferson 1787 (Hale & Co., New York, n.d.)

Anne Carey (ed.), *Diary and Letters of Gouverneur Morris* (Morris, 1889)

Nikolai Karamzin, *Letters of a Russian Traveler 1789–90*, trans. Florence Jonas (Columbia University Press, 1957)

On the Palais-Royal

Mark Girouard, 'Rout to Revolution', *Country Life* 179i, 30 January 1986

J. Adhémar, 'Les musées de cire en France, Curtius, le banquet royal, les têtes coupées', *Gazette des Beaux-Arts* 92 (1978), 203–214

Evelyn Farr, *Before the Deluge: Parisian Society in the Reign of Louis XVI* (Peter Owen, 1994)

Darrin McMahon, 'The Birthplace of the Revolution: Public Space and

Political Community in the Palais-Royal of Louis-Philippe-Joseph d'Orléans', *French History* 10 (1996)

On the broader social background and changing social climate

Daniel Roche, *The People of Paris: An Essay in Popular Culture in the Eighteenth Century* (University of California Press, 1987)

David Garrioch, *The Making of Revolutionary Paris* (University of California Press, 2002)

Tim Blanning, *The Culture of Power and the Power of Culture: Old Regime Europe 1660–1789* (Oxford University Press, 2002)

George Rudé, *The Crowd in the French Revolution* (Oxford University Press, 1959)

Simon Schama, *Citizens: A Chronicle of the French Revolution* (Viking, 1989)

Colin Jones, *The Great Nation: France from Louis XV to Napoleon, 1715–1799* (Allen Lane, 2002)

William Doyle, *Origins of the French Revolution* (Oxford University Press, 1963)

——*The Oxford History of the French Revolution* (Oxford University Press, 1989)

On the outbreak of the Revolution

David McCallum, 'Waxing Revolutionary: Reflections on a Raid on a Waxworks at the Outbreak of the French Revolution', *French History* 16 (2002)

Thomas Carlyle, *The French Revolution: A History*, ed. J. Holland Rose (Bell, 1913)

Jacques Godechot, *The Taking of the Bastille*, trans. Jean Stewart (Faber, 1970)

On the progress of the Revolution, 1789–1794

Mona Ozouf, *Festivals and the French Revolution*, trans. Alan Sheridan (Harvard University Press, 1988)

David Lloyd Dowd, *Pageant-Master of the Republic: Jacques-Louis David and the French Revolution* (University of Nebraska Press, 1948)

Anita Brookner, *Jacques-Louis David* (Chatto & Windus, 1980)

Thomas E. Crow, *Painters and Public Life in Eighteenth Century Paris* (Yale University Press, 1985)

Helen Hinman, 'Jacques Louis David et Madame Tussaud', *Gazette des Beaux-Arts* 66 (1965), 331–338

Tessa Murdoch, 'Madame Tussaud and the French Revolution', *Apollo* 130i, July–September 1989

Simon Lee, 'Artists and the Guillotine', *Apollo* 130i, July–September 1989

David Bindman, *The Shadow of the Guillotine: Britain and the French Revolution* (British Museum Publications, 1989)

Aileen Ribeiro, *Fashion in the French Revolution* (Batsford, 1988)

Gwyn Williams, *Artisans and Sans-Culottes: Popular movements in France and Britain during the French Revolution* (Libris, 1989)

Albert Soboul, *The Parisian Sans-Culotte and the French Revolution, 1793–4*, trans. Gwynne Lewis (Clarendon Press, 1964)

George Pernoud and Sabine Flaissier, *The French Revolution*, trans. Richard Graves (Secker & Warburg, 1960)

Jean Robiquet, *Daily Life in the French Revolution* (1938), trans. James Kirkup (Weidenfeld & Nicolson, 1964)

Linda Kelly, *Women of the French Revolution* (Hamish Hamilton, 1987)

Frédéric Loliée, *Prince Talleyrand and his Times*, trans. Bryan O'Donnell (John Long, 1911)

On the Terror

Daniel Arasse, *The Guillotine and the Terror*, trans. Christopher Miller (Lane, 1989)

Philip Gwyer and Peter McPhee (eds.), *The French Revolution and Napoleon: A Sourcebook* (Routledge, 2002)

David Jordan, *The King's Trial: The French Revolution vs Louis XVI* (University of California Press, 2004)

Olivier Blanc, *Last Letters: Prisons and Prisoners of the French Revolution* (André Deutsch, 1987)

Eyewitnesses

Gouverneur Morris, *A Diary of the French Revolution*, ed. Beatrix Carey Davenport (Harrap, 1939)

The Reign of Terror: A Collection of Authentic Narratives of the Horrors Committed

by the Revolutionary Government of France under Marat and Robespierre (Leonard Smithers, 1899)

Grace Elliott, *Journal of My Life during the Revolution* (Rodale Press, 1859)

Peter Vansittart (ed.), *Voices of the French Revolution* (Collins, 1989)

Colin Jones (ed.), *Voices of the Revolution* (Salem House, 1988)

Aftermath

Jean Robiquet, *Daily Life in France under Napoleon*, trans. Violet Macdonald (Allen & Unwin, 1962)

Martin Lyons, *Napoleon Bonaparte and the Legacy of the French Revolution* (Macmillan, 1994)

ENGLAND 1802–1850

On waxworks

E. J. Pyke, *A Biographical Dictionary of Wax Modellers* (Oxford University Press, 1975)

On interest in Napoleon

Alexandra Franklin and Mark Philp, *Napoleon and the Invasion of Britain* (Bodleian Library, 2003)

Stuart Semmel, *Napoleon and the British* (Yale University Press, 2004)

On fairs and popular entertainment

Thomas Frost, *The Old Showman and the Old London Fairs* (Chatto & Windus, 1881)

Cornelius Walford, *Fairs, Past and Present* (Elliot Stock, 1883)

David Kerr Cameron, *The English Fair* (Sutton, 1998)

Mervyn Heard, 'Paul de Philipstal and the Phantasmagoria in England, Scotland and Ireland', part one, *New Magic Lantern Journal* 8 (1996) October: part two 8 (1997) October – two outstanding articles by a magic lantern maestro

Duncan Dallas, *The Travelling People* (Macmillan, 1971)

M. Willson Disher, *The Greatest Show on Earth as Performed for over a Century at Astley's . . . Royal Amphitheatre of Arts* (Bell, 1937)

Hugh Honour, 'The Colosseum', *Country Life*, 113i, 2 January 1953

—— 'Egyptian Hall', *Country Life*, 115i, 7 January 1954

Aleck Abrahams, 'Curiosities of the Egyptian Hall', *The Antiquary*, 1907

Richard D. Altick, *The Shows of London* (my desert-island book – a magisterial and magical history of exhibitions in the capital) Belknap Press, 1978

Ricky Jay, *Extraordinary Exhibitions . . . Broadsides from the Collection of Ricky Jay* (Quantuck Lane Press, 2005) – ephemera-based enchantment

—— *Learned Pigs and Fire-Proof Women* (Robert Hale, 1987) – completely charming

Herman Furst von Pückler-Muskau, *A Regency Visitor: The English Tour 1826–1828* (Collins, 1957)

On London, 1835–1850

Charles Knight (ed.), *London* (Charles Knight & Co., 3 vols., 1841) – an excellent profile of the Victorian city emerging from Georgian London

The Shows of London (as above)

John Timbs, *Curiosities of London: Exhibiting the Most Rare and Remarkable Objects of Interest in the Metropolis with nearly 60 Years of Recollections* (London, 1855)

Thomas Shepherd, *London Interiors: A Grand National Exhibition of the Religious, Regal and Civic Solemnities, Public Amusements, Scientific Meetings and Commercial Scenes of the British Capital 1841–1844* (Joseph Mead, 1841)

David Bartlett, *What I Saw in London, or Man and Things in the Great Metropolis* (Derby & Miller, 1852)

P. T. Barnum, *The Life of P.T. Barnum Written by Himself* (Sampson Low, 1855)

Raymund Fitsimons, *Barnum in London* (Geoffrey Bles, 1969)

Charles Dickens

Charles Dickens, *The Pickwick Papers* (inc. *Pickwick Advertiser*), monthly, April 1836 to November 1837

—— *Nicholas Nickleby* (inc. *Nickleby Advertiser*), monthly, April 1838 to October 1839

—— *The Old Curiosity Shop*, *Master Humphrey's Clock*, weekly, April 1840 to February 1841

—— *Oliver Twist*, monthly, February 1837 to April 1839

—— *A Tale of Two Cities* (Penguin, 2000)

—— 'Our Eyewitness' in 'Great Company' *All the Year Round*, 31 December 1859 and 7 January 1860

Michael Slater (ed.), *Dickens's Journalism*, vol. 2: *The Amusements of the People and Other Papers: Reports, Essays and Reviews 1834–51* (Dent, 1996)

Bernard Darwin, *The Dickens Advertiser* (Elkin Matthews & Marrot, 1930)

Paul Schlicke, *Dickens and Popular Entertainment* (Allen & Unwin, 1985)

On advertising

'A Paper on Puffing', *Ainsworth's Magazine*, July 1842

'The Advertising System', 77, *Edinburgh Review*, February 1843

Charles Dickens, 'Bill-Sticking', *Household Words*, 2 March 1851

'Advertisements', *Quarterly Review* 98 (June–September 1855)

The Grand Force, Frasers Magazine, 79, March 1869

Henry Sampson, *A History of Advertising* (Chatto & Windus, 1874)

On change, and the Victorian world view

John Copeland, *On Roads and their Traffic 1750–1850* (David & Charles, 1968)

Richard Altick, *The English Common Reader: A Social History of the Mass Reading Public 1800–1900* (Oxford University Press, 1957)

—— *The Presence of the Present: Topics of the Day in the Victorian Novel* (Ohio State University Press, 1991)

H. Turner, *A Collector's Guide to Staffordshire Pottery Figurines* (MacGibbon & Kee, 1971)

Thomas Balston, *Staffordshire Portrait Figures of the Victorian Age* (Faber, 1958)

Cyril Williams-Wood, *Staffordshire Pot Lids and their Potters* (Faber, 1972)

Louis James, *Print and the People 1819–1851* (Allen Lane, 1976)

Thomas Carlyle, *On Heroes, Hero Worship and the Heroic in History* (James Fraser, 1841)

—— *Past and Present* (Oxford University Press, 1843)

—— *Sartor Resartus, The Tailor Retailored* (1833–4)

Helmut and Alison Gernsheim, *L. J. M. Daguerre. The History of the Diorama and the Daguerreotype* (Secker & Warburg, 1956)

On Madame Tussaud

Although I have taken a very different route, the following authors who made earlier journeys helped me to plot my course:

Leonard Cottrell, *Madame Tussaud* (Evans, 1951)

Anita Leslie and Pauline Chapman, *Madame Tussaud: Waxworker Extraordinary* (Hutchinson, 1978)

Pauline Chapman, *The French Revolution as Seen by Madame Tussaud, Witness Extraordinary* (Quiller Press, 1989)

—— *Madame Tussaud in England* (Quiller Press, 1992)

Teresa Ransom, *Madame Tussaud* (Sutton Publishing, 2003)

On Madame Tussaud's

John Theodore Tussaud, *The Romance of Madame Tussaud's* (Odhams Press, 1921)

Edward Gatacre and Laura Dru, 'Portraiture in le cabinet de cire Curtius and its successor, Madame Tussaud's Exhibition', conference paper ('atti del I congresso internazionale sulla ceroplastica nella scienza e nell'arte', Florence, 1975)

Pamela Pilbeam, *Madame Tussaud and the History of the Waxworks* (Hambledon & London, 2003) – an excellent academic but accessible study spanning the origins of exhibition to the present day

Sources for the Epilogue

Peter Bailey, ' "A Mingled Mass of Perfectly Legitimate Pleasures": The Victorian Middle Class and the Problem of Leisure', *Victorian Studies* 21, 4 (summer 1978) 7–28

The Economist, 31 May 1851

—— 26 October 1850

—— 28 October 1851

Fraser's Magazine, January 1852

Illustrated London News, May, June, July 1851

Punch, 13 April 1850 and 1 February 1851

Other sources

Ephemera, catalogues, posters, advertisements, newspapers and periodicals in the Guildhall Library, the London Library, the British Library, the British Library Newspapers Collection at Colindale, the Theatre Museum, The Dickens Museum, the John Johnson Collection of Printed Ephemera, the Bodleian Library, and Madame Tussauds Archives in Acton and Marylebone

Index

Numerals in italics denote illustrations.

337

Dickens, Charles: *A Tale of Two Cities*, 116; on Chamber of Horrors, 146, 268–9; Mrs Salmon's waxworks in novels, 184; *David Copperfield*, 184; Sarah Beffen in novels, 220; *Little Dorrit*, 220; *Nicholas Nickleby*, 220; *The Old Curiosity Shop*, 220, 232, 265, 270; comparison with MT, 263–5; *Pickwick Papers*, 263, 264; *Sketches by Boz*, 263; on MT, 269, 270–2, 314; patronage of MT, 269; omission from Tussaud exhibition, 272–3; *Our Mutual Friend*, 275; on MT's coronation tableaux, 278; on fairs, 280; on test-driving Napoleon's carriage, 280; on Tom Thumb, 288; on the Colosseum, 291; celebrity status, 300–1; on Napoleon's relic, 307; *Martin Chuzzlewit*, 308

Diderot, Denis, 21; letter to Voltaire, 13; (with d'Alembert), *Encyclopédie*, 13

Dillon, Henrietta-Lucy *see* Tour du Pin, Madame de La (*née* Henrietta-Lucy Dillon)

dioramas, 262–3

Directory (France), 170; life under, 170–2; dress of the directors, 171

Disraeli, Benjamin: on rich–poor divide, 251

Dover: MT in, 180, 256

dress: deception of, 17–19; second-hand clothes, 17; liberation in, 36; importance of dress for MT's models, 38, 75–6, 78, 121, 133, 171, 222, 269; MT's attention to dress detail, 38, 75, 133, 269; 'cleaning', 46; MT's memoirs as costume history, 75, 133; change of function, 77; meltdown of metal accessories, 121; sans-culottes, 132–4; and political allegiance, 133–4; MT's doormen's uniforms, 163; multicultural under the Directory, 170–1; Napoleon, 173–4; MT's own, 222; *see also* fashion(s)

Du Barry, Madame (*née* Jeanne Bécu), 15; modelled by Curtius, 15, 80, 152; MT on, 204

Dublin: MT in, 206–7, 209; *see also* Ireland

Ducrow, Andrew (stunt rider), 219, 253

Dugazon, Madame (actress), 129

Dumas, Alexander, the elder, 320

Durham: MT in, 250

Eastlake, Sir Charles: portrait of Napoleon, 242

economic disasters: fashions and entertainments based on, 37, 50; fiscal collapse in 1795, 168

Economist, The, 318

Edgeworth, Maria: on George IV, 245

Edinburgh, 199; French émigrés in, 199, 201; MT in, 199–201, 203, 240; MT's voyage to, 200; opening hours of MT's exhibition, 202; MT's closing of Edinburgh exhibition, 205

Edinburgh Evening Courant, 199, 201, 204, 205

Edinburgh Review, 309

education: and entertainment, England, 188, 216, 253, 281, 289, 291, 319; pedagogical function of museums, 2; France, the Church and, 13–14; and MT's exhibition, 165, 185, 204, 223–4, 232, 257, 271–2, 288; and voyeurism, 230

Egyptian Hall, 219, 242, 290–1

Eliott, Grace: on Marie Antoinette, 76; memoir of the French Revolution, 113; on diminishing respect for royal family, 125; on riot at Comédie Italienne, 129; on revolutionary theatre, 154–5

Elizabeth, Madame (sister of Louis XVI), 62; and MT, 61, 62–3; character and appearance, 63; MT on, 65; at Comédie Italienne, 129; execution, 156–7

endorsements: royal, 49, 256–7, 264; MT's, 256–7, 301–2

England, 216–17; influence on French, 83, 84; French Revolution memorabilia, 115; Anglo-French relations, 179, 199, 279; Treaty of Amiens, 179, 198; war with France, 198–9; fear of the crowd, 216, 244; middle classes, 216, 226, 305; inequality, 217; communications, 218; provincial towns, 219; travelling shows, 219–21; national institutions, public relations and, 281–2; changes, 300–1; rise in technological innovation, 300; *see also* London

Enlightenment writers: state control, 35

entertainment: waxworks as, 44–5

entertainment(s): elite and popular, 30–1, 289, 316, 319; hierarchy in Paris, 30; increased interest in light entertainment in Paris, 30, 31–2, 35; Palais-Royal, Paris, 32; based on serious subjects, 37; range in Paris, 40; and war, Paris, 130; under the Directory, 170–1; education and, England, 188, 216, 253, 281, 289, 291, 319; gentrification in England, 216; gentrification of pleasure, England, 216; pictorial, increase in, 262–3; MT's understanding of, 281; and 'recreation', 318, *see also* fun; commercial *see* commercial entertainment

entrance fees *see* admission fees

Eon, Chevalier d', 18–19

ephemeral interests: culture of impermanence, 5, 23, 124; in celebrities, 24–5, 277–8

Era, The, 303

escapism, 44–5

Ewing: wax exhibition, 237

execution: Grosholtz family as executioners, 10; capital punishment, 131; memorabilia, 190; *see also* guillotine

exoticism: exhibitions of, 26